NATIONAL GALLERY OF IRELAND
ILLUSTRATED SUMMARY CATALOGUE OF PAINTINGS

Front cover shows a detail from *The Dillettanti:* Jeronimus Tonneman and His Son Jeronimus by Cornelis Troost, painted in 1736.

Back cover shows a detail from *A Scene in the Phoenix Park* by Walter Osborne.

NATIONAL GALLERY OF IRELAND

Illustrated Summary Catalogue of Paintings

Introduction by
Homan Potterton, Director

Gill and Macmillan

First published 1981 by
Gill and Macmillan Ltd
Goldenbridge
Dublin 8
with associated companies in
London, New York, Delhi, Hong Kong,
Johannesburg, Lagos, Melbourne,
Singapore, Tokyo

7171 1145 8

British Library Cataloguing in Publication Data
National Gallery of Ireland
National Gallery of Ireland illustrated summary
catalogue of paintings.
1. National Gallery of Ireland—Catalogs
I. Title II. Potterton, Homan
759.94 N1250

ISBN 0-7171-1144-X
ISBN 0-7171-1145-8 Pbk

The National Gallery of Ireland acknowledges the generous
patronage of Allied Irish Banks Limited, Ireland, which
enables the proceeds of sale of this Catalogue to be used
to the benefit of the Gallery.

Origination by Healyset, Dublin
Printed by Criterion Press Ltd, Dublin
Bound by John F. Newman and Son Ltd, Dublin

PREFACE

This Catalogue lists the basic data on all the paintings (in oil, tempera, etc) in the National Gallery of Ireland, including those on indefinite loan and in store. Accompanying each description is an illustration of every painting. The Catalogue excludes the collection of watercolours and drawings which, it is hoped, will be published in a subsequent similar volume.

The book therefore illustrates 2,200 paintings, of which perhaps one half or more have never before been illustrated. The text of the Catalogue is based on the concise *Catalogue of the Paintings* prepared by Michael Wynne and published in 1971. To this has been added all the acquisitions made during the following decade (up to December 1980). The Introduction, which relates the history of the Gallery, draws on unpublished material contained in the minutes of the meetings since 1854 of the Board of Governors and Guardians. The Appendices (prepared by Fintan Cullen, Adrian Le Harivel and Anne Millar) represent the first attempt ever at listing pictures according to subject matter and provenance.

The preparation of the Catalogue has placed a considerable burden on most of the small number of people employed in the National Gallery of Ireland and, not least, because of the brisk schedule that was set for publication. A number of pictures had to be specially surface-cleaned and varnished (by our restorers Andrew O'Connor and Sergio Benedetti) prior to photography (by Michael Olohan and John Kellett). Every photograph had to be assembled and checked (by John Hutchinson, Barbara Dawson and Adrian Le Harivel). The preparation of the text, incorporating corrections, new attributions and acquisitions, was carried out by Adrian Le Harivel and Michael Wynne. In writing that part of the Introduction which deals with the building, I have drawn heavily on material assembled for me by Catherine de Courcy and the Gallery library staff. For myself, and on behalf of the Board of Governors and Guardians who have supported the project from the outset, it is a pleasure to record a debt of gratitude to these and all members of staff in the Gallery.

The Catalogue has been published by Gill and Macmillan of Dublin and we are grateful to Michael Gill for his personal supervision of the project, and Deirdre Rennison for her practical assistance in seeing it to fruition.

The thanks of the National Gallery of Ireland, and those readers who may derive benefit from this *Illustrated Summary Catalogue of Paintings*, must go to our sponsors Allied Irish Banks Limited, Ireland, who have generously financed the entire production costs of the book. For the Gallery, this sponsorship means not only the publication of the Catalogue, but also a long-term endowment as the entire proceeds of sale of the paperback edition will accrue to the benefit of the National Gallery of Ireland.

Homan Potterton
Director
National Gallery of Ireland
Dublin
July 1981

FOREWORD

The National Gallery of Ireland is part of the heritage of Ireland. Since it was founded in 1854, it has been fortunate in having a succession of dedicated Boards of Governors and Guardians, distinguished Directors and generous Patrons. In consequence, the Gallery justifiably is well regarded among the National Galleries of the world.

The support which a country gives to its National Gallery and the interest which it takes in seeing that its treasures are cherished and protected must surely be an indication of the maturity of that country. The Gallery in turn has a duty to make its treasures readily available to the public, together with sufficient documentation and information to afford visitors to the Gallery a deeper appreciation of the Collection.

Allied Irish Banks is honoured to have an opportunity to act as Patron to the publication of this comprehensive illustrated Catalogue of the paintings in Ireland's National Gallery.

Niall Crowley
Chairman
Allied Irish Banks Limited
Dublin
July 1981

CONTENTS

KEY TO CATALOGUE ENTRIES

1. Artist's surname and first name
 or anglicised name (e.g. Titian)
 or name in common usage (e.g. Fra Angelico)
 or painting school if the artist is not yet identified. A hyphenated title, such as Flemish-French School, denotes an unknown Flemish artist working in France.
 Pictures painted in collaboration are listed under the name of the principal painter.
 Attributed to X: similar to signed or documented pictures by the artist
 Studio of X: painted in the artist's studio
 Circle of X: painted in the artist's milieu
 School of X: painted by a contemporary in the artist's style
 Follower of X: a later imitator of the artist
 After X: a later copy or pastiche of the artist's work
2. Dates of birth and death if known, or period when active as an artist, e.g. fl(oruit) 1840-75.
3. Painting school (town, region or country) with which the artist is associated; all artists of the Irish School are listed together (pp. 189-311).
4. Permanent Catalogue number. Pictures from the Sir Alfred Chester Beatty Gift carry the suffix CB.
5. Picture title or portrait sitter(s).
6. Any signature or relevant inscription.
7. Measurements in centimetres: height x width (x depth for 4170, 4171).
8. Medium and support: all pictures are understood to be in oil on canvas unless otherwise stated.
9. Provenance of picture.

INTRODUCTION

On a cold January day in 1864, in an age when Ireland was 'making all the rapid strides in the onward and upward march of material prosperity and social elevation', those already successful in the march — among whom were several ladies — elevated themselves still further on open banked seats on a site on Leinster Lawn facing Merrion Square. Before the assembly was a colossus covered in green baize: it was the statue of William Dargan by Thomas Farrell (1827-1900) which was shortly to be unveiled by the Lord Lieutenant, the Earl of Carlisle. Adjacent to the 'immense throng of ladies, noblemen and gentlemen' was a building (Fig. 1) which, 'although neither attractive nor striking, presented a massive and permanent appearance'. It was the new National Gallery of Ireland. Lord Carlisle and his suite, preceded by outriders, arrived shortly before two o'clock, unveiled the statue and, subsequently, from a dais at the east end of the picture gallery (Fig. 2) on the first floor of the building, inaugurated the National Gallery, and withdrew. The visitors remained to 'lounge through the galleries for some time admiring what they saw, and passing the highest eulogiums on both the galleries and the works which they contained'. And so *The Daily Express* described the opening of the National Gallery of Ireland.

The Gallery as it appeared on that day has remained, with the exception of additions and decor, largely unchanged. The annex that flanked the main building at the east end was subsequently altered in 1902 to form what is now a central portico; but in 1864 it was a vestibule and 'court' called the Nineveh and Egyptian Court as it housed plaster casts of Egyptian sculpture. The main hall on the ground

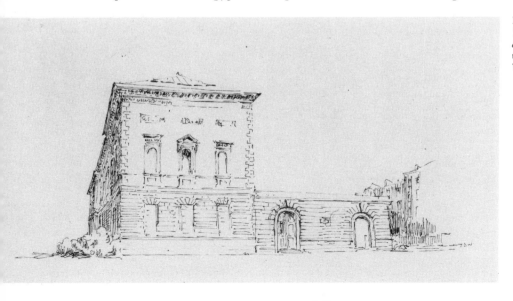

Fig. 1
The National Gallery as it appeared in 1864 (Reconstruction drawing by Jeremy Williams)

floor was, and still is, encircled by corinthian columns which carry an entablature decorated with festoons of shamrock and Irish harps contained in laurel wreaths. In 1864 this was the sculpture court (Fig. 3) containing plaster casts after Roman and Greek originals. It had windows along its north side only, a floor of maroon encaustic tiles and walls that were painted silver-grey. The walls and ceiling of the picture gallery above were painted maroon in imitation of the Grand Gallery in the Louvre, and the small cabinet rooms (now the French Rooms) were coloured a 'peculiar shade of green'. The building was lit by gas.

The National Gallery of Ireland was established under Act of Parliament in 1854. The idea of the Gallery stemmed from the exhibition of paintings which formed a part of the Great Exhibition in Dublin in 1853. That Exhibition was held in a temporary 'crystal palace' on Leinster Lawn (see end-papers, hard-bound edition), the site now occupied by the National Gallery. At the close of the Exhibition, the Irish Institution was 'established for the eventual formation of an Irish National Gallery' and annually, from 1854 for a number of years, loan exhibitions of Old Master Paintings were held by the Irish Institution at the Royal Hibernian Academy and elsewhere. The purpose of these exhibitions was to stimulate interest in the proposed National Gallery; at the same time, gifts of money and pictures were solicited for the future Gallery. By 1855, eleven pictures — the first of which was Barret's *Landscape with Fishermen* (No. 1909) — had been presented; in 1856 the Irish Institution made their first purchase for the Gallery — Koninck's *Portrait of a Burgher* (No. 329) which was acquired for £42.

The Great Exhibition of 1853 had been financed in large part by an Irish railway magnate, William Dargan (1799-1867), and at the close of the Exhibition a committee was formed and subscriptions were raised to commemorate in permanent form Dargan's generosity. Having collected £5,000, the Committee decided that an Irish National Gallery would be a suitable testimonial for Dargan and this money was placed at the disposal of the Irish Institution for the purposes of the proposed Gallery.

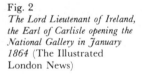

Fig. 2
The Lord Lieutenant of Ireland, the Earl of Carlisle opening the National Gallery in January 1864 (The Illustrated London News)

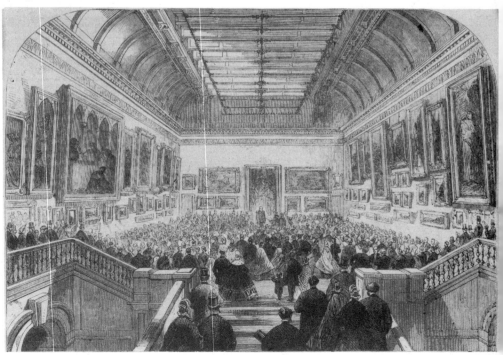

The Committee of the Irish Institution early considered the question of a site for the Gallery. The Royal Dublin Society, whose premises were then Leinster House, resolved in 1854 to build a Natural History Museum on the south side of Leinster Lawn to the designs of Frederick Clarendon (1820-1904). After negotiations the Society agreed to give up a portion of the Lawn on the north side for the Gallery provided the building would correspond in external design to the new Museum. The Committee of the Irish Institution at their meeting in January 1855 considered a ground plan which incorporated in a pseudo-Palladian complex the new Natural History Museum, Leinster House and the proposed National Gallery.

Designs for the National Gallery were prepared by the painter George Mulvany (1809-69), who was also a trustee of the Irish Institution and who later was to become the first Director of the National Gallery. Mulvany's designs, which no longer exist, were probably exclusively for the interior arrangement of the Gallery with an exterior that imitated Clarendon's Natural History Museum. Under the National Gallery of Ireland Act 1854, the Gallery was to include space for Marsh's Library which was to be transferred from its site near St Patrick's Cathedral and Mulvany's design, which was approved by the Board in November 1855, made provision to that effect. As the building of the Natural History Museum had been estimated to cost a total of £10,000, the Board of Governors and Guardians, on Mulvany's advice, was confident that the building should cost no more than £11,000. £5,000 was contributed by the Dargan Trustees and the Treasury

Fig. 3
The Sculpture Gallery (now Room Ia) looking east, c.1900 (National Library of Ireland, Lawrence Collection)

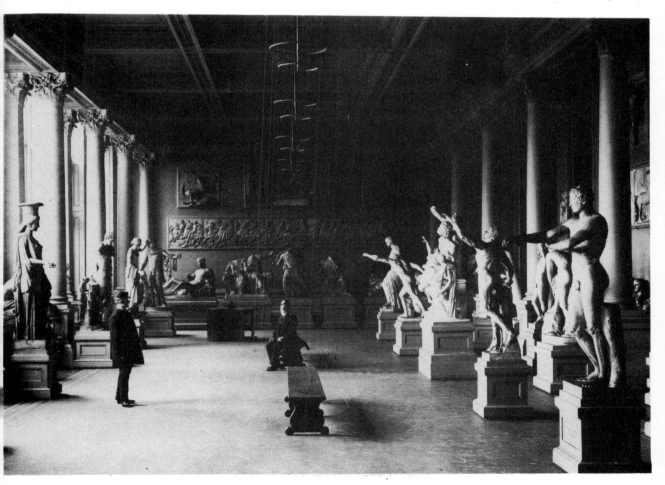

promised £6,000. The plan to house Marsh's Library in the National Gallery was, however, later abandoned when Sir Benjamin Lee Guinness restored the Library's own building, and Mulvany's design for the Gallery/Library was also subsequently rejected. The principal engineer and architect of the Commissioners of Public Works, Jacob Owen (1778-1870), advised his Chairman, Sir Richard Griffith (1784-1878), as to the unsuitability of Mulvany's design. As a consequence, Griffith together with Colonel Sir Thomas Larcom (1801-79) the Under-Secretary for State, invited Charles Lanyon (1813-89) of the Belfast firm of Lanyon and Lynn to design a National Gallery. Lanyon presented his designs, which also included provision for Marsh's Library, to the Board in February 1857 and they were accepted. However when tenders for the execution of the design were submitted, the Board realised that Lanyon's building, at a cost of £23,000, would be vastly more expensive than they could afford; Lanyon was asked to modify his intentions and he altered his plans accordingly. His designs, however, (of which he submitted a total of four) were finally rejected, mainly on account of the fact that the building would be larger than its counterpart — the Natural History Museum — and that his principal staircase, rising in his final plan from a Grand Sculpture Hall to the Picture Gallery above, was to occupy one-third of the cubic content of the building.

During February 1858, Captain Francis Fowke (1823-65) prepared plans which modified Lanyon's design. Fowke, who was a native of Ballysillan, Co. Tyrone, was a Captain in the Royal Engineers who had been in charge of the machinery at the Paris Exhibition of 1854. From 1857 he was Inspector for Science and Art and from 1860, Architect and Engineer in the Science and Art Department, London. Subsequent to his work on the National Gallery of Ireland he was to become, in 1862, Superintendent of the construction of the South Kensington Museum. Fowke's designs for the National Gallery of Ireland, which were an adaptation of Lanyon's first design, showed, in his own words, 'that uniformity of elevation, ample accommodation and interior architectural effect

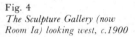

Fig. 4
The Sculpture Gallery (now Room 1a) looking west, c.1900

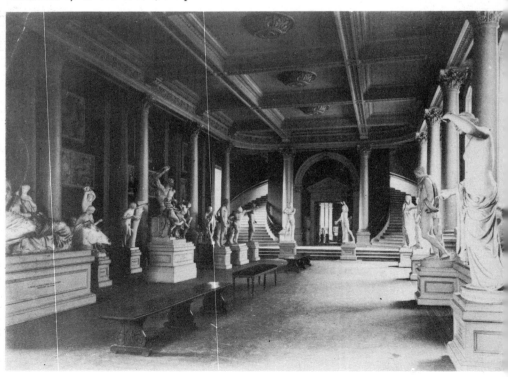

are, not only not incompatible with, but will be best studied by the adaptation of a building of the same dimensions as the opposite wing'. Fowke shortened Lanyon's building so that it conformed in length (225 ft) to Clarendon's building opposite and in adapting the interior he took great care that provision was made for an 'efficient system of warming and ventilation' as well as lighting by gas. He dispensed with the Grand Staircase and, citing the example of the 'Sala a Croce Greca' in the Vatican, designed a staircase that was an integral part of the picture galleries themselves (Fig. 4). This staircase, which the *Freeman's Journal* in 1864 described as the finest in Dublin with the exception of that at the Mater Hospital, rises in a perron from the ground floor Sculpture Gallery to a mezzanine landing from where a broad flight of steps leads to the main Picture Gallery above (Fig. 5). From the Picture Gallery, lateral staircases (Fig. 6) lead to what Fowke intended as rooms for cabinet pictures. The introduction of these rooms allowed for the provision of a mezzanine floor in which Fowke placed the Board Room and other offices. At the top of the smaller staircases and at the entrances to the cabinet rooms, Fowke placed recessed landings or vestibules, 'the central space between which is thrown into an ornamental recess for the reception of a large fresco-painting or statue'. Apart from the staircase, the most noble of Fowke's modifications was probably the substitution of free-standing corinthian columns for Lanyon's pilasters in the Sculpture Hall.

At the same time as negotiations relating to the building of the National Gallery were taking place, other members of the Board of Governors and Guardians,

Fig. 5
The main Picture Gallery of the original building (Photo taken about 1960)

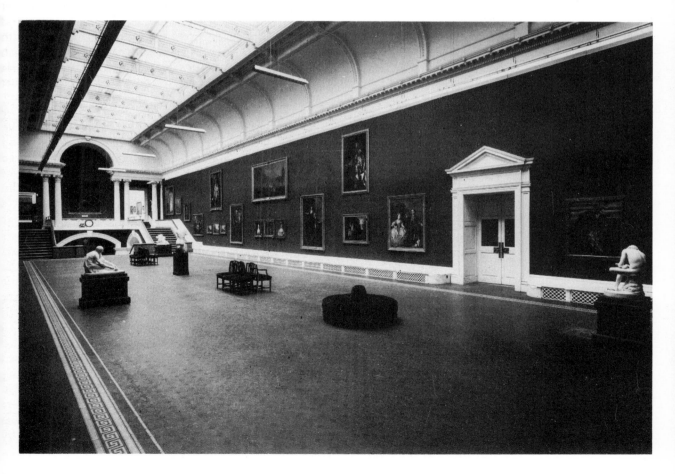

notably the Lord Chancellor Sir Maziere Brady (1796-1871), were applying themselves diligently to the formation of a Collection. On 3 December 1855, the Board considered a letter from Signor Aducci of Rome offering his gallery of pictures for sale. The Board replied to this proposal that they were not in a position to purchase an entire gallery of pictures but they nevertheless requested from Aducci a list of paintings and prices. The contact with Aducci (about whom little is known) was a valuable one for the Gallery and the Board purchased from him a total of sixteen paintings for a sum of £1,700. A number of these pictures, which arrived in Dublin in 1857, had come from the celebrated collection of Cardinal Fesch. They included works by Boulogne the Elder (No. 1889), Coypel (No. 113), Procaccini (No. 1820) and two magnificent canvases by Lanfranco (No. 67 and No. 72) from the basilica of San Paolo fuori le Mure in Rome. The purchase of these paintings was effected with the help of a personal loan from Sir Maziere Brady — who was later repaid — and the deal with Aducci was negotiated with the help of a British dealer in Rome, Robert MacPherson. MacPherson seized the opportunity of contact with the National Gallery of Ireland and subsequently sold to the Gallery, under the same arrangement with Sir Maziere Brady, a further twenty-three pictures for a total sum of £1,633. The quality of the paintings sold by MacPherson was less high than the Aducci pictures, but they included important pictures by Pietro della Vecchia (No. 94) and Padovanino (No. 87).

Concerning themselves with these and other purchases as well as the arrangements for the building of the Gallery, it was not until 1862 that the Board considered the question of appointing their first Director. The post seems not to have been advertised and, on 6 September of that year George Mulvany, who had acted as Secretary to the Board since 1855, was appointed Director (Fig. 7). At the same time Thomas Henry Killingly was appointed Registrar and John Moore Resident Porter; and with a grant of £250 for six months from the Lords Commissioners of Her Majesty's Treasury, the Board proposed to pay the Director a salary of £25 per month, the Registrar £10 per month and the Resident Porter £3.6s.8d. per month.

Mulvany, who was born in Dublin, came from a family of artists; his father, the landscape and figure painter Thomas James Mulvany, R.H.A. (1779-1865), had been first Keeper of the Royal Hibernian Academy; his uncle was John George Mulvany, R.H.A. (d.1838) and George Francis was himself a portrait and subject painter (see page 268). It was not unusual for the Board to appoint an artist to the post; similar positions were occupied elsewhere by artists and Mulvany's contemporaries at the London National Gallery were Sir Charles Eastlake and Sir Frederick Burton. Mulvany had studied at the Royal Hibernian Academy's schools and in his youth had travelled in Italy. He was knowledgeable about art and, as Secretary of the Royal Irish Institution and later of the Board of the National Gallery and subsequently as its first Director, he showed himself an able administrator and — what was more important in those early days of the Gallery — tough, persistent and shrewd in dealing with his peers, namely the Lords Commissioners of Her Majesty's Treasury.

Mulvany set about his task as Director with gusto and assurance and within his first year attended a number of important auctions in England where he purchased pictures for the Gallery: the Carr sale at Shipton in Yorkshire in 1862, and the sales of the Bromley-Davenport, Blamire, Archdeacon Thorp and Allnutt collections in 1863. Some, although not all, of the paintings he purchased at these sales were distinguished: Marco Palmezzano's *Virgin Enthroned* (No. 117) for 320 guineas (Davenport sale); the magnificent altarpiece of *The Church Triumphant* (No. 46) by Jordaens at the Allnutt sale for £84; and in the *St John in the Wilderness* (No. 63),

which was included in the Thorp sale as attributed to Titian, Mulvany found a bargain for £29.8s.; he himself thought the picture 'most probably Salvator Rosa' but it has subsequently turned out to be an important copy after Titian by Gian Antonio Guardi.

In 1864 Mulvany travelled on the continent, to Paris in April and in the months of September, October and November, to 'the most important cities in Germany, Italy and Spain . . . in connection with and furtherance of the interests of the Gallery'. During his six and a half years as Director, Mulvany purchased a total of about seventy pictures. His taste tended towards important names from the 17th Century, such as Rubens (No. 60) purchased for £720; Velazquez (No. 1930) for £7; Velazquez (No. 14) together with Spanish School (No. 1894) for £111; Ribalta (No. 34) for £315; Preti (No. 366) purchased as Caravaggio for £100; Cantarini (No. 71) purchased as Guercino for £75; and Van Dyck (No. 1937) purchased as a copy for £5.10s. A number of these pictures were copies and indeed were known to be such by Mulvany; but the policy of the Board at this time was that as 'it may be impossible to obtain an example of the greatest names in the history of art (they) may for years be only known to the Irish public through the imperfect means of copying'. Mulvany also bought a number of Dutch pictures: Bega (No. 28) for £40.19s.; Bergen (No. 59) for £69.6s.; Flinck (No. 64) price unknown; de Heem (No. 11) for £68.5s.; S. Ruisdael (No. 27) for £122; J. Ruisdael (No. 37) for £470, and more unusually, some fine German and early Netherlandish paintings by painters including Pencz (No. 1373) for £41; Strigel (No. 6) purchased as Altdorfer for £160; David (No. 13) purchased as van der Goes for £30; and after Mabuse (No. 361) purchased as a copy for £20. The first purchases were made out of monies donated by the public and out of a special fund voted by Parliament (£2,500 in 1863-4 and £2,500 in 1865). In 1866 the Treasury agreed to an annual purchase grant of £1,000, contingent upon a like sum being raised by public subscription.

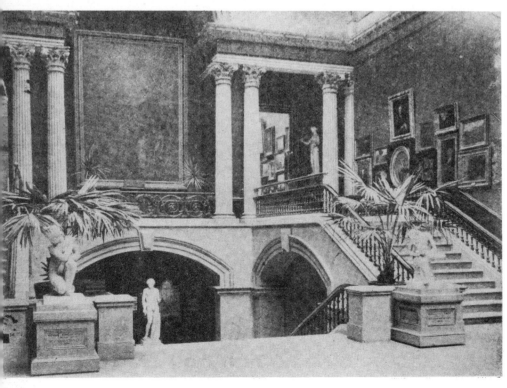

Fig. 6
The staircase in the Picture Gallery, c.1900

Mulvany wrote the first Catalogue of the Collection (which was based on that of the Louvre) in time for the opening in 1864: 8,119 copies of it were sold in that year. During the first ten months the Gallery was open to the public in 1864, it was visited by 167,698 people; the annual attendance figures for the next three years were 89,943, 109,605 and 128,680.

By the time Mulvany died on 6 February 1869, the Gallery was fully established. The building of the Sculpture and Picture Galleries was complete. The nucleus of the Collection, which was hung according as acquisitions were made rather than in schools, was formed and included some two hundred paintings of all schools, a small collection of Old Master drawings and a collection of casts after the antique. These were purchased in Italy, London and elsewhere after considerable effort on the part of Mulvany and the Board. The Collection was catalogued and the Gallery was well attended by the public. On the material side, over £6,000 had

Fig. 7
*Self-portrait of George Mulvany,
Director 1862-9* (coll.
National Gallery of Ireland)

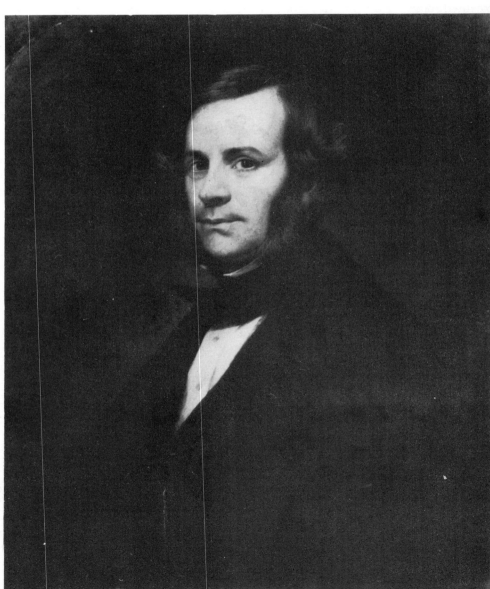

been raised by public subscription for the purchase of works of art, the Gallery was administered with a grant from Government and the building maintained by the Commissioners of Public Works. The Gallery's existence in this form was due in large part to the lifetime efforts of George Mulvany.

With the death of Mulvany, the Board advertised the post of Director. Applications were received from five Royal Hibernian Academicians: J.R. Marquis, Patrick Vincent Duffy, Thomas Bridgford, Stephen Catterson Smith and Michael Angelo Hayes. One additional application came from Henry Doyle and, at their meeting on 22 March 1869, the Board appointed Doyle Director. Doyle (1827–92) (Fig. 8) was a native of Dublin and the son of a famous father, John Doyle (H.B., the political cartoonist). Although Doyle had received his early training as an artist in Dublin, he was established in London at the time of his appointment to the Directorship. He was known as a portrait painter and had also executed some decorations for churches, book illustrations and, like his father, had published cartoons in *Punch*. He was a Commissioner for the International Exhibition in London in 1862, but it was as Director of the National Gallery of Ireland for twenty-three years that he found his true niche. In asking him to accept a Companionship of the Bath in 1880, Mr Gladstone referred to him as 'the energetic and effective head of a public establishment' and on his death in 1892 at the age of sixty-five the Board of Governors and Guardians recorded their 'deep sense of the zeal and faithfulness, as well as the remarkable ability, with which he performed his duties, qualities which have left their mark for ever on the Gallery'. This was a just assessment of Doyle's contribution to the National Gallery of Ireland. With a limited amount of money at his disposal (the purchase grant stood at £1,000 per annum throughout his time) Doyle bought, mainly at Christie's in London, with exceptional skill and style. A study of the catalogues of the sales he attended, and the prices he paid for pictures, suggest that on more than one occasion he probably made a spur of the moment decision and secured for the Gallery an important picture at a bargain price. Of the pictures he bought, he paid £8 for ter Borch (No. 270); 15 guineas for Bleker (No. 246); £5.15s. for Moreelse (No. 263); £44.2s. for Zurbarán (No. 273); £31.10s. for Flinck (No. 254); £56.14s. for Van Dyck (No. 275); £43.1s. for Wynants (No. 280); £32.10s. for Gainsborough (No. 191); and Fra Angelico's *Martyrdom of Saints Cosmas and Damian* (No. 242) was acquired for as little as £73.10s. in 1886. These pictures are all of quality and the fact that they were cheap at the time may be demonstrated by comparison with the prices Doyle paid for other paintings: Sorgh (No. 269) for £131.5s.; van den Eeckhout (No. 253) for £122.5s.; Ruisdael (No. 507) for £257.15s. Apart from the Fra Angelico, Doyle purchased for the Gallery pictures which remain today among the greatest masterpieces in the Collection: Rembrandt's *Rest on the Flight into Egypt* (No. 215) for £514; Poussin's *Entombment* (No. 214) for £503; Titian's *Ecce Homo* (No. 75) for £70.18s.; Steen's *The Village School* (No. 226) for £420 and Reynolds's *Earl of Bellamont* (No. 216) for £550.

The smooth administration of the Gallery under Doyle suffered a set-back in 1871 when the elegantly scripted minutes of the then Registrar, Thomas Henry Killingly suddenly come to an end. A sub-committee of the Board examined 'the severe charges brought by the authorities of the Treasury against the Registrar . . . and such charges being, for the most part, substantially confirmed, we are of the opinion that Mr Killingly has laid himself open to grave reprehensions for great negligence and irregularity in the discharge of his official duties'. Killingly's misdeed seems to have arisen out of the fact that, on occasion, Mulvany bought pictures for the Gallery out of his own pocket and was then reimbursed. After Mulvany's death, Killingly's books, which showed the details of such trans-

actions, were questioned. Although the Board found that 'no single incidence o
misappropriation or dishonesty can be laid to Mr Killingly's charge', the Treasury
insisted that Killingly should be dismissed. Subsequently, in 1872, the Board
appointed Phillip Kennedy Registrar.

Doyle initiated a policy of buying pictures by Irish artists and opened one of the
smaller rooms as an Irish Gallery. In 1884 he established the National Portrait
Gallery and applied to the Treasury for a special grant for this purpose — which
was refused. He re-hung the Gallery according to schools and published revised
editions of the Catalogue in 1875, 1879 and 1890. During his Directorship the

Fig. 8
Henry Doyle, Director 1869-92

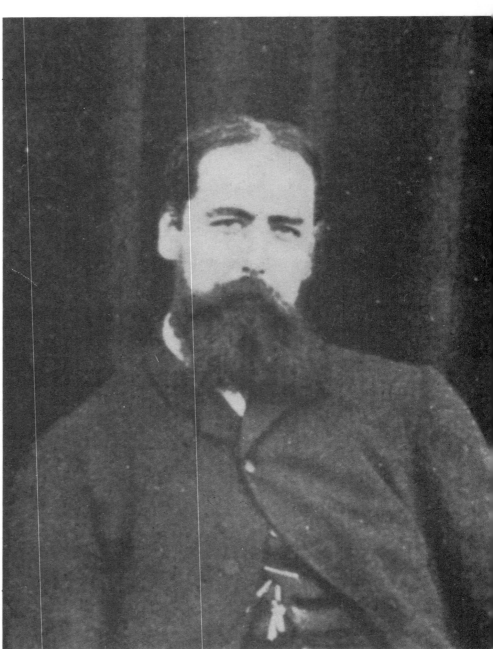

Gallery seems to have maintained its popularity with the public. In the year of his appointment 117,942 people visited the Gallery but this figure soon levelled off at an average of 80,000 to 90,000 per year during the remainder of his term of office. Doyle's last act as Director was a submission to the Treasury for an extension to the building, for which the Board considered the outline plans drawn up by Sir Thomas Newenhan Deane (d.1900) at their meeting on 26 November 1891. This was Doyle's last meeting before his death on 17 February 1892; Deane's extension was not built until ten years later under quite different circumstances and on quite a different scale.

At their meeting on 24 March 1892, the Board of Governors and Guardians elected Walter Armstrong (1850–1918) Director (Fig. 9 and see Osborne [No.

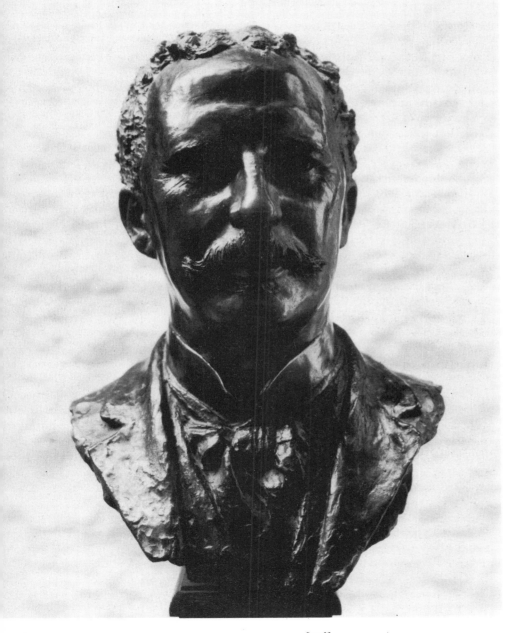

Fig. 9
Walter Armstrong, Director 1892-1914 Bust by Onslow Ford (coll. National Gallery of Ireland)

1389]) and directed the Registrar to write to the Lord Lieutenant 'to state, for the information of His Excellency' that Armstrong had been appointed. The Civil Service Commission wrote in reply 'for specific evidence of Mr Walter Armstrong's fitness for the post of Director'. The Board firmly responded to this request with the information that they 'knew Mr Armstrong to possess the necessary qualifications for the post of Director of *their* Gallery'. Armstrong, in fact, was superbly qualified for the post and was the first scholar-Director of the Gallery (both his predecessors having been painters). He was English by birth and educated at Harrow and Exeter College, Oxford, and his literary and art historical record was impressive. At the time of his appointment he had published books on *Alfred Stevens* (1881), *Millais* (1885), *Breton Riviere* (1891), *Peter de Wint* (1888) and *Scottish Painters* (1888). His referees included the brilliant Director of the Mauritshaus in The Hague, Abraham Bredius, the Director of the London National Gallery, Sir Frederick Burton, and the President of the Royal Academy Lord Leighton. Bredius described Armstrong as 'one of the best among the *very few* real connoisseurs of the old Dutch School in England'; Burton referred to his writings as 'evincing, comprehensive and diligent research in the history of art'; and Leighton was confident that Armstrong would devote to the Gallery 'that zeal and solicitude which so delightful and already important a Gallery deserves'.

During his Directorship Armstrong continued to publish and book after book came out almost on a yearly basis: *Orchardson* (1895), *Velasquez* (1896), *Reynolds* (1900), *Raeburn* (1901), *Gainsborough* (1904), *The Peel Collection and the Dutch School* (1904) and *Lawrence* (1913). For the Gallery itself, Armstrong's Catalogue of 1898 represented a marked improvement on its predecessors, the last of which had been published in 1890. Completely revised, updated and largely rewritten, it included details of pictures, drawings, the National Portrait Collection and sculpture.

In March 1894 P.W. Kennedy, who had been Registrar for almost twenty-two years and who was then aged eighty-five, retired. In tendering his resignation to the Board he asked if he 'perhaps might be allowed to point out that during the 21 years of my service I have received no increase of pay and have never had any vacation with the exception of one week during the summer of 1885'. Armstrong, as Director, was singularly lucky in the replacement that was found for Kennedy: Walter Strickland (1850–1928) (Fig. 10).

Strickland's appointment was one which would reflect credit on the Gallery and much of his time must have been spent on the compilation of his *Dictionary of Irish Artists* which was published in 1913 and which still remains a standard work. He also took a keen interest in the development of the National Portrait Collection. The minutes he took at Board Meetings are witness to his methodical approach and, between himself and Armstrong, the Gallery was in good hands. The Annual Reports give a fair impression of life in the Gallery in those years and the standards that were set. Each year a number of paintings were cleaned, although the reports do not say by whom; a number of pictures were newly framed and each year more and more were glazed out of Armstrong's concern to protect them. As was to be expected from Armstrong's interests, a number of Dutch pictures were purchased during his time, generally for very reasonable prices: Maes (No. 347) for £120; Claesz (No. 326) for £40; Ochtervelt (No. 435) for £31; Duyster (No. 333) for £50; de Witte (No. 450) for £50; Leyster (No. 468) for £30; Schalcken (No. 476) for £150; Troost (No. 497) for £120; and du Jardin (No. 544) for £100. Annually Armstrong added oils, drawings and engravings to the National Portrait Collection, as well as the Collection of Irish and British paintings. More surprisingly for him were the early Italian pictures he bought: Mantegna (No. 442) for £2,000; Filippino Lippi (No. 470) bought as Raffaellino del Garbo for £1,500; School of Verrocchio (No.

519) purchased as Lorenzo di Credi for £250; Costa (No. 526) for £1,250; and Uccello (No. 603) bought as Lorentino d'Arezzo for £250. Other major pictures which Armstrong added to the Collection included Rubens (No. 427) for £150; Ijsenbrandt (No. 498) purchased as Mostaert for £160; Goya (No. 572) for £600; Chardin (No. 478) for £750; and the beautiful *Portrait of a Lady* by Pourbus (No. 606) for £1,000.

In October 1897 Armstrong was summoned by letter from the Countess of Milltown to Russborough 'on Thursday next, the 21st instant. There is a train that leaves Terenure at twenty minutes past eight o'clock and another at eleven o'clock

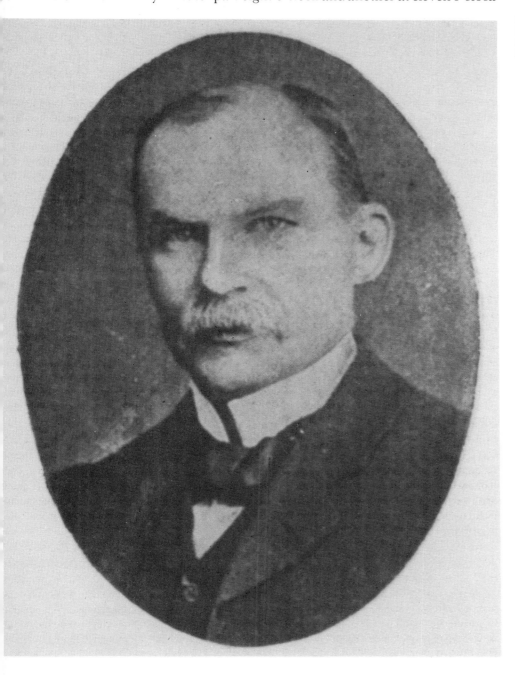

Fig. 10
Walter Strickland, Registrar 1894-1915 and Acting Director 1915-16

a.m. which will take you to Featherbed Lane, where I will have a man waiting to open the gate for you'. On these romantic terms, the gate that was opened for the National Gallery, and the way that was paved along Featherbed Lane, were among the most important events in the history of the Gallery. Lady Milltown announced her intention of presenting to the Gallery 'in memory of my husband the sixth Earl of Milltown, the pictures, prints, works of art and antique furniture now at Russborough'. The Board, at their meeting on 11 November 1897, resolved 'to accept Lady Milltown's gift with the warmest and most grateful thanks'. The majority of pictures in the Milltown Gift (see page 355) had been purchased in Italy by the 1st Earl of Milltown in the middle of the 18th Century and they included the usual Grand Tour paintings by Batoni (Nos. 701, 702, 703, 704, 1650, 1697), Panini (Nos. 725, 726, 727, 728) and Vernet (Nos. 1045, 1732, 1733, [1744]), as well as a number of Florentine 17th Century pictures by Lorenzo Lippi (No. 1747), Dandini (No. 1683), Ficherelli (Nos. 1070, 1707, 1746) and Furini (Nos. 1658, 1679, 1716, 4002). Outstanding among the collection, which included the group of caricatures by Reynolds (Nos. 734, 735, 736, 737), was Poussin's *Holy Family* (No. 925).

Negotiations over the reception of the Milltown Gift were not always as cordial and friendly as the initial encounter between the Board and Lady Milltown had been; in fact it was not until early in 1906 that the collection came to the Gallery. In sum, a group of seventy-two pictures was selected at Russborough as being suitable; but, 'in the period between the summer of 1899, when Lady Milltown ceased to permit the Gallery authorities to visit Russborough, and the execution of the deed of gift in 1902. . .a large number of pictures, pieces of furniture and other objects were added to the list'. On the subject of these pictures, the Director reported that 'in addition to the general undesirability of those additional pictures from an artistic standpoint, they have been rendered more fully unacceptable by some process of cleaning, renovation of frames, etc.'. The total number of pictures delivered to the Gallery came to about two hundred. The extra paintings, being of a fairly typical 'country-house collection' type, were understandably not necessarily of the quality which Armstrong as Director would deliberately want to acquire. With time, however, very few can really be seen as unwelcome additions to the Collection. The Board, on grounds of merit and as a result of Armstrong's report, hesitated to exhibit the entire collection, but Lady Milltown, through her agent, informed them in November 1906 'that under the circumstances, it would be wholly impossible to enter into any discussions as to the merits of any items of the collection which they (the Board) are bound to exhibit' and she instructed the Board to proceed forthwith to clear the entire top suite of rooms in the building for the reception of the gift. Within a month she threatened to institute legal proceedings against the Board unless her wishes were complied with. Contrite, the Board replied immediately 'that they have arranged, provisionally, the pictures and works of art in the upper rooms of the National Gallery; they beg that Lady Milltown will fix any date that may be convenient to her to inspect the arrangements which, they trust, will meet with her approval.'

In 1901, under the terms of the will of Sir Henry Page Turner Barron, Armstrong was allowed to make his choice, on behalf of the Gallery, of ten pictures from Barron's collection. Barron (1824–1900), whose father lived in Ireland, had been a diplomat all his life and had formed a collection of pictures mainly of the Dutch School. Before his death he had presented some paintings by Maes (No. 204), Furini (No. 368 and No. 1967) and Cignani (No. 183) to the Gallery, and Armstrong's choice from his estate (see page 358) included exquisite paintings by Rubens (No. 513) and S. Ruisdael (No. 507).

With the offer of the Milltown Gift in 1897, the Board immediately requested from the Government finance for the building of the extension to the Gallery which had first been requested in 1891. In October 1898 the Office of Public Works confirmed that £20,250 had been authorised by the Treasury for a new extension according to the revised plans of Sir Thomas Newenham Deane, which the Board sanctioned at the same meeting. The new building was started in the autumn of 1899 and was finally opened to the public in March 1903. The new extension to the Gallery by Deane which, after his death in 1900 was supervised by his son Thomas Manly Deane (1851–1933), provided an increase in hanging space of one hundred and forty per cent. The building consisted of two floors above a basement with seven rooms (octagonal on the ground floor) on each floor. It extended parallel to the original building behind Fowke's 'Egyptian' lobby which Deane altered to create an external three-bay portico (Fig. 11) and an interior hall with the Director's office and Board Room above it. Internally, the decoration of the rooms was limited to carved walnut door openings which were executed by Carlo Cambi of Siena (Fig. 12). Armstrong, who suggested the octagonal shape of the ground floor rooms as well as other features, thought the finished building 'the best Picture Gallery in the United Kingdom'. Such approval was not to come however from the discerning Lady Milltown. While recognising 'the most glaring instances of disorder and incongruity' in the arrangement of the pictures, she considered the new vestibule 'really a passage' and required that 'all the dados in the rooms be raised to the height they are at Russborough'.

With the building of the new extension, the turn-stiles in the Gallery were removed and attendance figures are not recorded thereafter for some years. During Armstrong's Directorship, they had declined from 90,413 in 1892 to 72,117 in 1900. Armstrong retired at the end of March 1914 and, at their meeting on 25 February in that year, the Board considered applications for the Directorship from the Registrar, Strickland, and Sir Hugh Lane. Lane was elected Director and attended on his first Board at their meeting on 1 April 1914.

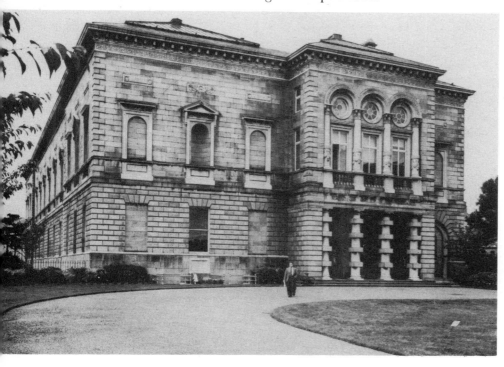

Fig. 11
The National Gallery as it appeared from 1903-64

Hugh Lane (1875–1915) (Fig. 13 and see Harrison [No. 1280]) was the son of a clergyman from Cork and the nephew, on his mother's side, of Lady Gregory. He was educated privately and had travelled widely on the continent as a child. At the age of eighteen he was apprenticed to Colnaghi's and later worked in the Marlborough Gallery in London. In 1898, aged twenty-three and almost without capital, he set himself up as a picture dealer in No. 2 Pall Mall Place, London. He was soon to become enormously successful.

In 1902–03 Lane helped to organise an exhibition of Old Masters at the Royal Hibernian Academy and in 1904 he mounted an exhibition of Irish paintings at the Guildhall in London. From that time Lane's main interest lay in founding a gallery of modern art in Dublin and in 1908 the Municipal Gallery of Modern Art was opened. It was Lane's intention that the Gallery would 'always fulfil the object for which it was intended and, by ceding to the National Gallery those pictures which, having stood the test of time, are no longer modern, make room for good examples of the movements of the day'. The foundation of the Municipal Gallery was beset by difficulties and controversy, mainly on account of the provision of a suitable building; but no such controversy attended Lane's association with the National Gallery. Lane, who had been knighted in 1909 in recognition of the services he had rendered to Ireland, had been appointed a Governor and Guardian of the National Gallery of Ireland in 1904 and was therefore associated with the Gallery for ten years before becoming Director.

Fig. 12
One of the new rooms opened to the public in 1903

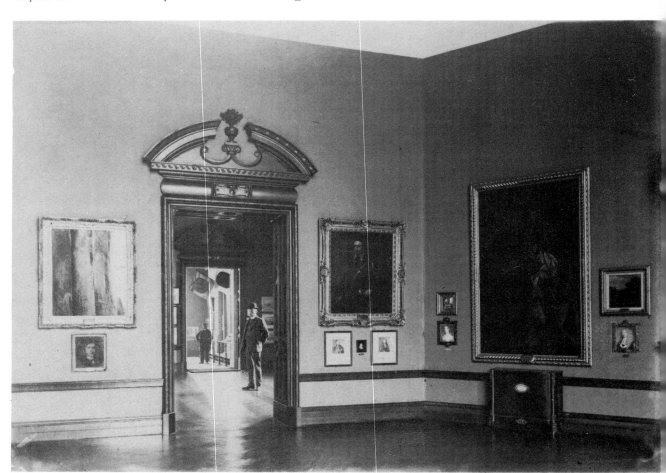

While the Board did not appoint Lane as a part-time Director, they stipulated that 'no conditions other than those provided in the National Gallery Act of 1854 (of which there are none) should apply to his hours of attendance'. The Lords Commissioners of Her Majesty's Treasury assumed that 'it would appear that Sir Hugh Lane is not required to devote his whole time to his official duties' and they sanctioned his appointment accordingly, that is, as a part-time Director. It was not until forty-two years later that the Directorship of the National Gallery of Ireland was to become, again, a full-time post.

Lane inaugurated his Directorship in the manner he intended to continue (Fig.

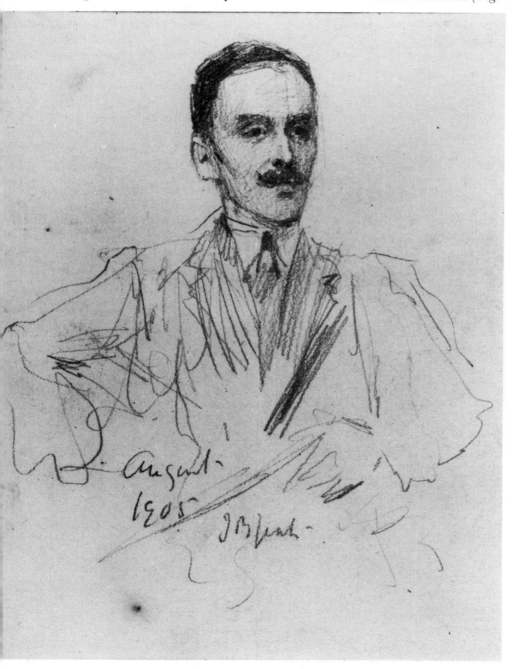

Fig. 13
Hugh Lane, Director 1914-15
Drawing by John Butler Yeats (coll. National Gallery of Ireland)

14). At his second meeting on 22 April 1914, he presented El Greco's *St Francis* (No. 658), Veronese's *Portrait of a Lady* (No. 657) and the version of Piazzetta's *Decorative Group* (No. 656). In his all too brief period as Director — no more than ten Board meetings over a period of eleven months — Lane presented a total of twenty-four pictures to the Gallery in this way (page 354). On 7 May 1915, returning from America, Lane was drowned when his ship, the Lusitania, was torpedoed off Cork. The Board summoned a special meeting and recorded their 'horror at the foul, wholesale murder committed, in which so valuable a life was lost'.

Lane's will, dated 11 October 1913, was one of outstanding generosity. He bequeathed all his 'modern pictures of merit, other than a group of pictures lent by me to the London National Gallery . . . to the Dublin Gallery of Modern Art . . .; and the remainder of my property to the National Gallery of Ireland to be invested and the income spent on buying pictures of deceased painters of established merit'.

Fig. 14
Sir Hugh Lane producing masterpieces for Dublin
Cartoon by Max Beerbohm (coll. Hugh Lane Municipal Gallery)

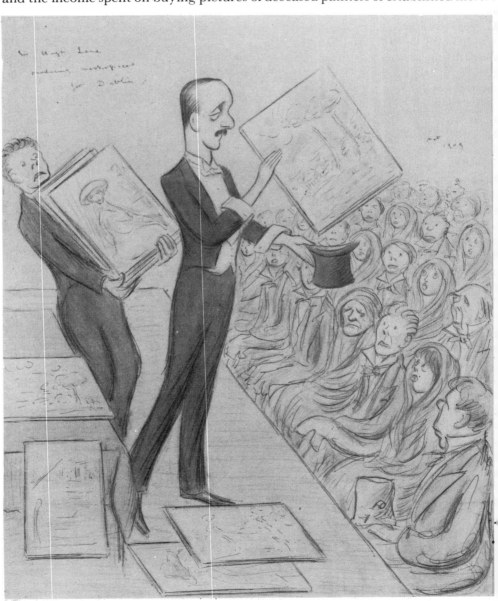

His property included his home, Lindsey House in Chelsea and its contents, and the Board of Governors and Guardians wisely applied to the courts for permission to retain forty-three of the more important Old Masters owned by Lane at the time of his death. Lane's bequest to the Gallery (page 360) included a number of the Gallery's masterpieces: Titian (No. 782), Sebastiano del Piombo (No. 783), Claude Lorraine (No. 763), Goya (No. 784), Poussin (No. 814 and No. 816), Van Dyck (No. 809), Lawrence (No. 788), Hogarth (No. 791 and No. 792) and Gainsborough (Nos. 793, 794, 795, 796).

With Lane's unexpected death, the Board appointed Strickland acting-Director for a period of one year; James Stephens (c.1881-1951) (see Tuohy [No. 1126]) was appointed to a temporary clerkship in the place of the Registrar. Stephens, who was living in Paris at this time, was a poet and author and very much associated with Ireland's struggle for independence in the first decades of this century. His novel *The Crock of Gold* was published in 1912 and his appointment to the National Gallery caused something of a fuss. A majority of the Board considered that he would 'add lustre to the Gallery' and that his appointment was 'desirable as a recognition and encouragement of literary eminence'; a minority felt, perhaps justifiably, that Stephens had no qualifications for the discharge of the duties of the post.

In 1916, to the disappointment of the acting-Director Strickland, the Board appointed Robert Langton Douglas (1864–1951) (Fig. 15) Director; at the same time, Strickland retired. Douglas was the son of an English clergyman and his only Irish connection seems to have been that his father was educated at Trinity College Dublin, although at the time of his appointment Douglas certainly knew such figures from the Irish literary world as W.B. Yeats, Lady Gregory, George Moore and AE (George Russell). He had been educated at New College Oxford and was ordained a priest in the Church of England in 1888. He had a strong interest in Italian art, which chaplaincies in Leghorn and later Genoa allowed him to indulge. He left the Church in 1900 and took up a Chair of Modern History and English Language at the University of Adelaide in Australia. Douglas published a monograph on Fra Angelico in 1900; his *History of Siena* came out in 1902; he edited (conjointly) Crowe and Cavalcaselle's *A History of Italian Painting;* and, in the first years of the century, he established a reputation as a scholar and connoisseur of 15th Century Italian art. Having resigned from Adelaide in 1902 he turned to art dealing, at which he was soon to become enormously successful. He numbered among his clients Wilhelm Bode of the Berlin Museum, J. Pierpoint Morgan, and J.G. Johnson of Philadelphia; later Douglas sold paintings directly to the Metropolitan Museum, New York. Douglas was therefore a distinguished figure in the international art world at the time he took up the Directorship of the National Gallery of Ireland in 1916. There was nothing unprecedented in the Board appointing a dealer to the post as his predecessor, Hugh Lane, had been in the same category with, it might be said, tremendous benefit to the Gallery. The Governors and Guardians might well have had the same expectations of Douglas but, in the event, they were to get rather more than they could have expected.

The post at this time was a part-time one, and Douglas was allowed to continue his activities as a dealer. He also enlisted in the army. In retrospect, his Directorship of just seven years was a rather breathless affair. He made a start by presenting to the Gallery Sir Martin Archer Shee's *Portrait of Tom Moore* (No. 775); he bought a few good pictures from himself, fought with one of his Board members (Thomas Bodkin — who sought to have him imprisoned), defaced the Minute Book, was censured by the Board and, as a final gesture, presented a choice painting by Frans Post (No. 847). At the same meeting on 4 June 1923, he resigned.

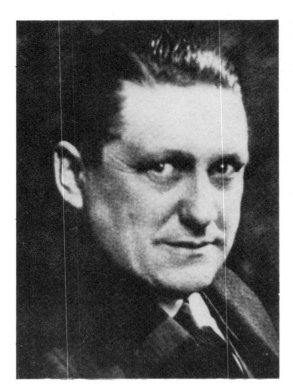

Fig. 15
*Robert Langton Douglas, Director
1916-23*

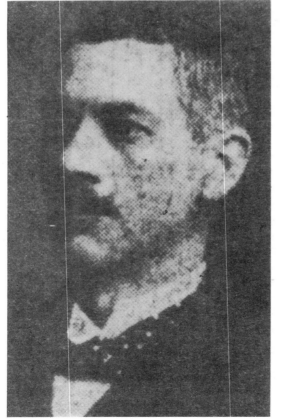

Fig. 16
*Lucius O'Callaghan, Director
1923-7*

In his first years Douglas had little or no money to spend on pictures. The purchase grant, which had stood at £1,000 per annum almost from the foundation of the Gallery, was withdrawn in 1915 owing to the exigencies of war, and it took time for Hugh Lane's estate to be wound up and the money invested to provide an income for purchases. When this happened Douglas spent it well: Hobbema's *The Ferry Boat* (No. 832) was purchased in 1921 for £1,000. Douglas's other purchases included Pantoja's *Portrait of Juana de Salinas* (No. 829) for £900 and a number of 15th Century Italian pictures: Silvestro dei Gherarducci (No. 841) which he bought as Taddeo di Bartolo for £1,000; Master of St Augustine (No. 823) for £2,500; Antoniazzo Romano (No. 827) for £1,836.16s.2d.; Girolamo di Benvenuto (No. 839) for £480; Biagio di Antonio Utile (No. 842) bought as Botticini for £500; Girolamo da Santa Croce (No. 846) for £500; and Alejo Fernandez (No. 818) for £1,000. Douglas received the bequest of Hugh Lane, which was exhibited for the first time in the Gallery in 1918 (see page 360) and also that of the work of Nathaniel Hone the Younger, bequeathed to the Gallery by his widow in 1919. It was Mrs Hone's intention that a representative group of Hone's paintings should be selected for the Gallery and exhibited in a special room; also that other paintings in the artist's studio should be sold by her executors to provide the finance necessary for the building of such a room. Through the offices of one of the Governors and Guardians, Dermod O'Brien, who was also an executor of Mrs Hone, ninety oils and ninety-nine watercolours were shown in the Gallery in the summer of 1921. Finally, as late as 1951, two hundred and seven oil paintings and a number of watercolours were permanently accepted by the Gallery.

Douglas absented himself from the Gallery as soon as he had handed in his resignation and James Stephens, who by this time had been appointed Registrar, took six weeks leave in Paris. A sub-committee of the Board was arranged to attend to the business of the Gallery; this consisted of Dermod O'Brien, Thomas Bodkin, Lucius O'Callaghan and Blair Browne. Apart from seeing to the advertisement for the vacant Directorship, the committee (mainly in the person of Bodkin) set about some purchases. Ter Borch's much damaged *Four Spanish Monks* (No. 849) was purchased from Hofstede de Groot for £1,571.7s.4d. as well as Pompe's *Seascape* (No. 850) from London dealers at £50.

Political events in Ireland from 1916 to 1922 seem to have had little effect on the affairs of the Gallery. The Board, at their meeting on 2 February 1921, devoted little time to a discussion of 'a communication from the Under-Secretary Dublin Castle regarding administrative changes necessitated by the passing into law of the Government of Ireland Act'. The following year the Director reported that he had called in the various loans of pictures to the Vice-Regal Lodge and the Chief Secretary's and Under-Secretary's Lodges. It appears, however, that owing to 'military considerations' the Gallery was closed for some period, certainly in 1923 and probably during 1921 and 1922 as well.

In November 1923 the Board considered applications for the Directorship, the most distinguished of which came from the editor of *The Burlington Magazine* R.R. Tatlock, J.G. van Regteran Altena and the Irish architect and Board member Lucius O'Callaghan. The Government having 'suggested' a month previously that Gallery letter-headings and Departmental descriptions should, henceforth, be set out in both Irish and English, the Board wisely appointed O'Callaghan. Lucius O'Callaghan (1878-1954) (Fig. 16) was an architect by profession, a member of the Royal Hibernian Academy and an ex-President of the Royal Institute of Architects in Ireland. In his application for the Directorship he put forward the fact that 'for many years I have taken a deep interest in pictures, chiefly of Dutch 17th Century work, and I have made a particular study of the subject of conservation

of works of art'. O'Callaghan also assumed that 'in the event of my appoint-ment . . . the Board . . . would permit me to continue to practise as an architect'.

O'Callaghan was certainly the least qualified of all Directors of the National Gallery of Ireland but, nevertheless, in the dim period for the Gallery during the 1920s, he conducted affairs in a quiet and efficient manner. From the Lane Fund his purchases included Strozzi's *Summer and Spring* (No. 856) for £350; Lotto's *Portrait of a Nobleman* (No. 866) for £1,000 and the *Assumption of the Virgin* by the Pseudo Domenico di Michellino (No. 861) for £2,000. O'Callaghan also received the bequest of Edward Martyn of a number of French nineteenth-century pictures and drawings, most of which Martyn had bought in Paris.

On account of ill health, James Stephens offered his resignation in December 1924. Early next year Brinsley McNamara (1890-1963) (Fig. 17) was appointed temporary Registrar and, on Stephens' final resignation in December 1925, McNamara became Registrar. McNamara had been a member of the Abbey Theatre Company since 1909 and had written a number of plays for the Abbey; in

Fig. 17
Brinsley McNamara, Registrar 1925-60 Portrait by Hilda Roberts (coll. The Abbey Theatre)

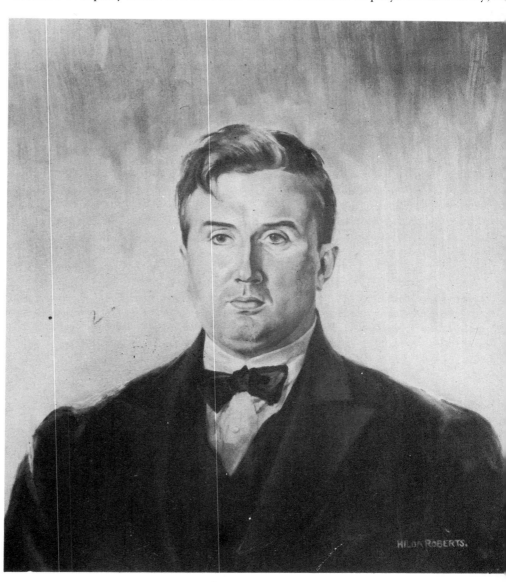

act his best known play *Look at the Heffernans* was performed at the Abbey the year
fter he became Registrar, in 1926. While at the National Gallery he also found
ime to write a number of plays, novels and short stories.

With the resignation of O'Callaghan in June 1927 (owing to the pressure of his
rivate practice as an architect) Thomas Bodkin, a member of the Board of
Governors and Guardians, was appointed Director. Thomas Bodkin (1887–1961)
Fig. 18 and see Sleator [No. 4084]) was born in Dublin and had been educated at
elvedere, Clongowes and University College Dublin. He had practised as a
arrister in Dublin from 1911-16 when he became Secretary to the Commissioners

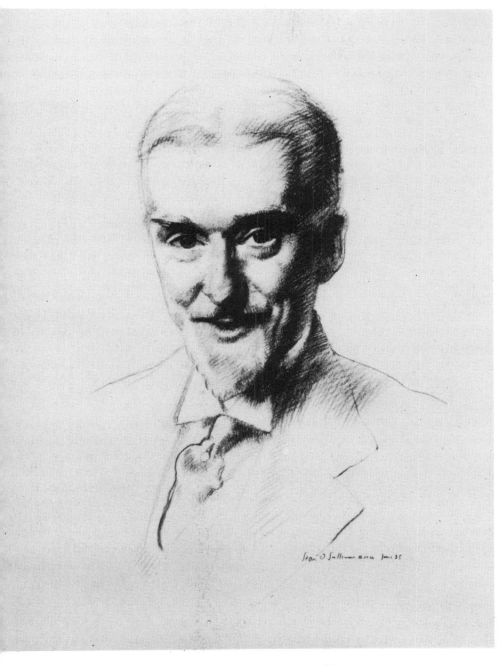

Fig. 18
*Thomas Bodkin, Director 1927-
35* Drawing by Sean
O'Sullivan (coll. National
Gallery of Ireland)

of Charitable Bequests and Donations in Ireland. His book *Four Irish Landscape Painters* had been published in 1920 and *The Approach to Painting* in 1927; in that year he was elected Director of the National Gallery, of which he had been Governor and Guardian since 1917. Bodkin, like his three predecessors, was a part time Director and continued his work while at the Gallery as Secretary to the Commissioners of Charitable Bequests and Donations. He was an energetic Director and saw to the publication of the 1928 Catalogue as well as one of the last ever text Catalogues of the Gallery — that published in 1932. He organised several exhibitions in the Gallery including, annually, one of Recent Acquisitions. His book *Hugh Lane and his Pictures* was published in 1932.

Bodkin's period as Director coincided with a period of extreme economic depression in Ireland and any attempt made by him to improve conditions in the Gallery with regard to extra staff or funding met with blank refusal from Government. His Board supported him fully. From 1931, delegations from the Board attended regularly on President Cosgrave, the Minister for Education and the Minister for Finance to seek full-time status for the Director, financial provision for staff and an increase in the purchase grant. The total Vote for the administration of the Gallery stood at £3,875 in 1934, a figure which — the Board was quick to point out — compared ill with the £5,145 that was the last grant made 'under the regime of the British Government' in 1921-2. Bodkin resigned from the Gallery regretfully in 1935 and in his long letter of resignation to the Board expressed the hope that as 'Professor of the History of Fine Art and Director of the Barber Institute (in Birmingham) I shall be able to use such talent as I may have to better advantage than I could ever have done under existing circumstances in the National Gallery of Ireland'. Bodkin's appointment as first Director of the Barber Institute was a signal opportunity and one which, from 1935-52, he carried out with distinction. In the words of his biographer Alan Denson, 'there had been a decade earlier in his career in which he had daily been frustrated in his activities and was haunted by a sad descant of disappointment; but not whilst he was at Birmingham'.

Bodkin's acquisitions have stood the test of time. Frequently he bought in Ireland and the eclectic nature of the pictures he purchased suggest that he had a keen eye for quality pictures — school and period notwithstanding. Among his most significant purchases were Brueghel's *Peasant Wedding* (No. 911) bought in Dublin for £1,200; Lastman's *Joseph Selling Corn* (No. 890) bought in Belfast for £300; Corot (No. 950) for £63; Sisley (No. 966) for £54; and Delacroix (No. 964) purchased with Forain (No. 965) for £2,300.

With the departure of Bodkin, the Board appointed Brinsley McNamara acting Director. He obviously enjoyed the task and proposed several pictures to the Board for purchase. Nor was McNamara someone to do things by half measure, and the purchases he proposed included an early Italian *Adoration of the Shepherds*, a Filippino Lippi, a Murillo, a Boucher, and a self-portrait of Samuel van Hoogstraten. The Board declined all of these proposals and in doing so seem to have developed a preference for declining acquisitions rather than accepting them. At the same time the Board made representations to the Government that the Directorship should be full-time; again, however, that proposal was refused.

With the advertisement for the post of Director, applications were received from fourteen candidates — including Thomas McGreevy and Nikolaus Pevsner. At their meeting on 3 July 1935, the Board elected Dr George Furlong as Director and he took up office on 1 October. Furlong (1898-) (Fig. 19) was young (thirty-seven at the time), and exceptionally well qualified for the post. Irish by birth, he had been educated at Clongowes and had obtained his degree from University

ollege Dublin in Mental and Moral Science. He had studied at the Sorbonne and
t the Universities of Munich and Vienna, where he had been awarded a
Doctorate in 1928 for a thesis on Anglo-Saxon book illustrations of the 10th and
1th Centuries. Fluent in French and German, he had trained as a guide in the
Kunsthistorisches Museum Vienna and had been a lecturer at the London
National Gallery and the Tate Gallery for some years before becoming Director of
he National Gallery of Ireland.

Furlong immediately put in hand the cleaning of some pictures. In a professional
manner, Sebastian Isepp of the Kunsthistorisches Museum came to the Gallery in

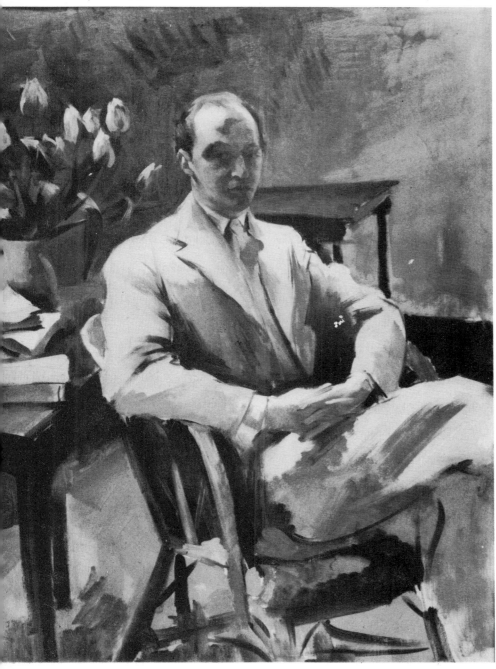

Fig. 19
George Furlong, Director 1935-50 Portrait by Judy Boland
(Private collection)

1936 and reported on a number of pictures needing restoration, includin
Perugino's *Pietà* (No. 942) which was subsequently cleaned in Vienna. In 1937 th
Department of Finance was persuaded to increase the annual purchase gran
from £1,000 to £2,000 — the first increase since the grant originally given in 186(
but on account of the War, it was soon cut again and only reinstated to £2,000 i
1946-7. However the limited income from the Lane Fund allowed Furlong t
make some choice and a number of very beautiful and unusual acquisition
including the exceptional Castiglione (No. 994) for £378; van Scorel (No. 997) f(
£400; de Cock (No. 1001) for £250; de Coster (No. 1005) for £50; Allori (No. 108
for £60; Penni (No. 1018) for £252; Crespi (No. 1020) for £30; Butteri (No. 1021) f(
£670; Bartolo (No. 1089) for £125; Tintoretto (No. 1122) for £5,000; Roymerswae
(No. 1115) for £1,000. Furlong also received, in 1939 and 1940 respectively, th
small bequests of Miss H. Reid (page 360) and Mr Patrick Sherlock (page 360

The 1930s and 40s were not an easy period for the National Gallery of Irelanc
apart from the War, there was a general apathy towards the Gallery, both on th
part of the Government and also from the public. Attendance figures becon
available again from 1936 and they reveal that in that year only 39,336 peop
visited the Gallery; by 1941 this figure had descended to 24,723. When th
Emergency was declared in 1940, the Minister for Education recommended th;
some of the most valuable pictures in the Gallery should be evacuated for safet
One hundred and twenty-three of the best pictures were placed in packing case
and stored in the vaults of the Bank of Ireland in Dublin. Furlong rightly proteste
that the maintenance of valuable pictures in packing cases over a prolonged peric
placed them in greater danger than if they had been left in the National Galler
and for that reason the pictures were returned to the Gallery in December 1941. I
April 1942 two hundred and twenty-five pictures were dispatched to th
Preparatory College, Tourmakeady, Co. Mayo, where they remained safely unt
June 1945. The predilection of the Board of Governors and Guardians f(
declining offers of purchase developed during the interregnum of Brinsle
McNamara, continued during Furlong's Directorship (although it was sometim
varied by the process of 'offer deferred'). In this way a painting by Gauguin, sever;
by Monet and a *Portrait of W.B. Yeats* by Augustus John were rejected. At the
meeting on 1 February 1950, the Board declined to purchase for £8,000 Murillo
Christ healing the Paralytic at the Pool of Bethesda (which was sold immediately then
after to the London National Gallery) and, at the same meeting, Furlong resignec

With Furlong's resignation, McNamara again became interregnum acting
Director, although this time with perhaps less optimism than previously. It was h
pleasant duty to read to the Board on 15 April 1950, a letter from George Bernar
Shaw — who died that year — on the subject of Prince Paul Troubetskoy's statue (
him (Shaw) which, he proposed, should be erected in no less a place than o
Leinster Lawn in front of the Gallery. McNamara also mentioned to the Board tha
'although most of Mr Shaw's remarks on the subject were phrased in his usu;
light-hearted manner, he paid tribute to the Gallery for a priceless part of h
education in recognition of which he had left it a third part of his residual estate
This meant, in effect, that for a period of fifty years after Shaw's death the Galler
would receive one-third of the royalties derived from his published works. Th
bequest was to be of enormous benefit to the Gallery.

Thomas McGreevy (1893-1967) (Fig. 20 and see Collie [No. 4029]) was electe
Director on 7 June 1950; he took up office a month later. McGreevy was, in his ow
words 'Irish by birth, origin and nationality'. He had served on the editorial staff (
the *Connoisseur* magazine, had been Reader in English at the Ecole Normal
Superieure of the University of Paris from 1927–30 and, at the same time, ha

worked on the Parisian art review *Formes*. He had been a lecturer at the London National Gallery and at the outbreak of war had assisted in a voluntary capacity in the evacuation of the pictures from that Gallery. He had published in a variety of periodicals and his book *Pictures in the Irish National Gallery* came out in 1951.

At McGreevy's first meeting he reported to the Board that the Taoiseach had informed him that Sir Alfred Chester Beatty (1875–1968) had made a gift to the nation of some ninety paintings, mainly of the Barbizon school. The pictures in this gift made to the nation at this time were ultimately, in 1978, consigned by the State to the care and custody of the National Gallery and form part of this Catalogue (see page 351). It is perhaps only in very recent years that the importance of the gift, which included Breton's masterpiece *The Gleaners* (No. 4213CB), has been fully realised. Chester Beatty was an American by birth and a mining engineer by profession. He made his fortune in mining in South Africa and, with a considerable

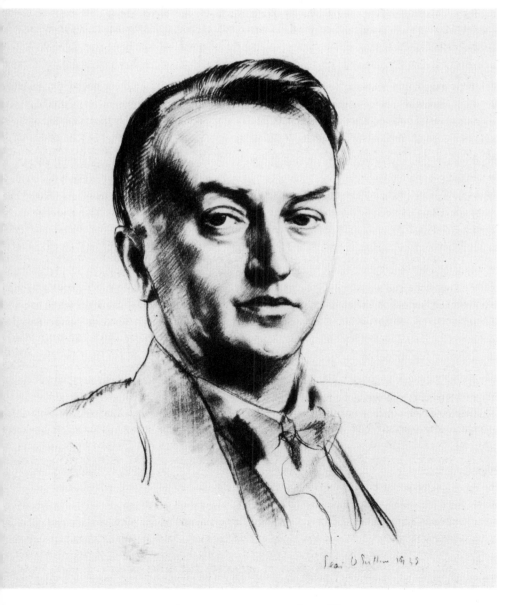

Fig. 20
Thomas McGreevy, Director 1950-63 Drawing by Sean O'Sullivan (coll. National Gallery of Ireland)

degree of expertise, amassed a fabulous collection of oriental art which is no[w] housed in the Chester Beatty Library in Dublin. During his lifetime he ha[d] presented a number of paintings of all schools to the National Gallery (see pag[e] 352).

McGreevy had been supported in his application for the Directorship by Dublin clergyman and well known collector of art, Monsignor Shine, and it is clea[r] from the purchases that McGreevy made in his first decade — many of which we[re] actually bought from Shine — that McGreevy valued greatly the judgment of h[is] mentor. Before 1958, when the purchasing power of the Board depended on th[e] Lane Fund and a grant-in-aid of £3,000 annually (reduced to £1,000 in 1956[)] McGreevy favoured purchases at under £1,000. His taste tended almost exclusive[ly] towards the religious and it cannot be said that the purchases he made at this tim[e] are among the most important pictures in the Collection: Dolci's *St Agnes* (N[o.] 1229) for £185; a copy after Guido Reni (No. 1239) for £50; Luini (No. 1249) f[or] £300; Cranach (No. 1278) for £600; Rubens (No. 1198) for £800; and (albeit [a] contemporary copy) Bandinelli (No. 1301) for £850; and School of Fr[a] Bartolommeo's *Holy Family* (No. 1232) for £3,000. In 1958 the Gallery received i[ts] first income from the Shaw estate — £1,000; but in the next few years the annu[al] income amounted to about £70,000.

The Board of Governors and Guardians reacted wisely to their new found wealt[h] and in 1960 resolved that 'in view of the present extent and variety of the Nation[al] Collection, and of the large funds at their disposal, no acquisitions of pictur[es] should be made, save those that have a special national interest, or are [of] outstanding aesthetic or historical importance'. The first purchase made from th[e] Shaw Fund was D. Tintoretto's *Venice* (No. 1384) for £23,000 in 1959 and this wa[s] followed by D. Ghirlandaio (No. 1385) for £7,395; Carreno (No. 1387) for £1,60[0] Le Nain (No. 1645) for £7,500; Nattier (No. 1646) for £7,000; Boucher (No. 172[2]) for £6,500; Navarrete (No. 1721) for £14,000 and two paintings by Murillo — *T[he] Holy Family* (No. 1719) for £40,000 and *St Mary Magdalen* (No. 1720) for £9,00[0]

The Government responded to news of the Shaw bequest in a variety of ways: o[n] the one hand they sanctioned a sum of £277,000 in 1962 for the building of a[n] extension to the Gallery — an extension which McGreevy had first asked for i[n] 1951; and, at the same time, with the retirement in 1960 of McNamara who ha[d] been Registrar for thirty-five years, the Government felt it was necessary that h[is] replacement 'should be someone familiar with Government accounting pro[-] cedures'. With a total annual income of £15,130 from the Government and [a] private income from the Shaw Fund of about £70,000 per annum, one migh[t] wonder at the logic of such a decision, particularly as the Gallery had bee[n] conceived and founded and, more to the point, flourished for a period of on[e] hundred and six years without the services of such an expert.

McGreevy, who was made a full-time Director in 1956 — the first since Walte[r] Armstrong — suffered ill health from 1958. From that time, during his severa[l] absences through illness, his duties were carried on by Dr William O'Sullivan wh[o] was seconded to the Gallery from the National Museum. McGreevy retired on 3[0] September 1963 and was succeeded by James White (1913–) (Fig. 21) wh[o] took up office on 1 June 1964.

The 1960s and 70s were a golden age for the National Gallery of Ireland. Fro[m] the unlikely source of a box-office hit in the cinemas of the world with the film *M[y] Fair Lady* (based on Shaw's *Pygmalion*) the Gallery could afford purchases such a[s] could never before have been contemplated. At the same time, the sudde[n] affluence and increased standard of living of the Irish people after decades o[f] depression since 1922, meant for the Gallery a level of popularity with the publi[c]

never hitherto known. The era opened with a new Director and a new extension to the building; and both were quite unlike any of their predecessors. The new extension (Fig. 22) — which gave ten new exhibition rooms (Fig. 23), conservation laboratories, a restaurant and a library — is cool and functional. An exception to its functionalism is its grand marble staircase (Fig. 24) which rises the height of the building and mocks the fact that Lanyon's plans for such grandeur over a hundred years earlier were abandoned on account of expense. The design of the new extension was mainly the work of Frank du Berry, an architect in the Office of the Commissioners of Public Works; at their meeting on 5 October 1962, the Board

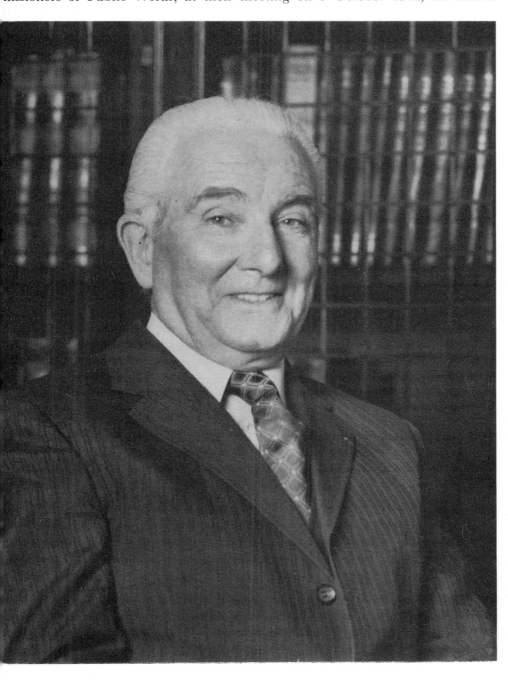

Fig. 21
James White, Director 1964-80

approved the plans and, at the same time, expressed their special appreciation of the architect, Mr du Berry, who had 'expended four hundred and six hours of unpaid overtime in six months to enable the plans to be completed'. Building began in late 1964 and the new rooms were opened on 25 September 1968.

Like the new extension, James White's style of Directorship also challenged the past and during his time the number of visitors to the Gallery each year soared from 68,137 in 1964 to an all-time record of 506,678 in 1977. He is Irish by birth and was educated at Belvedere College, Dublin. Until the age of fifty he had spent his life in business, although he was widely known as a lecturer and writer on art. In 1961 he was appointed Curator of the Dublin Municipal Gallery where, in a brief period of just two years, he established a reputation as a museum director of energy, flair and imagination. Like the pictures in the Municipal Gallery which Hugh Lane intended 'should be ceded to the National Gallery having stood the test of time', so James White came to the National Gallery as Director.

James White established a Conservation Department in the Gallery and, prior to the opening of the new extension in 1968, five restorers from the Istituto Centrale del Restauro in Rome came to the Gallery for several seasons and effected the long overdue cleaning of a large part of the Collection. Financed out of the

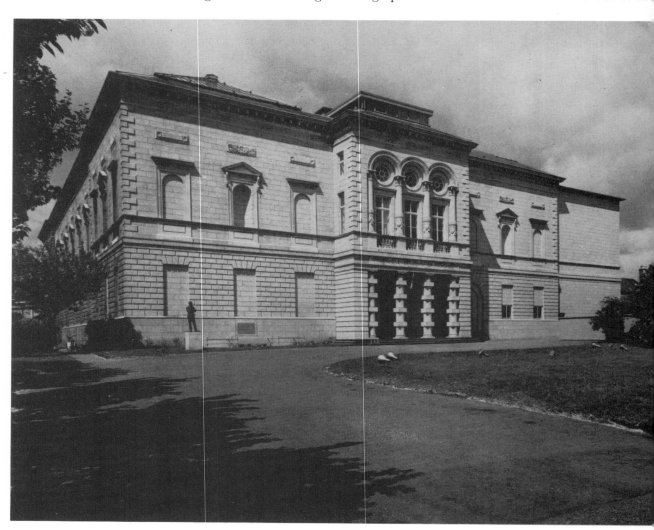

Shaw Fund, cleaning and restoration of the pictures meant a transformation in the appearance of the Gallery. The purchases of Mulvany, Doyle, Armstrong and others were suddenly seen in new light. The pictures purchased in Rome in the 1850s, which Bodkin in 1932 had described as 'remarkable for their area rather than their authenticity' were revealed, through the process of cleaning, to be what has reasonable claim to be considered the most important collection of Italian Seicento paintings outside of Italy. The Gallery sparkled, a small complement of professional staff were employed, an art library was opened to the public: the improvements so desperately wanted by Bodkin forty years previously were now effected.

With the Shaw Fund, important pictures were purchased: Giovanni di Paolo (No. 1768) for £78,853; Goya (No. 1928) for £225,000; Jacques Louis David (No. 4060) for £250,000; Gérard (No. 4055) for £40,000; Fragonard (No. 4313) for £375,000; and Étienne de La Tour (No. 1867) purchased as Georges de La Tour for £95,000. With a developing awareness of the Irish School of painting among the public, the Gallery kept abreast and bought a number of Irish pictures by Ashford (No. 4137) for £6,000 and (No. 4138) for £6,000; Roberts (No. 4052) for £8,000; Carver (No. 4065) for £4,500; Attributed to Grogan (No. 4303) for £15,000; Hunter (No. 4034) for £942 and (No. 4191) for £1,800; Roderic O'Conor (No. 4038) for £2,000, (No. 4057) for £2,700 and (No. 4134) for £2,100.

The Committee of the Irish Institution in 1854 had been encouraged to constitute a permanent public body and secure a suitable public building to be devoted exclusively to the reception of works of art, and the National Gallery of Ireland was founded. In an Address published in 1854 the Board of Governors and Guardians of the National Gallery of Ireland recorded 'the variety, extent and importance' of the pictures in the Irish Institution exhibition that year and 'the great advantages secured to the public by such opportunities for study as it

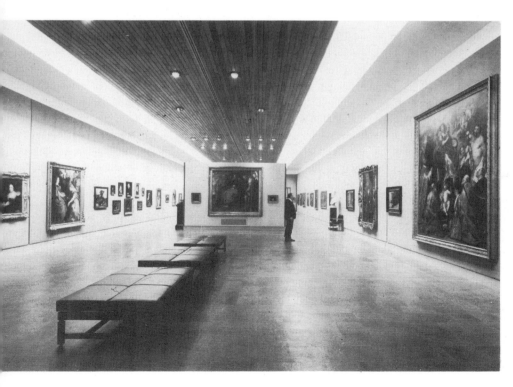

Fig. 23
One of the rooms added to the Gallery in 1968

supplied, the number of persons who took advantage of it, the interest excited by it among the public at large — increasing as the record of admissions proved'. Those same words might well have been written by the present-day Board of Governors and Guardians at the time of retirement of James White on 31 May 1980.

Bibliographical note: the information contained in this Introduction (and all quotations unless stated to the contrary) is derived from the Minutes of the meetings of the Board of Governors and Guardians, letter books and other manuscript material in the archive of the National Gallery of Ireland.

Fig. 24
The staircase of 1968

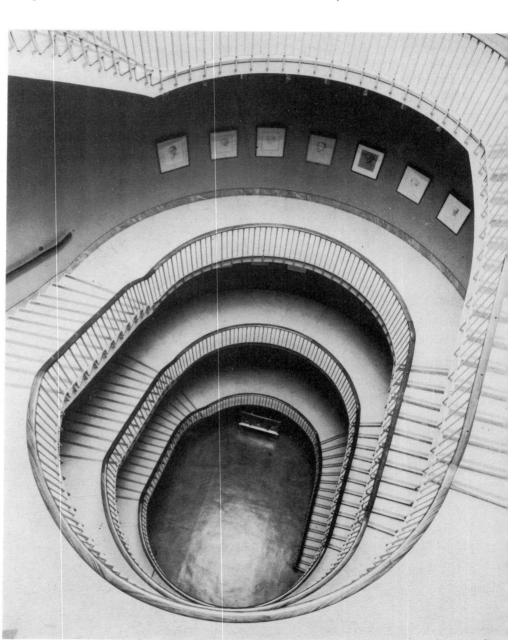

CONTINENTAL AND
BRITISH SCHOOLS

Claude Lorraine, *Juno Confiding Io to the Care of Argus,* (763, detail)

A

Aelst, Willem van (1626-c.83)
Amsterdam School
 1015 *A Still Life, Fruits*
 74 x 57
 Miss H. Reid Bequest, 1939

Aertsz, Pieter (1509-75)
Antwerp and Amsterdam Schools
 619 *An Eccentric Portrait of a Woman*
 69 x 53, on panel
 Purchased, Dublin, T. Stoker Sale,
 1910

1015

619

Aitkin, James (1846-97)
Scottish School
 627 *A Landscape*
 Signed: *James A. Aitkin '94*
 16 x 24, on panel
 Purchased, Dublin, Mrs Catterson
 Smith, 1912

Studio of **Albertinelli, Mariotto** (1475-1515)
Florentine School
 1100 *The Holy Family*
 117 x 155. on panel
 Purchased, London, Arcade Gallery,
 1942

627

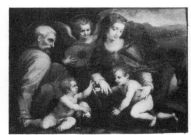
1100

Attributed to **Aldegrever, Heinrich** (1502-c.58)
German School
 73 *A Portrait of a Gentleman*
 Dated 1519
 43 x 30, on panel
 Purchased, London, Christie's, 1889

Allori, Alessandro (1535-1607)
Florentine School
 1088 *St John the Baptist*
 72 x 59, on panel
 Purchased, London, Arcade Gallery,
 1942

73

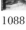
1088

Attributed to **Allston, Washington (1779-1843)**
American School
 4327 *An American Landscape*
 83 x 105.5
 Purchased, Belfast, Mr M. Solomon,
 1979

Attributed to **Amigoni, Jacopo (1675-1752)**
Venetian School
 1688 *The Birth of Cupid*
 122 x 152
 Purchased, Belfast, Mr A.
 Thompson, 1959

4327

1688

Angelico, Fra (1387-1455)
Florentine School
 242 *The Attempted Martyrdom of SS.*
 Cosmas and Damian with their Brothers
 36 x 46, tempera on panel
 Purchased, London, Christie's, 1886

Anthonisen, Aernout (c.1632-after 1688)
Dutch School
 152 *A River Scene with Shipping*
 Signed: *A.A.*
 65 x 95
 Purchased, London, Christie's, 1889

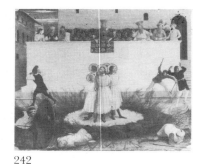

242

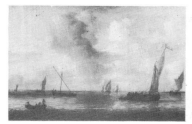

152

Antolinez, José (1635-75)
Spanish School
 31 *The Liberation of St Peter*
 Signed: *Josef Antolinez*
 167 x 124
 Purchased, Dublin, Mr T. Walker,
 1859

Antwerp Mannerist (c.1518)
 1162 *The Descent of the Holy Spirit*
 63 x 69, on panel
 Purchased, London, Mr C. Marshall
 Spink, 1948

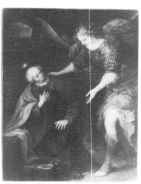

31

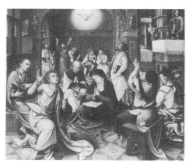

1162

Circle of **Appiani, Andrea (c.1754-1817)**
Milanese School
 1189 *Bonaparte as a General of the Army of*
 the Revolution
 36 x 32
 Milltown Gift, 1902

Armfield, George (fl.1840-75)
English School
 1714 *Duck Hunting*
 Signed: *G. Armfield 1867*
 26 x 38
 Milltown Gift, 1902

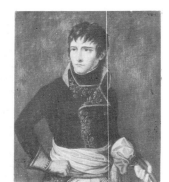

1189

1714

1718 *A Dog*
 34 x 46
 Milltown Gift, 1902

1718

Asch, Pieter van (1603-78)
Delft School
 343 *A Landscape with Figures*
 Signed with monogram
 43 x 55, on panel
 Purchased, Dublin, Mrs Algie,
 1894

343

Asia Minor School (15th century)
 1851 *Six Saints*
 17 x 14, tempera on panel
 Purchased, Mr W.E.D. Allen, 1968

Asia Minor School (early 18th century)
 1855 *St John*
 57 x 24, tempera on panel
 Purchased, Mr W.E.D. Allen, 1968

1851 1855

Austen, Winifred (19th century)
English School
 1931 *A Landscape Sketch*
 20.5 x 30.5
 Miss A. Callwell Bequest, 1904

1931

Austrian School (c.1800)
 4168 *Andrew, Count O'Reilly, (1742-1832)*
 72 x 53
 Purchased, Dublin, Malahide
 Castle Sale, 1976

4168

Avercamp, Hendrick (1585-c.1663)
Amsterdam School
 496 *A Winter Scene*
 Signed with monogram
 20 x 43, on panel
 Presented, Mr T. Ward, 1900

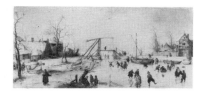

496

B

Bacchiacca (1494/5-1557)
Florentine School
 1332 *The Virgin and Child with St John*
 75 x 65, on panel
 Presented, Mr R. Clouston, 1855

Bachelier, Jean-Jacques (1724-1806)
French School
 167 *The Death of Milo of Croton*
 244 x 190
 Presented, Sir Arthur Guinness, 1856

1332

167

Bakhuysen, Ludolf (1631-1708)
Amsterdam School
 173 *The Dutch East India Fleet Leaving*
 Port
 Signed: *L. Bak. 1702*
 131 x 116
 Purchased, London, Christie's, 1883

 1673 *A Seacoast Scene with Shipwreck*
 Signed: *LB 1694·*
 49 x 74
 Milltown Gift, 1902

173

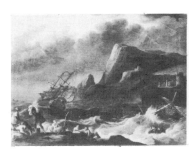

1673

Balducci, Giovanni (d.1603)
Italian School
 1282 *The Descent from the Cross*
 20 x 58, on panel
 Purchased, Dublin, Monsignor J.
 Shine, 1954

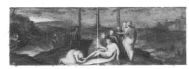

1282

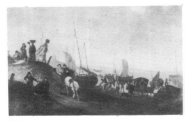

1706

Balen, Hendrik van (1575-1632)
Flemish School
 1706 *A Seacoast with Figures*
 Signed: *HB*
 63 x 92, on panel
 Milltown Gift, 1902

Balkan School (?) (late 15th century)
1856 *St Demetrius*
53 x 44.5, tempera on panel
Purchased, Mr W.E.D. Allen, 1968

After Bandinelli, Bartolommeo (1493-1560)
Florentine School
1301 *The Martyrdom of St Laurence*
(contemporary copy)
94 x 128, on panel
Purchased, London, W.M. Sabin
and Son, 1955

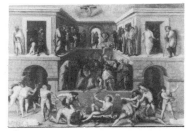

1301

1856

Baptiste (1634-99)
French School
1079 *A Flower Piece*
115 x 75
Milltown Gift, 1902

1647 *A Flower Piece*
77 x 64
Mrs F. O'Farrell Bequest, 1961

1079

1647

Barker, Thomas (1769-1847)
English School
377 *A Landscape near Bath*
Signed: *T. Barker, Pinx't, 1835*
70 x 91
Presented, Mr G. Salting, 1893

Barker, Thomas Jones (1815-82)
English School
1965 *The Charger of Captain Nolan
Returning with his Dead Master*
43 x 53.5, on board
Provenance unknown

377

1965

Follower of Barocci, Federico (1526-1612)
Italian School
1103 *The Absolution of St Francis*
57 x 36
Purchased, London, Singer
Galleries, 1943

1527 *The Flight into Egypt*
150 x 105
Presented, Sir Alfred Chester Beatty,
1954

1103

1527

Barret the Younger, George (c.1767-1842)
English School
415 *A Self-Portrait*
75 x 61, on panel
Purchased, Preston, Lancashire,
Mr J. Ward, 1894

415 1089

Bartolo, Andrea di (fl.1389-1428)
Sienese School
1089 *St Galganus*
39 x 38, on panel
Purchased, Mrs T. Jameson, 1942

School of **Bartolommeo, Fra (1472-1517)**
Florentine School
1232 *The Holy Family*
142 x 107, on panel
Purchased, Dublin, Monsignor J.
Shine, 1952

91

Bassano, Jacopo (1510-92)
Venetian School
91 *The Holy Family with Donors*
38 x 51
Purchased, Rome, Mr R.
MacPherson, 1856

1232

School of **Bassano**
1141 *The Procession to Calvary*
100 x 131
Presented, Sir Alec and Lady Martin
through the Friends of the
National Collections, 1947

1141 1665

1665 *Industry by Candlelight*
98 x 132
Milltown Gift, 1902

Bassano, Leandro (1557-1622)
Venetian School
97 *The Visit of the Queen of Sheba to Solomon*
168 x 112
Purchased, Rome, 1856

954

954 *The Building of the Ark*
94 x 128
Purchased, London, Mr T. Harris,
1932

97

astiani, Lazzaro (c.1425-1512)
enetian School
 352 *The Virgin and Child Enthroned*
 145 x 117, on panel
 Purchased, London, Christie's, 1891

astien-Lepage, Jules (1848-84)
rench School
 583 *Carlo Pellegrini, Caricaturist*
 Signed: *J. Bastien-Lepage*
 Dated 1879
 33 x 24
 Purchased, London, 1907

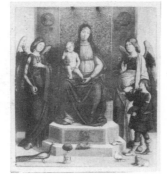
352

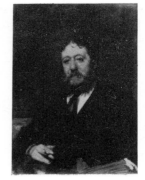
583

atoni, Pompeo (1708-87)
oman School
 109 *Pope Pius VI (Giovanni Angelo*
 Braschi, 1717-99, Pope from 1775)
 137 x 98
 Presented, Mr R. Tighe, 1875

 701 *Joseph Leeson, afterwards 1st Earl of*
 Milltown
 Signed: *Batoni Pinse Roma 1744*
 137 x 102
 Milltown Gift, 1902

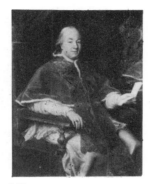
109

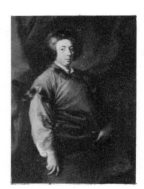
701

 702 *Joseph Leeson, afterwards 2nd Earl of*
 Milltown
 Inscribed: *PB 1751*
 99 x 73
 Milltown Gift, 1902

 703 *Lady Leeson as Diana*
 48 x 38
 Milltown Gift, 1902

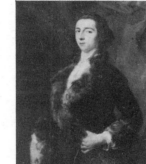
702

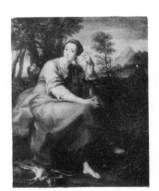
703

 704 *Venus and Cupid*
 56 x 71
 Milltown Gift, 1902

After **Batoni**
 909 *Joseph Leeson, afterwards 2nd Earl of*
 Milltown
 43 x 35
 Presented, V. Lawless, Lord
 Cloncurry, 1928

704

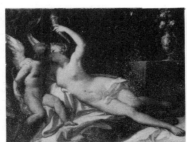
909

1650 *Lady Leeson as Diana*
 (copy of 703)
 46 x 33, on panel
 Milltown Gift, 1902

1697 *Joseph, 1st Earl of Milltown with his*
 Wife and Other Members of the Leeson
 Family
 65 x 46
 Milltown Gift, 1902

1650

1697

Bazzani, Giuseppe (1690-1769)
Mantuan School
 982 *Christ Meets His Mother*
 116 x 88
 Purchased, London, Mr W. Duits,
 1936

 983 *The Descent from the Cross*
 116 x 88
 Purchased, London, Mr W. Duits,
 1936

982

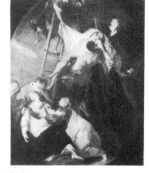

983

Beach, Thomas (1738-1806)
English School
 490 *A Portrait of a Gentleman*
 Signed: *T. Beach pinxit 1782*
 75 x 61
 Provenance unknown

Beccafumi, Domenico (1486-1551)
Sienese School
 840 *The Sacrament of Baptism*
 25 x 25, on panel
 Purchased, Captain R. Langton
 Douglas, 1922

490

840

Attributed to **Beccaruzzi, Francesco**
(fl.1520-50)
Italian School
 213 *SS. Jerome and Francis with Two*
 Donors
 119 x 225
 Purchased, Mr D. Sherratt, 1882

Attributed to **Beechey, William (1753-1839)**
English School
 1792 *A Member of the Grove Family*
 75.5 x 63
 Purchased, Surbiton, England,
 Mrs E. Grove, 1966

213

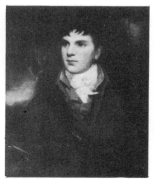

1792

Beerstraten, Jan-Abrahamsz (1622-66)
Amsterdam School
 679 *Winter: The Heylige-Weghts Gate at*
 Amsterdam, (1663)
 Signed: *J.A. Beerstraten*
 75 x 104, on panel
 Presented, Sir Hugh Lane, 1914

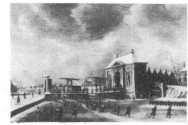

679

Bega, Cornelis (1620-64)
Haarlem School
 28 *Two Men Singing*
 Signed: *C. Bega, ao 1662*
 34 x 31, on panel
 Purchased, London, Blamire
 Collection Sale, 1863

28

Belle, Alexis (1674-1734)
French School
 912 *Sir Charles Haggerston*
 Inscribed on reverse and dated 1714
 148 x 116
 Purchased, London, W. Dyer and
 Son, 1928

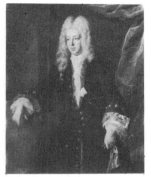

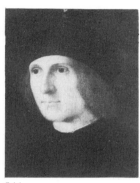

Bellini, Giovanni (c.1428-1516)
Venetian School
 244 *A Head of a Gentleman*
 31 x 23, on panel
 Purchased, London, Christie's, 1886

912

244

Attributed to Bellini
 100 *Portraits of Two Venetian Personages*
 Inscribed on reverse: *Navagero et*
 Beazzanno Poetes
 63 x 96, on panel
 Purchased, Paris, M. M. Auguiot,
 1867

100

181

Bellotto, Bernardo (1720-80)
Venetian School
 181 *A View of Dresden looking down the Elbe*
 50 x 84
 Purchased, Paris, M.B.
 Narischkine Sale, 1883

 182 *A View of Dresden looking up the Elbe*
 Signed: *Bernard Bellotto dit Canaletto*
 Peintre du Roi
 50 x 84
 Purchased, Paris, M.B.
 Narischkine Sale, 1883

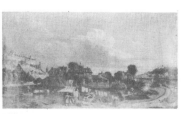

After Bellotto
 1960 *A View of Castle Sonnenstein on the*
 Elbe at Pirna
 72 x 123
 Presented, Mr R. Clouston, 1855

182

1960

Belmont, Ira Jean (1885-1964)
American School
 4190 *The Pines of Rome (Catacomb)*
 Signed: *I. J. Belmont*
 66 x 71
 Presented, New York, Mrs E.
 Belmont, 1976

4190

3

Attributed to **Benson, Ambrosius (1495-1550)**
Flemish School
 3 *A Portrait of a Lady, as the Magdalen,*
 Reading
 48 x 41
 Purchased, Paris, 1864

1998

176

Bentley (?) (19th century)
English School
 1998 *Cattle in a Landscape*
 39 x 41, on panel
 Provenance unknown

245

510

Berchem, Claes Pietersz (1620-83)
Haarlem School
 176 *An Italian Farmhouse*
 Signed: *Berchem*
 40 x 53, on panel
 Purchased, London, Christie's, 1884

 245 *A Stag Hunt*
 Signed: *Berchem*
 48 x 76
 Purchased, London, Christie's, 1886

 510 *An Italian Landscape*
 60 x 75
 Sir Henry Barron Bequest, 1901

 1657 *A Cattle Fair*
 107 x 135
 Milltown Gift, 1902

 1939 *A Landscape with Ford*
 85 x 111
 Purchased, Miss Cranfield, 1878

1657

1939

erchere, Narcisse (1819-91)
rench School
- 4209CB *An Arab Caravan Resting near Shore*
 Signed: *Berchere*
 81 x 101
 Sir Alfred Chester Beatty Gift, 1950

- 4210CB *An Eastern Scene with Minaret*
 Signed: *Berchere*
 41 x 32
 Sir Alfred Chester Beatty Gift, 1950

4209CB

4210CB

erckmans, Carlo (20th century)
lemish School
- 1955 *A Copy of a Portrait of a Lady by
 Adriaen Hanneman*
 Inscribed on reverse: *Copy by Carlo
 Berckmans from Antwerp, during his exile.
 Dublin 1918*
 76 x 63
 Provenance unknown

ergen, Dirck van (1645-90)
aarlem School
- 59 *The Old White Horse*
 58 x 51
 Purchased, London, Christie's, 1864

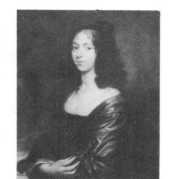

1955

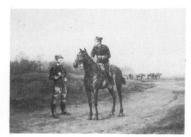

59

- 274 *Cattle in a Rocky Landscape*
 35 x 61
 Purchased, London, Christie's, 1887

Berne-Bellecour, Étienne (1838-1910)
rench School
- 1218 *Cavalry Colonel and Artillery Major at
 Manoeuvres*
 Signed: *E. Berne-Bellecour 1905*
 41 x 54, on panel
 Presented, Sir Alfred Chester Beatty,
 1951

274

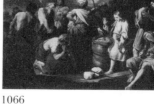

1218

Berthon, René (1776-1859)
rench School
- 133 *Lady Morgan, Writer, (1778-1859)*
 Signed: *Berthon*
 130 x 98
 Lady Morgan Bequest, 1860

Bertin, Nicolas (1668-1736)
rench School
- 1066 *The Finding of the Money in
 Benjamin's Sack*
 94 x 128
 Milltown Gift, 1902

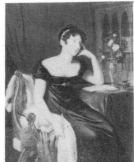

1066

133

1684 *Another version of 1066*
 98 x 130
 Milltown Gift, 1902

Bettera, Bartolommeo (early 17th century)
Bergamese School
 1014 *A Still Life*
 94 x 117
 Miss H. Reid Bequest, 1939

1684

1014

Biagio di Antonio Utile (15th century)
Florentine School
 842 *The Virgin and Child*
 78 x 58, on panel
 Purchased, Captain R. Langton
 Douglas, 1922

Biondo, Giovanni del (fl.1356-92)
Florentine School
 943 *The Virgin and Child with Angels*
 161 x 59, tempera on panel
 Purchased, Rome, Signor U.
 Jandola, 1931

842

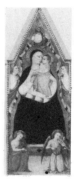
943

Blacklock, W. J. (1816-58)
English School
 503 *A View of Naworth Castle*
 41 x 72
 Presented, Sir Walter Armstrong,
 1900

Blanche, Jacques (1861-1942)
French School
 1051 *James Joyce, Author, (1882-1941)*
 Signed: *J.E. Blanche, 1934*
 82 x 65
 Purchased, London, Leicester
 Galleries, 1941

503

1051

Bleker, C. (fl. early 17th century)
Flemish School
 246 *A Raid on a Village*
 Signed: *C. Bleker. f. 1628*
 74 x 135, on panel
 Purchased, London, Christie's, 1885

Bloemen, Jan van (1662-1749)
Italo-Dutch School
 338 *An Italian Landscape*
 48 x 94
 Presented, Mr T. Berry, 1862

246

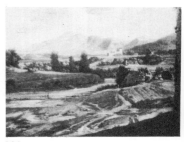
338

1672 *An Attack by Banditti*
50 x 65
Purchased, 1863

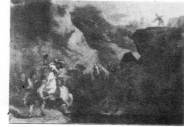

Bloemen, Pieter van (1657-1720)
Flemish School
1016 *A Landscape with Figures and Horses*
30 x 35.3
Miss H. Reid Bequest, 1939

1672

1016

Boel, Pieter (1622-74)
Flemish School
42 *Noah's Ark*
172 x 241
From the Irish Institution with which
it had been deposited for the
National Gallery of Ireland by
Edward Eliot, 3rd Earl of St
Germans, English Viceroy in
Ireland, 1854

42

47

Bol, Ferdinand (1616-80)
Amsterdam School
47 *David's Dying Charge to Solomon*
Signed: *F. Bol fecit 1643*
171 x 230
Provenance as above

810 *A Portrait of a Lady*
Signed: *F. Bol*
96 x 73
Sir Hugh Lane Bequest, 1918

1394 *The Holy Women at the Tomb*
104 x 123
Purchased, Dublin, Mr H. Naylor
Sale, 1959

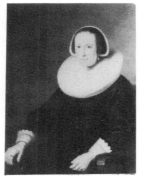

1394

810

Bolognese School (17th century)
1078 *Nymphs, Cupid and Satyr*
63 x 82
Milltown Gift, 1902

Bonheur, Rosalie (1822-99)
French School
4211CB *A Stag*
Signed: *Rosa Bonheur 1893*
46 x 38
Sir Alfred Chester Beatty Gift, 1950

1078

4211CB

[13]

Bonifazio de' Pitati (1487-1553)
Venetian School
178 *The Resurrection*
211 x 185
Purchased, Hamilton Palace Sale,
1882

1128

1128 *Isaac Blessing Jacob*
24 x 59, on panel
Purchased, London, Mr F. Drey,
1945

178

Follower of Bonifazio de' Pitati
1072 *The Adoration of the Magi*
173 x 103
Milltown Gift, 1902

Bonington, Richard (1801-28)
English School
537 *The Chibouk*
24 x 29
Purchased, London, Agnew, 1902

537

1072

Bonvin, François (1817-87)
French School
4291CB *A Still Life*
Signed: *F. Bonvin*
38 x 48
Sir Alfred Chester Beatty Gift, 1950

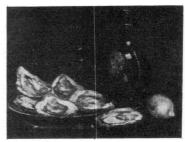

Borch, Gerard ter (1617-81)
Haarlem School
270 *Heer Hendricksen van Zwolle*
84 x 66
Purchased, London, Christie's, 1886

4291CB

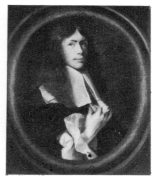

270

849 *Four Spanish Monks*
72 x 97
Purchased, Mr H. de Groot, 1923

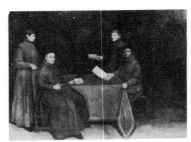

Attributed to Bordone, Paris (1500-71)
Venetian School
779 *St George and the Dragon*
152 x 168
Sir Hugh Lane Bequest, 1918

849

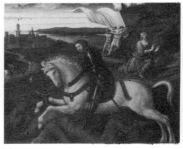

779

Follower of **Bosch, Hieronymous (c.1450-1516)**
Flemish School
 1320 *The Scourging at the Pillar*
 71 x 57, on panel
 Purchased, Dublin, Monsignor J.
 Shine, 1955

Both, Jan (c.1610-52)
Utrecht School
 179 *An Italian Landscape*
 Signed: *J. Both*
 74 x 100
 Purchased, Brussels, Comte
 Ferdinand Rasponi di Ravenna,
 1880

 706 *A Horse Drinking*
 32 x 24, on panel
 Milltown Gift, 1902

 4292CB *An Italian Landscape*
 Signed: *J. Both*
 80 x 97
 Sir Alfred Chester Beatty Gift, 1950

Boucher, François (1703-70)
French School
 1723 *A Young Girl in a Park*
 58 x 46
 Purchased, London, Wildenstein,
 1962

Boudewijns, Adriaen (1644-1711)
with
Bout, Pieter (1658-c.1702)
Flemish School
 1095 *A Landscape with Figures*
 28 x 44, on panel
 Milltown Gift, 1902

 1096 *A Landscape with Figures*
 28 x 44, on panel
 Milltown Gift, 1902

Boudin, Eugène (1824-98)
French School
 4212CB *Ships*
 Signed: *E. Boudin –89*
 117 x 159
 Sir Alfred Chester Beatty Gift, 1950

1320

179

706

4292CB

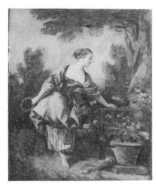

1723

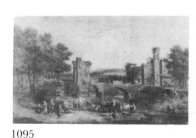

1095

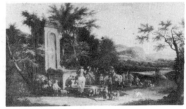

1096

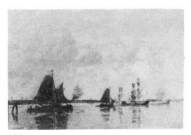

4212CB

Boulogne the Elder, Bon (1649-1717)
French School
 1889 *The Call of the Sons of Zebedee*
 310 x 252
 Purchased, Rome, Signor Aducci,
 1856

1032

After **Bourdon, Sébastien (1616-71)**
French School
 1032 *A Landscape*
 80 x 97
 Milltown Gift, 1902

1889

Attributed to **Bourdon**
 4197 *Phaeton*
 102 x 132
 Presented, Dr F. Henry, 1977

Boyle, George (late 19th century)
English School
 1139 *A Landscape*
 Signed: *George Boyle*
 Inscribed on reverse and dated 1888
 25 x 35
 Presented, Mr G. Boyle, 1947

4197

1139

Bradford, William (1827/30-92)
American School
 1872 *The Midnight Sun on Melville Sound*
 Signed: *W. Bradford '76*
 56 x 76
 Purchased, Dublin, Mr A. Windrim,
 1968

Brakenburg, Richard (1650-1702)
Dutch School
 1949 *An Interior with Figures*
 Signed: *R. Brakenburg 1689*
 40.8 x 49.7
 Provenance unknown

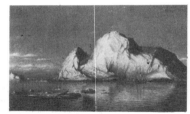
1872

1949

Brandon, Edouard (1831-97)
French School
 881 *Nathaniel Hone, Artist, (1831-1917)*
 Signed: *Ed. Brandon, 1870*
 43 x 37
 Purchased, Mr H. Hone, 1927

Bray, Solomon de (1597-1664)
Haarlem School
 180 *A Group of Two Boys*
 Signed: *D. Bray, 1651* or *1652*
 36 x 28, on panel
 Purchased, Mr J. Robinson, 1875

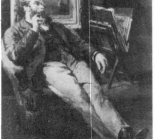
881

180

Breenberg, Bartholomaus (1599-before 1659)
Amsterdam School
700 *A Landscape with Ruins*
 51 x 64
 Milltown Gift, 1902

Brekelenkam, Quiringh van (c.1620-68)
Leyden School
1225 *The Pancake Seller*
 33 x 28, on panel
 Purchased, Mrs E. Finnegan, 1951

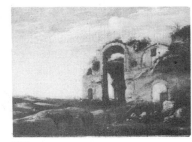

700

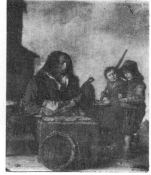

1225

Brescian School (16th century)
277 *St Jerome*
 148 x 108, on panel
 Purchased, London, Christie's
 Blenheim Palace Sale, 1886

Breslau, Louise (1856-1927)
Swiss School
908 *Berligot Ibsen (née Bjornsen)*
 Signed: *L. Breslau, 1889*
 131 x 90
 Presented, Mlle Zillhardt through
 the Friends of the National
 Collections, 1928

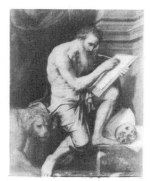

277

908

Breton, Jules (1827-1906)
French School
4213CB *The Gleaners*
 Signed: *Jules Breton 1854*
 93 x 138
 Sir Alfred Chester Beatty Gift, 1950

4214CB *A Girl with a Rake*
 Signed: *Jules Breton 1859*
 81 x 66
 Sir Alfred Chester Beatty Gift, 1950

4213CB

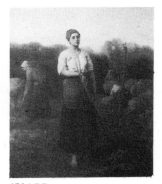

4214CB

Brett, John (1830-1902)
English School
1900 *A View of Felixstowe*
 Signed: *John Brett, Felixstowe, 21 June
 '93*
 18 x 36
 Sherlock Bequest, 1941

School of **Bronzino, Agnolo (1503-72)**
1989 *St Catherine*
 89 x 71
 Provenance unknown

1989

1900

Brooking, Charles (1723-59)
English School
237 *Dutch Men-of-War at Sea*
Signed with monogram of van de
Velde
41 x 61
Purchased, London, Christie's, 1876

237

Brouwer, Adriaen (c.1605-38)
Flemish School
356 *The Corn Doctor*
31 x 27, on panel
Purchased, London, Mr T. Larkin,
1892

356

Browne, Harris (fl.1889)
English School
622 *William Alexander, Protestant Arch-
bishop of Armagh, (1824-1911)*
89 x 68
Presented, Mr Justice Ross on behalf
of a committee representing all
religious denominations, 1912

Brueghel the Younger, Pieter (1564-1638)
Flemish School
911 *A Peasant Wedding*
Signed: *P. Brueghel, 1620*
89 x 112, on panel
Purchased, Dublin, Mr L. Wine,
1928

911

622

School of Bruyn, Bartholomeus (1493-1553/6)
Cologne School
404 *A Portrait of a Gentleman*
25.8 x 16, on panel
Presented, Mr H. Pfungst, 1895

Bugiardini, Giuliano (1475-1554)
Florentine School
1090 *The Holy Family*
dia. 89, on panel
Purchased, Mrs Mendelsohn-
Bartholdy, 1942

404

1090

Burnet, John (1784-1868)
English School
378 *Greenwich Pensioners*
43 x 73
Purchased, London, Shepherd
Bros., 1894

Butteri, Giovanni (c.1540-1606)
Florentine School
1021 *The Return from the Palio*
132 x 103
Purchased, Captain R. Langton
Douglas, 1940

378

1021

Attributed to **Butts, John (d.1764)**
English School
 4306 *A Woodland Scene*
 25 x 30.5, on panel
 Purchased, Dublin, Mr A. Collins,
 1978

Attributed to **Bylert, Jan van (1603-71)**
Utrecht School
 639 *A Portrait of a Boy*
 (traditionally said to represent
 Aelbert Cuyp)
 107 x 84, on panel
 Mrs Lecky Bequest, 1912

4306

639

C

Cameron, David (1865-1945)
Scottish School
 4293CB *The Wilds of Lochaber*
 153 x 183
 Sir Alfred Chester Beatty Gift, 1950

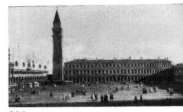

286

Canaletto (1697-1768)
Venetian School
 286 *A View of the Piazza San Marco*
 46 x 77
 Purchased, London, Christie's, 1885

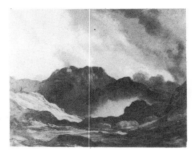

4293CB

Studio of **Canaletto**
 705 *The Grand Canal with the Church of*
 the Salute
 59 x 96
 Milltown Gift, 1902

 1043 *The Grand Canal with the Church of*
 the Carità
 59 x 96
 Milltown Gift, 1902

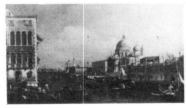

705

1043

Canevari, Giovanni (1789-1876)
Italian School
 4169 *Colonel Richard Wogan Talbot, 2nd*
 Baron Talbot de Malahide, (c.1766-
 1849)
 136 x 99
 Purchased, Dublin, Malahide Castle
 Sale, 1976

After **Cano, Alonso (1601-67)**
Spanish School
 369 *The Miracle of St Dominic*
 203 x 152
 Purchased, London, Christie's W.
 Graham Sale, 1886

4169

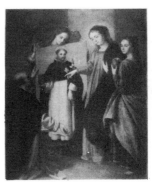

369

Cantarini, Simone (1612-48)
Bolognese School
71 *St John in the Wilderness*
 123 x 97
 Purchased, Rome, 1864

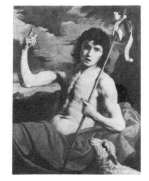

71

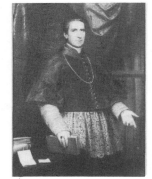

406

Capalti, Alessandro (c.1810-68)
Italian School
406 *John McHale, Archbishop of Tuam,*
 (1791-1881)
 137 x 98
 Presented, Monsignor McHale, 1890

Cappelle, Jan van de (1624-79)
Amsterdam School
74 *A Winter Scene*
 Signed: *JVC*
 43 x 53
 Purchased, London, Christie's, 1888

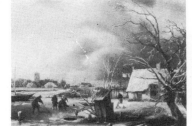

74

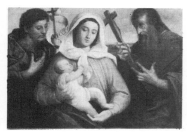

885

Cariani (16th century)
Italian School
885 *The Virgin and Child with SS. John the*
 Baptist and Jerome
 86 x 118
 Purchased, Mr H. Warren, 1927

Carlone, Carlo (1686-1775)
Venetian School
1640 *The Annunciation, (c.1749)*
 56 x 40
 Purchased, Miss K. Farrelly (legatee
 of Monsignor J. Shine), 1961

1640

367

Carpi, Girolamo da (1501-56)
Ferrarese School
367 *The Adoration of the Shepherds*
 66 x 94, on panel
 Purchased, Dublin, 1859

Attributed to **Carracci, Annibale (1560-1609)**
Bolognese School
673 *A Portrait of a Gentleman*
 50 x 39
 Presented, Sir Hugh Lane, 1914

After **Carracci**
990 *The Bath*
 64 x 81, on panel
 Milltown Gift, 1902

673

990

[21]

1331 *The Holy Family with St John*
 37 x 27
 Milltown Gift, 1902

Follower of **Carracci**
 1682 *The Pensive Muse*
 71 x 99
 Milltown Gift, 1902

1682

1331

Carré, Hendrik (1656-1721)
Dutch School
 1944 *A Portrait of a Lady*
 Signed: *H. Carré 1704*
 72 x 60
 Miss M. Crowe Bequest, 1970

Carreno, Juan de (1614-85)
Spanish School
 1387 *Infante Balthasar Carlos, (1629-46)*
 (after Velazquez)
 94 x 114
 Purchased, London, Agnew, 1959

1387

1944

Castiglione, Giovanni (1616-70)
Genoese School
 994 *A Shepherdess finding the Infant Cyrus*
 232 x 226
 Purchased, London, Christie's, 1937

Castro, Bernardo de (fl. c.1525)
Spanish School
 1109 *Gomez*
 72 x 48, on panel
 Purchased, London, Arcade
 Gallery, 1943

994

1109

Cazin, Jean (1841-1901)
French School
 4215CB *A Road with Farm Buildings*
 Signed: *J C Cazin*
 42 x 55
 Sir Alfred Chester Beatty Gift, 1950

 4216CB *A Windmill*
 Signed: *J C Cazin*
 82 x 100
 Sir Alfred Chester Beatty Gift, 1950

4215CB

4216CB

elesti, Andrea (1637-1700)
enetian School
 1925 *Count Alberto da Baone*
 206 x 140
 Purchased, Rome, Signor Aducci,
 1856

entral European School (late 17th century)
 1836 *An Altarpiece of Carved Wood*
 height of painted panel 40.5
 Purchased, Mr W.E.D. Allen, 1968

1925 1836

entral Greek School (late 17th century)
 1853 *The Virgin and Child*
 39.5 x 30.5, tempera on panel
 Purchased, Mr W.E.D. Allen, 1968

erezo, Mateo (1635-85)
panish School
 1528 *St Mary of Egypt*
 163 x 113
 Presented, Sir Alfred Chester Beatty,
 1954

1853 1528

hambers, George (1803-40)
nglish School
 403 *A Seascape*
 13 x 26, on board
 Purchased, London, Shepherd
 Bros., 1895

403

hanet, Henri (fl. after 1874)
rench School
 312 *Julia Kavanagh, Novelist, (1824-77)*
 Signed: *H. Chanet*
 53 x 49
 Presented, Mrs M. Kavanagh,
 1884

312

hardin, Jean-Baptiste (1699-1779)
rench School
 478 *Les Tours de Cartes*
 31 x 39
 Purchased, 1898

 799 *A Still Life*
 Signed: *Chardin 17 . . .*
 82.5 x 65
 Sir Hugh Lane Bequest, 1918

478 799

813 *The Young Governess*
 62 x 73
 Sir Hugh Lane Bequest, 1918

Chelminski, Jan van (1851-1925)
Polish School
 4217CB *Riders in Snow*
 Signed: *Jan v Chelminski*
 38 x 61
 Sir Alfred Chester Beatty Gift, 1950

813

4217CB

Cignani, Carlo (1628-1719)
Bolognese School
 183 *St Cecilia*
 140 x 145
 Presented, Sir Henry Barron, 1878

Claesz, Pieter (1597/8-1661)
Haarlem School
 326 *A Still Life*
 Signed with monogram and dated
 1637
 38 x 57, on panel
 Purchased, Paris, Sedelmeyer, 1893

183

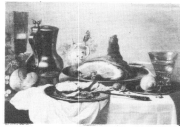

326

 1285 *A Still Life*
 Signed with monogram and dated
 1651
 50 x 69, on panel
 **Presented, Sir Alfred Chester Beatty,
 1953**

Claude Lorraine (1600-82)
French School
 763 *Juno Confiding Io to the Care of Argus*
 Signed: *Claudio IV f. Roma 1660*
 60 x 75
 Sir Hugh Lane Bequest, 1918

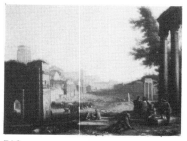

1285

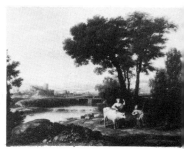

763

After **Claude Lorraine**
 719 *Rome, the Campo Vaccino*
 56 x 72
 Milltown Gift, 1902

Clerisseau, Charles (1721-1820)
French School
 884 *Roman Ruins*
 73 x 61
 Provenance unknown

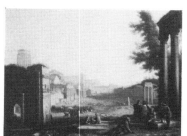

719

884

Coccorante, Leonardo (1680-1750)
Neapolitan School
 1744 *A Coast Scene with Ruins*
 69 x 99
 Milltown Gift, 1902

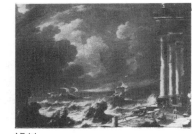

1744

Cock, Jan de (1503-c.26)
Flemish School
 1001 *The Flight into Egypt*
 34 x 24, on panel
 Purchased, Dr A. Scharf, 1938

1001

Codde, Pieter (1599-1678)
Haarlem School
 321 *An Interior with Figures*
 Signed with monogram
 32 x 41, on panel
 Purchased, London, Mr G. Smith,
 1892

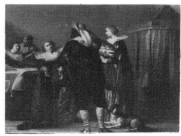

321

Coello, Alonso (1531/2-88)
Spanish School
 17 *Prince Alexander Farnese, (c.1560)*
 167 x 79
 Purchased, Rome, 1864

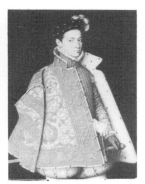

17

Collier, John (1850-1934)
English School
 899 *George Bernard Shaw, Dramatist,*
 (1856-1950)
 Signed: *John Collier, 1927*
 112 x 86
 Presented, Mrs B. Shaw, 1928

594

Collins, Charles (d.1744)
English School
 594 *Dead Game*
 Signed: *C. Collins*
 57 x 104
 Mrs Stretton Bequest, 1908

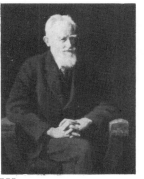

899

Collins, William (1788-1847)
English School
 648 *The Artist's Mother*
 36 x 30, on panel
 Presented, Sir Hugh Lane, 1913

 1802 *An Irish Coast*
 Signed: *Wm. Collins, 1839*
 40.8 x 56
 Purchased, Messrs Barry and
 Tattan, 1966

1802

648

Compe, Jan ten (1713-61)
Amsterdam School
1681　　*A Village with Windmill*
　　　　Signed: *ten Compe*
　　　　34 x 48, on panel
　　　　Milltown Gift, 1902

1681

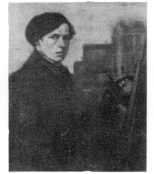

1327

Conder, Charles (1868-1909)
English School
1327　　*William Orpen, Artist, (1878-1931)*
　　　　76 x 61
　　　　Purchased, London, Leicester
　　　　Galleries, 1956

Coninck, David (1636-99)
Flemish School
717　　*A Cat, Rabbit and Poultry*
　　　　76 x 100
　　　　Milltown Gift, 1902

717

376

Constable, John (1776-1837)
English School
376　　*A Landscape near Salisbury*
　　　　29 x 38, on paper laid on canvas
　　　　Purchased, London, Agnew, 1893

798　　*A Portrait of a Child with a Dog*
　　　　74 x 95
　　　　Sir Hugh Lane Bequest, 1918

798

Constantinople School (c.1325)
(Margin 15th century)
1858　　*The Virgin and Child Hodigitria, with
　　　　John the Baptist and Twelve Prophets
　　　　on the Margin*
　　　　135 x 111, tempera on panel
　　　　Purchased, Mr W.E.D. Allen, 1968

1858

Constantinople School (late 14th century)
1843　　*The Crucifixion with the Virgin and
　　　　St John*
　　　　37 x 31, tempera on panel
　　　　Purchased, Mr W.E.D. Allen, 1968

Constantinople School (early 15th century)
1837　　*The Virgin and Child Hodigitria*
　　　　83 x 64, tempera on panel
　　　　Purchased, Mr W.E.D. Allen, 1968

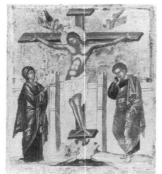

1843

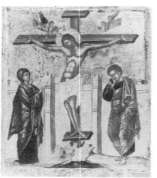

1837

Constantinople School (late 17th century)
1838 *St Anthony Abbot*
 35.5 x 20, tempera on panel
 Purchased, Mr W.E.D. Allen, 1968

Cooke, Edward (1811-80)
English School
593 *Venice, the Salute*
 79 x 67
 Mr H. Brunning Bequest, 1908

1838

593

After **Cooper, Samuel (1609-72)**
English School
249 *Oliver Cromwell, (1599-1658)*
 36 x 29
 Purchased, London, Christie's, 1886

264 *Richard Cromwell, (1626-1712)*
 40 x 32
 Purchased, London, Christie's, 1886

505 *Oliver Cromwell, (1599-1658)*
 69 x 56
 Purchased, London, Shepherd
 Bros., 1901

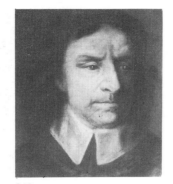

249

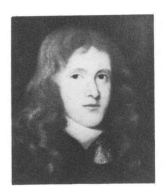

264

Coques, Gonzales (1614-84)
Flemish School
185 *A Portrait of a Lady*
 20 x 16, on metal
 Purchased, Brussels, Vicomte B. du
 Bus de Gisignies, 1882

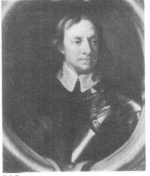

505

185

Cornelisz of Amsterdam, Jacob (1477-1533)
Flemish School
812 *The Adoration of the Magi*
 93 x 93, on panel
 Sir Hugh Lane Bequest, 1918

Corot, Jean-Baptiste (1796-1875)
French School
853 *Willows*
 Signed: *Corot*
 11 x 23, on panel
 Mr E. Martyn Bequest, 1924

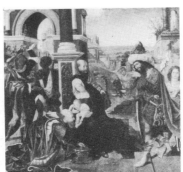

812

853

4218CB *An Interior of a Barn*
 Signed: *1874 Corot*
 48 x 72
 Sir Alfred Chester Beatty Gift, 1950

Corot
with
Daubigny, Charles (1817-78)
French School
 950 *A Landscape*
 Signed: *J.C. Corot, C. Daubigny,*
 1853
 142 x 207
 Purchased, London, Christie's, 1931

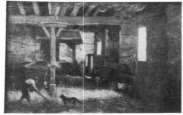

4218CB

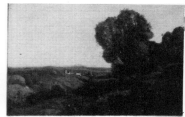

950

After **Correggio (1494-1534)**
Parmese School
 184 *The Head of St Catherine the Martyr*
 34 x 23, on panel
 Purchased, London, Christie's, 1881

 1042 *The Virgin and Child with SS. John the*
 Baptist, Geminian, Peter Martyr and
 George
 231 x 175
 Milltown Gift, 1902

 1071 *The Virgin and Child with SS. Jerome,*
 Mary Magdalen and Angels
 201 x 143
 Milltown Gift, 1902

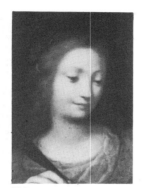

184

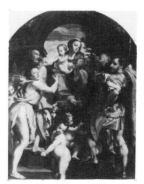

1042

Costa, Lorenzo (c.1460-1535)
Ferrarese School
 526 *The Holy Family*
 71 x 55, on panel
 Purchased, London, Lawrie and
 Co., 1901

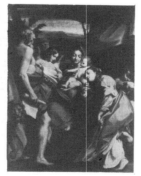

1071

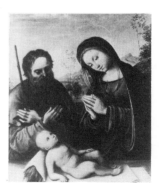

526

Coster, Adam de (c.1586-1643)
Flemish School
 1005 *A Man singing by Candlelight*
 123 x 93
 Purchased, Waterford Furnishing
 Co., 1938

Coter, Colijn de (fl.1480-c.1525)
Flemish School
 1380 *The Enthronement of St Romold*
 114 x 70, on panel
 Purchased, London, Christie's, 1958

1005

1380

Cotes, Francis (1726-70)
English School
373 *Anne Douglas Hamilton, Countess of Donegal*
Signed: *F. Cotes pxt 1766*
231 x 145
Purchased, London, Christie's, 1890

417 *Maria Gunning, Countess of Coventry, (1733-60)*
75 x 62
Purchased, London, Lawrie and Co., 1894

373 417

Cotignola, Francesco da (fl. c.1500)
with
Cotignola, Bernardino da (d.1531)
Romagna School
106 *The Christ Child adored by the Virgin and Saints, (1509)*
183 x 152
Purchased, London, 1864

Courbet, Gustave (1819-77)
French School
1722 *Dr Adolphe Marlet*
Signed: *G.C.*
56 x 46
Purchased, London, Mathiesen Gallery, 1962

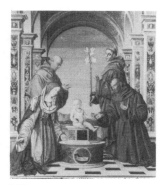

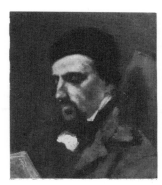

106 1722

Couture, Thomas (1815-79)
French School
4219CB *A Judge Asleep at Table*
Signed: *T C*
40 x 48
Sir Alfred Chester Beatty Gift, 1950

4220CB *'La Peinture Realiste'*
Signed: *T C 1865*
56 x 45
Sir Alfred Chester Beatty Gift, 1950

4221CB *A Man with Bagpipes*
Signed: *T C*
146 x 114
Sir Alfred Chester Beatty Gift, 1950

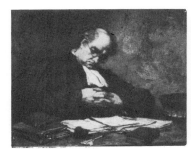

4219CB

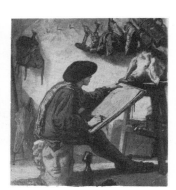

4220CB

Cox, David (1783-1859)
English School
375 *A View of Harborne Church, near Birmingham*
Signed: *David Cox*
19 x 29
Purchased, London, Christie's, 1892

4221CB

375

Coypel, Antoine Charles (1694-1752)
French School
113 *Christ Curing One Possessed*
 Signed: *A.C. Coypel, anno 1717*
 359 x 253
 Purchased, Rome, Signor Aducci,
 1856

Attributed to **Coypel, Noel (1628-1707)**
French School
1656 *The Triumph of Amphitrite*
 99 x 131
 Milltown Gift, 1902

1656

113

Cranach the Elder, Lucas (1472-1553)
Danubian School
186 *Judith with the Head of Holofernes*
 Signed with device
 44 x 31, on panel
 Purchased, London, Cox, 1879

471 *Christ on the Cross*
 Signed with device and dated 1540
 25 x 18, on panel
 Purchased, London, Christie's, 1897

973 *St Christopher*
 103 x 37, on panel
 Purchased, Van Diemen and Co.,
 1934

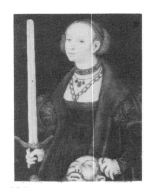

186

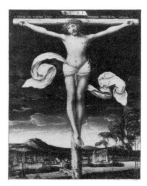

471

After **Cranach**
1278 *The Virgin and Child with Angels*
 72 x 50
 Purchased, Dublin, Monsignor J.
 Shine, 1954

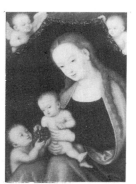

Crespi, Giuseppe (1665-1747)
Bolognese School
1020 *The Massacre of the Innocents*
 131 x 180
 Purchased, London, Dr A. Scharf,
 1940

973

1278

Crome, John (1768-1821)
Norwich School
1110 *A Heath Scene: Sun after Storm*
 70 x 89
 Purchased, London, A. Tooth and
 Son, 1943

1020

1110

Croos, Antonie van der (c.1606-after 1662)
Amsterdam School
 328 *The Castle of Egmont, near Alkmaar*
 Signed: *A. Croos. f. 1669*
 65 x 80
 Purchased, London, Christie's, 1892

328

1307

Cross, Amy (20th century)
American School
 1307 *Benedict Fitzpatrick*
 Signed: *Amy Cross*
 91 x 71
 Presented, Mr Eamon de
 Valera, 1955

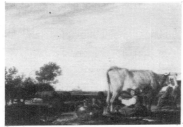

49

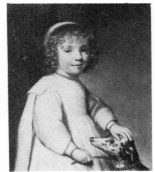

151

Cuyp, Aelbert (1620-91)
Dordrecht School
 49 *Milking Cows*
 Signed: *A. Cuyp*
 51 x 67, on panel
 Presented, Mr J. Heugh, 1872

Cuyp, Jacob Gerritsz (1594-c.1651)
Dordrecht School
 151 *A Girl with a Dog*
 60 x 50, on panel
 Purchased, Hadzor Sale, 1889

 346 *A Portrait of an Old Lady*
 72 x 58, on panel
 Purchased, London, Mr W.
 Abraham, 1894

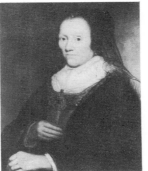

346

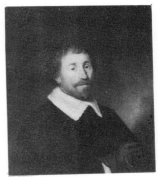

1047

 1047 *A Portrait of a Gentleman*
 Signed: *J.G. Cuyp 1651*
 74 x 59, on panel
 Purchased, Mr J. Cogan, 1940

 1048 *A Portrait of a Lady*
 Signed: *J.G. Cuyp 165(?)*
 74 x 59, on panel
 Purchased, Mr J. Cogan, 1940

1048

D

Dalmasio (early 15th century)
Italian School

 1113 *Four Quatrefoil Medallions of Saints*
 (each) 12 x 12, tempera on panel
 Purchased, London, Mr F. Drey,
 1943

1113

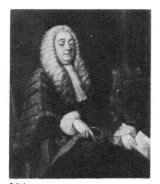

259

Danby, James Francis (1816-75)
English School

 259 *The Last Gleam of Sunset*
 29 x 41
 Purchased, London, 1875

 4024 *A Boat and Breakwater by the Seashore*
 at Sunset
 Signed: *Jas Danby 1871*
 28 x 61
 Provenance unknown

4024

Dance, Nathaniel (1734-1811)
English School

 504 *John, Lord Bowes, Lord Chancellor,*
 (1690-1767)
 122 x 97
 Purchased, Teddington, Miss
 Millard, 1900

504

 959 *Arthur Murphy, Actor and Author,*
 (1727-1805)
 76 x 63
 Purchased, Mr H. Davis, 1933

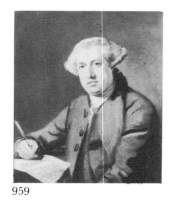

1683

Dandini, Cesare (1596-1658)
Florentine School

 1683 *Moses driving away the Shepherds*
 206 x 272
 Milltown Gift, 1902

959

Daubigny, Charles (1817-78)
French School
 1215 *Sheepfold, Evening*
 (unfinished)
 164 x 306
 Presented, Sir Alfred Chester Beatty,
 1951

 1796 *A Landscape*
 Signed: *Daubigny*
 18.5 x 33.8, on panel
 Presented, Friends of the National
 Collections

 4222CB *Cattle on a Riverbank*
 Signed: *Daubigny 1874*
 44 x 69, on panel
 Sir Alfred Chester Beatty Gift, 1950

David, Gerard (c.1450-1523)
Flemish School
 13 *Christ bidding farewell to the Virgin*
 118 x 61, on panel
 Purchased, London, Christie's, 1869

David, Jacques Louis (1748-1825)
French School
 4060 *The Funeral of Patroclus*
 Signed: *J.L. David f. Roma 1779*
 94 x 218
 Purchased, London, Heim, 1973

School of **David**
 1895 *The Emperor Napoleon I, in Coronation*
 Robes
 263 x 204
 Milltown Gift, 1902

Deane, Charles (fl.1815-51)
English School
 854 *A View of Cheyne Walk, Chelsea*
 70 x 91
 Presented, Sir Alec Martin, 1924

Decamps, Alexandre (1803-60)
French School
 4223CB *A Horse with Child holding Reins*
 Signed: *D C*
 16 x 25, on panel
 Sir Alfred Chester Beatty Gift, 1950

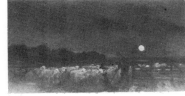
1215

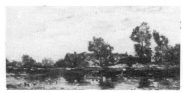
1796

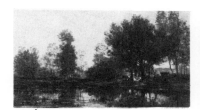
4222CB

13

4060

1895

854

4223CB

De Gree, Peter (1751-89)
Flemish School
 1106 *A Group of Children*
 112 x 142
 Presented, Mr H. Jacob through the
 Friends of the National Collections,
 1943

Delacroix, Eugène (1798-1863)
French School
 964 *Demosthenes on the Seashore*
 Signed: *Eug. Delacroix 1859*
 49 x 60, on panel
 Purchased, Paris, Mr G. Bernheim,
 1934

1106

964

Delen, Dirck van (1605-71)
with
Hals, Dirck (1591-1656)
Haarlem School
 119 *An Interior with Ladies and Cavaliers*
 Signed: *Dirck van Delen 1629*
 72 x 95, on panel
 Purchased, Paris, Secretan Sale,
 1889

119

332

Delff, Jacob (c.1550-1601)
Delft School
 332 *A Portrait of a Gentleman*
 69 x 53, on panel
 Presented, Mr A. Brady, 1864

Desportes, François (1661-1743)
French School
 670 *A Group of Dead Game*
 91 x 73
 Presented, Sir Hugh Lane, 1914

 671 *A Group of Dead Game*
 Signed: *F. Desportes 1707*
 91 x 73
 Presented, Sir Hugh Lane, 1914

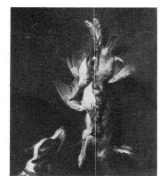

670

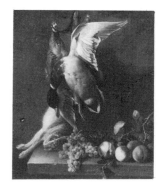

671

Detaille, Jean-Baptiste (1848-1912)
French School
 1292 *A Cavalry Officer*
 Signed: *Edouard Detaille '87*
 46 x 38
 Presented, Sir Alfred Chester Beatty,
 1954

 4224CB *A Trumpeter on Horseback*
 Signed: *E Detaille 1884*
 21 x 13, on panel
 Sir Alfred Chester Beatty Gift, 1950

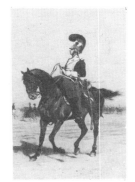

1292

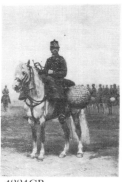

4224CB

[34]

4225CB *Autumn Manoeuvres*
Signed: *Edouard Detaille 1877*
46 x 65
Sir Alfred Chester Beatty Gift, 1950

4226CB *Napoleon and Troops*
Signed: *Edouard Detaille 1902*
69 x 96, on panel
Sir Alfred Chester Beatty Gift, 1950

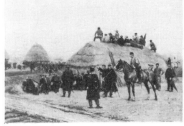 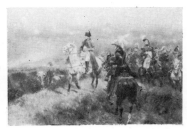

4225CB 4226CB

Diano, Giacinto (1731-1804)
Neapolitan School

357 *The Dedication of the Temple at
Jerusalem (c.1766)*
77 x 142
Purchased, Dublin, 1859

357

Diaz de la Pena, Narcisse (1807-76)
French School

4227CB *A Landscape with Figures*
Signed: *N. Diaz 1873*
46 x 58, on panel
Sir Alfred Chester Beatty Gift, 1950

4227CB

Dicksee, John (1817-1905)
English School

135 *Henry M. Lawrence, Anglo-Indian
Soldier and Administrator, (1806-57)*
95 x 75
Purchased, Mr J. Dicksee, 1874

Dietrich, Christian (1712-74)
German School

1230 *The Sleeping Shepherd*
dia. 28, on copper
Milltown Gift, 1902

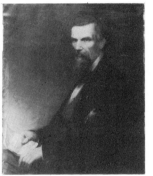

135 1230

Dobson, William (1611-46)
English School

250 *A Portrait Group*
144 x 186
Purchased, London, Christie's, 1886

1150 *Sir Richard Nagle*
108 x 85
Presented, Mrs E. Banon, 1947

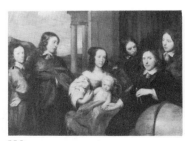

250

1150

Dodson, Sarah (d.1906)
American School
 4000 *Mayfield Convent*
 35.5 x 44.5
 Presented, Mr R. Dodson, 1919

4000

1229

Dolci, Carlo (1616-86)
Florentine School
 1229 *St Agnes*
 64 x 53
 Purchased, London, Mr C.
 Marshall Spink, 1951

Attributed to **Domenichino (1581-1641)**
Bolognese School
 70 *St Cecilia*
 (after Raphael)
 232.5 x 145
 Presented, Viscount Powerscourt,
 1866

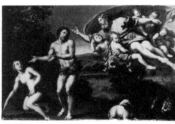

1083

After **Domenichino**
 1083 *The Expulsion of Adam and Eve*
 123 x 175
 Milltown Gift, 1902

70

 1885 *The Last Communion of St Jerome*
 392.5 x 241.5
 Provenance unknown

 1910 *The Martyrdom of St Stephen*
 172.5 x 121.5
 Purchased, Rome, Mr R.
 MacPherson, 1856

1885

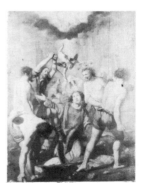

1910

Pseudo Domenico di Michellino (1417(?)-91)
Italian School
 861 *The Assumption of the Virgin, with SS.*
 Francis and Bonaventura
 190 x 170, tempera on panel
 Purchased, Mr A. Gore, 1925

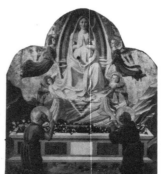

Doughty, William (fl.1775-82)
English School
 787 *Miss Sisson*
 74 x 61
 Sir Hugh Lane Bequest, 1918

861

787

Drake, Cecil (20th century)
English School
 4046 *Dorothy Moulton, Wife of Sir Robert Meyer*
 Signed: *Cecil Drake*
 82· x 51
 Presented, Messrs P. Bander and C. Smythe, 1972

Dreux, Alfred de (1810-60)
French School
 4228CB *A Rider in Red Coats in a Forest*
 Signed: *Alfred Dreux*
 47 x 57
 Sir Alfred Chester Beatty Gift, 1950

Droochsloot, Joost (1586-1666)
Utrecht School
 252 *The Ferry*
 Signed with monogram and dated 1642
 61 x 107, on panel
 Purchased, London, Christie's, 1885

Attributed to **Dubois, Ambrose (1543-1614)**
French School
 1812 *The Siege*
 151 x 201
 Purchased, Derry, 1967

Duck, Jacob (c.1600-after 1660)
Utrecht School
 335 *An Interior with Woman Sleeping*
 Signed: *J. Duck*
 29 x 24, on panel
 Purchased, Sir Walter Armstrong, 1891

Dughet, Gaspard (1614-75)
French School
 713 *A Landscape with Figures*
 79 x 142
 Milltown Gift, 1902

Dupré, Jules (1811-89)
French School
 1255 *A Seascape*
 Signed: *Jules Dupré*
 66 x 82
 Presented, Sir Alfred Chester Beatty, 1953

 4229CB *Cows in a Pond*
 38 x 46
 Sir Alfred Chester Beatty Gift, 1950

4228CB

4046

252

1812

335

713

1255

4229CB

Durand, Charles (1838-1917)
French School
 1979 *A Portrait Sketch of a Young Girl*
 Inscribed on reverse and dated 1885
 33 x 27
 Presented, Dr E. Fitzpatrick on
 behalf of the Executors of the late
 Mrs R. Parker, 1970

1979

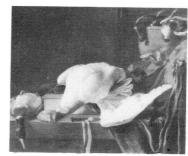

961

Dusart, Christian (1618-81)
Dutch School
 961 *A Still Life*
 Signed: *C J Dusart f.1650*
 86 x 102
 Dr T. Smith Bequest, 1933

Dusart, Cornelis (1660-1704)
Haarlem School
 324 *A Dutch Merrymaking*
 Signed: *Corn. Dusart fl 1692*
 34 x 39
 Presented, Mr S. Joseph, 1892

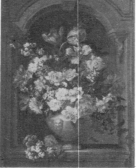

324

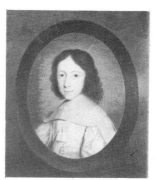

291

Dutch School (17th century)
 291 *William, Prince of Orange, afterwards*
 King of England, as a Boy
 46 x 36, on panel
 Purchased, London, Christie's
 Hardwicke Sale, 1888

 877 *A Flower Piece*
 94 x 74
 Presented, Executors of the late Mr
 J. Poe, 1926

 1063 *A Boy with Dogs*
 102 x 100
 Sherlock Bequest, 1940

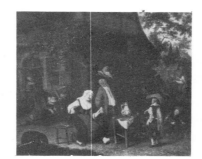

877

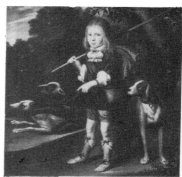

1063

 1087 *An Interior*
 49 x 37, on panel
 Sherlock Bequest, 1940

 1639 *René Descartes, Philosopher, (1596-*
 1650)
 30 x 26, on panel
 Purchased, Miss K. Farrelly
 (legatee of Monsignor J. Shine),
 1961

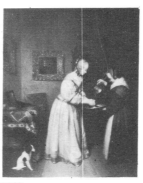

1087

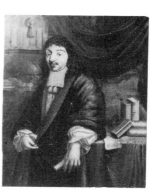

1639

1694 *A Music Party Out of Doors*
 48 x 40
 Milltown Gift, 1902

1698 *A Portrait of a Young Girl*
 67 x 52
 Milltown Gift, 1902

1972 *Horsemen in a Landscape with Ruins*
 55 x 65
 Sherlock Bequest, 1940

1694

1698

Dutch School (18th century)

1971 *A Landscape with a Coach Party*
 49 x 65
 Sherlock Bequest, 1940

1972

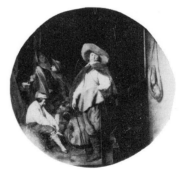
1971

Duyster, Willem (1599-1635)
Amsterdam School

333 *An Interior with Figures*
 105 x 76, on panel
 Purchased, London, Christie's, 1892

436 *An Interior with Soldiers*
 Signed with monogram and dated
 1632
 dia. 47, on panel
 Purchased, D. Bourke, 7th Earl of
 Mayo, 1895

556 *A Portrait Group: A Man and his
 Wife*
 64 x 51, on panel
 Miss A. Clarke Bequest, 1903

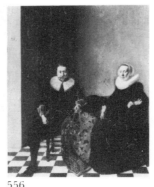
333

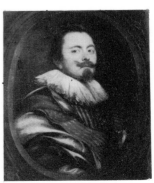
436

Dyck, Anthony van (1599-1641)
Flemish School

235 *Frederick Marselaer, Diplomat*
 69 x 57
 Purchased, Paris, Mr M.
 Schneider, 1876

556

235

275 *A Study for a Picture of St Sebastian*
 94 x 48
 Purchased, London, Christie's, 1883

809 *A Boy standing on a Terrace*
 186 x 123
 Sir Hugh Lane Bequest, 1918

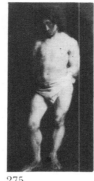 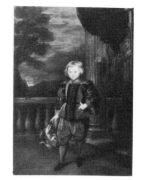

275 809

Studio of **van Dyck**

359 *A Portrait of a Lady*
 91 x 71
 Purchased, Paris, 1864

672 *A Portrait of a Gentleman*
 61 x 46, on panel
 Purchased, Paris, 1866

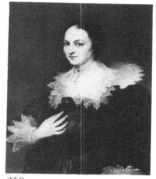 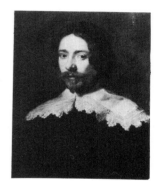

359 672

After **van Dyck**

389 *The Children of Charles I, King of*
 England
 61 x 74
 Purchased, London, Christie's, 1884

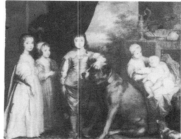

389

413 *Thomas Wentworth, Earl of Strafford,*
 (1593-1641)
 122 x 97
 Presented, Mr C. Marley in
 memory of Mr H. Doyle, 1892

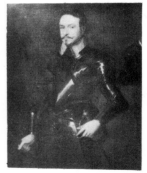

413

1372 *The Concert*
 128 x 150
 Provenance unknown

1661 *St Sebastian*
 147 x 100
 Milltown Gift, 1902

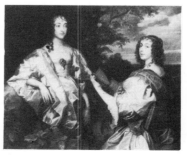

1372 1661

1738 *Prince Rupert*
 218 x 130
 Milltown Gift, 1902

1937 *Isabella of Austria*
 115 x 89
 Purchased, Shipton, Carr Sale,
 1862

1994 *Frans Francken Junior*
 25 x 20, on panel
 Provenance unknown

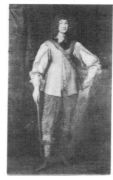
1738

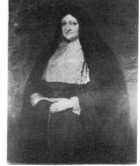
1937

Dyck, Herman (1812-74)
German School
 169 *The Last of the Brotherhood*
 133 x 101
 Presented, Mr T. Berry, 1865

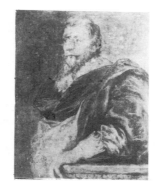
1994

169

E

Eddis, Eden (1812-1901)
English School
464 *William A'Court, Lord Heytesbury,*
 English Viceroy in Ireland, (1779-
 1860)
 127 x 99
 Presented, J. Daly, 4th Lord
 Dunsandle, 1897

1974 *The Hon. Mrs Heytesbury*
 127 x 101
 Provenance unknown

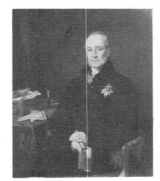

464

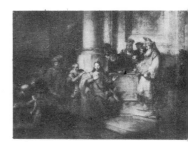

1974

Eeckhout, Gerbrand van den (1621-74)
Amsterdam School
107 *A Portrait of a Rabbi*
 74 x 61
 Purchased, London, Christie's, 1889

253 *Christ teaching in the Temple*
 Signed: *G.V. Eeckhout fe. Ao. 1658*
 61 x 79
 Purchased, London, Christie's, 1885

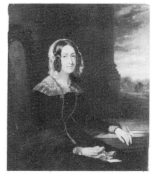

253

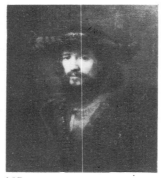

107

Einsle, Anton (1801-71)
Austrian School
1153 *Baroness Minarelli*
 Signed: *Ant. Einsle f 1845*
 79 x 63
 Presented, Mrs E. Banon, 1947

Elwes, Simon (1902-75)
English School
1980 *The Most Reverend John Charles*
 McQuaid, Archbishop of Dublin and
 Primate of Ireland
 Signed: *Simon Elwes 69*
 127 x 102
 Presented, Sir John Galvin, 1970

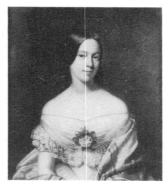

1153

1980

Studio of **Empoli, Jacopo da (1554-1640)**

Florentine School

 1068 *The Adoration of the Shepherds*
 112 x 98
 Milltown Gift, 1902

 1671 *Susanna and the Elders*
 72 x 98
 Milltown Gift, 1902

1671

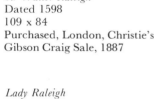

1068

English School (16th century)

 281 *Sir Walter Raleigh*
 Dated 1598
 109 x 84
 Purchased, London, Christie's
 Gibson Craig Sale, 1887

 282 *Lady Raleigh*
 112 x 86
 Purchased, London, Christie's
 Gibson Craig Sale, 1887

 304 *Robert Dudley, Earl of Leicester*
 51 x 37, on panel
 Purchased, London, Christie's, 1888

 541 *Elizabeth I, Queen of England*
 34 x 26, on panel
 Purchased, London, Shepherd
 Bros., 1903

 549 *Anne Boleyn*
 57 x 42, on panel
 Purchased, London, Shepherd
 Bros., 1903

 759 *Anne Stanhope, Duchess of Somerset*
 50 x 42, on panel
 Milltown Gift, 1902

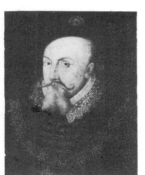

281

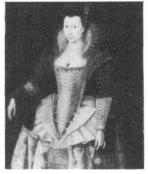

282

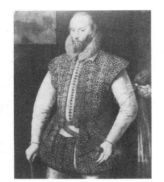

304

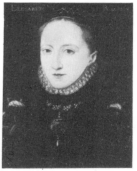

541

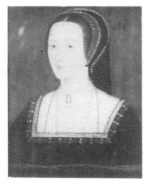

549

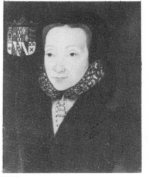

759

[**43**]

880 *Henry Sidney*
 58 x 48, on panel
 Purchased, Mr W. Permain, 1926

1195 *The Fair Geraldine (Elizabeth,*
 Daughter of Garret Og Fitzgerald)
 46 x 34, on panel
 Purchased, London, Christie's, 1950

1266 *Mary Tudor, Queen of England*
 66 x 51, on panel
 Presented, Sir Alfred Chester Beatty,
 1953

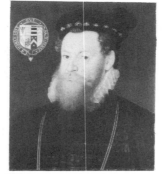

880

1195

English School (c.1670)

4160 *John Talbot, 1st Earl of Shrewsbury*
 124 x 100
 Purchased, Dublin, Malahide
 Castle Sale, 1976

1266

4160

English School (c.1690)

4198 *Double Portrait of Two Gentlemen*
 98 x 138
 Presented, Dr F. Henry, 1977

4198

401

English School (17th century)

401 *Joseph Addison*
 16 x 13.7, on copper
 Purchased, London, Christie's, 1886

410 *Adam Loftus, Lord Chancellor*
 Dated 1619
 221 x 132
 Presented, E. Guinness, 1st Lord
 Iveagh, 1891

644 *Robert Boyle*
 74 x 59
 Purchased, London, Heyman, 1906

410

644

1149 *Lady Anne Hamilton*
 74 x 61
 Presented, Mrs E. Banon, 1947

4167 *Richard Talbot, Earl and Duke of*
 Tyrconnell, (1630-91)
 118 x 91
 Purchased, Dublin, Malahide
 Castle Sale, 1976

4328 *Patrick Sarsfield*
 76 x 63
 Mrs W. Kennedy Bequest, 1979

1149

4167

4328

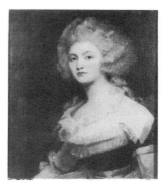
1152

English School (18th century)

1152 *Francesca Lyons*
 76 x 63
 Presented, Mrs E. Banon, 1947

1662 *An Indian Hunting Scene*
 112 x 147
 Milltown Gift, 1902

1662

1663

1663 *An Indian Hunting Scene*
 114 x 150
 Milltown Gift, 1902

1676 *An Interior with Woman and Still Life*
 42 x 35, on panel
 Milltown Gift, 1902

1696 *A Lady as a Sybil*
 32 x 27
 Milltown Gift, 1902

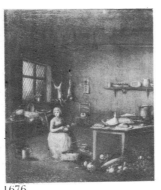
1676

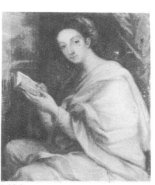
1696

1868 *The Earl of Bath*
 34 x 26, on paper
 Provenance unknown

1932 *Sailing Ships Off Shore*
 35.5 x 44.5
 Sherlock Bequest, 1940

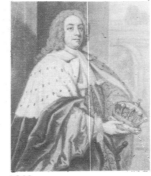

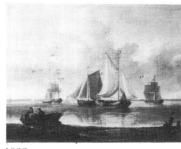

1932

1868

English School (early 19th century)

1959 *A Landscape with Horseman, Mother and Child*
 71.5 x 99
 Provenance unknown

1961 *A Portrait of a Lady*
 33.5 x 29.5
 Provenance unknown

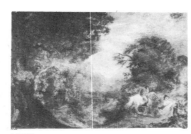

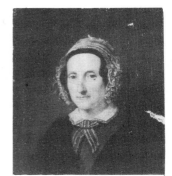

1959

1961

English School (mid 19th century)

1951 *A Two-Funnelled Paddle-steamer with Two Small Sailing Boats*
 30.3 x 45.7
 Provenance unknown

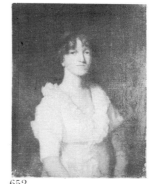

1951

652

English School (19th century)

652 *A Portrait of a Lady*
 44 x 32
 Presented, Sir Hugh Lane, 1913

1154 *Margaret d'Este*
 61 x 46
 Presented, Mrs E. Banon, 1947

1685 *A Coast Scene*
 24 x 32
 Milltown Gift, 1902

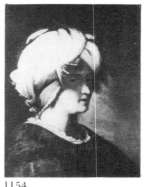

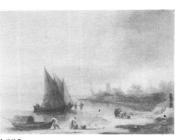

1685

1154

1973 *A Conversation in the Train*
 112 x 143
 Provenance unknown

1976 *A Mother and Child*
 128 x 101
 Provenance unknown

4312 *Thomas Moore in his Study at*
 Sloperton Cottage
 30 x 36, on panel
 Purchased, Mr R. Davids, 1978

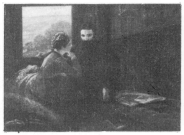

1973

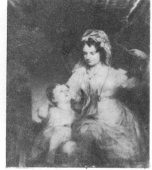

1976

English School (20th century)
4039 *A Man-of-War at Anchor*
 61 x 91
 Presented, Sir Alfred Chester Beatty,
 1971

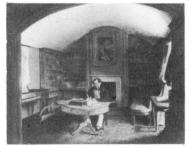

4312

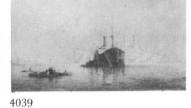

4039

English-Irish School (c.1730)
1947 *A Portrait of a Lady*
 (after a Continental master)
 40.5 x 32.5
 Provenance unknown

1948 *A Portrait of a Young Lady*
 (after a Continental master)
 41.2 x 32
 Provenance unknown

1947

1948

Essex, William (1784-1869)
English School
4015 *Thomas Moore, Poet*
 (after Lawrence)
 Inscribed and dated 1838
 dia. 33, enamel on metal
 Purchased, London, Mr A.
 Buttery, 1906

Etty, William (1787-1849)
English School
591 *A Nude: Study from a Model*
 56 x 40
 Purchased, Sir James Linton, 1908

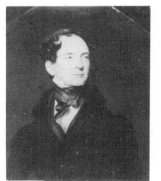

4015

591

Attributed to **Everdingen, Albert van (1621-**
Dutch School **75)**
 1890 *A Landscape with a Mountain Torrent*
 64 x 81
 Presented, Mr R. Clouston, 1855

1890

F

Faber, Conrad (c.1500-52/3)
Rhenish School

21 *Katherina Knoblauchin*
Dated 1532 on reverse
51 x 36, on panel
Purchased, London, Farrer Sale,
1866

243 *Heinrich Knoblauch*
Dated 1529 on reverse
50 x 38, on panel
Purchased, Beckett-Denison Sale,
1885

School of **Faber**

804 *A Portrait of a Gentleman*
48 x 36, on panel
Sir Hugh Lane Bequest, 1918

After **Fabre, François (1766-1837)**
French School

1970 *John Henry, 2nd Marquis of
Lansdowne*
Inscribed and dated at Florence
1795
106 x 86
Purchased, Mrs H. Greene
Collection

Fagan, Robert (1745-1816)
English School

1135 *A Portrait Group: Sarah and Geoffrey
Amherst*
Signed: *Robert Fagan . . . 1811*
49 x 62
Purchased, London, Arcade
Gallery, 1947

4061 *Sir George Wright, 2nd Baronet,
(c.1770-1812)*
213 x 145
Purchased, London, Fine Art
Society, 1973

21

243

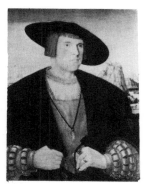
804

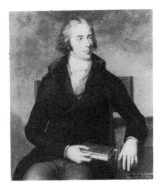
1970

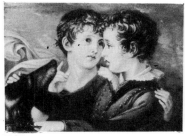
1135

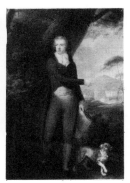
4061

Fennell, John (1807-85)
English School
 1903 *A Tournament*
 35.5 x 61
 Purchased, Dublin, Mr G. Laffan,
 1969

1903

Fernandez, Alejo (c.1470-1543)
Spanish School
 818 *The Holy Family with St Anne*
 51 x 36, on panel
 Purchased, Captain R. Langton
 Douglas, 1918

818

Fernandez, Juan (fl. c.1640)
Spanish School
 4186 *A Still Life with Citrons, a Knife and*
 Peapods on a Stone Ledge
 36 x 52
 Purchased, London, Mr N. Orgel,
 1976

4186

Ferrari, Orazio dei (1605-57)
Genoese School
 4302 *The Incredulity of St Thomas*
 189 x 128
 Purchased, Dun Laoghaire, St
 Michael's Hospital, 1978

4302

Ferri, Ciro (1634-89)
Roman School
 1670 *The Expulsion of Hagar*
 136 x 97
 Milltown Gift, 1902

Feselen, Melchior (fl.1522-38)
German School
 1176 *Judith with the Head of Holofernes*
 dia. 32, on panel
 Purchased, Dublin, J.H. North and
 Co., 1948

1670 1176

After **Feti, Domenico (1589-1624)**
Roman School
 898 *The Parable of the Lord of the*
 Vineyard
 62 x 39, on panel
 Presented, Dr T. Bodkin, 1927

Fiammingo, Paolo (c.1540-96)
Flemish School
 1834 *The Feast of the Gods*
 123.5 x 167.2
 Purchased, Dublin, Mr G. Kenyon,
 1968

1834

898

Ficherelli, Felice (1605-60)
Florentine School

 1070 *The Sacrifice of Isaac*
 68.5 x 98.5
 Milltown Gift, 1902

 1707 *St Mary Magdalen*
 117 x 86
 Milltown Gift, 1902

 1746 *Lot and his Daughters*
 159 x 176
 Milltown Gift, 1902

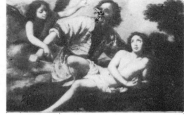

1070

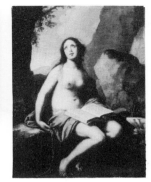

1707

Fielding, Copley (1787-1855)
English School

 1131 *A Landscape*
 Signed: *CVF 1836*
 21 x 25, on panel
 Sherlock Bequest, 1940

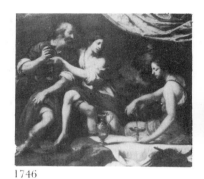

1746

1131

Flemish School (c.1500)

 1359 *A Portrait of a Lady*
 60 x 46, on panel
 Presented, W. Howard, 8th Earl of
 Wicklow, 1957

Flemish School (16th century)

 350 *St Mary Magdalen in the Desert*
 24 x 19, on panel
 Purchased, Newcastle-on-Tyne,
 Signor A. Rotondo, 1889

 1049 *Triptych with the Virgin of the Seven*
 Sorrows (centre), Nativity (left) and
 Resurrection (right)
 107 x 147, on panel
 Purchased, Mr M. Cogan, 1940

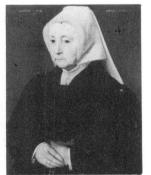

1359

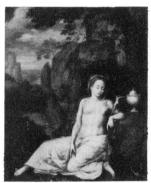

350

Flemish School (c.1650)

 1913 *The Blinding of Seleucis*
 64 x 90, paper laid down on canvas
 Purchased, Dublin, Mr G. Kenyon,
 1969

1049

1913

Flemish School (17th century)

1990 *A Still Life with Fish*
 77 x 103
 Provenance unknown

1993 *A Butcher's Shop*
 40 x 67.5
 Provenance unknown

1990

1993

Flemish-French School (1568)

4093 *The Provost and the Aldermen of Paris*
 in Prayer before the Holy Trinity
 130 x 150, on panel
 Presented, Mrs A. Murnaghan in
 memory of Mr Justice J.
 Murnaghan, 1974

4093

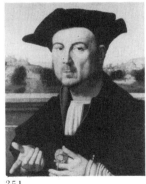
64

Flinck, Govaert (1615-60)

Amsterdam School

 64 *Bathsheba's Appeal*
 Signed: *G. Flinck, f. 1651*
 104 x 152
 Purchased, London, Mr M.
 Anthony, 1867

 254 *The Head of a Rabbi*
 64 x 47, on panel
 Purchased, London, Christie's, 1886

254

351

Florentine School (15th century)

 112 *The Adoration of the Magi*
 8 x 55, on panel
 Purchased, Rome, Mr R.
 MacPherson, 1856

112

 351 *A Portrait of a Gentleman*
 55 x 42, on panel
 Purchased, London, Mr G.
 Donaldson, 1893

778 *The Battle of Anghiari*
 Signed: *P.V.*
 61 x 205, tempera on panel
 Sir Hugh Lane Bequest, 1918

778

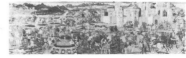
780

780 *The Taking of Pisa*
 Signed: *P.V.*
 61 x 205, tempera on panel
 Sir Hugh Lane Bequest, 1918

Florentine School (17th century)
4096 *A Crowd at City Gates*
 27 x 16, on paesina stone
 Provenance unknown

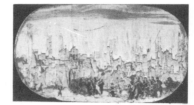
4096

76

Fontana, Lavinia (1552-1614)
Bolognese School
76 *The Visit of the Queen of Sheba to Solomon*
 256 x 325
 Purchased, London, Christie's, 1872

460 *A Portrait of an Italian Warrior, (Count Martinengo?)*
 89 x 65
 Purchased, London, Christie's, 1885

965

Forain, Jean (1852-1931)
French School
965 *A Scene in the Law Courts*
 Signed: *Forain*
 74 x 82
 Purchased, Paris, Mr G. Bernheim, 1934

460

4230CB *A Court Scene*
 Signed: *J.L. Forain*
 55 x 74
 Sir Alfred Chester Beatty Gift, 1950

Forbes-Robertson, Johnston (1853-1937)
English School
1211 *Charlotte McCarthy*
 61 x 51
 Presented, Mrs L. McCarthy-Gimson, 1951

4230CB

1211

1807 *J.H. McCarthy, Actor, (1851-1936)*
 60.8 x 50.8
 Mrs L. McCarthy-Gimson Bequest,
 1966

Forbes, Stanhope (1857-1947)
English School
 4338 *Miss Ormsby, later Mrs Homan*
 Signed: *SA Forbes 1879*
 53.5 x 43
 Presented, Mr T. Homan, 1980

1807 4338

Fragonard, Jean-Honoré (1732-1806)
French School
 4313 *Venus and Cupid* or *Day*
 114 x 133
 Purchased, New York, Wildenstein.
 1978

Franciabigio (1482-1525)
Florentine School
 1290 *The Canonization of St Nicholas of*
 Tolentino
 18 x 26, tempera on panel
 Purchased, Dublin, Mrs Jeffares,
 1954

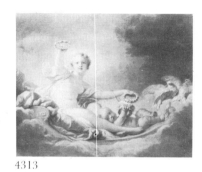 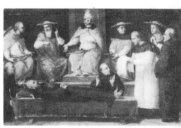

 1290

4313

Francia, Francesco (1450-1517)
Bolognese School
 190 *Lucretia*
 61 x 48, on panel
 Purchased, Mr G. Salting, 1879

Francken I, Jerome (1540-1610)
Flemish School
 4094 *The Marriage Feast at Cana*
 73 x 99, on panel
 Purchased, Dublin, Mr Justice J.
 Murnaghan Sale, 1974

4094

190

Francken III, Frans (1607-67)
Flemish School
 1708 *The Adoration of the Magi*
 36 x 28, on copper
 Milltown Gift, 1902

 1709 *The Adoration of the Shepherds*
 36 x 28, on copper
 Milltown Gift, 1902

1708 1709

ranco-Flemish School (c.1475)

 1272 *The Mass of St Gregory*
 135 x 50, on panel
 Purchased, Dublin, Monsignor J.
 Shine, 1953

rench School (11th-12th centuries)

 4170 *The Large Apse from the Chapel of St*
 Pierre de Campublic, Beaucaire, France:
 Christ in Judgement with the Evangelists
 and Six Apostles
 460 x 425 x 233, dry fresco on plaster
 transferred to canvas laid onto panel
 Purchased, Geneva, Mr R. Ferrero,
 1976

 4171 *The Small Apse from the Chapel of St*
 Pierre de Campublic, Beaucaire, France:
 The Annunciation and Adoration of the
 Magi with Six Apostles
 325 x 200 x 90, dry fresco on plaster
 transferred to canvas laid onto panel
 Purchased, Geneva, Mr R. Ferrero,
 1976

rench School (17th century)

 428 *Le Comte de Roucy*
 Dated 1670
 66 x 57
 Purchased, Dublin, Bennett, 1895

 1166 *A Landscape with Tobias and the Angel*
 76 x 132
 Presented, Miss K. Murphy, 1948

 1421 *A Portrait of a Lady*
 39 x 30, on panel
 Presented, Sir Alfred Chester Beatty,
 1954

 1999 *The Allegory*
 105.5 x 89
 Provenance unknown

rench School (18th century)

 1700 *A Landscape with Ruins*
 69.5 x 111
 Milltown Gift, 1902

1272

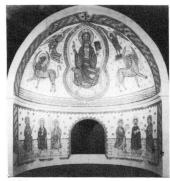

4170

4171

428

1166

1421

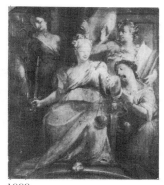

1999

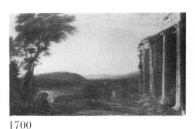

1700

1701 *A Classical Landscape*
49 x 66
Milltown Gift, 1902

1701

4199

French School (19th century)
4199 *A Portrait of a Gentleman*
55 x 46
Presented, Dr F. Henry, 1977

4311 *Monsieur le Comte de Basterot*
79 x 64
Presented, Mrs J. Smith, 1978

4311

4231CB

Fromentin, Eugène (1820-76)
French School
4231CB *An Arab Horseman*
Signed: *Eug. Fromentin*
111 x 144
Sir Alfred Chester Beatty Gift, 1950

4232CB *Arab Horsemen in a Landscape*
Signed: *Eug. Fromentin*
73 x 110
Sir Alfred Chester Beatty Gift, 1950

4233CB *An Oriental Battle Incident*
Signed: *Eug. Fromentin*
31 x 41, on panel
Sir Alfred Chester Beatty Gift, 1950

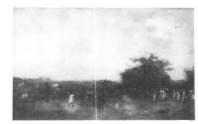
4232CB

4233CB

Fry, Roger (1866-1934)
English School
1124 *Red Earth*
Signed: *Roger Fry 19 . . .*
43 x 61
Mr M. Kennedy Bequest, 1945

1124

Furini, Francesco (1604-46)
Florentine School
368 *Charity*
75 x 58
Presented, Sir Henry Barron. 1878

368

1658 *Hylas and the Nymphs*
117 x 157
Milltown Gift, 1902

1658

1679

1679 *St Mary Magdalen*
41 x 34, on parchment
Milltown Gift, 1902

1716 *The Crucifixion of a Female Saint*
42 x 34, on parchment
Milltown Gift, 1902

4002 *A Male Figure*
35 x 25, on parchment
Milltown Gift, 1902

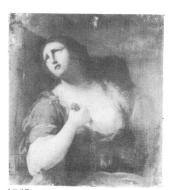
1716

4002

tyle of **Furini**
1967 *Lucretia Stabbing Herself*
88 x 74
Presented, Sir Henry Barron, 1878

urse, Charles (1868-1904)
nglish School
977 *Thomas Spring Rice, 2nd Baron
Monteagle, (1849-1926)*
91 x 69
Presented, Lord Monteagle, 1935

1967

977

fter **Fuseli, Jean-Henri** (1741-1825)
wiss School
1745 *A Coast Scene with Shipwreck*
83 x 122
Milltown Gift, 1902

yt, Jan (1611-61)
lemish School
43 *The Head of a Wild Boar*
52 x 69
Purchased, Dublin, Mr W. Brocas
Collection, 1866

1745

43

1907 *A Dog and Dead Game*
76 x 100
Milltown Gift, 1902

1907

G

Gabrielli, Gaspar (fl.1803-30)
Italo-Irish School
4202 *A Landscape with Diana and*
 Attendants
 Signed: *Gaspar Gabrielli f 1803*
 117 x 112
 Purchased, Dublin, Dr Doyle Sale,
 1977

325

4202

Gael, Barendt (c.1620-after 1687)
Haarlem School
325 *A Landscape with Figures*
 Signed: *B. Gael*
 25 x 33, on panel
 Presented, London, Mr H. Pfungst,
 1893

Gainsborough, Thomas (1727-88)
English School
129 *Hugh Smithson (Percy), Duke of*
 Northumberland, Viceroy in Ireland
 Signed: *T. Gainsborough, R.A.*
 74 x 61
 Purchased, London, H. Graves and
 Co., 1872

129

191

191 *A View of Suffolk*
 47 x 61
 Purchased, London, Christie's, 1883

565 *James Quin, Actor, (1693-1766)*
 231 x 150
 Purchased, London, Lawrie and
 Co., 1904

668

668 *The Gamekeeper*
 117 x 147
 Presented, Sir Hugh Lane, 1914

565

675 *John Gainsborough*
58 x 48
Presented, Sir Hugh Lane, 1914

793 *Mrs King (née Spence)*
75 x 62
Sir Hugh Lane Bequest, 1918

794 *General James Johnston*
206 x 141
Sir Hugh Lane Bequest, 1918

795 *Mrs Horton, afterwards Duchess of Cumberland*
Dated 1766
75 x 62
Sir Hugh Lane Bequest, 1918

796 *A Landscape with Cattle*
128 x 99
Sir Hugh Lane Bequest, 1918

675

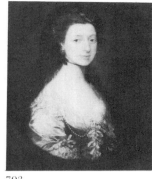

793

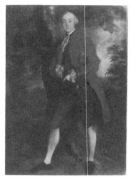

794

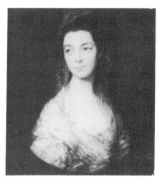

795

After **Gainsborough**

1943 *Lady Conyngham*
Inscribed on reverse and dated 1779
90 x 72
Provenance unknown

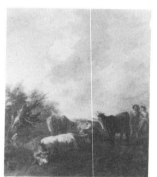

796

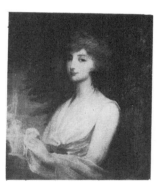

1943

Garstin, Norman (1842-1926)
English School

892 *The Last of the Fair*
Signed: *Norman Garstin*
76 x 65
Presented, the artist's widow, 1927

4308 *A Portrait of his Wife*
Signed: *Norman Garstin, Newlyn, '89*
71 x 51
Mr A. Garstin Bequest, 1978

892

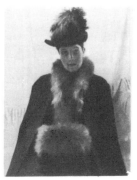

4308

Genisson, Victor (1805-60)
with
Villems, Florent (1823-1905)
Belgian School
168 *An Interior of the Church of St Jacques,*
 Antwerp
 Signed: *Genisson 1839*
 Willems 1843
 160 x 127
 Presented, F. Caulfield, 2nd Earl of
 Charlemont, 1853

Gentileschi, Orazio (1565-1647)
Roman School
980 *David and Goliath*
 186 x 135
 Purchased, London, Mr T. Harris,
 1936

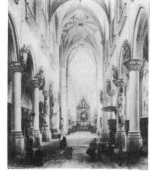
168

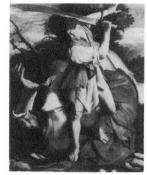
980

Gérard, Baron (1770-1837)
French School
4055 *Julie Bonaparte, Queen of Naples, with*
 her Daughters, Zénaïde and Charlotte
 against the Park of Malmaison
 Signed: *F. Gerard*
 199 x 142
 Purchased, London, Heim, 1972

Géricault, Theodore (1791-1824)
French School
828 *A Horse*
 66 x 82
 Purchased, Captain R. Langton
 Douglas, 1920

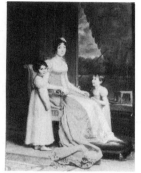
4055

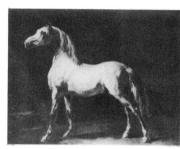
828

German School (c.1500)
750 *A Portrait of a Gentleman*
 33 x 25, on panel
 Milltown Gift, 1902

German (Westphalian ?) School (16th century)
974 *A Portrait of a Young Lady*
 Signed with monogram *ER* and
 dated 1567
 62 x 44, on panel
 Purchased, Van Diemen and Co.,
 1934

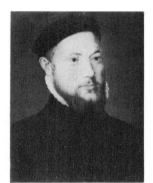
750

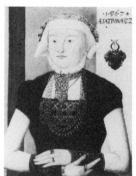
974

Gerome, Jean (1824-1904)
French School
1256 *A Caravan on the Nile*
 Signed: *J.L. Gerome*
 60 x 81
 Presented, Sir Alfred Chester Beatty,
 1953

4234CB *An Eastern Scene*
 Signed: *J L Gerome*
 81 x 65
 Sir Alfred Chester Beatty Gift, 1950

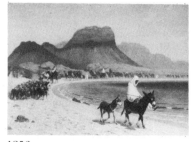
1256

4234CB

Ghirlandaio, Domenico (1449-94)
Florentine School
 1385　*Presumed Portrait of Clarice Orsini,*
　　　　Wife of Lorenzo the Magnificent
　　　　75 x 52, on panel
　　　　Purchased, London, Mr C.
　　　　Marshall Spink, 1959

Ghirlandaio, Ridolfo (1483-1561)
Florentine School
 620　*Santa Conversazione – The Virgin*
　　　　Enthroned with Saints
　　　　28 x 22, on panel
　　　　Purchased, Rome, Signor A.
　　　　Imbert, 1910

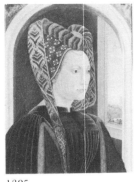
1385

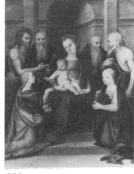
620

Giordano, Luca (1632-1705)
Neapolitan School
 79　*St Sebastian after Martyrdom*
　　　　152 x 27
　　　　Presented, A. Fitzgerald, 3rd Duke
　　　　of Leinster, 1868

 1069　*St John Preaching in the Wilderness*
　　　　133 x 127
　　　　Milltown Gift, 1902

 1988　*Aesop*
　　　　124 x 97
　　　　Purchased, Dublin, 1857

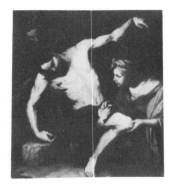
79

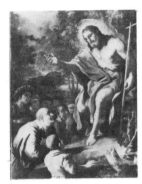
1069

Giorgio d'Alemagna (fl.1441-79)
Ferrarese School
 1117　*A Reliquary Panel with Crucifixion*
　　　　6 x 5, tempera on panel; 17 x 11
　　　　with frame
　　　　Purchased, Mr A. Rosenthal, 1942

Girolamo di Benvenuto (1470-1524)
Sienese School
 839　*The Virgin and Child with Saints*
　　　　67 x 43, tempera on panel
　　　　Purchased, Captain R. Langton
　　　　Douglas, 1922

Glannon, Edward (20th century)
American School
 4121　*The Mother, East Side, New York*
　　　　20 x 26, on board
　　　　Presented, Co. Clare, Mr and Mrs
　　　　W. Philips, 1974

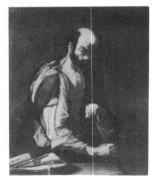
1988

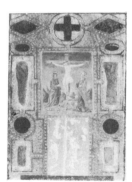
1117

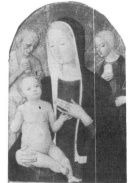
839

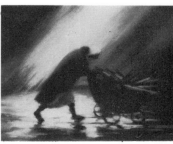
4121

Gleizes, Albert (1881-1953)
French School
- 1308 *A Painting*
 Signed: *1923 Albert Gleizes*
 105 x 75
 Evie Hone Bequest, 1955

Gonzales, Eva (1849-83)
French School
- 4050 *Two Children Playing on the Sand
 Dunes*
 Atelier Stamp: *Eva Gonzales*
 46 x 56
 Purchased, Paris, Jacques Daber,
 1972

Good, Thomas (1789-1872)
Scottish School
- 472 *An Old Scots Woman*
 23 x 18, on panel
 Purchased, London, Mr D.
 Rothschild, 1897

Goubau, Antoine (1616-98)
Flemish School
- 540 *A Farm Yard*
 Signed: *A. Goubau, f.*
 26 x 35, on panel
 Purchased, London, Mr A.
 Buttery, 1903

Gower, George (1540-96)
English School
- 419 *A Portrait of a Gentleman*
 Dated 1584
 96 x 75, on panel
 Purchased, London, 1892

Goya, Francisco de (1746-1828)
Spanish School
- 572 *A Lady in a Black Mantilla*
 54 x 43
 Purchased, Paris, Marques de la
 Vega Inclan, 1905

- 600 *El Conde del Tajo*
 61 x 51
 Purchased, London, Sulley and
 Co., 1908.

- 784 *A Woman in a White Fichu ('La Moue')*
 57 x 48
 Sir Hugh Lane Bequest, 1918

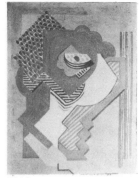

1308

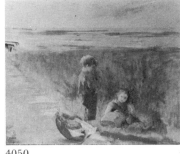

4050

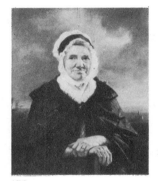

472

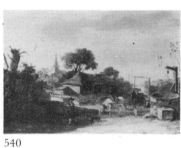

540

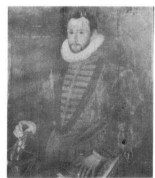

419

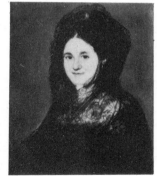

572

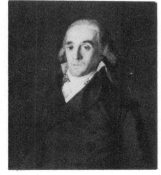

600

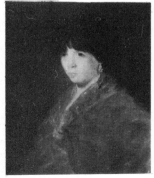

784

[**63**]

1928 *El Sueno*
46.5 x 76
Purchased, London, Agnew, 1969

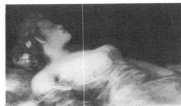
1928

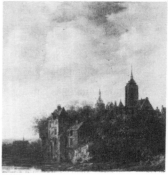
236

Goyen, Jan van (1596-1665)
Haarlem School
236 *A View of a Town in Holland*
Signed with monogram and dated
1650
36 x 33, on panel
Purchased, London, Messrs
Robinson and Fisher, 1875

807 *A View of Rhenen-on-the-Rhine*
Signed with monogram and dated
1644
64 x 94, on panel
Sir Hugh Lane Bequest, 1918

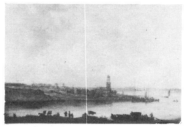
807

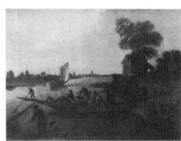
1715

Graat, Barent (1628-1709)
Amsterdam School
1715 *A Canal Scene with Figures*
28 x 36
Milltown Gift, 1902

Grammorseo, Pietro (fl.1521-27)
Piedmontese School
771 *The Immaculate Conception*
Signed: *Petrus Gramorseus faciebat
1526*
177 x 80, on panel
Presented, Sir Henry Howorth,
1902

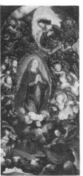
771

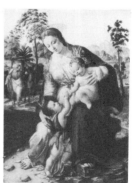
98

Attributed to **Granacci, Francesco (1477-1543)**
Florentine School
98 *The Holy Family with St John in a
Landscape, (c.1494)*
100 x 71, on panel
Purchased, Paris, Comte de Choiseul
Sale, 1866

Grant, Duncan (b.1885)
Scottish School
1884 *A View of Thames Bridge*
Signed: *D. Grant '33*
46 x 81.3
Presented, Sir Alfred Chester Beatty,
1953

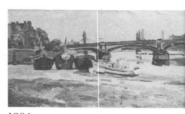
1884

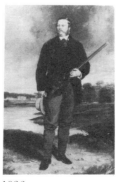
1036

Grant, Francis (1810-78)
Scottish School
1036 *Edward Nugent Leeson, 6th Earl of
Milltown, (1835-71)*
240 x 148
Milltown Gift, 1902

1322 *Seymour Sydney Hyde, 6th Earl of*
 Harrington, (1845-66)
 283 x 213.5
 Milltown Gift, 1902

Greco, El (1541-1614)
Spanish School
 658 *St Francis in Ecstasy*
 114 x 104
 Presented, Sir Hugh Lane, 1914

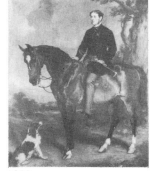
1322

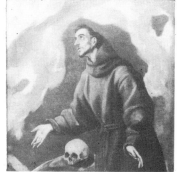
658

Greco-Venetian School (15th century)
 1303 *The Mystical Sufferings of Christ*
 40 x 30, tempera on panel
 Purchased, Dublin, Monsignor J.
 Shine, 1955

Greek School (17th century)
 1835 *A Casket of Carved and Gilt Wood*
 Bearing the Deesis on Front
 56.5 x 27.5
 Purchased, Mr W.E.D. Allen, 1968

1835

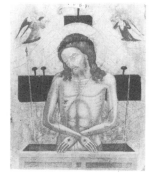
1303

 1847 *Two Military Saints*
 16 x 11, tempera on panel
 Purchased, Mr W.E.D. Allen, 1968

Greek School (c.1700)
 1849 *The Archangel Michael between SS.*
 George and Nicholas
 29 x 21.5, tempera on panel
 Purchased, Mr W.E.D. Allen, 1968

1847

1849

Greuze, Jean-Baptiste (1725-1805)
French School
 803 *The Capuchin Doll*
 43 x 37
 Sir Hugh Lane Bequest, 1918

After Greuze
 1035 *La Belle Gabrielle*
 65 x 55
 Milltown Gift, 1902

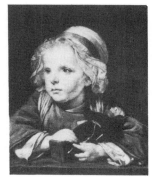
803

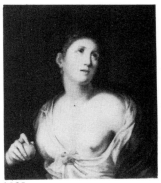
1035

1420 *Weep Not*
 52 x 46
 Purchased, Mrs E. Barrington,
 1960

Griffier the Elder, Jan (c.1655-1718)
Amsterdam School
336 *A Landscape*
 Signed: *J. Griffier*
 48 x 63, on panel
 Purchased, London, Radcliffe,
 1864

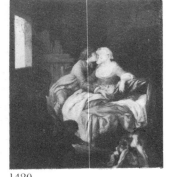

1420

336

Gris, Juan (1887-1927)
Hispano-French School
1313 *A Guitar, Glasses and a Bottle*
 Abstract on reverse
 Dated 1914 by Newspaper
 60 x 81, collage laid on canvas
 Evie Hone Bequest, 1955

1313

1313 reverse

Guardi, Antonio (1698-1760)
Venetian School
63 *St John in the Wilderness*
 (after Titian)
 147 x 221
 Purchased, Durham, Archdeacon
 Thorp Sale, 1863

Guardi, Francesco (1712-93)
Venetian School
92 *The Doge Wedding the Adriatic*
 39 x 57
 Purchased, London, Christie's, 1864

63

92

819 *A Landscape*
 27 x 22
 Purchased, Captain R. Langton
 Douglas, 1918

Guercino (1591-1666)
Bolognese School
192 *St Joseph with the Christ Child*
 99 x 77
 Purchased, London, Christie's, 1882

819

192

Studio of **Guercino**

 1323 *The Triumph of David*
 135 x 175
 Milltown Gift, 1902

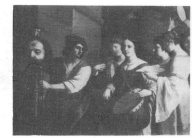

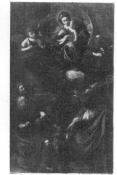

After **Guercino**

 483 *The Virgin and Child with Saints and
 Donors*
 335 x 192
 Presented, Mr F. Baring, 1893

1323

483

 1659 *A Winged Figure*
 78 x 102
 Milltown Gift, 1902

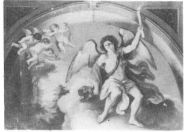

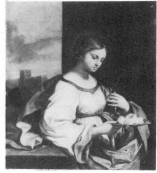

 1668 *St Agatha*
 109 x 99
 Milltown Gift, 1902

 1686 *Aurora*
 100 x 137
 Milltown Gift, 1902

1659

1668

 1692 *An Angel Leading Innocence to Heaven*
 64 x 48.3
 Milltown Gift, 1902

Guillaumet, Gustave (1840-87)
French School
 4235CB *Women in an Eastern Courtyard*
 Signed: *Guillaumet*
 104 x 73
 Sir Alfred Chester Beatty Gift, 1950

1686

1692

Gurschner, Herbert (b.1901)
Austro-English School
 1184 *Lawrence 'of Arabia'*
 Commissioned by donor, 1934
 Signed: *Gurschner - Tirol London*
 97 x 76
 Presented, Major D. Chapman-
 Huston, 1950

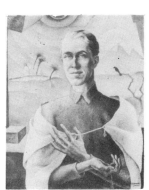

4235CB

1184

Gyselaer, Nicolas de (c.1590-after 1654)
Utrecht School

327 *An Interior with Figures*
 Signed: *N.D. Giselaer*
 34 x 56, on panel
 Purchased, London, Mr S. Smith,
 1893

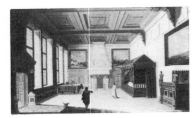

327

H

Haansbergen, Johannes van (1642-1705)
Utrecht School
 341 *A Classical Landscape*
 40.5 x 55
 Presented, Mr J. Stronge, 1857

Hagen, Joris van der (1620-69)
The Hague School
 515 *The Ferry Boat*
 Signed: *J. Ruysdal, f.*
 V. Velde f.
 86 x 77
 Sir Henry Barron Bequest, 1901

Hale, Edward (1852-1924)
English School
 1808 *Charlotte McCarthy, Sister of J.H.*
 McCarthy
 91.3 x 60.8
 Mrs L. McCarthy-Gimson Bequest,
 1966

Hall, Sydney (1842-1922)
English School
 481 *Charles Stewart Parnell, Statesman,*
 (1846-91)
 Signed: *S.P. Hall, 1892*
 112 x 86
 Presented, Sir John Brunner, 1898

Hals, Frans (c.1580-1666)
Haarlem School
 193 *A Young Fisherboy of Scheveningen*
 Signed with monogram
 72 x 58
 Purchased, Paris, Mr J. Wilson,
 1881

Halswelle, Keeley (1832-91)
Scottish School
 391 *A Landscape near Pangbourne*
 61 x 34
 Purchased, London, Christie's, 1891

341

515

1808

481

193

391

392 *A Landscape near Southwold*
 Signed: *KH*
 61 x 34
 Purchased, London, Christie's, 1891

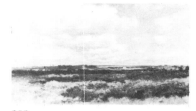

392

Attributed to **Hanneman, Adriaen (c.1601-71)**
The Hague School
 438 *Amelia of Solms, Princess of Orange (?),*
 (d.1675)
 75 x 61
 Purchased, London, Mr S.
 Gooden, 1896

438

Harding, James (1798-1863)
English School
 385 *A Landscape*
 29 x 44
 Purchased, London, Mr T.
 McLean, 1893

385

Hare, St George (1857-1933)
English School
 4203 *A Self-Portrait*
 Signed: *Hare*
 69 x 58
 Purchased, Dublin, Godolphin
 Gallery, 1977

4203

Harlow, George (1787-1819)
English School
 160 *Miss Boaden*
 33 x 26
 Purchased, London, Mr H.
 Waters, 1870

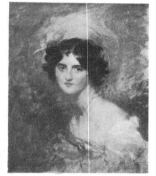

 255 *William Lamb, 2nd Viscount Melbourne,*
 English Statesman, (1779-1848)
 18 x 15, on panel
 Purchased, London, Christie's, 1887

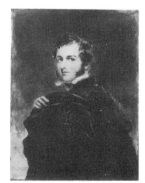

160 255

Harpignies, Henri (1819-1916)
French School
 1328 *A Landscape*
 Signed: *H.J. Harpignies*
 66 x 81
 Presented, Sir Alfred Chester Beatty,
 1956

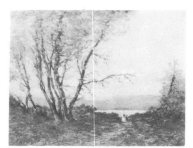

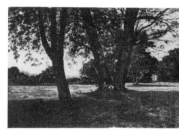

 4236CB *A Country Scene*
 Signed (twice): *H Harpignies*
 50 x 69
 Sir Alfred Chester Beatty Gift, 1950

1328 4236CB

4237CB *A River Scene*
 Signed: *H Harpignies 1887*
 49 x 66
 Sir Alfred Chester Beatty Gift, 1950

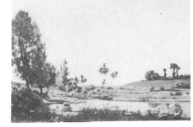

asselt, Izaak van (17th century)
rdrecht School
 897 *A Beggar before a Doorway*
 Signed: *J.C.V. Hasselt ao 1659*
 55 x 39, on panel
 Purchased, Durlacher, 1927

4237CB 897

ayman, Francis (1708-76)
nglish School
 295 *A Scene from a Shakespeare Play (Henry*
 IV, Part II, Act III)
 100 x 125
 Purchased, London, Christie's, 1888

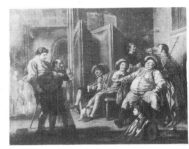

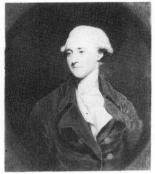

ayter, George (1792-1871)
nglish School
 297 *Richard Burke, Son of Edmund Burke,*
 Parliamentary Agent of the Catholic
 Committee, (1758-94)
 (after Reynolds)
 75 x 61
 Provenance unknown

295 297

 559 *George Tierney, English Statesman,*
 (1761-1830)
 Inscribed on reverse and dated
 1823
 90 x 69
 Purchased, London, Toone, 1904

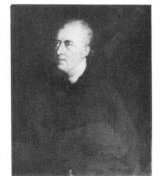

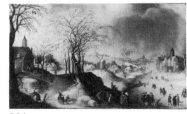

ecke, Claesz van der (c.1580-1658)
utch School
 904 *A Landscape*
 Signed: *C. Hecke fecit*
 52 x 86, on panel
 Purchased, Mr C. Cassen, 1928

904

559

eda, Willem (1594-1680)
aarlem School
 514 *A Still Life*
 55 x 73, on panel
 Sir Henry Barron Bequest, 1901

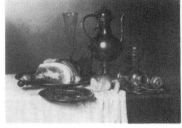

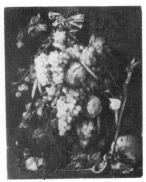

eem, Jan de (1606-83/4)
utch School
 11 *A Fruit Piece, with Skull, Crucifix and*
 Serpent
 Signed: *J. de Heem, f.a. 1633*
 84 x 64
 Purchased, London, Blamire
 Collection Sale, 1863

514

11

Heere, Lucas de (1534-84)
Flemish School
 400 *Mary Tudor, Queen of England,*
 (1516-58)
 dia. 17, on panel
 Purchased, London, Sir William
 Drake, 1891

Heimbach, Christian (c.1613-78)
German School
 610 *Supper by Candlelight*
 37 x 29, on panel
 Purchased, London, Mr A.
 Buttery, 1910

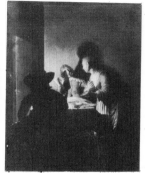
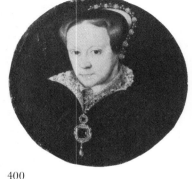

400 610

Helmick, Howard (1845-1907)
American School
 4294CB *The Bookworm*
 45 x 54
 Sir Alfred Chester Beatty Gift, 1950

Helst, Bartholomeus van der (1613-70)
Amsterdam School
 55 *A Portrait of a Gentleman*
 Signed: *B. Vander Helst, 1645*
 102 x 84
 Purchased, Paris, 1864

 65 *A Portrait of an Old Lady*
 Signed: *B. Vander Helst, 1641*
 69 x 59, on panel
 · Purchased, Dublin, Mr W. Brocas
 Collection, 1866

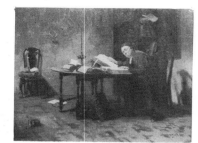
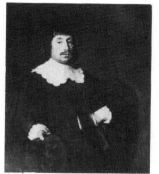

4294CB 55

Helt-Stockade, Nicolaes van (1614-69)
Amsterdam School
 1046 *Jupiter and Ganymede*
 Signed: *Stocade. f.*
 121 x 114
 Presented, Mr P. Higgins, 1940

Hemessen, Jan van (c.1501-before 1566)
Flemish School
 1177 *An Interior*
 34 x 49, on panel
 Purchased, Dublin, J.H. North and
 Co., 1948

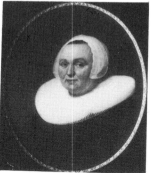
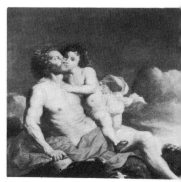

65 1046

Henner, Jean (1829-1905)
French School
 4238CB *A Nude*
 Signed: *J Henner*
 35 x 22, on panel
 Sir Alfred Chester Beatty Gift, 1950

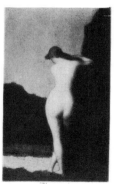

1177 4238CB

4295CB *Monsieur A. Koch*
Signed: *à mon ami A. Koch*
 J Henner
32 x 24
Sir Alfred Chester Beatty Gift, 1950

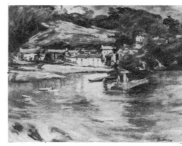

1286

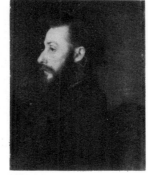

4295CB

enry, Grace (1868-1953)
ottish and Irish Schools

1286 *Glandore, County Cork*
Signed: *G.H.*
51 x 61, on panel
Presented, Mrs C. Meredith, 1953

1287 *Drying Sails at Chioggia*
Signed: *G.H.*
33 x 25, on board
Presented, Mrs C. Meredith, 1953

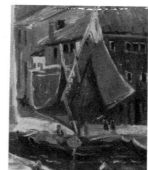

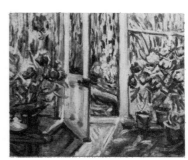

1288

1288 *A Wexford Garden*
Signed: *G. Henry*
51 x 61
Presented, Mrs C. Meredith, 1953

1287

1922 *Master Conor Padilla*
Signed: *G. Henry*
36 x 28, canvas laid on board
Presented, Mr C. Padilla, 1969

4193 *A Lake Scene with Boats and a House*
Signed: *G Henry*
15 x 18
Purchased, Mrs J. Wood, 1977

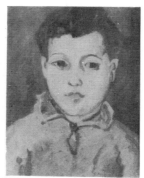

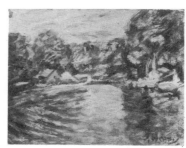

4193

4194 *Boats on a Lake*
18 x 13, on panel
Purchased, Mrs J. Wood, 1977

1922

rp, Willem van (1614-77)
mish School

342 *The Jug of Beer*
33 x 47, on panel
Purchased, London, Christie's, 1890

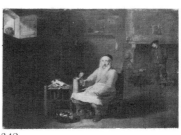

342

4194

1082 *Herod and Salome*
60 x 84
Milltown Gift, 1902

1082

461

Herring, John (1795-1865)
English School
461 *A Horse Drinking*
Signed: *J.F. Herring, Senr., 1854*
32 x 44, on panel
Presented, Dr Barry, 1873

Hervier, Louis (1818-79)
French School
4239CB *A Farm Courtyard*
48 x 37
Sir Alfred Chester Beatty Gift, 1950

4239CB

4192

Hill, Derek (b.1916)
English School
4192 *Sir Robert Meyer, (b.1879)*
41 x 36
Purchased, the artist, 1977

Hobbema, Meindert (1638-1709)
Amsterdam School
832 *The Ferry Boat*
Signed: *M. Hobbema*
28 x 32
Purchased, Captain R. Langton
Douglas, 1921

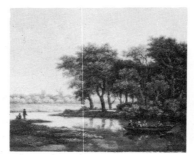
832

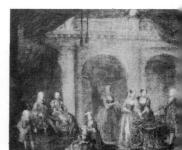
126

Hogarth, William (1697-1764)
English School
126 *George II, King of England and his Family*
62 x 74
Purchased, Whitehead Sale, 1874

398 *Benjamin Hoadly, M.D.*
Signed: *W. Hogarth pinxt 1740*
74 x 63
Purchased, London, 1891

560 *George Wade, English Field Marshal, (1673-1748)*
32 x 25
Purchased, Dublin, Miss R. Campbell, 1904

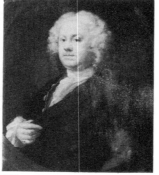
398

560

618 *The Denunciation*
 Signed: *W. Hogarth p.174-*
 50 x 66
 Presented, Mr F. Murray, 1911

791 *The Mackinnon Children*
 180 x 143
 Sir Hugh Lane Bequest, 1918

792 *The Western Family*
 Signed: *W. Hogarth pinx.17..*
 72 x 84
 Sir Hugh Lane Bequest, 1918

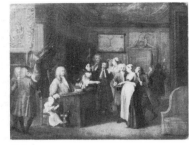

618

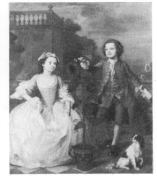

791

After **Hogarth**

127 *Gustavus Hamilton, 2nd Viscount Boyne,*
 (1639-1723)
 50 x 37
 Presented, Mrs Noseda, 1873

1958 *A Self-Portrait*
 75.5 x 63
 Provenance unknown

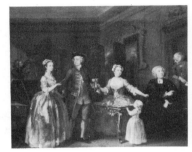

792

127

After **Holbein the Younger, Hans (1497-1543)**
South German School

370 *Sir Henry Wyat*
 36 x 32, on panel
 Purchased, London, Christie's, 1892

1265 *Edward VI, King of England*
 32 x 27, on panel
 Presented, Sir Alfred Chester Beatty,
 1953

1958

370

Holl, Frank (1845-88)
English School

777 *Garnet, Lord Wolseley, (1833-1913)*
 Signed: *Frank Holl 1886*
 112 x 86
 Presented, Dowager Lady
 Wolseley, 1918

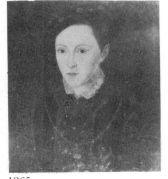

1265

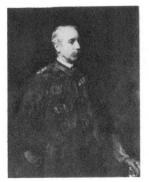

777

Holland, James (1800-70)
English School
437 *The Amphitheatre at Verona*
Signed: *J.H. '45*
37 x 27, on board
Purchased, London, Mr T.
McLean, 1896

Hondecoeter, Melchior (1636-95)
Utrecht School
35 *A Stork and a Vulture*
115 x 142
Purchased, London, Mr M.
Anthony, 1867

509 *Poultry*
Signed: *M.D. Hondecoeter*
99 x 126
Sir Henry Barron Bequest, 1901

Hondt, Hendrick de (fl.1637-45)
Haarlem School
512 *An Interior of a Guardroom*
58 x 79
Sir Henry Barron Bequest, 1901

Attributed to **Honthorst, Gerrit van (1590-1656)**
Dutch School
1379 *A Wedding Feast*
Signed with unidentified
monogram and dated 1628
146 x 205
Purchased, Dublin, Mr K.
Maughan, 1958

Hooch, Pieter de (1629-81)
Delft School
322 *Players at Tric-Trac*
Signed: *P. de Hooch*
46 x 33, on panel
Purchased, London, Haines Bros.,
1892

Hoppner, John (1758-1810)
English School
256 *A Presumed Portrait of Mrs Musters
(Mary Chaworth)*
51 x 42
Purchased, 1887

566 *A Self-Portrait*
75 x 61
Presented, Sir Hugh Lane, 1904

437

35

509

512

1379

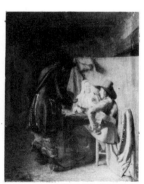
322

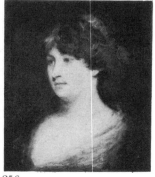
256

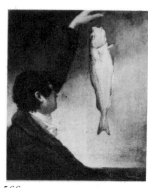
566

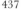

Horemans, Jan (1682-1759)
Flemish School
 589 *A Kitchen Interior, People Seated and*
 Standing before a Fire
 28 x 24
 Presented, Sir Hugh Lane, 1907

Horemans, Jan Joseph (1714-after 1790)
Flemish School
 590 *An Interior. People Seated at a Table*
 39 x 30
 Presented, Sir Hugh Lane, 1907

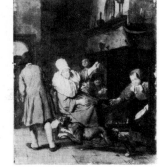
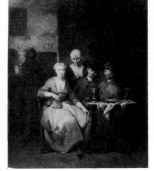

589 590

Horstok, Johannes Petrus (1745-1825)
Haarlem School
 650 *A Portrait of a Gentleman*
 Signed: *J.P. Horstock, fe. 1801*
 48 x 38
 Presented, Sir Hugh Lane, 1913

Huber, Wolfgang (c.1490-1553)
Austrian School
 15 *Anthony Hundertpfundt*
 Signed with monogram and dated
 1526
 66 x 47, on panel
 Purchased, London, Christie's, 1872

650 15

Hudson, Thomas (1701-79)
English School
 293 *Diana, Countess of Mountrath, (1746)*
 Signed: *Tho. Hudson, pinxit*
 124 x 99
 Purchased, London, Christie's, 1888

 294 *John Carteret, afterwards Earl of*
 Granville, (1690-1763)
 65 x 50
 Purchased, London, Christie's, 1888

293 294

Hunt, William (1790-1864)
English School
 683 *The Artist's Mother*
 26 x 20
 Presented, Sir Hugh Lane, 1914

Huysmans, Cornelisz (1648-1727)
Flemish School
 199 *A Landscape with Figures*
 16 x 23
 Purchased, Brussels, Vicomte B. du
 Bus de Gisignies, 1882

199

683

Huysum, Jan van (1682-1749)
Amsterdam School
50 *A Bouquet of Flowers*
 67 x 56
 Purchased, Mr W. Ellis Collection,
 1864

50

I

Ibbetson, Julius (1759-1817)
English School
434 *A Landscape with Cattle*
 36 x 46 .
 Purchased, Dublin, Lt-Col. Hopton
 Scott, 1895

Ijsenbrandt, Adriaen van (fl.1510-51)
Flemish School
498 *The Virgin and Child in a Landscape*
 37 x 30, on panel
 Purchased, London, Colnaghi, 1900

School of **Ijsenbrandt**
552 *The Temptation of St Anthony*
 34 x 25, on panel
 Purchased, 1904

Inchbold, John (1830-88)
English School
586 *A View of Lake Leman from above*
 Montreux
 Signed: *J.W. Inchbold*
 76 x 51
 Mr W. Brooke Bequest, 1907

Innes, George (1825-94)
American School
1293 *A Seacoast, Evening*
 Signed: *G. Innes*
 46 x 66
 Presented, Sir Alfred Chester Beatty,
 1954

Isabey, Eugène (1803-86)
French School ·
4241CB *The Arrival of the Diligence*
 Signed: *E Isabey 75*
 64 x 52
 Sir Alfred Chester Beatty Gift, 1950

434

498

552

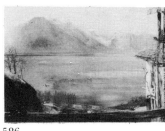
586

1293

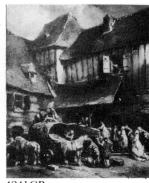
4241CB

Israels, Joseph (1824-1911)
Dutch School
 4242CB *An Old Man with Child in a Highchair*
 Signed: *Joseph Israels*
 29 x 39, on panel
 Sir Alfred Chester Beatty Gift, 1950

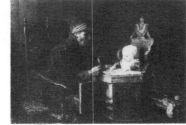

4242CB

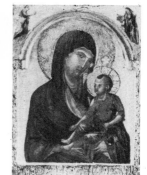

868

Italian School (14th century)
 868 *The Virgin and Child*
 36 x 27, tempera on panel
 Purchased, Dublin, Mrs Scott,
 1926

Italian School (15th century)
 4091 *The Virgin and Child with Saints*
 dia. 89, on panel
 Purchased, Dublin, Mrs A.
 Murnaghan, 1974

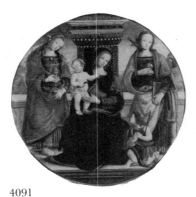

4091

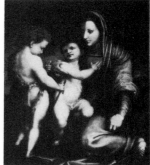

1080

Italian School (16th century)
 1080 *The Virgin and Child with St John*
 73 x 58
 Milltown Gift, 1902

 1335 *The Muse of Sculpture*
 93 x 73.5
 Purchased, Rome, Mr R.
 MacPherson, 1856

 1336 *The Virgin and Child with St John and*
 Angels
 73 x 58, on panel
 Presented, Mr R. Clouston, 1855

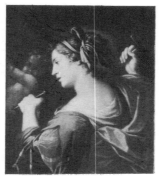

1335

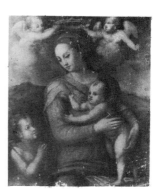

1336

 1337 *The Virgin and Child with St John and*
 Angels
 89 x 69
 Provenance unknown

 1533 *Cardinal Roberto de Nobili, (1541-59)*
 88 x 68
 Presented, Sir Alfred Chester Beatty,
 1954

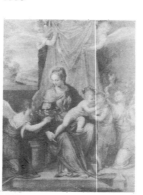

1337

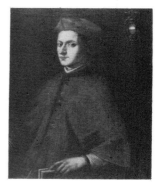

1533

Italian School (c.1660)

4159 *Peter Talbot, Archbishop of Dublin,*
(1620-80)
72 x 62
Purchased, Dublin, Malahide
Castle Sale, 1976

4159

1040

Italian School (17th century)

1040 *The Mystic Marriage of St Catherine*
65 x 50
Milltown Gift, 1902

1667 *Cain and Abel*
200 x 147
Milltown Gift, 1902

1740 *A Sybil*
94 x 74
Purchased, Rome, Mr R.
MacPherson, 1856

1667

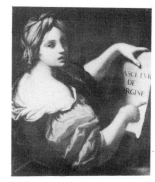

1740

4004 *The Holy Family*
83 x 116, on copper
Purchased, Mr J. Levi, 1939

4048 *Hannibal (?)*
214 x 303
Provenance unknown

4337 *A Shield, Medusa on Convex Side*
dia. 58.5
Provenance unknown

4004

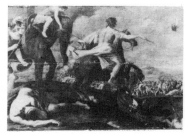

4048

4337

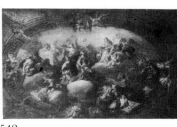

542

Italian School (18th century)

542 *A Design for a Ceiling*
63 x 98.3
Purchased, Dublin, Mr J. O'Reilly,
1902

1084　*A Pope*
57 x 49
Milltown Gift, 1902

1693　*The Little Recording Angel*
74 x 59
Milltown Gift, 1902

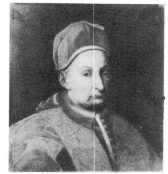
1084

1693

Italo-Flemish School (c.1600)
1317　*Democritus and Heraclitus*
81 x 102
Presented, Mrs J. Douglas, 1956

1749　*St Jerome*
35 x 50, on panel
Purchased, Blamire Collection
Sale, 1863

1317

1749

Italo-Flemish School (17th century)
4095　*The Virgin and Child*
37 x 29, on copper
Provenance unknown

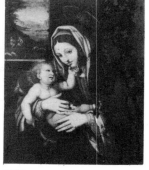
4095

ℐ

Jackson, John (1778-1831)
English School
 257 *Thomas Moore, Poet, (1779-1852)*
 Inscribed on reverse and dated
 Rome 1818
 60 x 51
 Purchased, Dublin, Bennett, 1887

4243CB

257

Jacque, Charles (1813-94)
French School
 4243CB *Poultry among Trees*
 Signed: *C E Jacque*
 27 x 45, on panel
 Sir Alfred Chester Beatty Gift, 1950

 4244CB *Sheep*
 Signed: *Ch. Jacque*
 81 x 100
 Sir Alfred Chester Beatty Gift, 1950

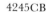

 4245CB *Sheep in a Barn*
 Signed: *Ch. Jacque*
 48 x 65
 Sir Alfred Chester Beatty Gift, 1950

4244CB 4245CB

 4246CB *Sheep in a Barn with Chickens*
 Signed: *Ch. Jacque*
 45 x 71
 Sir Alfred Chester Beatty Gift, 1950

 4247CB *A Shepherd and Flock*
 Signed: *C E Jacque '76*
 67 x 82
 Sir Alfred Chester Beatty Gift, 1950

4246CB

4247CB

4248CB *A Shepherdess and Sheep with Dog near a Wood*
Signed: *Ch. Jacque*
44 x 69
Sir Alfred Chester Beatty Gift, 1950

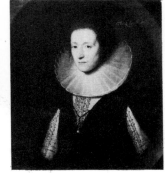

4248CB

Attributed to **Jamesone, George (c.1590-1644)**
Scottish School
534 *Lady Alexander*
75 x 64
Presented, Sir Hugh Lane, 1902

534

Janssens, Abraham (1575-1632)
Flemish School
1010 *Moses Striking the Rock*
129 x 188
Presented, Miss E. Gorst, 1939

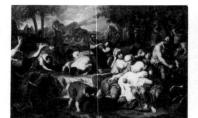

1010

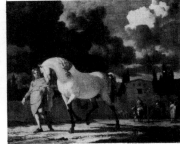

Jardin, Karel du (1622-78)
Amsterdam School
544 *The Riding School*
Dated Rome 1678
60 x 74
Purchased, London, Messrs Forbes
and Patterson, 1903

544

'J.B.' (fl.1889)
1059 *A Mountain Landscape*
Signed with monogram and dated
1889
25 x 36
Sherlock Bequest, 1940

1059

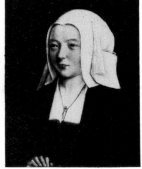

Attributed to **Joest, Jan (1460-1519)**
Dutch School
751 *A Portrait of a Lady*
32 x 25, on panel
Milltown Gift, 1902

751

John, Augustus (1878-1961)
English School
859 *Dr Kuno Meyer, Poet and Scholar,*
(1858-1919)
91 x 76
Purchased, Miss A. Meyer, 1924

1329 *Carlotta*
91 x 71
Presented, Sir Alfred Chester Beatty,
1956

859

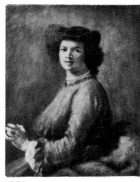

1329

4185 *Francis McNamara*
Signed: *John*
76 x 46
Purchased, Mr R. Byng, 1976

44

ngh, Ludolf de (1616-79)
utch School

44 *A Shooting Party*
56 x 83, on panel
Purchased, London, Foster, 1873

148 *A Dutch Canal Boat Station*
Signed: *L.D. Jongh*
52 x 65, on panel
Purchased, London, Christie's, 1889

148

4249CB

ngkind, Johan (1819-91)
utch School

4249CB *A Village Church*
Signed: *Jongkind 1862*
43 x 56
Sir Alfred Chester Beatty Gift, 1950

4250CB *A Windmill in Moonlight*
Signed: *Jongkind 1868*
33 x 25
Sir Alfred Chester Beatty Gift, 1950

4250CB 532

nson, Cornelis (1593-1661/2)
nglo-Dutch School

532 *A Portrait of an Officer in Armour*
75 x 65, on canvas
Purchased, 1903

584 *A Portrait of a Gentleman*
Signed: *C.J. fecit 1628*
76 x 63
Purchased, London, Mr A.
Buttery, 1907

1383 *Arthur Ussher*
79 x 63
Purchased, Mr A. Ussher, 1957

584 1383

Jordaens, Jacob (1593-1678)
Flemish School

 38 *St Peter finding the Tribute Money*
 (after Rubens)
 199 x 218
 Purchased, London, Christie's, 1873

 46 *The Church Triumphant*
 280 x 231
 Purchased, London, 1863

 57 *The Supper at Emmaus*
 195 x 210
 Presented, Mr C. Bianconi, 1865

38

46

Joseph, George (1764-1846)
English School

 416 *John Stevenson, Composer, (1762-1833)*
 74 x 61
 Presented, T. Taylour, 3rd
 Marquess of Headfort, 1892

57

416

Jouderville, Isaac de (17th century)
Leyden School

 433 *A Portrait of a Young Gentleman*
 48 x 37, on panel
 Purchased, London, Lawrie and
 Co., 1895

433

K

Camper, Godart (1614-79)
Leyden School

806 *The Violinist*
 49 x 41, on panel
 Sir Hugh Lane Bequest, 1918

806

200

Kauffman, Angelica (1740-1807)
Swiss School

200 *A Portrait Group: The Earl of Ely,*
 (d.1783), with his Wife, his Niece, Dolly
 Monroe, and Angelica Kauffman
 Signed: *Angelica Kauffman . . . pinxt*
 1771
 243 x 287
 Presented, J. Loftus, 4th Marquess
 of Ely, 1878

405 *Dorothea (Dolly) Monroe, (d.1811)*
 76 x 61
 Purchased, London, Christie's, 1891

887 *George Robert Helen, (d.1793)*
 76 x 63
 Presented, Mrs M. Jack, 1919

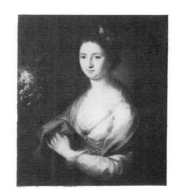

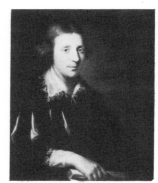

405

887

888 *Mrs Helen (Dorothea Daniel), (d.1806)*
 76 x 63
 Presented, Mrs M. Jack, 1919

Attributed to **Kauffman**
444 *A Portrait of a Lady*
 75 x 63
 Lady Fitzgerald Bequest, 1896

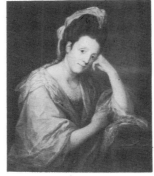

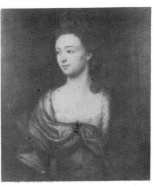

888

444

Keil, Bernhardt (1624-87)
Danish School
 4092 *The Embroidery Shop*
 153 x 186
 Purchased, Dublin, Mrs A.
 Murnaghan, 1974

4092

1306

Kelly, Gerald (1879-1972)
English School
 1306 *Mr Durham, (1910)*
 73 x 60
 Presented, Miss V. Durham, 1955

 1411 *A View of Vallata della Fontana Buona*
 from the Monte Negro
 Inscribed on reverse and dated
 1932
 34 x 42, on panel
 Mr R. Best Bequest, 1959

 1412 *Ywein Pwe (Eleven Dancers)*
 32 x 42, on panel
 Mr R. Best Bequest, 1959

1411

1412

Kennedy, Charles (1852-98)
English School
 543 *The Boy and the Dryad*
 Signed: *C.N. Kennedy '89*
 157 x 106
 Presented, the artist's widow, 1903

Kennedy, William (1813-65)
Scottish School
 386 *The Head of a Girl*
 dia. 27, on panel
 Purchased, London, Christie's, 1887

543

386

Kessel, Johannes van (1641-80)
Amsterdam School
 933 *The Dam at Amsterdam*
 Signed: *J.V. Kessel, 1669*
 70 x 84
 Purchased, London, Mr A.
 Buttery, 1930

Kettle, Tilly (1735-86)
English School
with
Cuming, William (1769-1852)
Irish School
 1783 *James Gandon, Architect, (1743-1823)*
 123 x 98
 Purchased, London, Sotheby's, 1965

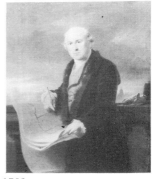

933

1783

Key, Thomas (c.1544-after 1589)
Flemish School
330 *A Portrait of a Gentleman*
 Dated 1579
 46 x 33, on panel
 Purchased, London, Fine Art
 Society, 1893

576 *A Portrait of a Gentleman*
 38 x 28, on panel
 Purchased, Captain R. Langton
 Douglas, 1906

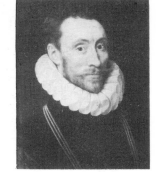
330

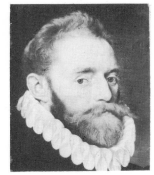
576

Keyser, Thomas de (1596/7-1667)
Amsterdam School
469 *An Interior with Figures*
 Signed: *D. Keij*
 32 x 36, on panel
 Purchased, London, Mr A.
 Buttery, 1897

469

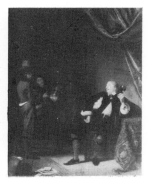
834

Kick, Simon (1603-52)
Dutch School
834 *A Self-Portrait, Painting*
 92 x 69, on panel
 Purchased, Captain R. Langton
 Douglas, 1921

Kneller, Godfrey (1646-1723)
Anglo-German School
296 *Richard Steele, Dramatist and Essayist,*
 (1672-1729)
 86 x 70
 Purchased, London, Christie's, 1889

311 *King William III of England Returning*
 from the Peace of Ryswyk, Margate,
 1697, (painted c.1701)
 139 x 122
 Purchased, London, Christie's, 1886

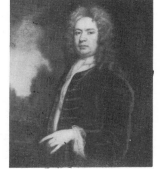
296

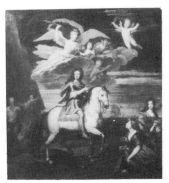
311

485 *James Butler, 2nd Duke of Ormonde,*
 (1665-1745)
 125 x 102
 Purchased, London, Mr W. Green,
 1899

486 *Godert de Ginkell, (1630-1703)*
 125 x 100
 Purchased, London, Mr W. Green,
 1899

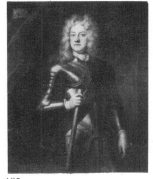
485

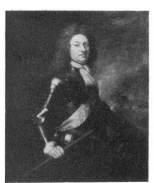
486

4336 *William Congreve*
 90 x 35
 Presented, Dublin, Mr J.
 Chambers, 1980

School of **Kneller**
 474 *Thomas, Marquess of Wharton, (1648-*
 1715)
 122 x 101
 Purchased, Dublin, Mr J. Nairn,
 1897

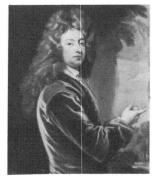 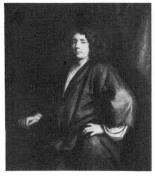

4336 474

Knight, John (1843-1908)
English School
 948 *'The White Walls of Old England'*
 Signed: *J. Buxton Knight '93*
 102 x 127
 Presented, Mr W. Hutcheson Poe,
 1931

948 53

Knijf, Wouter (fl. c.1650)
Dutch School
 53 *The Windmill, (1663)*
 102 x 129
 Purchased, Bishop of Ely Sale,
 1864

After **Koninck, Salomon (1609-56)**
Amsterdam School
 329 *A Portrait of a Burgher*
 132 x 107
 Purchased, Mr B. Watkins, 1856

329

L

Lambinet, Émile (1815-77)
French School
424 *A Landscape*
 Signed: *Emile Lambinet, Juillet,*
 1851
 89 x 70
 Purchased, London, Mr T.
 McLean, 1894

Lancret, Nicolas (1690-1745)
French School
802 *Mischief ('La Malice')*
 36 x 29
 Sir Hugh Lane Bequest, 1918

Landseer, Edwin (1802-73)
English School
139 *Members of the Sheridan Family, (1847)*
 107 x 166
 Purchased, London, Christie's, 1874

4333 *A King Charles Spaniel*
 Signed: *E. Landseer*
 35 x 35
 Miss M. Wallis Bequest, 1980

Lanfranco, Giovanni (1582-1647)
Roman School
67 *The Last Supper*
 229 x 426
 Purchased, Rome, Signor Aducci,
 1856

72 *The Miracle of the Loaves and Fishes*
 229 x 426
 Purchased, Rome, Signor Aducci,
 1856

424

802

139

4333

67

72

Largillière, Nicolas (1656-1746)
French School
 1735 *A Portrait of a Lady*
 75 x 63
 Purchased, Mr A. Cottingham,
 1963

Lastman, Pieter (1583-1633)
Amsterdam School
 890 *Joseph Selling Corn in Egypt*
 Signed: *P. Lastman, fecit 1612*
 58 x 87, on panel
 Purchased, Belfast, Mr B. McCoy,
 1927

La Tour, Étienne de (1621-92)
French School
 1867 *The Image of St Alexis*
 143.5 x 117
 Purchased, Paris, Heim, 1968

Attributed to **Lauri, Filippo (1623-94)**
Roman School
 989 *Rebecca at the Well*
 32 x 57
 Milltown Gift, 1902

Laurie-Wallace, John (1863-after 1947)
American School
 1731 *Thomas Brennan*
 76 x 63
 Presented, Miss M. Farmer
 through the Government, 1963

Lawrence, Thomas (1769-1830)
English School
 131 *Murrough O'Brien, Marquess of*
 Thomond, (d.1808)
 140 x 107
 Purchased, London, Cox, 1874

 299 *John Jeffreys Pratt, Marquess of*
 Camden, (1759-1840)
 Inscribed on reverse and dated
 1802
 74 x 61
 Purchased, London, Christie's, 1888

 300 *John Wilson Croker, (1780-1857)*
 75 x 63, on panel
 Purchased, London, Christie's, 1887

890

1735

989

1867

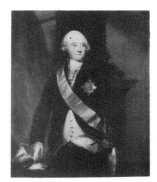

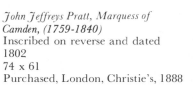

1731

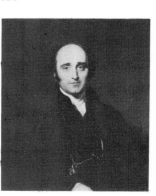

131

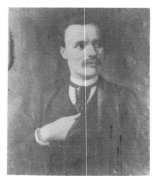

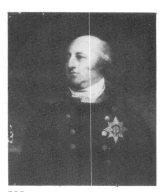

299

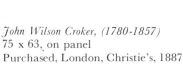

300

379 *Francis William Caulfield, 2nd Earl of Charlemont, (1775-1863)*
(Fragment of family group painted in 1812)
76 x 61
Purchased, London, Mr S. Gooden, 1894

520 *John Philpot Curran, Orator and Statesman, (1750-1817)*
73 x 61
Presented, Dublin, E. Guinness, 1st Lord Iveagh, 1901

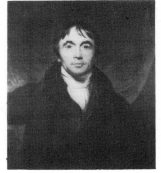

379

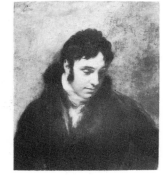

520

788 *Lady Elizabeth Foster, afterwards Duchess of Devonshire*
240 x 148
Sir Hugh Lane Bequest, 1918

Lebel, Jean (fl.1767-74)
French School

721 *Fête Champêtre – Dance*
Signed: *J. Lebel*
36 x 46
Milltown Gift, 1902

788

721

722 *Fête Champêtre – Music*
Signed: *J. Lebel*
36 x 46
Milltown Gift, 1902

Lefebvre, Jules (1836-1911)
French School

4296CB *Lauretta*
46 x 38
Sir Alfred Chester Beatty Gift, 1950

722

4296CB

Lehmann, Ludwig (1824-1901)
Danish School

1816 *Charles William, 4th Duke of Leinster*
Signed: *L.L. 1876*
76.3 x 64.3
Lady Helen Fitzgerald Bequest, 1967

1817 *Caroline, Duchess of Leinster*
Signed: *L.L. 1876*
76.5 x 64.2
Lady Helen Fitzgerald Bequest, 1967

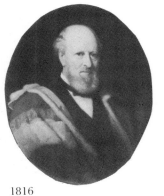

1816

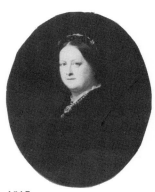

1817

Lely, Peter (1618-80)
Anglo-Dutch School

136 *James Butler, 1st Duke of Ormonde, (1610-88)*
 229 x 132
 Presented, G. Howard, 7th Earl of Carlisle, 1864

550 *Margaret Lemon*
 126 x 103
 Purchased, London, Shepherd Bros., 1903

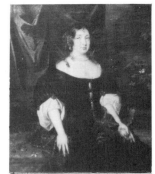

136

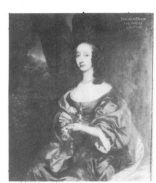

550

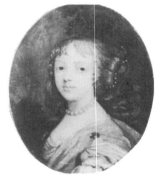

260

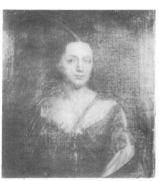

414

Attributed to **Lely**

260 *A Portrait of a Girl, Sketch*
 49 x 33
 Purchased, London, Christie's, 1886

414 *A Portrait of a Lady*
 74 x 61
 Purchased, London, Christie's, 1889

1108 *A Portrait of a Cavalier*
 88 x 66
 Presented, Mrs C. Meredith, 1943

1830 *Elizabeth Dering, Lady Davell*
 125.5 x 100
 Presented, Sir Alfred Chester Beatty, 1954

1831 *Thomas, Earl of Ossory, (d.1680)*
 123 x 118
 Presented, Sir Alfred Chester Beatty, 1954

4140 *James Butler, 1st Duke of Ormonde, (1610-88)*
 123 x 100
 Purchased, Dublin, Malahide Castle Sale, 1976

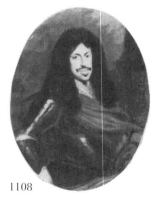

1108

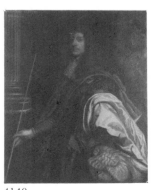

1830

1831

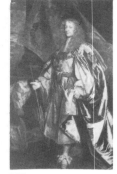

4140

4141 *Richard Talbot of Malahide, (1638-1703)*
 62 x 64
 Purchased, Dublin, Malahide
 Castle Sale, 1976

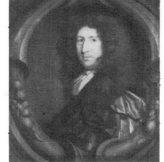

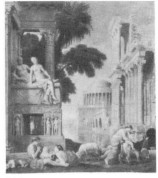

4141 800

Lemaire, Jean (1598-1659)
French School

800 *The Youthful Romulus*
 163 x 140
 Sir Hugh Lane Bequest, 1918

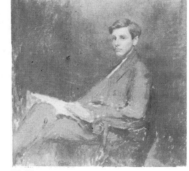

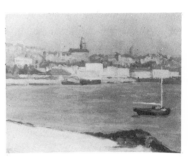

1168

Lemercier, Eugène (1886-1915)
French School

1167 *A Portrait of a Young Gentleman*
 50 x 60
 Presented, Messrs M. Garbaye and
 M. de Letre, 1948

1167

1168 *The Port of Boulogne*
 Signed: *E.L.*
 50 x 61
 Presented, Messrs M. Garbaye and
 M. de Letre, 1948

1169 *A Sunset*
 46 x 38, on board
 Presented, Messrs M. Garbaye and
 M. de Letre, 1948

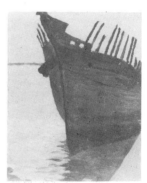

1170 *A Ship's Prow*
 46 x 34, canvas laid on panel
 Presented, Messrs M. Garbaye and
 M. de Letre, 1948

1169 1170

1171 *An Apple Tree in Blossom*
 24 x 33, on panel
 Presented, Messrs M. Garbaye and
 M. de Letre, 1948

1172 *A Study for 'Contemplation'*
 90 x 50
 Presented, Messrs M. Garbaye and
 M. de Letre, 1948

1171

1172

Lemoine, François (1688-1737)
French School
 724 *Elymas the Sorcerer Struck with Blindness,*
 Sketch
 91 x 76
 Milltown Gift, 1902

Le Nain, Louis (1593-1648)
French School
 1645 *The Adoration of the Shepherds*
 Signed: *L. Nain, f.1644*
 59 x 67
 Purchased, Paris, Heim. 1961

Lépine, Stanislas (1835-92)
French School
 4251CB *A Mother and Child in a Street*
 Signed: *S. Lepine*
 56 x 38
 Sir Alfred Chester Beatty Gift, 1950

 4252CB *A River Scene*
 Signed: *S Lepine '68*
 27 x 55
 Sir Alfred Chester Beatty Gift, 1950

Lessore, Thérèse (1884-1945)
English School
 1143 *The Circus at Bath*
 77 x 52
 Presented, Sickert Trust, 1947

Le Sueur, Eustache (1617-55)
French School
 1196 *Christ in the House of Martha and Mary*
 89 x 73
 Presented, Mr and Mrs J. Hunt,
 1950

Leys, Hendrick (1815-69)
Belgian School
 4253CB *Faust and Margaret*
 Signed: *H Leys*
 40 x 29, on panel
 Sir Alfred Chester Beatty Gift, 1950

 4297CB *A Humanist Scholar (Erasmus?)*
 Dictating to a Scribe
 60 x 77, on panel
 Sir Alfred Chester Beatty Gift, 1950

724

1645

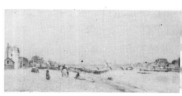

4251CB

4252CB

1143

1196

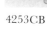

4297CB

4253CB

[96]

Leyster, Judith (1609-60)
Haarlem School
 468 *An Interior: Woman Sewing by
 Candlelight*
 dia. 28, on panel
 Purchased, London, Colnaghi, 1897

L'Hermitte, Léon (1844-1925)
French School
 4254CB *A Fishing Scene*
 Signed: *L L'Hermitte 1921*
 66 x 100
 Sir Alfred Chester Beatty Gift, 1950

 4255CB *A Harvest Scene*
 96 x 75
 Sir Alfred Chester Beatty Gift, 1950

Liège School (16th century)
 1641 *The Descent from the Cross*
 37 x 35, on panel
 Purchased, Miss K. Farrelly
 (legatee of Monsignor J. Shine),
 1961

Lievens, Jan (1607-74)
Amsterdam School
 607 *A Portrait of an Old Man (Rembrandt's
 Father?)*
 56 x 47, on panel
 Presented, Sir Edgar Vincent, 1910

Lingelbach, Johannes (1622-74)
Haarlem School
 348 *A Hunting Party*
 Signed: *J. Lingelbach*
 35 x 42, on panel
 Purchased, London, Mr S.
 Gooden, 1894

Linnell, John (1792-1882)
English School
 649 *A Portrait of a Lady*
 Signed: *T.W. Lawrence*
 25 x 19, on panel
 Presented, Sir Hugh Lane, 1913

 843 *William Mulready, Artist, (1786-1863)*
 Signed: *J. Linnell*
 30 x 25, on panel
 Purchased, W. Dyer and Son, 1922

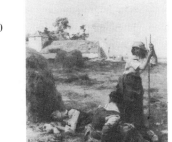

468

4254CB

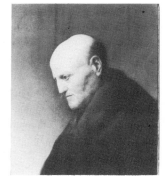

4255CB

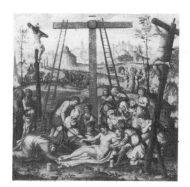

1641

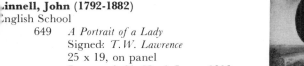

607

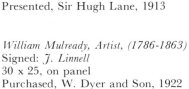

348

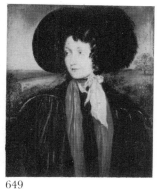

649

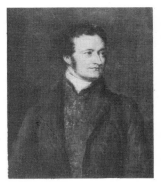

843

844 *William Collins, Artist, (1788-1847)*
30 x 25, on panel
Purchased, W. Dyer and Son, 1922

Lippi, Filippino (1457-1504)
Florentine School
470 *A Portrait of a Musician*
51 x 36, on panel
Purchased, London, Lawrie and
Co., 1897

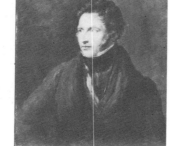
844

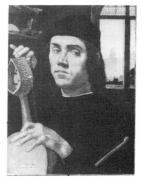
470

Lippi, Lorenzo (1606-65)
Florentine School
1747 *Medoro and Angelica*
173 x 238
Milltown Gift, 1902

Livesay, Richard (d.1823)
English School
4051 *James Caulfield, 1st Earl of Charlemont,
(1728-99)*
71 x 53
Purchased, London, Sabin
Galleries, 1972

1747

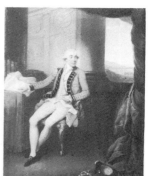
4051

Llanos-y-Valdes, Sebastian de (1602-68)
Spanish School
760 *The Virgin of the Rosary*
Signed: *D. SeBastian Dellanos y Valdes
faciebat ano de 1667*
231 x 185
Presented, Sir Hugh Lane, 1915

Attributed to **Longhi, Allessandro (1738-1813)**
Venetian School
1814 *A Lady Holding a Fan*
52.7 x 42.8
Purchased, Derry, 1967

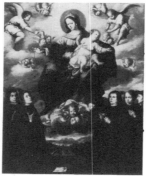
760

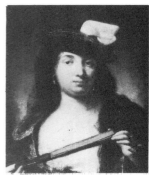
1814

Longhi, Pietro (1702-85)
Venetian School
261 *Christopher Nugent, Soldier and
Administrator, (d.1742)*
74 x 58
Purchased, London, 1886

952 *The Artist painting a Lady's Portrait*
61 x 50
Purchased, Captain R. Langton
Douglas, 1932

261

952

orme, Anthonie de (fl.1627-73)
Dutch School
 516 *An Interior of a Church*
 Dated 1650
 90 x 123, on panel
 Sir Henry Barron Bequest, 1901

 558 *An Interior of the Groote Kerk,*
 Rotterdam
 85 x 72
 Purchased, London, Patterson,
 1903

516

558

Lotto, Lorenzo (c.1480-1556)
Venetian School
 866 *A Portrait of a Nobleman*
 83 x 71
 Purchased, London, Agnew, 1925

Loutherbourg, Philip de (1740-1812)
French School
 165 *A Storm at the Entrance of a*
 Mediterranean Port
 Signed: *P.J. de Loutherbourg 1768*
 97 x 160
 Purchased, London, Mr M.
 Anthony, 1867

165

866

Lower Rhine School (mid 15th century)
 1216 *The Pietà*
 114 x 146, on panel
 Provenance unknown

Lucas, John (1807-74)
English School
 143 *Arthur Wellesley, 1st Duke of*
 Wellington, (1769-1852)
 97 x 74
 Purchased, London, Christie's, 1875

1216

143

After **Luini, Bernardino (1480-1532)**
Milanese School
 1249 *St Catherine Reading*
 74 x 64, on panel
 Purchased, Reverend P. Gorry,
 1952

Lundens, Gerrit (1622-c.83)
Amsterdam School
 1033 *A Village Merrymaking*
 85 x 110
 Milltown Gift, 1902

1249

1033

Luycks, Christiaan (1623-after 1653)
Flemish School
 529 *A Still Life*
 48 x 63, on panel
 Presented, Mr T. Ward, 1901

529

Luytens, Charles (late 19th century)
English School
 4207 *Mrs Arabella Eliza Persse Joyce*
 Signed: *C L 22 April 77*
 176 x 64
 Presented, Mrs R. Gahan, 1977

4207

Lys, Jan (c.1600-29)
German School
 981 *The Vision of St Jerome*
 112 x 90
 Purchased, Dublin, Reverend J.
 Shine, 1936

981

M

Maas, Dirck (1659-1717)
Haarlem School
147 *William, Prince of Orange, Hunting at Loo*
Signed: *D. Maas*
42 x 36
Purchased, London, Christie's, 1875

After **Mabuse (fl.1503-32)**
Flemish School
361 *The Adoration of the Magi*
65 x 48, on panel
Purchased, Shipton, Carr Sale, 1862

147

361

Machiavelli, Zenobio de (1418-79)
Florentine School
108 *The Virgin Enthroned with the Christ Child and Saints*
Signed: *OPUS ÇENOBII DEMACHIAVELIS*
133 x 150, on panel
Purchased, London, Christie's, 1861

108

204

Maes, Nicolaes (1632-93)
Amsterdam School
204 *A Portrait of a Lady*
55 x 43
Presented, Sir Henry Barron, 1878

347 *Vertumnus and Pomona*
Signed: *N. Maas, 1673*
47 x 61, on panel
Purchased, Paris, Bourgeois, 1894

Attributed to **Maes**
362 *A Portrait of a Lady*
74 x 64
Presented, Mr M. Brooks, 1867

347

362

Magnasco, Alessandro (1667-1749)
Genoese School
 678 *A Landscape with Figures*
 104 x 83
 Presented, Sir Hugh Lane, 1914

Mallary, (fl. c.1800)
French School
 4189 *Lady Pamela Fitzgerald, (d.1831), and
 her Daughter*
 130 x 100
 Presented, Mrs P. Selby-Smith,
 1976

678

4189

Copy of **Mallary** by **A. de Brie**
 568 *Lady Pamela Fitzgerald*
 Painted in 1903 from the original
 painted in 1800
 126 x 99
 Presented, Mr G. Wyndham, 1904

Mandyn, Jan (1500-c.60)
Flemish School
 1296 *Christ in Limbo*
 36 x 61, on panel
 Purchased, London, Agnew, 1954

568

1296

Mangin, Marcel (fl.1875-1914)
French School
 958 *Claude Bernard, Physiologist, (1813-78)*
 72 x 58
 Presented, Mrs W. O'Brien, 1932

Mantegna, Andrea (1431-1506)
Paduan School
 442 *Judith with the Head of Holofernes*
 46 x 36, tempera on linen
 Purchased, London, Colnaghi, 1896

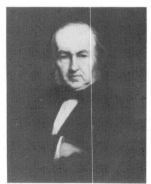
958

442

Maratti, Carlo (1625-1713)
Roman School
 81 *Jupiter and Europa*
 244 x 422
 Purchased, Rome, Mr R.
 MacPherson, 1856

After **Maratti**
 298 *Father Luke Wadding, Scholar, Founder
 of Irish College of St Isidore, Rome,
 (1588-1657)*
 66 x 51
 Purchased, Newcastle, Signor A.
 Rotondo, 1889

81

298

1703 *The Holy Family with SS. Elizabeth and John*
76 x 63
Milltown Gift, 1902

Darco 1705

1703

archand, Jean (1883-1940)
ench School
1259 *A Street in Damascus*
Signed: *J. Marchand*
92 x 73
Presented, Sir Alfred Chester Beatty, 1953

1259

1260 *A Cabaret Scene*
Signed: *J. Marchand*
73 x 92
Presented, Sir Alfred Chester Beatty, 1953

1262 *Goldfish*
Signed: *J. Marchand*
54 x 66
Presented, Sir Alfred Chester Beatty, 1953

1260

1262

1263 *A Girl in a Basket Chair*
Signed: *J. Marchand*
66 x 46
Presented, Sir Alfred Chester Beatty, 1953

1311 *Paris Roofs*
Signed: *J. Marchand*
81 x 65
Evie Hone Bequest, 1955

1263

1311

Marcke, Emile van (1827-90)
elgian School
4284CB *Cows in A River*
Signed: *E van Marcke*
73 x 92
Sir Alfred Chester Beatty Gift, 1950

Marieschi, Michele (1696-1743)
enetian School
473 *A View of the Piazza San Marco, Venice*
55 x 83
Purchased, 1902

4284CB

473

Marinot, Maurice (1882-1960)
French School

4016 *A Bather, 1934*
 Signed: *Marinot*
 33 x 24, on board
 Presented, Mme F. Marinot, 1970

4017 *A Snow Scene at Breviandes, 1951*
 33 x 41, on board
 Presented, Mme F. Marinot, 1970

4018 *A Landscape in the Forest of Othe, 1929*
 27 x 41
 Presented, Mme F. Marinot, 1970

4019 *Marcelle, 1904*
 24 x 19
 Presented, Mme F. Marinot, 1970

4020 *A Study for David, 1905*
 Signed: *M Marinot*
 27 x 22
 Presented, Mme F. Marinot, 1970

4021 *Florence in a Hat, 1924*
 41 x 33, on board
 Presented, Mme F. Marinot, 1970

4022 *Pike, 1949*
 46 x 55
 Presented, Mme F. Marinot 1970

4023 *The Avenue at Vermoise*
 Signed: *Marinot*
 46 x 55
 Presented, Mme F. Marinot, 1970

4016

4017

4018

4019

4020 4021

4022

4023

Maris, Jacob (1837-99)
Dutch School
 4256CB *A Windmill and Water*
 Signed: *J Maris*
 66 x 55
 Sir Alfred Chester Beatty Gift, 1950

Markievicz, Casimir de (fl. early 20th century)
Polish School
 1231 *The Artist's Wife, Constance, Comtesse de Markievicz, Irish Painter and Revolutionary, (1868-1927)*
 205 x 91
 Purchased, Dublin, Mr P. Egan, 1952

4256CB

1231

Marquet, Albert (1875-1947)
French School
 1822 *Porquerolles*
 Signed: *Marquet* (twice)
 Painted September 1938
 Purchased, London, Crane Kalman Gallery, 1967

Maso da San Friano (see over)

Master of the Barbara Legend (fl. c.1470-1500)
Flemish School
 360 *The Miracles of St Nicholas of Bari*
 97 x 66, on panel
 Purchased, London, Christie's, 1862

1822

360

Master of the Magdalen Legend (c.1490)
Flemish School
 1381 *The Departure of St Romold*
 58 x 42, on panel
 Purchased, London, Christie's Chatsworth Sale, 1958

Master of Marradi (fl. c.1480-1500)
Italian School
 110 *The Story of Lucretia*
 39 x 149, on panel
 Purchased, Rome, Mr R. MacPherson, 1856

110

Master of the Parrot (16th century)
Flemish School
 772 *The Holy Family*
 88 x 72, on panel
 Presented, Mr L. Hirsch, 1905

Master of the Prodigal Son (16th century)
Flemish School
 845 *Rebecca at the Well*
 61 x 93, on panel
 Presented, New York, Mr J. Quinn, 1923

1381

772

845

Maso da San Friano (1536-71)
Italian School

103 (A) *The Pietà,* (B) *St Apollonia,*
 (C) *St Peter*
 (103, 104, 1864 and 1865, formed a
 gradino)
 Pietà: 21 x 47, on panel
 Saints: 18 x 18, on panel
 Purchased, Rome, 1864

1864 104(B) 104(A) 103(C)

104 (A) *St Francis,* (B) *St Laurence,*
 (C) *St Jerome,* (D) *St Benedict*
 18 x 18, on panel
 Purchased, Rome, Signor
 Menchetti, 1865

1864 *St Bartholomew*
 18.2 x 19.6, on panel
 Purchased, London, Agnew, 1968

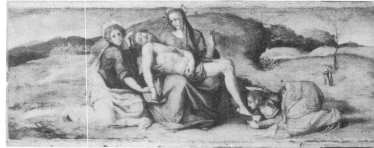

103(A)

1865 *St Zenobius*
 17.8 x 19.3, on panel
 Purchased, London, Agnew, 1968

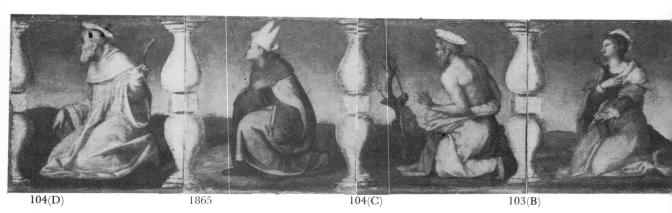

104(D) 1865 104(C) 103(B)

Master of St Augustine (c.1500)
Flemish School
823 *Scenes from the Life of St Augustine*
137 x 66, on panel
Purchased, Captain R. Langton
Douglas, 1919

Master of St Verdiana (c.1380-c.1410)
Florentine School
1201 *The Virgin and Child with Saints and Donors*
111 x 153, tempera on panel:
triptych
Presented, Sir Alfred Chester Beatty,
1951

Master of the Tired Eyes (fl. c.1540)
Flemish School
903 *A Portrait of an Old Lady*
31 x 24, on panel
Purchased, Benedict and Co., 1928

Maubert, James (d.1746)
English School
4340 *Henrietta, Duchess of Bolton*
Signed: *J. Maubert pinx 1721*
120 x 148
Purchased, London, Sotheby's,
1980

Mauve, Anton (1838-88)
Dutch School
4257CB *A Shepherd and Sheep*
Signed: *A Mauve*
33 x 41, on panel
Sir Alfred Chester Beatty Gift, 1950

Mazo, Juan del (c.1612-67)
Spanish School
659 *The Musicians*
38 x 28
Purchased, London, Christie's, 1914

Mazzolino, Ludovico (c.1480-after 1530)
Ferrarese School
666 *Pharaoh and his Host Overwhelmed in the Red Sea*
Dated 1521
125 x 157, on panel
Purchased, London, Christie's, 1914

Medley, Robert (b.1905)
English School
1125 *Trout on Grass*
Signed: *R. Medley, '30*
31 x 51
Mr M. O'Kennedy Bequest, 1945

823

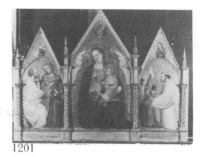
1201

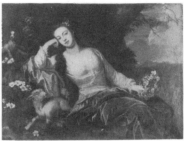
4340

903

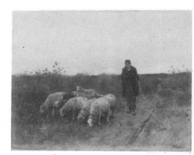
4257CB

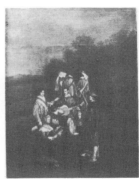
659

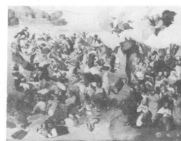
666

1125

Meissonier, Ernest (1815-91)
French School

 4258CB *A Man in Contemporary Dress*
 Signed: *E M 184 . .*
 24 x 19, on panel
 Sir Alfred Chester Beatty Gift, 1950

 4259CB *A Man in Armour Standing*
 Signed: *Meissonier 1849*
 28 x 19, on panel
 Sir Alfred Chester Beatty Gift, 1950

 4260CB *A Man Reading Seated at Table*
 Signed: *E Meissonier 1862*
 23 x 17, on panel
 Sir Alfred Chester Beatty Gift, 1950

 4261CB *Two Men, One Playing a Guitar*
 Signed: *E Meisonnier 1865*
 29 x 22, on panel
 Sir Alfred Chester Beatty Gift, 1950

 4262CB *A Man in a Red Cloak*
 Signed: *E Meissonier 1867*
 28 x 18, on panel
 Sir Alfred Chester Beatty Gift, 1950

 4263CB *A Group of Cavalry in the Snow*
 Signed: *E Meissonier 1876*
 37.5 x 47, on panel
 Sir Alfred Chester Beatty Gift, 1950

Mengs, Raphael (1728-79)
Italian School

 120 *The Transfiguration*
 (after Raphael)
 411 x 274
 Purchased, London, 1864

Mesdag, Hendrik (1831-1915)
Dutch School

 4264CB · *A Seascape*
 91 x 61
 Sir Alfred Chester Beatty Gift, 1950

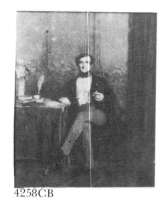

4258CB

4259CB

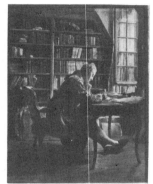

4260CB

4261CB

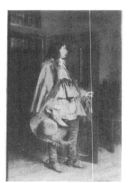

4262CB

4263CB

120

4264CB

After **Metsu, Gabriel (1629-67)**
Dutch School
 1996 *A Cavalier and Lady*
 37 x 30, on panel
 Purchased, London, 1863

Meulen, Adam van der (1632-90)
with
Bout, Peeter (1658-1719)
Flemish School
 1711 *Biblical (?) Figures in a Classical*
 Landscape
 29 x 40
 Milltown Gift, 1902

 1713 *Figures in a Classical Landscape*
 29 x 40
 Milltown Gift, 1902

Michel, Georges (1763-1843)
French School
 487 *La Plaine de St Denis*
 52 x 69
 Purchased, Dublin, Art Loan
 Exhibition, 1899

 1253 *A Landscape with Storm*
 30 x 47
 Presented, Sir Alfred Chester Beatty,
 1953

After **Michelangelo (1475-1564)**
Florentine School
 1892 *St Jerome in the Desert*
 183 x 135
 Purchased, Rome, Signor Aducci,
 1856

Michelin, Jean (1623-95)
French School
 1378 *A Peasant Family*
 44 x 54
 Purchased, London, Mrs C. Drey,
 1958

Miereveld, Michiel van (1567-1641)
Delft School
 39 *A Portrait of a Lady*
 67 x 55, on panel
 Purchased, London, Christie's, 1872

1996

1711

1713

487

1253

1892

1378

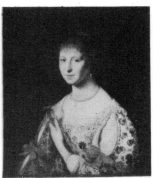

39

Attributed to **Mignard, Pierre (1612-95)**
French School
 1801 *The Way to Calvary*
 62 x 77
 Presented, Dr T. MacGreevy, 1966

1801

Milanese School (c.1520)
 1250 *The Virgin and Child*
 42 x 33, on panel
 Purchased, Dublin, Monsignor J.
 Shine, 1953

Millet, Jean-François (1814-75)
French School
 4265CB *A Country Scene with Stile*
 Signed: *J F Millet*
 54 x 64
 Sir Alfred Chester Beatty Gift, 1950

4265CB

Mogford, Thomas (1800-68)
English School
 518 *John Henry Foley, Sculptor, (1818-74)*
 39 x 30, on board
 Purchased, Guernsey, Grigg, 1901

518

Mola, Pier Francesco (1612-66)
Italian School
 1893 *St Joseph's Dream*
 192 x 159
 Purchased, Rome, Signor Aducci,
 1856

45

Molenaer, Jan (c.1605-68)
Haarlem School
 45 *Peasants Teaching a Cat and Dog to
 Dance*
 Signed: *J. Molenaer*
 53 x 71, on panel
 Purchased, London, Foster, 1873

1893

 1529 *A Village Fair*
 58 x 91, on panel
 Presented, Sir Alfred Chester Beatty,
 1954

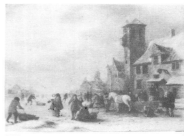

Molenaer, Klaes (fl.1651-76)
Haarlem School
 682 *A Winter Scene*
 Signed: *K. Molenaar*
 46 x 61, on panel
 Mrs Nugent Bequest, 1914

1529

682

Molyn the Elder, Pieter de (1595-1661)
Dutch School
 8 *The Stadtholder Going to the Chase*
 Signed: *P. de Molyn, fecit 1625*
 34 x 56, on panel
 Purchased, Paris, 1864

Attributed to **Monamy, Peter (c.1670-1749)**
English School
 1038 *A Seascape*
 72 x 95
 Milltown Gift, 1902

8

1038

 1039 *A Seascape*
 81 x 99
 Milltown Gift, 1902

Monet, Claude (1840-1926)
French School
 852 *A River Scene, Autumn*
 Signed: *Claude Monet*
 55 x 65
 Mr E. Martyn Bequest, 1924

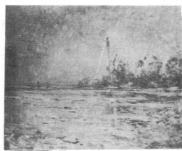

1039

852

Attributed to **Monet**
 1009 *A Landscape*
 Signed: *Claude Monet*
 55 x 65, on panel
 Purchased, Mr O. Loeser, 1938

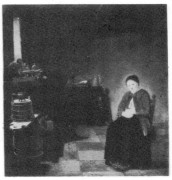

Monogrammist I.S. (17th century)
Dutch School
 247 *A Dutch Kitchen Interior*
 Dated 1642
 42 x 38, on panel
 Purchased, London, Christie's, 1885

1009

247

Montemezzano, Francesco (c.1540-after 1602)
Venetian School
 1028 *A Portrait of a Young Prince*
 23 x 76, on panel
 Miss K. Ffrench Bequest, 1939

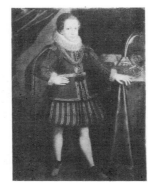

Monticelli, Adolphe (1824-86)
French School
 4298CB *A Landscape*
 46 x 55
 Sir Alfred Chester Beatty Gift, 1950

4298CB

1028

Moore, Jacob (1740-93)
English School
1876　*A City on Fire*
243 x 170
Presented, Mr E. Cane, 1862

Morales, Luis de (1509-86)
Spanish School
1　*St Jerome in the Wilderness*
62 x 45, on panel
Purchased, London, Mr H.
Waters, 1872

Moran, Edward (1829-1901)
American School
1530　*The Burning of the 'Philadelphia'*
Signed: *Edw. Moran*
67 x 55
Presented, Sir Alfred Chester
Beatty, 1954

Moreau, Luc (1882-1948)
French School
1264　*The Knock-Out*
Signed: *Luc-Albert Moreau*
90 x 70
Presented, Sir Alfred Chester
Beatty, 1953

Moreelse, Paulus (1571-before 1638)
Utrecht School
263　*A Portrait of a Child*
Signed: *Moreelse ft. 1623*
106 x 83
Purchased, London, Christie's, 1885

Attributed to **Moreelse**
640　*Hugo de Groot or Grotius, Scholar,*
Jurist and Diplomat. (1583-1645)
64 x 53, on panel
Mrs Lecky Bequest, 1912

Morisot, Berthe (1841-95)
French School
984　*Le Corsage Noir*
73 x 65
Purchased, London, Knoedler and
Co., 1936

Morland, George (1763-1804)
English School
206　*A Landscape with Figures and Cattle*
Signed: *G. Morland*
53 x 56
Purchased, London, Christie's, 1883

1876

1

1530

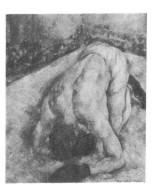

1264

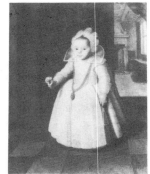

263

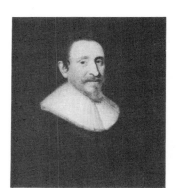

640

984

206

1710 *A Rocky Landscape with Waterfall and*
Figures
Signed: *G. Morland, 1794*
28 x 38, on panel
Milltown Gift, 1902

1710

Morland, Henry (1730-97)
English School
524 *Captain Ross*
75 x 63
Purchased, London, Agnew, 1901

524

Follower of **Moro, Antonio (c.1517-75)**
Dutch School
1690 *A Portrait of a Gentleman*
76 x 60, on panel
Milltown Gift, 1902

Moroni, Giambattista (c.1520/5-78)
Bergamese School
105 *A Widower with his Two Children*
126 x 98
Purchased, London, 1866

1690 105

Follower of **Moroni**
860 *A Portrait of a Gentleman*
119 x 101
Presented, Executors of the late Sir
Claude Phillips, 1925

Moscow School (15th century)
1844 *The Entry into Jerusalem*
33.5 x 26, tempera on panel
Purchased, Mr W.E.D. Allen, 1968

860 1844

Moscow School (early 16th century)
1850 *SS. George and Demetrius of Thessalonica*
33 x 29, tempera on panel
Purchased, Mr W.E.D. Allen, 1968

Moscow School (mid 16th century)
1846 *The Virgin's Protection, or Stole*
36 x 31.5, tempera on panel
Purchased, Mr W.E.D. Allen, 1968

1850 1846

Moscow School (late 16th century)
 1842 *The Nativity of Christ*
 30.5 x 26, tempera on panel
 Purchased, Mr W.E.D. Allen, 1968

Moscow School (early 17th century)
 1840 *The Birth of Christ*
 37 x 31.5, tempera on panel
 Purchased, Mr W.E.D. Allen, 1968

 1845 *The Birth of Christ*
 31.5 x 25, tempera on panel
 Purchased, Mr W.E.D. Allen, 1968

Moscow School (late 17th century)
 1841 *The Nativity*
 35.5 x 30.5, tempera on panel
 Purchased, Mr W.E.D. Allen, 1968

Moucheron, Frederick de (1633-86)
Amsterdam School
 52 *A Landscape*
 113 x 91
 Purchased, Durham, Archdeacon
 Thorp Sale, 1863

 337 *An Italian Landscape with Muleteers*
 40 x 33, on panel
 Purchased, London, 1863

Moyaert, Claesz (c.1592-1655)
Amsterdam School
 1175 *St John Preaching*
 44 x 65, on panel
 Mr M. de Groot Bequest, 1948

Munns, Henry (1832-98)
English School
 770 *Francis Danby, Artist, (1793-1861)*
 76 x 63
 Presented, Worcestershire, Mrs
 Pemberton, 1915

1842

1840

1845

1841

52

337

1175

770

Murillo, Bartolomé (1618-82)
Spanish School

30 *Joshua van Belle*
 Inscribed on reverse and dated
 1670
 125 x 102
 Purchased, London, 1866

1719 *The Holy Family*
 205 x 167
 Purchased, London, Agnew, 1962

1720 *St Mary Magdalen*
 152 x 104
 Purchased, Paris, Heim, 1962

Attributed to **Murillo**

33 *The Infant St John Playing with a*
 Lamb
 61 x 44
 Purchased, Paris, Besborodko Sale,
 1869

Mytens, Jan (c.1614-70)
The Hague School

62 *A Family Group: Husband and Wife, with*
 Children and Attendants
 Signed: *ao. 1661 Mytens F:*
 134 x 167
 Purchased, Paris, Marquis de la
 Rochelle, 1873

150 *A Lady Playing a Lute*
 Signed: *Mytens pincxit 1648*
 79 x 63
 Purchased, Hadzor Sale, 1889

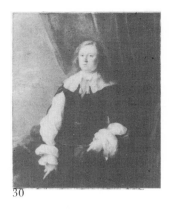
30

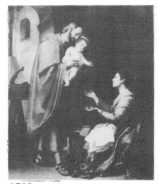
1719

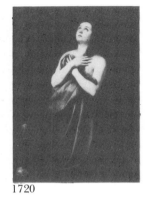
1720

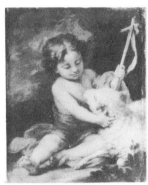
33

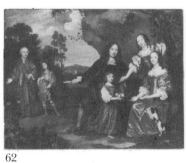
62

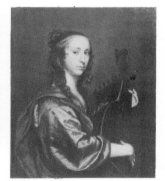
150

Nattier, Jean (1685-1766)
French School
1646 *Carlotta Frederika Sparre, Countess Fersen*
 Signed: *Nattier p.x. 1741*
 64 x 53
 Purchased, Paris, Heim, 1961

Navarrete, Juan (1526-79)
Spanish School
1721 *Abraham and the Three Angels*
 286 x 238
 Purchased, Paris, Heim, 1962

1646

1721

Neapolitan School (16th century)
339 *The Head of an Ecclesiastic*
 63 x 54, on panel
 Purchased, London, Christie's, 1891

1074

Neapolitan School (17th century)
1074 *Bacchanalian Boys*
 38 x 99
 Milltown Gift, 1902

339

1075 *Infant Satyrs at Play*
 38 x 99
 Milltown Gift, 1902

1075

Neer, Aert van der (1603/4-77)
Amsterdam School
66 *A Riverside Town on Fire*
 56 x 69
 Purchased, London, Farrer Sale,
 1866

66

School of **van der Neer**

 1992 *A Town on Fire*
 32.7 x 41.5, on panel
 Provenance unknown

1992

Neer, Hendrik van der (1634-1703)
Amsterdam School

 61 *Preparing for the Chase*
 56 x 48, on copper
 Purchased, London, Farrer Sale,
 1866

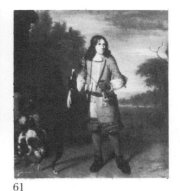

61

Neranne, A. (fl.1639-42)
Dutch School

 1678 *A Portrait of an Old Gentleman*
 47 x 36, on panel
 Milltown Gift, 1902

Neuville, Alphonse de (1835-85)
French School

 4266CB *A Soldier*
 24 x 14, on panel
 Sir Alfred Chester Beatty Gift, 1950

1678

4266CB

 4267CB *A Soldier with Other Troops in the*
 Background
 Signed: *A de Neuville 1884*
 50 x 40
 Sir Alfred Chester Beatty Gift, 1950

 4268CB *A Battle Scene, a Soldier in a Barn*
 Signed: *A de Neuville*
 72 x 91
 Sir Alfred Chester Beatty Gift, 1950

4268CB

4267CB

Newton, Gilbert (1794-1835)
English School

 210 *James Kenny, Dramatist, (1780-1849)*
 24 x 22, on panel
 Purchased, London, Mrs Cox, 1878

Newton, Nigel (b.1903)
English School

 1252 *George W. Russell (AE), Economist,*
 Painter and Poet
 36 x 30
 Presented, Executors of the late Mr
 E. Marsh, 1953

210

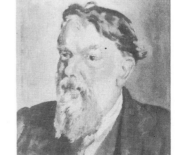

1252

4036 *Joseph Holloway*
Signed: *N.Newton 33*
34 x 31
Transferred from the National
Library, 1971

Nicolas, Frances (1400-65)
Franco-Spanish School
1013 *St Jerome Translating the Gospels*
98 x 59, tempera on panel;
137 x 95 including frame
Purchased, Captain R. Langton
Douglas, 1893

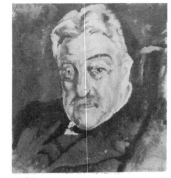

4036

1013

Novgorod School (early 15th century)
1857 *The Miracle of St George and the Dragon*
73.5 x 63, tempera on panel
Purchased, Mr W.E.D. Allen, 1968

Nuzzi, Mario (1603-73)
Roman School
262 *A Woman's Head Surrounded by Flowers*
113 x 83
Purchased, London, Christie's, 1885

1857

262

chtervelt, Jacob (1634/5-1708/10)
nsterdam School
435 *A Lady Leaning Out of a Window*
 25 x 22, on panel
 Purchased, London, Foster, 1895

641 *A Lady with a Dog*
 23 x 19, on panel
 Presented, Sir Walter Armstrong,
 1912

435

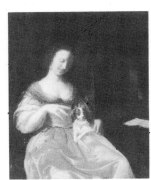
641

liverio, Alessandro (fl.1532-44)
enetian School
239 *A Portrait of a Gentleman*
 Signed: *Alesander Oliverius V*
 67 x 57, on panel
 Purchased, Hamilton Palace Sale,
 1882

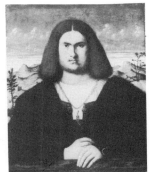
239

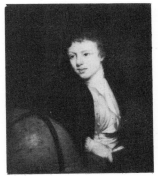
482

pie, John (1761-1807)
nglish School
482 *William Rowley, English Admiral,*
 (1690-1768)
 75 x 63
 Mrs A. Rowley Bequest, 1898

614 *James Barry, Artist, (1741-1806)*
 74 x 61
 Purchased, Dublin, Mr H. Watson,
 1910

ttributed to Opie
878 *A Presumed Portrait of Thomas Girtin,*
 Artist, (1775-1802)
 22 x 19
 Presented, Executors of the late Mr
 J. Poe, 1926

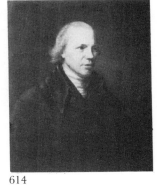
614

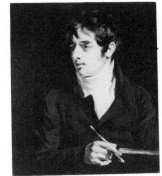
878

Orchardson, William (1832-1910)
Scottish School
 1130 *A Landscape*
 Signed: *W. Orchardson, 1885*
 41 x 61
 Sherlock Bequest, 1940

1130

1224

Orley, Barent van (c.1493-1541)
Flemish School
 1224 *The Virgin of the Prophecies*
 34 x 25, on panel
 Purchased, London, Colnaghi, 1951

643

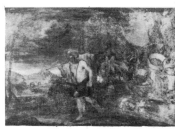
1691

Attributed to **Orley**
 643 *A Portrait of a Gentleman*
 23 x 18, on panel
 Purchased, Lippmann, 1912

Attributed to **Orrente, Pedro (1588-1644)**
Spanish School
 1691 *A Landscape with a Traveller*
 46.5 x 68
 Milltown Gift, 1902

716

1674

Os, Jan van (1744-1808)
Dutch School
 716 *Fruit and Dead Game*
 86 x 71
 Milltown Gift, 1902

 1674 *A Seascape with Boats*
 41 x 67, on panel
 Milltown Gift, 1902

32

Ostade, Adriaen van (1610-85)
Haarlem School
 32 *Boors Drinking and Singing*
 32 x 51, on panel
 Purchased, London, Christie's, 1873

P

Padovanino (1590-1650)
Venetian School
87 *Penelope Brings the Bow of Odysseus to her Suitors*
196 x 236
Purchased, Rome, Mr R. MacPherson, 1856

After **Padovanino**
1338 *The Virgin and Child*
85 x 68
Purchased, 1859

Attributed to **Pagani, Paolo (1661-1716)**
Italian School
1086 *The Death of Lucretia*
97 x 135
Milltown Gift, 1902

Paget, Henry Marriott (1856-1936)
English School
915 *John Todhunter, Poet and Physician, (1836-1916)*
Signed: *H.M. Paget*
79 x 63
Presented, Mrs Todhunter, 1928

1419 *Lilly (Susan) Yeats*
51 x 41
Presented, Mr G. Paget, 1960

Palamedesz, Anthonie (1601-73)
Delft School
36 *A Portrait of a Gentleman*
67 x 56, on panel
Purchased, Dublin, 1872

87

1338

1086

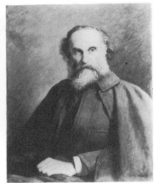
915

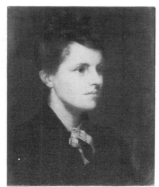
1419

36

[121]

531 *An Interior of a Guardroom*
 30 x 36, on panel
 Purchased, London, Mr A. Buttery,
 1901

Palma Giovane (1544-1628)
Venetian School
 68 *The Virgin and Child with Saints and*
 Angels
 229 x 142
 Purchased, Rome, Signor Aducci,
 1856

Palma Vecchio (1480-1528)
Venetian School
 580 *The Holy Family*
 57 x 84, on panel
 Purchased, London, Mr A. Buttery,
 1906

Palmezzano, Marco (1458-1539)
Umbro-Romagnolo School
 117 *The Virgin Enthroned with SS. John the*
 Baptist and Lucy, (1513)
 Signed: *Marchus Palmizanus Pictor*
 orolivi fecit MDXIII
 218 x 188, on panel
 Purchased, London, Christie's, 1863

 364 *St Philip Benizzi (1233-85)*
 122 x 91, on panel
 Purchased, Rome, Mr R.
 MacPherson, 1856

Panico, Antonio (c.1575-c.1620)
Italian School
 89 *Christ on the Cross, with SS. Francis*
 and Anthony of Padua
 313 x 234
 Purchased, Rome, Signor Aducci,
 1856

Panini, Giovanni Paolo (1691-1765)
Roman School
 95 *A Fête in the Piazza Navona, Rome, on*
 the Birth of a Dauphin in France, 1729
 Signed: *I.P. Panini, Roma, 1731*
 109 x 246
 Purchased, London, Christie's Lord
 Ashburton Sale, 1871

 725 *The Colosseum*
 Signed: *I.P. Panini. Romae, 1740*
 73 x 99
 Milltown Gift, 1902

531

68

580

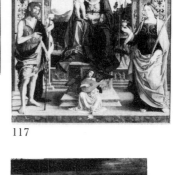
117

364

89

95

725

726 *The Forum*
 Signed: *I.P. Panini. Romae, 1740*
 73 x 99
 Milltown Gift, 1902

727 *Roman Ruins, with Fifteen Figures*
 Signed: *I.P. Panini, Romae, 1740*
 73 x 99
 Milltown Gift, 1902

726 727

728 *Roman Ruins, with Eleven Figures*
 Signed: *I.P. Panini, Romae, 1740*
 73 x 99
 Milltown Gift, 1902

Attributed to **Panini**
 1531 *Ruins with Figures*
 71 x 98
 Presented, Sir Alfred Chester
 Beatty, 1954

728 1531

Pantoja de la Cruz, Juan (1551-1608)
Spanish School
 829 *Juana de Salinas*
 105 x 82
 Purchased, Dublin, Messrs Harris
 and Sinclair, 1920

Paolo, Giovanni di (c.1403-83)
Sienese School
 1768 *The Crucifixion*
 163 x 99, tempera on panel
 216 x 170 with restored terminals
 Purchased, New York, Wildenstein,
 1964

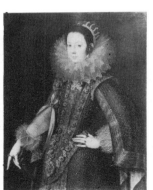 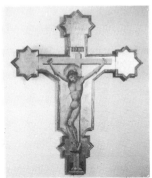

829 1768

Pape, Abraham de (c.1620-66)
Leyden School
 149 *The Repast*
 48 x 38, on panel
 Purchased, London, Christie's
 Hadzor Sale, 1889

Partridge, John (1790-1872)
English School
 140 *Thomas Wyse, Author, Parliamentarian*
 and Diplomat, (1791-1862)
 71 x 91
 Purchased, London, Christie's, 1874

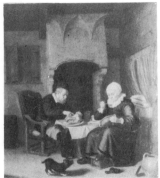

140

149

Pascucci, Francesco (fl.1787-1803)
Italian School
1918 *The Nativity*
 Signed: *Fran Pascucci 17 . .*
 273 x 180, on panel
 Purchased, Rome, Signor Aducci,
 1856

1918

4269CB

Pasini, Alberto (1826-99)
Italian School
4269CB *An Arab Soldier Seated by a Gateway*
 Signed: *A. Pasini*
 41 x 34
 Sir Alfred Chester Beatty Gift, 1950

4270CB *Horses and Buildings*
 Signed: *A. Pasini*
 17 x 22
 Sir Alfred Chester Beatty Gift, 1950

4270CB

4271CB *An Eastern Scene*
 Signed: *A. Pasini*
 22 x 16
 Sir Alfred Chester Beatty Gift, 1950

4271CB

Passeri, Giovanni (1610-79)
Roman School
993 *A Party Feasting in a Garden*
 Signed: *IO: Baptista Passarus Rom . .*
 facie
 74 x 62
 Purchased, London, Colnaghi, 1937

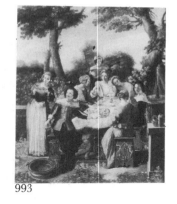

993

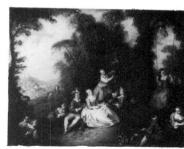

729

Pater, Jean-Baptiste (1695-1736)
French School
729 *Fête Champêtre*
 38 x 47
 Milltown Gift, 1902

730 *Fête Champêtre*
 38 x 47
 Milltown Gift, 1902

731 *A Rural Scene with Figures*
 25 x 34, on panel
 Milltown Gift, 1902

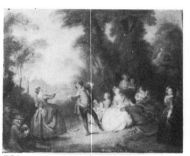

730

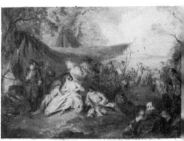

731

Peeters, Bonaventura (1614-52)
Flemish School
743 *A Seaport*
 43 x 56, on panel
 Milltown Gift, 1902

Pellegrini, Giovanni (1675-1741)
Venetian School
467 *Bathsheba*
 124 x 99
 Presented, Mr. J. Orpin, 1897

1938 *Susannah and the Elders*
 122.6 x 104.3
 Provenance unknown

Pencz, Georg (c.1500-50)
South German School
372 *A Portrait of a Young Gentleman*
 Signed with monogram and dated
 1547
 42 x 28, on panel
 Purchased, London, Christie's, 1894

1373 *Georg Vischer, Sculptor, (c.1520-92)*
 Signed with monogram and dated
 1549
 86 x 66
 Purchased, Paris, 1864

Penni, Gianfrancesco (1488-1528)
Roman School
1018 *A Portrait of a Gentleman*
 52 x 41, on panel
 Purchased, London, Christie's, 1939

Pensionante del Saraceni (fl. c.1610-20)
Italian School
1178 *St Peter Denying Christ*
 104 x 133
 Purchased, Mr F. Drey, 1948

Pereda, Antonio (c.1610-78)
Spanish School
667 *Jael and Sisera*
 124 x 133
 Presented, Sir Hugh Lane, 1914

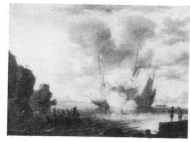
743

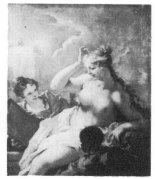
467

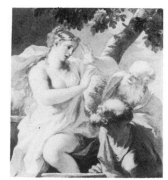
1938

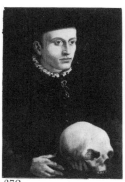
372

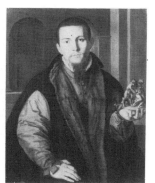
1373

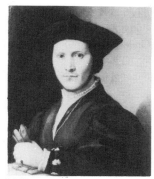
1018

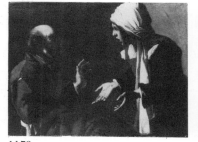
1178

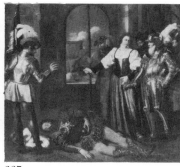
667

Attributed to **Perreal, Jean (1455-1530)**
French School
 1358 *A Portrait of a Nobleman or Prince*
 33 x 26, on panel
 Presented, Miss J. Levins, 1957

Perronneau, Jean-Baptiste (1715-83)
French School
 920 *A Portrait of a Gentleman*
 Signed: *Perronneau, 1766*
 72 x 59
 Purchased, London, Agnew, 1929

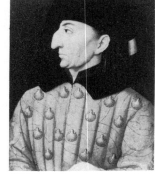

1358

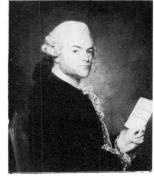

920

Perugino (1446-1523)
Umbrian School
 942 *The Pietà*
 Signed: *Petrus Perusinus Pinxit*
 169.5 x 171.5, on panel
 Purchased, London, Christie's, 1931

Studio of **Piazzetta, Giovanni-Battista (1682-1754)**
Venetian School
 656 *A Decorative Group*
 210 x 150
 Presented, Sir Hugh Lane, 1914

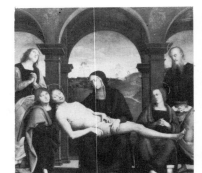

942

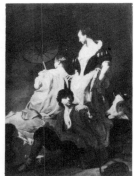

656

Picasso, Pablo (1881-1973)
Spanish School
 1314 *A Collage*
 Dated 1913 by Newspaper
 45 x 48
 Evie Hone Bequest, 1955

Pickersgill, Henry (1782-1875)
English School
 409 *Thomas Drummond, Statesman, (1797-1840)*
 89 x 70
 Purchased, Dublin, Sir Francis
 Brady, 1891

1314

409

After **Pietro da Cortona (1596-1669)**
Roman School
 4006 *Adam and Eve with Cain and Abel*
 76 x 54
 Milltown Gift, 1902

Pillement, Jean (1727-1808)
French School
 939 *A Landscape with Muleteers and Peasants*
 49 x 68, on board
 Purchased, Paris, M. J. Charpentier,
 1930

4006

939

940 *A Landscape with Weavers and Peasants*
 49 x 68, on board
 Purchased, Paris, M. J. Charpentier,
 1930

940

Piombo, Sebastiano del (1485-1547)
Venetian and Roman Schools
 783 *Cardinal Antonio Ciocchi del Monte,*
 Jurisconsult, (1461-1533)
 88 x 69
 Sir Hugh Lane Bequest, 1918

783

Pisano, Giacomo del (fl. after 1445)
Sienese School
 1202 *The Virgin and Child with SS. Mary*
 Magdalen and Peter
 Signed: *Iacomo del Pisano*
 171 x 164, on panel
 Presented, Sir Alfred Chester
 Beatty, 1951

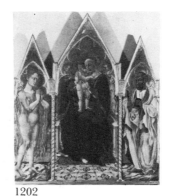

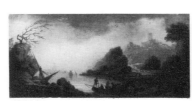

1093

1202

Piscelli, Andrea (18th century)
Italian School
 1093 *A Lake Scene with Figures*
 44 x 92
 Milltown Gift, 1902

 1094 *A Coast Scene with Shipwreck*
 Signed: *Andrea Piscelli*
 44 x 92
 Milltown Gift, 1902

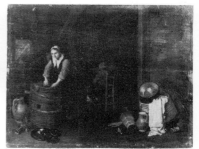

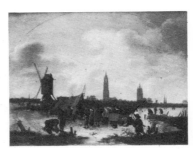

1094

9

Poel, Egbert van der (1621-64)
Dutch School
 9 *An Interior*
 38 x 48, on panel
 Purchased, London, Christie's, 1888

 22 *A Scene on the Ice: A View of Delft in the*
 Distance
 47 x 61, on panel
 Purchased, London, 1864

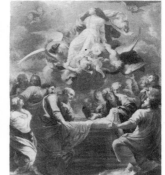

Poerson, Charles (1609-67)
French School
 1896 *The Assumption of the Virgin*
 254.5 x 211
 Purchased, Rome, Signor Aducci,
 1856

22

1896

Pompe, Gerrit (1655-1705)
Dutch School
 850 *A Seascape*
 Signed: *G. Pompe 1690*
 47 x 39, on panel
 Purchased, W. Dyer and Son, 1923

Poorter, Willem de (c.1608-48)
Leyden School
 380 *The Robing of Esther*
 38 x 30, on panel
 Presented, Sir Walter Armstrong,
 1893

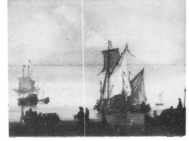
850

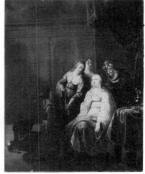
380

Pordenone, Giovanni (1483-1539)
Friuli School
 88 *A Count of Ferrara*
 107 x 94
 Purchased, Rome, Mr R.
 MacPherson, 1856

Post, Frans (c.1612-80)
Haarlem School
 847 *A View in Brazil*
 Signed: *F. Post*
 49 x 62, on panel
 Presented, Captain R. Langton
 Douglas, 1923

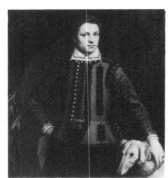
88

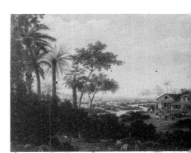
847

Pot, Hendrik (c.1585-1657)
Haarlem School
 443 *A Portrait of a Gentleman*
 Signed with monogram
 34 x 29, on panel
 Purchased, London, Christie's, 1896

Potter, Paulus (1625-54)
Amsterdam School
 56 *A Head of a White Bull*
 77 x 61
 Purchased, Whitehead Sale, 1868

443

56

Potter, Pieter (1597-1652)
Amsterdam School
 323 *Soldiers in a Guard-Room*
 Signed: *P. Potter, f.*
 26 x 32, on panel
 Presented, Mr R. Millner, 1893

 445 *A Mounted Cavalier*
 Signed: *P. Potter*
 14 x 16, on panel
 Lady Fitzgerald Bequest, 1896

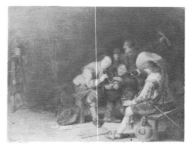
323

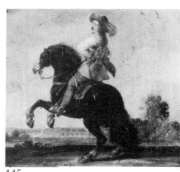
445

[**128**]

Pourbus the Younger, Frans (c.1570-1622)
Flemish School

606 *A Portrait of a Lady*
 Dated 1592
 104 x 74, on panel
 Purchased, London, Sulley and Co.,
 1910

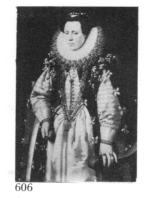

Pourbus, Pieter (c.1523-84)
Flemish School

189 *The Golden Calf*
 91 x 147, on panel
 Purchased, London, Foster, 1882

189

1223 *The Annunciation*
 104 x 81, on panel
 Purchased, London, Mr C. Marshall
 Spink, 1951

606

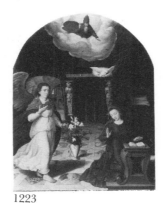

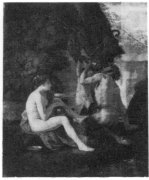
214

Poussin, Nicolas (1594-1665)
French School

214 *The Entombment*
 94 x 130
 Purchased, Hamilton Palace Sale,
 1882

1223

814 *Acis and Galatea*
 98 x 137
 Sir Hugh Lane Bequest, 1918

816 *Bacchante and Satyr*
 73 x 59
 Sir Hugh Lane Bequest, 1918

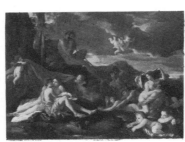
814

816

925 *The Holy Family*
 79 x 106
 Milltown Gift, 1902

Powell, John (fl.1770-85)
English School

1660 *Charles Stanhope, 5th Earl of*
 Harrington
 (after Reynolds)
 241 x 145
 Milltown Gift, 1902

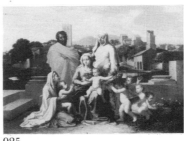
925

1660

Preti, Mattia (1613-99)
Italian School
 366 *The Decollation of St John*
 135 x 97
 Purchased, Rome, 1864

681

Prins, Johannes Huibert (1757-1806)
The Hague School
 681 *The Weigh-House on the Buttermarket,*
 Amsterdam
 32 x 43, on panel
 Presented, Sarah Purser, 1914

366

Pritchett, Edward (fl.1828-64)
English School
 446 *A View of the Piazzetta, Venice*
 Signed: *E. Pritchett*
 35 x 30
 Lady Fitzgerald Bequest, 1896

 447 *A View of the Piazza San Marco, Venice*
 Signed: *E. Pritchett*
 35 x 30
 Lady Fitzgerald Bequest, 1896

446

447

 1186 *A View of the Riva Schiavone, Venice*
 Signed: *E. Pritchett*
 46 x 36
 Presented, Mrs J. Mann, 1950

 1187 *The Salute from the Piazzetta, Venice*
 Signed: *E. Pritchett*
 46 x 36
 Presented, Mrs J. Mann, 1950

1186

1187

Procaccini, Giulio (1570-1625)
Italian School
 1820 *The Apotheosis of St Charles Borromeo,*
 with the Archangel Michael
 384 x 250
 Purchased, Rome, Signor Aducci,
 1856

Procter, Dod (1891-1972)
English School
 1294 *A Girl Asleep*
 Signed: *Dod Procter*
 61 x 58
 Presented, Sir Alfred Chester
 Beatty, 1954

1820

1294

Procter, Ernest (1886-1935)
English School
 1268 *The Devil's Disc*
 Signed: *Ernest Procter*
 30 x 46
 Presented, Sir Alfred Chester
 Beatty, 1953

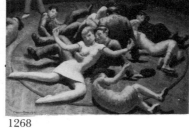

1268

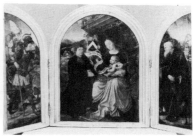

4315

Attributed to **Provost, Jan (c.1465-1529)**
Flemish School
 4315 *The Virgin and Child Enthroned with*
 Donor in a Landscape (centre) with
 St George (left) and St Eustace (right)
 Triptych: centre 94 x 66, wings
 94 x 26 (each), on panel
 Purchased, Co. Kildare, Reverend
 F. Crosby, 1979

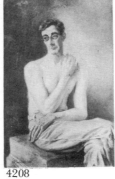

Purtscher, Alfens (b.1885)
Austrian School
 4208 *Lennox Robinson*
 Signed: *A Purtscher 1933*
 114 x 68, on panel
 Presented, Dr Michael Scott, 1977

4208

Q

Quadal, Martin (1736-1808)
Austrian School
1763 *James Caulfield, 1st Earl of Charlemont*
 Signed: *M.F. Quadal pinc 1790*
 99 x 74
 Purchased, New York, Norton
 Galleries, 1964

1899 *Deers' Heads*
 74 x 90
 Transferred from the National
 Museum, 1968

Quillard, Pierre (1701-33)
French School
564 *Wedding Festivities*
 49 x 66
 Purchased with a donation from the
 Friends of the National Collections,
 1904

Quinkhard, Jan (1688-1772)
Amsterdam School
238 *A Portrait of a Lady*
 92 x 71
 Presented, Viscount Powerscourt,
 1878

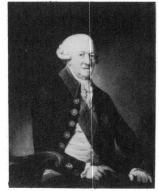

1763

1899

564

238

R

Raeburn, Henry (1756-1823)
Scottish School

430 *General Sir James Steuart-Denham,*
(1744-1839)
124 x 98
Purchased, London, Lawrie and
Co., 1895

523 *David Stewart Erskine, 11th Earl of*
Buchan, (1742-1829)
75 x 68
Purchased, London, Agnew, 1901

4037 *Matthew Fortescue of Stephenstown,*
(1791-1845)
127 x 102
Purchased, Co. Louth, Mr D.
Hamilton, 1971

Raffaëlli, Jean François (1850-1924)
French School

1257 *The Alexander III Bridge, Paris*
Signed: *J. F. Raffaëlli*
73 x 93
Presented, Sir Alfred Chester
Beatty, 1953

Ramsay, Allan (1713-84)
Scottish School

570 *Sir John Tyrell, Bart.*
Signed: *A. Ramsay pinxt 1752*
124 x 99
On indefinite loan from the
Commissioners of Public Works

Flemish (?) copy of Raphael (1483-1520)
Umbrian and Roman Schools

171 *SS. Peter and John at the Beautiful Gate*
376 x 541, tempera on paper
Presented, Mrs Nicolay

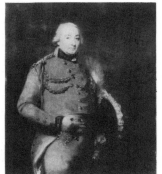

430

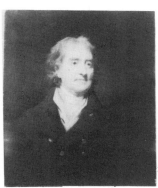

523

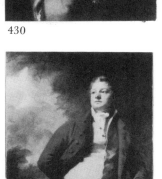

1257

4037

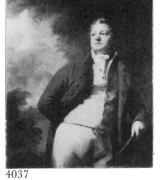

171

570

[133]

172 *Elymas the Sorceror Struck with Blindness*
 376 x 452, tempera on paper
 Presented, Mrs Nicolay

172

After **Raphael**
 1041 *The Head of St Peter*
 48 x 48
 Milltown Gift, 1902

 1267 *Raphael*
 40 x 31, on panel
 Presented, Sir Alfred Chester
 Beatty, 1953

1041

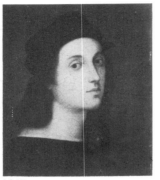

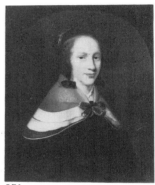

Ravesteyn, Jan van (c.1570-1657)
The Hague School
 571 *A Portrait of a Girl*
 69 x 56, on panel
 Lady Ferguson Bequest, 1905

1267 571

Reinagle, Philip (1749-1833)
English School
 676 *Mrs Congreve with her Children*
 Signed: *Php. Reinagle 1782*
 80.5 x 106
 Presented, Mr E. Turton, 1914

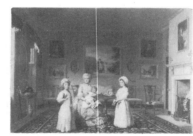

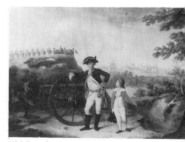

 1213 *Captain William Congreve, with his Son*
 81 x 106
 Purchased, Mrs A. Brown, 1951

676 1213

Rembrandt (1606-69)
Leyden and Amsterdam Schools
 48 *The Head of an Old Gentleman*
 Signed: *Rembrandt f.*
 62 x 46, on panel
 Purchased, London, Christie's, 1871

 215 *Rest on the Flight into Egypt*
 Signed: *Rembrandt f. 1647*
 34 x 48, on panel
 Purchased, London, Christie's, 1883

215

48

319 *Louis van der Linden*
 66 x 52, on panel
 Purchased, Brussels, Dansaert, 1890

808 *A Portrait of a Young Lady, (c.1633)*
 72 x 62
 Sir Hugh Lane Bequest, 1918

319

808

chool of **Rembrandt**
 439 *Playing 'La Main Chaude'*
 20 x 26, on panel
 Purchased, London, Mr H.
 Buttery, 1896

ollower of **Rembrandt**
 1677 *A Portrait of an Old Gentleman*
 44 x 34, on panel
 Milltown Gift, 1902

439

1677

ttributed to **Reni, Guido (1575-1642)**
olognese School
 1334 *St Jerome*
 74 x 62
 Purchased, London, Mr W.
 Anthony, 1864

1334

118

fter **Reni**
 118 *A Group of Saints Interceding for the City*
 of Bologna
 61 x 36, on copper
 Purchased, London, Christie's, 1889

 1065 *The Sewing Virgin*
 142 x 111
 Milltown Gift, 1902

 1239 *St Catherine*
 59 x 47
 Purchased, Reverend P. Gorry, 1952

1065

1239

1695 *The Crucifixion of St Peter*
62 x 49
Milltown Gift, 1902

1908 *The Rape of Europa*
182 x 238
Milltown Gift, 1902

1695

1908

Renieri, Niccolo (c.1590-1667)
Italo-French School

363 *St Mary Magdalen*
120.5 x 99
Purchased, London, Christie's
G. Perkins Sale, 1890

901

Reynolds, Frank (fl.1850-95)
English School

901 *A Group of Irish Coursing Enthusiasts*
Signed: *F. Reynolds, 1869*
107 x 233.5
Presented, Dr Willoughby, 1928

363

Reynolds, Joshua (1723-92)
English School

137 *Captain George Edgcumbe, afterwards 1st
Earl of Mount-Edgcumbe, (1720-95)*
76 x 63
Purchased, London, Mr M.
Anthony, 1867

216 *Charles Coote, 1st Earl of Bellamont,
(1738-1800)*
245 x 162
Purchased, London, Christie's, 1875

217 *Robert Henley, 2nd Earl of Northington,
(1747-86)*
126 x 100
Purchased, London, H. Graves and
Co., 1884

733 *George Grenville, Marquess of Buckingham,
and his Family*
241 x 183
Milltown Gift, 1902

137

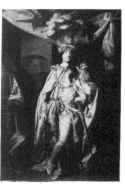

216

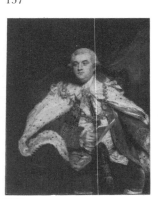

217

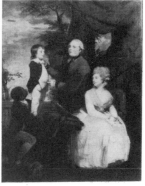

733

[136]

734 *A Parody on Raphael's School of Athens,*
(1751)
Inscribed on reverse: *Joseph Henry*
(Reynolds pinxt) Romae 1751
97 x 135
Milltown Gift, 1902

735 *A Caricature: Sir William Lowther and*
Joseph Leeson Senior, (1751)
76 x 53
Milltown Gift, 1902

736 *A Caricature: Lord Bruce, Mr Ward,*
Joseph Leeson Junior and Joseph Henry,
(1751)
63 x 49
Milltown Gift, 1902

737 *A Caricature: Sir Thomas Kennedy, Lord*
Charlemont, Mr Ward and Mr Phelps,
(1751)
63 x 52
Milltown Gift, 1902

790 *Mrs F. Fortescue*
75 x 62
Sir Hugh Lane Bequest, 1918

1734 *Richard Malone, Lord Sunderlin*
76 x 63
Purchased, Mr A. Cottingham, 1963

4064 *Emily Mary, Duchess of Leinster, (1740-*
1832)
31 x 24
Presented, The Misses Broadstreet,
before 1930

4326 *Rt Hon. John Hely Hutchinson, (d.1794),*
Provost of Trinity College, Dublin
128.8 x 99.1
Purchased, London, Christie's, 1979

734

735

736

737

790

1734

4064

4326

After **Reynolds**
1165 *Denis Daly*
76 x 63
Purchased, Mr W. Brimage, 1948

Ribalta, Francesco de (1565-1628)
Spanish School
34 *A Legend of St Anthony*
164 x 125
Purchased, Leeds, Mr J. Whatman,
1868

1165

34

Ribera, Jusepe de (1589-1652)
Spanish School
219 *St Procopius*
Signed: *Jusepe de Ribera Espanol f.*
1630
90 x 70
Purchased, C. Fitzgerald, 4th Duke
of Leinster, 1879

Attributed to **Ribera**
12 *St Joseph*
76 x 64
Purchased, Shipton, Carr Sale, 1862

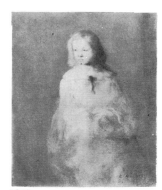
219

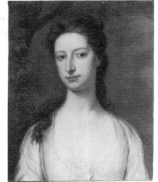
12

1377 *St Sebastian*
179 x 131
Presented, Mr B. Watkins, 1854

Ribot, Augustin (1823-91)
French School
1217 *A Portrait of a Young Girl*
Signed: *Ribot*
27 x 22
Presented, Sir Alfred Chester Beatty,
1951

1377

1217

Ricci, Sebastiano (1659-1734)
Venetian School
1099 *Archimedes and Hiero of Syracuse*
104 x 84
Purchased, Dr A. Scharf, 1942

Attributed to **Richardson, Jonathan (1665-1745)**
English School
642 *Kitty Clive, (Catherine Rafter), Actress,*
(1711-85)
70 x 44
Purchased, London, Christie's, 1910

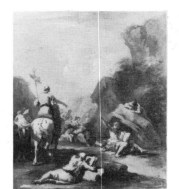
1099

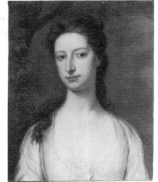
642

Richmond, George (1809-96)
English School
 316 *The Reverend Charles Foster, Protestant*
 Divine and Scholar, (1790-1871)
 89 x 71
 Presented, the artist, 1890

Rigaud, Hyacinthe (1659-1743)
French School
 1729 *Philippe Roettiers*
 81 x 64
 Purchased, Dublin, Mr W.
 Marshall, 1962

Attributed to **Rigaud**
 4166 *Patrick Sarsfield, Earl of Lucan, (d.1693)*
 55 x 47
 Purchased, Dublin, Malahide Castle
 Sale, 1976

After **Rigaud**
 1138 *Richard Talbot, Duke of Tyrconnell,*
 (1630-91)
 130 x 103
 Purchased, Dowager Viscountess
 Gormanston, 1947

Riley, John (1646-91)
English School
 4162 *Sir William Talbot of Carton, (1643-*
 1724)
 77 x 64
 Purchased, Dublin, Malahide Castle
 Sale, 1976

Attributed to **Riley**
 4163 *A Portrait of a Gentleman, possibly*
 Patrick Sarsfield, (d.1693)
 124 x 102
 Purchased, Dublin, Malahide Castle
 Sale, 1976

Riminaldi, Orazio (1593-1630)
Roman School
 1235 *Love Triumphant*
 178 x 122
 Purchased, Rome, Mr R.
 MacPherson, 1856

[handwritten: Now Giudo Rucillo Minotti 4-27-85]

Rimini School (15th century)
 1022 *The Crucifixion and (below) 'Noli Me*
 Tangere'
 25 x 15, tempera on panel, (painted
 surface), 30 x 21 (including frame)
 Purchased, Captain R. Langton
 Douglas, 1940

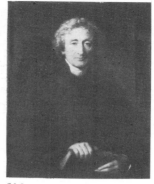

316

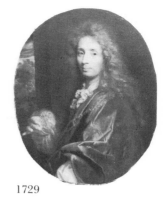

1729

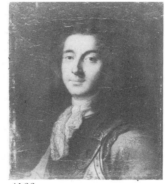

4166

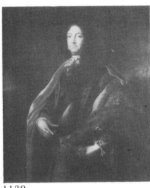

1138

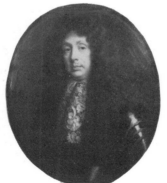

4162

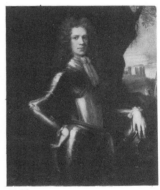

4163

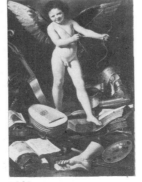

1235

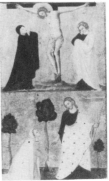

1022

Robert, Hubert (1733-1808)
French School
896 *The Apotheosis of Jean Jacques Rousseau*
 Signed: *H. Robert, 1794*
 62 x 81
 Purchased, Paris, M. J. Charpentier,
 1927

896

220

Roberts, David (1796-1864)
Scottish School
220 *The Temple of Neptune at Paestum*
 Signed: *David Roberts, R.A. 1856*
 90 x 127
 Purchased, London, H. Graves and
 Co., 1877

Romagna School (c.1500)
4090 *The Death of Procris*
 61 x 69, on panel
 Purchased, Dublin, Mrs A.
 Murnaghan, 1974

4090

1911

Roman School (17th century)
1911 *The Holy Family with Several Monks*
 279 x 200
 Purchased, Rome, Signor Aducci,
 1856

Romano, Antoniazzo (fl.1460-1508)
Roman School
827 *A Votive Picture: the Virgin Invoking God
 with the Healing of Pope Leo I* (lower
 border)
 111 x 77, on panel
 Purchased, Captain R. Langton
 Douglas, 1920

After **Romano, Giulio (1499-1546)**
Italian School
1940 *The Holy Family with SS. John and
 Elizabeth*
 140 x 110
 Purchased, Rome, Mr R.
 MacPherson, 1856

827

1940

Romeyn, Willem (c.1624-c.94)
Haarlem School
345 *A Landscape with Cattle*
 36 x 32, on panel
 Purchased, London, Christie's, 1893

Romney, George (1734-1802)
English School
381 *Titania, Puck and the Changeling, (1793)*
 104 x 135
 Purchased, London, Christie's, 1894

345

381

674 *The Artist's Wife*
55 x 44
Presented, Sir Hugh Lane, 1914

786 *A Portrait of a Lady*
126 x 100
Sir Hugh Lane Bequest, 1918

789 *Mrs Edward Taylor (née Janverin)*
77 x 62
Sir Hugh Lane Bequest, 1918

1164 *Mary Tighe, Poet, (1747-91)*
77 x 63
Purchased, Mr W. Brumage, 1948

Attributed to **Romney**

1151 *Elizabeth Gunning, Duchess of Argyll*
76 x 63
Presented, Mrs E. Banon, 1947

Rosa, Salvator (1615-73)
Neapolitan School

96 *A Landscape with the Baptism in the Jordan*
147 x 221
Purchased, Rome, Mr R. MacPherson, 1856

Attributed to **Rosa**

738 *A Mountain Landscape*
74 x 97
Milltown Gift, 1902

739 *A Mountain Landscape*
74 x 97
Milltown Gift, 1902

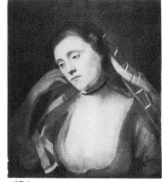
674

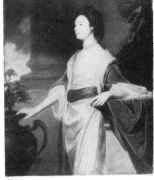
786

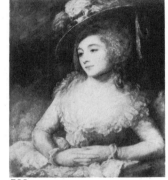
789

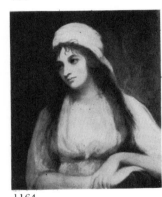
1164

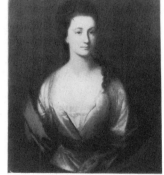
1151

96

738

739

Rosa da Tivoli (1657-1706)
German School
- 1664 *A Landscape with Cattle*
 100 x 137
 Milltown Gift, 1902

- 1666 *A Landscape with Cattle*
 100 x 137
 Milltown Gift, 1902

1664

1666

Roslin, Alexander (1718-93)
Swedish School
- 1824 *Le Marquis de Vaudreuil, (1724-1802)*
 212 x 155
 Purchased, Paris, Heim, 1967

Ross, Christina (1843-1906)
English School
- 573 *Robinetta*
 (after Reynolds)
 76 x 64
 Presented, Colonel Y. Burges, 1905

1824

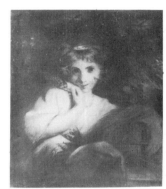
573

Rossum, Johan van (fl.1654-73)
South Holland School
- 623 *Adriaen van Ostade*
 76 x 63
 Purchased, London, Mr A. Buttery,
 1912

Rottenhammer, Johann (1564-1625)
German School
- 1067 *The Adoration of the Magi*
 55 x 44, on copper
 Milltown Gift, 1902

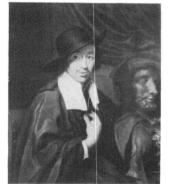
623

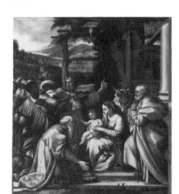
1067

Rouland, Orlando (1871-1945)
American School
- 1269 *Mrs Gorges (née Kelly)*
 122 x 82
 Presented, Dublin, Mrs Gorges,
 1953

Rousseau, Théodore (1812-67)
French School
- 4272CB *A Country Scene*
 Signed: *Th. Rousseau*
 17 x 22, on panel
 Sir Alfred Chester Beatty Gift, 1950

1269

4272CB

4273CB *A Country Scene with a Child*
Signed: *Th. Rousseau*
35 x 46, on panel
Sir Alfred Chester Beatty Gift, 1950

4274CB *Les Coteaux de Melun*
Signed: *Th. Rousseau*
43 x 66, on panel
Sir Alfred Chester Beatty Gift, 1950

4273CB

4274CB

Roworth, Edward (20th century)
South African School

968 *Senator Colonel Maurice Moore*
Signed: *Edward Roworth, 1921*
127 x 103
Presented, Senator Colonel Moore,
1934

Roymerswaele, Marinus van (1497-1567)
Flemish School

1115 *The Calling of St Matthew*
83 x 109, on panel
Purchased, London, Mrs M. Drey,
1944

968

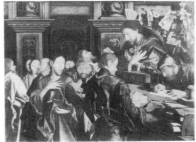
1115

Rubens, Peter Paul (1577-1640)
Flemish School

51 *St Francis of Assisi*
183 x 91
Purchased, London, Christie's, 1871

60 *The Annunciation*
183 x 152, on panel
Purchased, Paris, M. M. François,
1868

427 *St Dominic*
183 x 91
Purchased, F. Hervey, 3rd Marquess
of Bristol, 1895

Rubens
with
Brueghel, Jan 'Velvet' (1568-1625)

513 *Christ in the House of Martha and Mary*
64 x 61, on panel
Sir Henry Barron Bequest, 1901

51

60

427

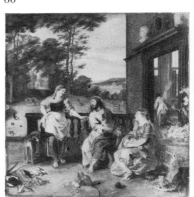
513

After **Rubens**

154 *The Judgement of Paris*
152 x 200
Presented, Mr W. Browne, 1864

1198 *The Hippopotamus Hunt*
24 x 33, on panel
Purchased, Mrs D. May, 1951

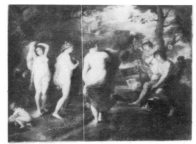

154

1198

1705 *A Classical Scene*
61 x 93, on panel
Milltown Gift, 1902

1941 *The Descent from the Cross*
147 x 111
Presented, Mr T. Berry, 1859

1991 *The Judgement of Paris*
136 x 184
Milltown Gift, 1902

1705

1941

School of **Rubens**

1064 *The Triumph of Bacchus*
122 x 168
Milltown Gift, 1902

1991

1064

Ruisdael, Jacob van (1628/9-82)
Haarlem School

37 *A Wooded Landscape*
Signed: *Ruysdael, 1678*
61 x 76
Purchased, London, Christie's, 1873

916 *A Stormy Sea*
90 x 124
Purchased, Miss H. Campbell, 1929

37

916

Ruisdael

with

Keyser, Thomas de (1596/7-1667)

Amsterdam School

287 *A Wooded Scene near The Hague with Burgmeester Graeff, his Wife, Two Sons and Servants*
Signed with monograms
117 x 171
Purchased, London, Christie's, 1887

287

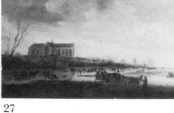

27

Ruisdael, Salomon van (c.1600-70)

Haarlem School

27 *A View of the Town of Alkmaar, Winter*
Signed: *S.R.*
51 x 88
Purchased, Paris, Marquis de la Rochelle, 1873

507 *The Halt*
Signed with monogram and dated 1667
99 x 153
Sir Henry Barron Bequest, 1901

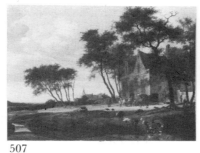

507

1854

Russian School (18th century)

1854 *A Four Leafed Folding Metal Icon*
17 x 39, enamel on brass
Purchased, Mr W.E.D. Allen, 1968

Ryckaert, David (1612-61)

Flemish School

340 *Dinner at a Farmhouse*
Signed: *D. Ryckaert*
62 x 79, on panel
Presented, Mr R. Clouston, 1855

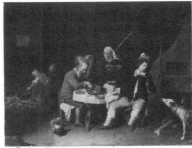

340

S

Sabatte, Fernand (1874-1940)
French School
1238 *The Arras Belfry, (1916)*
Signed: *Fernand Sabatte, Arras, 1917*
114 x 176
Major T. Fuge Bequest, 1952

1238

449

Saftleven, Cornelis (1607-81)
Utrecht School
449 *An Interior, with Tobit and the Angel*
51 x 65, on panel
Presented, Sir Walter Armstrong,
1896

Salmeggia, Enea (c.1558-1626)
Bergamese School
78 *St John the Evangelist*
173 x 76
Purchased, Durham, Archdeacon
Thorp Sale, 1863

80 *St Bartholomew*
173 x 76
Purchased, Durham, Archdeacon
Thorp Sale, 1863

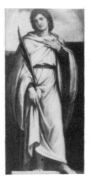

78

80

Salzburg School (c.1425)
979 *The Crucifixion*
25 x 24, on panel
Purchased, Vienna, Gallerie St
Lucas, 1936

Santa Croce, Girolamo da (fl.1503-56)
Venetian School
846 *The Pietà*
97 x 107
Purchased, London, Sacred Heart
Convent, Hammersmith, 1923

979

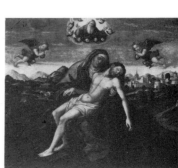

846

argent, John (1856-1925)
Anglo-American School
817 *Woodrow Wilson, (1856-1924)*
 Signed: *John S. Sargent, 1917*
 153 x 109
 Sir Hugh Lane Bequest, 1918

921 *The Bead Stringers of Venice*
 Signed: *John S. Sargent*
 56 x 82
 V. Lawless, Lord Cloncurry
 Bequest, 1929

921

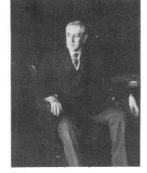

817

assoferrato (1605-85)
Roman School
83 *Mater Dolorosa*
 48 x 37
 Purchased, Paris, Besborodko Sale,
 1869

93 *The Virgin and Child*
 (after Raphael's Foligno Virgin)
 104 x 75
 Purchased, Milan, Bastini, 1873

83

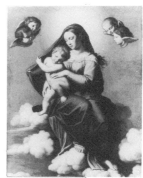

93

chalcken, Godfried (1643-1706)
Leyden School
476 *A Scene from Cervantes' La Gitanilla*
 Signed: *G. Schalcken*
 42 x 30, on panel
 Purchased, London, Colnaghi, 1898

chäuffelin, Hans (1515-c.82)
Swiss School
16 *The Arrival of the Holy Family in*
 Bethlehem
 42 x 33, on panel
 Purchased, London, 1863

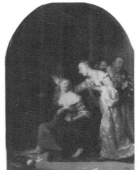

476

16

cheffer, Ary (1795-1858)
Franco-Dutch School
1226 *The Arrest of Charlotte Corday*
 45 x 56
 Presented, Mr S. Philipson, 1951

chiffer, Matthias (1744-1827)
Austrian School
1886 *An Interior with a Fancy Dress Ball in*
 Progress
 62 x 77.5, on panel
 Milltown Gift, 1902

1226

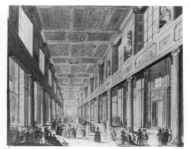

1886

1887 *An Interior with a Banquet Taking Place*
 61.5 x 71.2, on panel
 Milltown Gift, 1902

1887

4275CB·

Schreyer, Christian (1828-99)
German School
4275CB *Arab Horsemen*
 57 x 69
 Sir Alfred Chester Beatty Gift, 1950

4276CB *Eastern Soldiers with a Horse Drinking*
 Signed: *Ad. Schreyer*
 24 x 46, on panel
 Sir Alfred Chester Beatty Gift, 1950

4276CB

997

Scorel, Jan van (1495-1562)
Flemish School
997 *The Adoration of the Magi*
 93 x 75, on panel
 Purchased, Dr O. Wertheimer, 1937

1391

1391 reverse

Follower of Scorel
1391 *The Crucifixion of St Peter;*
 Portraits of Donors on reverse
 (wing of a triptych)
 164 x 56, on panel
 Purchased, Dublin, J. Adam and
 Son, 1958

1392 *The Crucifixion of St Andrew;*
 Portraits of Donors on reverse
 (wing of a triptych)
 164 x 56, on panel
 Purchased, Dublin, J. Adam and
 Son, 1958

1392

1392 reverse

.cott, Samuel (1710-72)
.nglish School
 677 *A View of Old Westminster Bridge,*
 (c.1765)
 89.5 x 119
 Purchased, London, Christie's, 1914

.ottish School (16th century)
 4139 *James Crichton, (1560-82)*
 75 x 62
 Purchased, Dublin, Malahide Castle
 Sale, 1976

677

4139

.gar, William (fl.1585-1633)
.nglish School
 283 *Robert Devereux, Earl of Essex*
 Dated 1590
 112 x 86, on panel
 Purchased, London, H. Graves and
 Co., 1886

.eisenegger, Jacob (1505-67)
.ustrian School
 902 *A Portrait of a Lady, presumed to be a*
 Daughter of the Emperor Charles V
 37 x 31, on panel
 Purchased, Benedict and Co., 1928

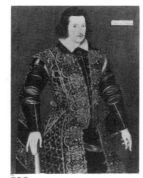

283

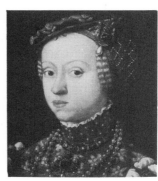

902

.udio of Sesto, Cesare da (1477-1523)
.ilanese School
 365 *The Virgin and Child with St John*
 100 x 74, on panel
 Purchased, Rome, Mr R.
 MacPherson, 1856

.erwin, John (1751-90)
.nglish School
 396 *The Installation Banquet of the Knights of*
 St Patrick, (1783), sketch
 63 x 76
 Presented, C. Fitzgerald, 4th Duke
 of Leinster, before 1898

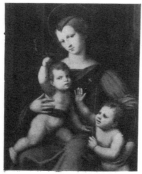

365

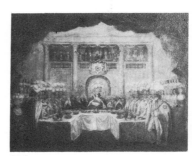

396

.iberechts, Jan (1627-1703)
.lemish School
 900 *A Landscape with Figures*
 Signed: *J. Siberechts en Anvers 1671*
 73 x 86
 Purchased, Captain R. Langton
 Douglas, 1928

.idaner, Henri Le (1862-1939)
.rench School
 1244 *Versailles: Cour d'Honneur*
 Signed: *Le Sidaner*
 65 x 81
 Presented, Sir Alfred Chester
 Beatty, 1952

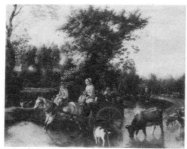

900

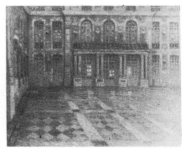

1244

Sienese Copyist (late 19th century)

 1203 A Fragment of Fresco
 43 x 55
 Presented, Sir Alfred Chester
 Beatty, 1951

 1204 A Fragment of Fresco
 34 x 46
 Presented, Sir Alfred Chester
 Beatty, 1951

 1205 A Fragment of Fresco
 36 x 45
 Presented, Sir Alfred Chester
 Beatty, 1951

 1206 A Fragment of Fresco
 27 x 18
 Presented, Sir Alfred Chester
 Beatty, 1951

 1207 A Fragment of Fresco
 30 x 36
 Presented, Sir Alfred Chester
 Beatty, 1951

Signorelli, Luca (c.1441-1523)
Umbro-Florentine School

 266 *Christ in the House of Simon the Pharisee*
 26 x 90, on panel
 Purchased, London, Christie's
 Somervell Sale, 1887

After **Signorelli**

 522 *A Portrait of a Gentleman*
 27 x 22
 Presented, Mr H. Pfungst, 1901

Studio of **Signorelli**

 494 *The Flagellation*
 77 x 64
 Presented, Sir Frederick Burton,
 1900

1203

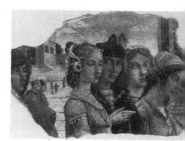

1204

1205

1206

266

1207

522

494

Silvestro dei Gherarducci (d.1399)
Florentine School
- 841 *The Assumption of St Mary Magdalen*
 145 x 71, tempera on panel
 Purchased, Captain R. Langton
 Douglas, 1922

Simpson, John (1782-1847)
English School
- 318 *William IV, King of England,*
 (1765-1837)
 89 x 69
 Presented, Mr H. Doyle, 1886

Sisley, Alfred (1839-99)
French School
- 966 *The Canal du Loing at St Mammes*
 Signed: *Sisley '88*
 38.2 x 56
 Purchased, Paris, Durand-Ruel,
 1934

Slingeland, Pieter van (1640-91)
Leyden School
- 267 *A Portrait of a Lady*
 Signed: *P.V. Slingeland*
 36 x 29, on panel
 Purchased, London, Christie's
 Nieuwenhuys Sale, 1886

- 268 *Christopher Dimpfel*
 Dated 1674
 23 x 16, on panel
 Purchased, Bennett, 1878

Smibert, John (1688-1751)
Anglo-American School
- 465 *George Berkeley, Philosopher, (1685-*
 1733), with his Wife and Friends
 61 x 70
 Purchased, London, Mr J. Mossop,
 1897

Smith, George (1714-76)
English School
- 383 *A Landscape*
 51 x 63
 Presented, Mr G. Coffey, 1894

- 740 *A Landscape*
 99 x 125
 Milltown Gift, 1902

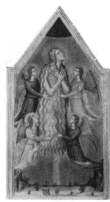
841

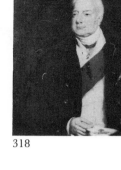
318

966

267

268

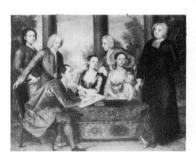
465

383

740

Smith, Matthew (1879-1959)
English School
1123 *A Cornish Landscape*
 Signed: *M.S.*
 50 x 60
 Mr M. Kennedy Bequest, 1945

Snyders, Frans (1579-1657)
Flemish School
25 *A Boar Hunt*
 127 x 208
 Purchased, London, 1864

811 *A Breakfast*
 91 x 155
 Sir Hugh Lane Bequest, 1918

Soest, Gerard van (c.1600-81)
Westphalian or Dutch School
605 *A Self-Portrait*
 74 x 61
 Purchased, London, Shepherd Bros.,
 1909

Sogliani, Giovanni (1492-1544)
Florentine School
4089 *The Virgin and Child with St John the
 Baptist*
 64 x 56, on panel
 Purchased, Dublin, Mrs A.
 Murnaghan, 1974

Soldenhoff, Alexander van (1882-1951)
Swiss School
826 *La Fuite*
 46 x 37
 Presented, Mr M. O'Connor, 1919

Solemackers, Frans (1635-after 1665)
Flemish School
225 *Cattle in a Hilly Landscape*
 Signed: *J.F. Solemackers*
 38 x 33
 Purchased, Brussels, Vicomte B. du
 Bus de Gisignies, 1882

Solimena, Francesco (1657-1747)
Neapolitan School
626 *Winter: a Man Warming his Hands*
 62 x 107, on panel
 Presented, Mr A. Buttery, 1911

1123

25

811

605

4089

826

225

626

1107 *St Simplicius*
127 x 86
Presented, Mrs C. Meredith, 1943

Somerville (19th century)
Scottish School

1952 *A Landscape with a Cottage*
23 x 22.8, on panel
Provenance unknown

1107

1952

Sorgh, Hendrijk (c.1611-70)
Haarlem School

269 *The Breakfast*
Signed: *H.M. Sorgh, 1656*
32 x 25, on panel
Purchased, London, Christie's, 1886

269

212

Spagna, Giovanni Lo (c.1450-1528)
Italian School

212 *The Virgin and Child with SS. Francis and Catherine of Siena*
47 x 35, on panel
Purchased, Hamilton Palace Sale, 1882

Spanish School (c.1520)

354 *The Martyrdom of a Saint: the Holy Family* on reverse
142 x 132, oil and tempera on panel
354, 4025 and 4026 form part of one large picture, still incomplete
Purchased, Dublin, Mr J. O'Hea, 1894

354

354 reverse

4025 *A Landscape with Canopy and Legionary at Base; the Virgin and Other Figures* on reverse
151 x 130, oil and tempera on panel
Purchased, Dublin, Richmond Hospital, 1971

4025

4025 reverse

[153]

4026　　*A Landscape with an Angel Bearing the Crown of Martydom; St James Driving out a Devil* on reverse
151 x 130, oil and tempera on panel
Purchased, Dublin, Richmond Hospital, 1971

4026

4026 reverse

1026

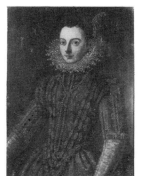

1027

Spanish School (17th century)

1026　　*Christ as a Man of Sorrows*
34 x 24, on panel
Miss K. Ffrench Bequest, 1939

1027　　*A Portrait of a Gentleman in Armour*
56 x 45, laid on panel
Miss K. Ffrench Bequest, 1939

1689　　*The Emperor Charles V*
(copy)
37 x 32, on panel
Milltown Gift, 1902

1689

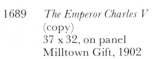

1704

1704　　*A Portrait of a Lady*
84 x 65
Milltown Gift, 1902

1894　　*A Female Saint Writing*
167.5 x 111
Purchased, Madrid, 1865

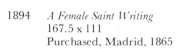

1987　　*St Isidore*
141 x 100
Provenance unknown

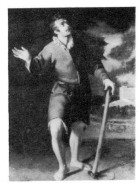

1894

1987

[154]

pilsbury, Maria (Mrs Taylor) (1777-1823)
English School
 567 *Mrs Henry Grattan, (née Henrietta Fitzgerald), (d.1838)*
43 x 34
Presented, Mrs Lecky, 1904

Stanfield, William (1793-1867)
English School
 1891 *A Seascape with a Port*
61.5 x 51.5
Sherlock Bequest, 1941

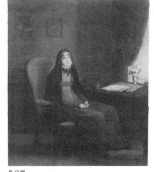

567

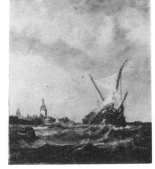

1891

Steen, Jan (1626-79)
Haarlem School
 226 *The Village School*
109 x 81
Purchased, London, Colnaghi, 1879

 227 *A Woman Mending a Sock*
31 x 27, on panel
Purchased, Messrs Robinson and Fisher, 1875

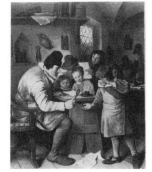

226

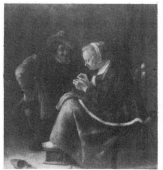

227

Steenwyck the Younger, Hendrik van (1580-c.1649)
Dutch School
 10 *An Interior of a Church, with Figures*
dia. 17, on metal
Purchased, London, Christie's, 1888

Steer, Philip (1860-1942)
English School
 1258 *A Woodland Scene*
Signed: *P. W. Steer*
26 x 35, on panel
Presented, Sir Alfred Chester Beatty, 1953

 4277CB *A Country Scene with Pond*
Signed: *P. W. Steer*
61 x 81
Sir Alfred Chester Beatty Gift, 1950

Stern, Ignaz (1698-1746)
German School
 1739 *Cupid Chastised*
175 x 126
Purchased, Rome, Signor Aducci, 1856

10

1258

4277CB

1739

Stevens, Alfred (1823-1906)
Belgian School
 1104 *A Portrait of a Young Lady*
 Signed: *A. Stevens, 1868*
 55 x 39, on panel
 Purchased, London, A. Reid and
 Lefevre Ltd, 1943

 4278CB *A Lady in a Black Dress*
 Signed: *A Stevens*
 61 x 41
 Sir Alfred Chester Beatty Gift, 1950

1104 4278CB

Stevenson, Robert (1847-1900)
Scottish School
 1417 *A Village Church*
 14 x 20
 Mr R. Best Bequest, 1959

Stomer, Matthias (c.1600-after 1650)
Italo-Dutch School
 425 *The Betrayal of Christ*
 201 x 279
 Presented, Sir George Donaldson,
 1894

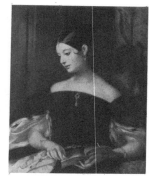 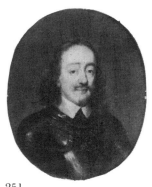

1417 425

Stone, Frank (1800-59)
English School
 1044 *Lady Harrington*
 92 x 72
 Milltown Gift, 1902

Stone, Henry (1616-53)
English School
 251 *Charles I, King of England, (1600-49)*
 24 x 19, on panel
 Purchased, London, Christie's, 1886

1044 251

Stoop, Dirck (c.1610-86)
Utrecht School
 285 *A Hunting Party*
 58 x 71, on panel
 Purchased, London, Christie's, 1889

Storck, Abraham (c.1630-1710)
Amsterdam School
 228 *The Entrance to a Dutch Harbour*
 Signed: *A. Storck fecit*
 75 x 89
 Presented, H. Dawson-Damer, 3rd
 Earl of Portarlington, 1878

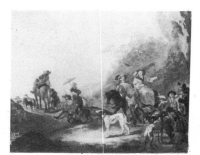

285 228

Stothard, Thomas (1755-1834)
English School
536 *War*
 57 x 65
 Purchased, London, Agnew, 1902

536

6

Strigel, Bernhard (c.1460-1528)
German School
6 *Count Montfort and Roetenfels*
 Dated 1523
 30 x 20, on panel
 Purchased, Paris, Comte de
 Choiseul Sale, 1866

Strij, Jacob van (1756-1815)
Dordrecht School
344 *A Landscape with Cattle*
 74 x 58, on panel
 Purchased, Mrs Algie, 1894

344

781

Strozzi, Bernardo (1581-1644)
Genoese School
781 *A Portrait of a Gentleman*
 138 x 107
 Sir Hugh Lane Bequest, 1918

856 *Spring and Summer*
 72 x 128
 Purchased, Dublin, Messrs Harris
 and Sinclair, 1924

856

562

Stuart, Gilbert (1755-1828)
American School
562 *William Burton-Conyngham, (d.1796)*
 91 x 71
 Purchased, London, Christie's, 1904

680 *A Portrait of a Lady*
 70 x 58
 Purchased, London, Mr R. Thomas,
 1914

822 *Edmond Sexton, Viscount Pery,*
 (1719-1806)
 76 x 63
 Presented, Miss F. Knox, 1919

680

822

907 *John Shaw, Captain, United States Navy,*
 (1773-1823)
 89 x 68
 Presented, Mr S. Scott, 1928

1133 *John Beresford, M.P., (1738-1805)*
 76 x 63
 Purchased, London, Christie's, 1946

1163 *Henry Grattan, Statesman, (1746-1820)*
 75 x 63
 Purchased, Mr W. Brimage, 1948

1743 *Sir John Sinclair*
 76 x 63
 Presented, Mr A. Brady, 1865

1829 *Bernard Shaw, (b. c.1739/40)*
 76.3 x 63.2
 Purchased, London, Agnew, 1967

After Stuart

499 *Robert Shaw, M.P., (1749-96)* ·
 74 x 61
 Purchased, Mr L. Deane, 1900

867 *John Foster, Lord Oriel, (1740-1828)*
 88 x 70
 Purchased, London, Mr R. Thomas,
 1925

Stubbs, George (1724-1806)
English School
 906 *Sportsmen at Rest*
 62 x 82
 Sir Hugh Lane Bequest, 1918

907

1133

1163

1743

1829

499

906

867

Styrian School (15th century)

 978 *The Apostles Bidding Farewell*
 Dated 1494 on reverse
 55 x 125, on panel
 Purchased, Vienna, Gallerie St
 Lucas, 1936

978

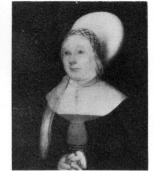

Suess von Kulmbach, Hans (c.1480-1522)
South German School

 371 *A Portrait of a Lady*
 Dated 1515
 40.7 x 31, on panel
 Purchased, London, Christie's, 1892

371

Swagers, Frans (1756-1836)
Franco-Dutch School

 448 *A Landscape*
 Signed: *Swagers*
 25 x 20
 Lady Fitzgerald Bequest, 1896

448 741

Swanevelt, Herman van (c.1600-55)
Dutch School

 741 *Rebecca at the Well*
 140 x 127
 Milltown Gift, 1902

Swinton, James (1816-88)
English School

 331 *Lady Claude Hamilton*
 222 x 128
 Presented, the artist's widow, 1893

331

T

School of Tassi (c.1580-1644)
Roman School

- 1751 *A Coast Scene*
 39 x 62
 Milltown Gift, 1902

- 1752 *A Coast Scene*
 39 x 62
 Milltown Gift, 1902

1751

1752

Tchelitchev, Pavel (1898-1957)
Russian School

- 4088 *James Joyce, (1882-1941)*
 81 x 54
 Purchased, Paris, M. G. Martin du
 Nord, 1974

Tempel, Abraham van den (1622-72)
Dutch School

- 1062 *A Portrait of a Lady*
 88 x 72
 Sherlock Bequest, 1940

4088

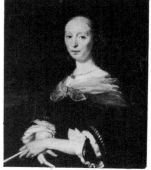

1062

Teniers the Younger, David (1610-90)
Flemish School

- 23 *'Hustle Cap'*
 Signed: *D. Teniers fecit*
 23 x 33, on panel
 Purchased, London, Phillips, 1864

- 288 *A Portrait of a Gentleman*
 (after Titian)
 17 x 12, on panel
 Purchased, London, Christie's
 Blenheim Palace Sale, 1886

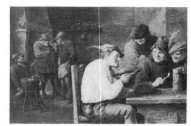

23

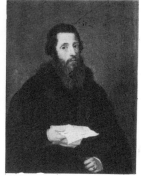

288

289 *A Portrait of a Gentleman*
 (after Titian)
 17 x 12, on panel
 Purchased, London, Christie's
 Blenheim Palace Sale, 1886

290 *Salvator Mundi*
 (after Palma Giovane)
 23 x 17, on panel
 Purchased, London, Christie's, 1886

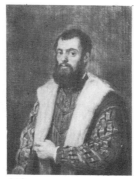 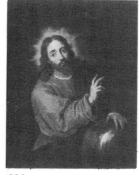

289 290

334 *An Interior of a Farmhouse*
 49 x 66, on panel
 Purchased, London, Christie's, 1893

390 *The Three Philosophers*
 (after Giorgione)
 21 x 30, on panel
 Purchased, London, Mr C.
 Donaldson, 1894

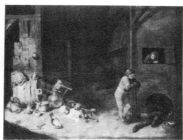 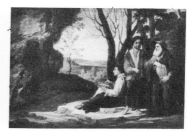

334 390

441 *The Resurrection*
 (after Bassano)
 30 x 20, on panel
 Purchased, Drogheda, Mrs
 Chadwick, 1896

1655 *The Ecstasy of St Francis*
 37 x 48
 Milltown Gift, 1902

1805 *Peasants*
 (after Brouwer)
 30 x 23, on panel
 Dr B. Somerville-Large Bequest,
 1966

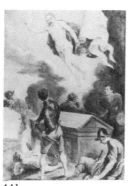 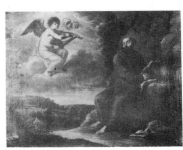

441 1655

Teniers the Younger
with
Uden, Lucas van (1595-1672)
Flemish School

41 *Peasants Merrymaking*
 Signed: *Lucas van Uden* and with
 Teniers monogram
 107 x 208
 Purchased, London, Christie's, 1874

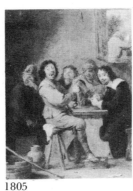

1805 41

Thaulow, Frits (1847-1906)
Norwegian School
 4279CB *A Bridge over a River in a Town*
 Signed: *Frits Thaulow*
 47 x 57
 Sir Alfred Chester Beatty Gift, 1950

4279CB

Thulden, Theodor van (1606-69)
Flemish School
 2 *A Vision of St Ignatius, sketch*
 63 x 56, on panel
 Purchased, Shipton, Carr Sale, 1862

2

 752 *The Charity of St Elizabeth of Hungary*
 56 x 40, on panel
 Milltown Gift, 1902

Tiepolo, Giovanni Battista (1696-1770)
Venetian School
 353 *An Allegory of the Incarnation*
 58 x 44, on paper, laid on canvas
 Purchased, London, Christie's, 1891

752

353

 1111 *Christ in the House of Simon the Pharisee*
 (after Veronese)
 132 x 159
 Purchased, Mr F. Drey, London,
 1943

Tilson, Henry (1659-95)
English School
 4158 *Sir Gilbert Talbot, (d.1723)*
 72 x 62
 Purchased, Dublin, Malahide Castle
 Sale, 1976

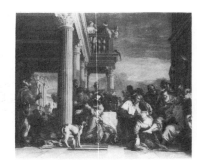

1111

4158

Tintoretto, Domenico (1560-1635)
Venetian School
 1384 *Venice, Queen of the Adriatic, Crowning*
 the Lion of St Mark
 136 x 106
 Purchased, London, Agnew, 1959

Tintoretto, Jacopo (1518-94)
Venetian School
 82 *A Portrait of a Gentleman*
 53 x 43
 Purchased, Paris, Mr O. Mundler,
 1867

1384

82

90 *A Venetian Gentleman*
 Dated 1555
 116 x 80
 Purchased, London, Christie's, 1866

121 *A Portrait of a Lady*
 112 x 85
 Purchased, Florence, Mr F.
 Murray, 1880

768 *Diana and Endymion*
 138 x 202
 Sir Hugh Lane Bequest, 1918

1122 *A Venetian Senator*
 84 x 60
 Purchased, London, Mr F. Drey,
 1945

1793 *The Miracle of the Loaves and Fishes*
 320 x 556
 Presented, Mr and Mrs E. McGuire,
 1966

90

121

768

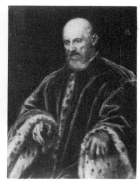

1122

1793

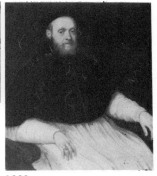

1333

Tintoretto, Marietta (1560-90)
Venetian School
 1333 *A Cardinal*
 102 x 84
 Purchased, Mr B. Watkins, 1860

Tissot, James (1836-1902)
French School
 1105 *A View of Greenwich Pier*
 63 x 91
 Purchased, London, Leicester
 Galleries, 1943

 1275 *A Scene from the Childhood of Christ
 in Egypt*
 Signed: *J.L. Tissot*
 69 x 85
 Presented, Sir Alfred Chester
 Beatty, 1954

1105

1275

4280CB *A Seated Lady with Children Kneeling at*
 a Shrine
 Signed: *J T*
 50 x 75
 Sir Alfred Chester Beatty Gift, 1950

4280CB

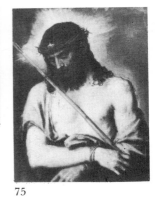

75

Titian (c.1480-1576)
Venetian School

 75 *Ecce Homo*
 72 x 55
 Purchased, London, Christie's, 1885

 84 *The Supper at Emmaus*
 163 x 200
 Purchased, Paris, Demidoff Sale,
 1870

 782 *Baldassare Castiglione, Diplomat and*
 Author, (c.1478-1529)
 124 x 97
 Sir Hugh Lane Bequest, 1918

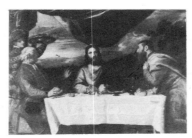

84

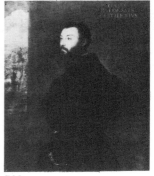

782

After Titian

 1029 *A Portrait of a Gentleman in Black*
 101 x 82
 Miss K. Ffrench Bequest, 1939

 1030 *Charles V on Horseback*
 77 x 71
 Miss K. Ffrench Bequest, 1939

1029

1030

 1037 *Venus Reclining*
 121 x 173
 Milltown Gift, 1902

 1942 *St Peter Martyr*
 194 x 146
 Purchased, Mr T. Walker, 1859

1037

1942

ollower of **Titian**
1324 *A Portrait of a Gentleman*
74 x 61
Mr T. Hutton Bequest, 1865

ommaso (15th century)
lorentine School
lso attributed to
orenzo di Credi (1459?-1537)
1140 *The Virgin and Child*
dia. 85, on panel
Purchased, London, Mr F. Drey,
1947

onks, Henry (1862-1937)
nglish School
985 *La Toilette*
Signed: *H. Tonks, 1936*
83 x 65
Presented, Friends of the National
Collections, 1936

opolski, Feliks (b.1907)
olish School
4066 *Maurice Collins, (d.1973)*
Signed: *Feliks Topolski 49*
36 x 64
Presented, Miss L. Collins, 1973

orrance, James (1859-1916)
cottish School
833 *Jessie at the Farm*
51 x 38
Presented, Executors of the late Mrs
Torrance, 1921

osini, Michele (1503-77)
lorentine School
77 *Venus and Cupid*
135 x 193, on panel
Presented, Viscount Powerscourt,
1864

roost, Cornelis (1697-1750)
msterdam School
497 *The Dilettanti: Jeronimus Tonneman
and his Son Jeronimus*
Signed: *C. Troost, 1736*
66 x 56, on panel
Purchased, London, Mr S.
Richards, 1900

ttributed to **Troppa, Girolamo (c.1636-c.1706)**
alian School
1669 *The Adoration of the Shepherds*
Signed with monogram *TR*
155 x 122
Milltown Gift, 1902

1324·

1140

985

4066

833

77

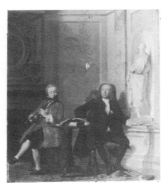
497

1669

Troy, François de (1645-1730)
French School
 723 *Bacchus and Ariadne*
 76 x 94
 Milltown Gift, 1902

Troyon, Constant (1810-65)
French School
 1254 *A Landscape with a Ferry*
 Signed: *C. Troyon*
 76 x 95
 Presented, Sir Alfred Chester
 Beatty, 1953

 4281CB *Cattle and Sheep*
 Signed: *C Troyon*
 34 x 48, on panel
 Sir Alfred Chester Beatty Gift, 1950

 4282CB *Cows and Sheep with a Herd*
 Signed: *C Troyon 1855*
 100 x 149
 Sir Alfred Chester Beatty Gift, 1950

 4283CB *Two Children with a Harbour and Houses*
 in the Background
 Signed: *C Troyon*
 61 x 51
 Sir Alfred Chester Beatty Gift, 1950

Turchi, Alessandro (1578-1649)
Italian School
 1031 *A Portrait of an Elderly Gentleman*
 85 x 68
 Milltown Gift, 1902

 1653 *An Angel Leading Lot and his Daughters*
 69 x 96
 Milltown Gift, 1902

Turner de Lond, William (fl.1767-1826)
English School
 1148 *George IV, King of England, Entering*
 Dublin, (1821)
 171 x 279
 Presented, Friends of the National
 Collections, 1947

723

1254

4281CB

4282CB

4283CB

1031

1653

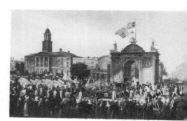
1148

U

Uccello (1397-1475)
Florentine School

603 *The Virgin and Child, (c.1440)*
58 x 37, tempera on panel
Purchased, Captain R. Langton
Douglas, 1909

Ugolino da Siena (fl. c.1295-c.1339)
Sienese School

1112 *The Prophet Isaiah*
39 x 25, tempera on panel
Purchased, London, Mr F. Drey,
1943

Unknown Artist (19th century)
4299CB *A Mother and Child*
Signed indistinctly
60 x 70
Sir Alfred Chester Beatty Gift, 1950

Unknown Artists (c.1900)
1243 *The Virgin Enthroned*
(after Gentile da Fabriano, c.1365-
1427)
166 x 55, tempera on panel
Presented, Sir Alfred Chester
Beatty, 1952

1953 *A View in a Park with the Seated Figure
of a Lady*
21 x 32
Provenance unknown

Upper Rhine School (early 16th century)
1305 *The Arrest of Christ*
201 x 277, on panel
Provenance unknown

603

1112

4299CB

1243

1953

1305

Utrecht, Adriaen van (1599-1652)
Flemish School

742　*A Still Life*
97 x 126, on panel
Milltown Gift, 1902

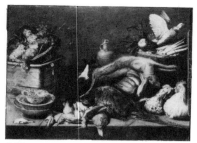

742

V

Vadder, Lodewijk de (1605-55)
Flemish School

271 *A Landscape with Figures and Cattle*
30 x 36
Purchased, London, Christie's, 1886

272 *A Landscape with Horseman and Peasants*
30 x 36
Purchased, London, Christie's, 1886

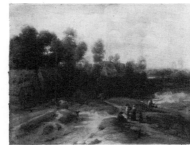
271

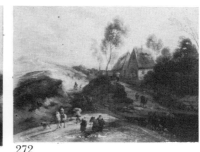
272

Valckenburg, Dirck (1675-1721)
Amsterdam School

625 *Poultry in a Landscape*
Signed: *D. Valckenburg, pinxit*
132 x 99
Mr W. Gumbleton Bequest, 1911

Vallain, Nanine (fl.1788-1810)
French School

669 *A Presumed Portrait of Letitia
Bonaparte, (née Ramolino, Madame
Mère), (1750-1836)*
86 x 68
Presented, Sir Hugh Lane, 1914

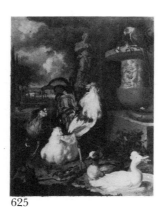
625

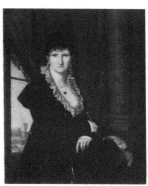
669

Vallejo, Francisco (late 18th century)
Mexican School

1798 *St John and the Lamb*
Signed: *Francus Anttus Vallejo fac. ao.
1770*
64.2 x 48.2, on copper
Purchased, Dublin, Mr J. Gorry,
1966

Circle of **Vasari, Giorgio (1511-74)**
Florentine School

1248 *The Virgin and Child with SS. Elizabeth
and John*
86 x 76, on panel
Purchased, Reverend P. Gorry,
1952

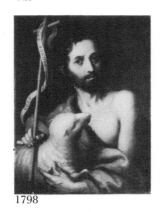
1798

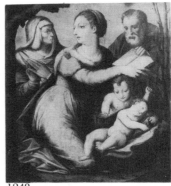
1248

Vecchia, Pietro della (1605-78)
Venetian School
94 *Timoclea Brought before Alexander*
 188 x 238
 Purchased, Rome, Mr R.
 MacPherson 1856

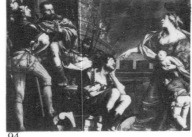

94

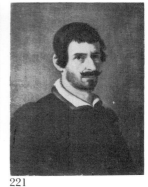

221

Attributed to **Velazquez (1599-1660)**
Spanish School
221 *A Portrait of a Gentleman*
 56 x 43
 Presented, Sir Richard Wallace,
 1879

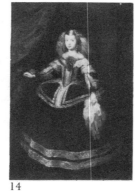

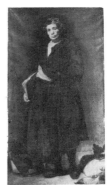

14 1118

After **Velazquez**
14 *The Infanta Maria Teresa, later Queen*
 of France
 87 x 59
 Purchased, Madrid, 1864

1118 *Aesop*
 149 x 122
 Mrs Lecky Bequest, 1912

1119 *The Infanta Margharita*
 149 x 122
 Mrs Lecky Bequest, 1912

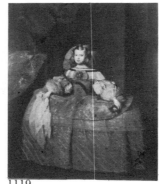

1119 1901

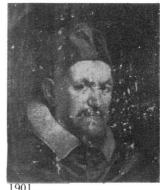

1901 *Innocent X*
 49.5 x 41
 Purchased, Rome, Mr R.
 MacPherson, 1856

1930 *Torquato Tasso*
 59 x 46
 Purchased, Shipton, Carr Sale, 1862

1984 *The Infante Balthasar Carlos*
 149 x 122
 Mrs Lecky Bequest, 1912

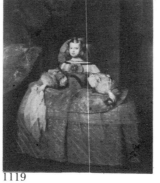

1930

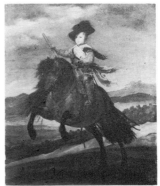

1984

1985　　*Menippus*
　　　　149 x 122
　　　　Mrs Lecky Bequest, 1912

1986　　*The Drinkers*
　　　　166 x 225
　　　　Mrs Lecky Bequest, 1912

1986

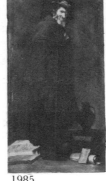

1985

elde the Elder, Willem van de (1611-93)
ith
elde the Younger, Willem van de (1633-1707)
msterdam School
　　1741　　*The Landing of William of Orange in
　　　　　　England, (1689)*
　　　　　　103 x 156
　　　　　　Purchased, London, 1857

1741

58

tudio of **Velde the Elder**
　　58　　*A Review of the Fleet by Charles II after
　　　　　the Battle of Solebay*
　　　　　118 x 187
　　　　　Purchased, London, Christie's, 1874

fter **Velde the Elder**
　　1742　　*The Embarkation of Charles II, (1660)*
　　　　　　34 x 60
　　　　　　Purchased, London, Christie's, 1880

　　1888　　*An Evening on the Ice*
　　　　　　36 x 44, on panel
　　　　　　Purchased, London, 1863

1742

1888

tudio of **Velde the Younger**
　　276　　*A Man-of-War Firing a Salute*
　　　　　239 x 157
　　　　　Purchased, London, Christie's, 1887

After **Velde the Younger**
　　1964　　*An English Sixth-Rate Ship Becalmed at
　　　　　　Anchor*
　　　　　　43 x 55
　　　　　　Sherlock Bequest, 1940

276

1964

Veli, Benedetto (1564-1639)
Florentine School
 1638 *The Mystic Marriage of St Catherine*
 Signed: *Beneds Veli ping. Flor. 1610*
 187 x 127
 Purchased, Miss K. Farrelly
 (legatee of Monsignor J. Shine),
 1961

Venetian School (c.1400)
 1302 *Christ on the Cross*, (fragment)
 35 x 26, tempera on panel
 Purchased, Dublin, Monsignor J.
 Shine, 1955

 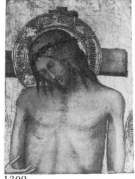

1638 1302

Venetian School (c.1500)
 480 *The Virgin and Child, Enthroned between*
 Angels
 136 x 202, on panel
 Purchased, London, 1866

Venetian School (16th century)
 4001 *The Last Supper*
 343 x 531
 Presented, Viscount Powerscourt,
 1857

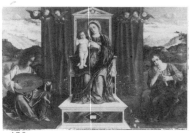 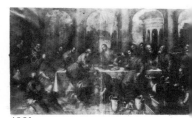

 4001

480

Venetian School (late 16th century)
 815 *Pluto and Proserpine*
 58 x 75
 Sir Hugh Lane Bequest, 1918

Vermeulen, Andries (1763-1814)
Dutch School
 432 *A Winter Scene*
 33 x 44, on panel
 Purchased, London, Christie's, 1889

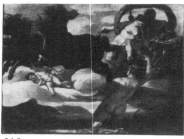 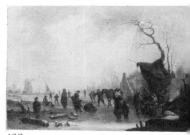

815 432

Vernet, Joseph (1714-89)
French School
 1045 *The Death of Regulus*
 (after Salvator Rosa)
 150 x 220
 Milltown Gift, 1902

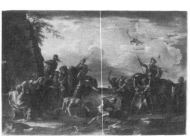 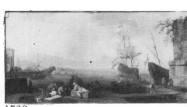

 1732

Attributed to **Vernet**
 1732 *A Coastal Scene*
 50 x 98
 Milltown Gift, 1902

1045

1733 *A Coastal Scene*
50 x 98
Milltown Gift, 1902

1750 *An Italian Landscape*
96 x 133
Presented, Mr T. Berry, 1862

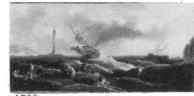
1733

1750

Veronese (1528-88)
Venetian School

115 *SS. Philip and James the Less*
204 x 156
Purchased, London, Christie's, 1889

657 *A Portrait of a Lady*
112 x 90
Presented, Sir Hugh Lane, 1914

115

657

After **Veronese**

744 *Europa and the Bull*
38 x 56
Milltown Gift, 1902

1085 *The Daughter of the Doge Mocenigo*
126.5 x 105
Presented, Mr E. Duckett, 1942

1962 *Christ at the Supper in the House of Levi*
301 x 136
Purchased, Durham, Archdeacon
Thorp Sale, 1863

744

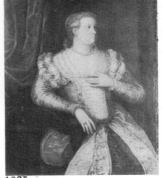
1085

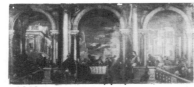
1962

School of **Verrocchio, Andrea del** (1435-88)
Florentine School

519 *The Virgin and Child with Angels*
dia. 85, on panel
Purchased, London, Mr A. Buttery,
1901

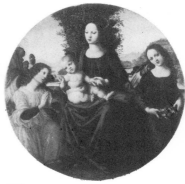
519

Veyrassat, Jules (1828-93)
French School
4285CB *Loading the Corn*
 Signed: *J Veyrassat*
 27 x 35, on panel
 Sir Alfred Chester Beatty Gift, 1950

Victoors, Jan (1620-c.76)
Amsterdam School
879 *The Levite and his Concubine, Gibeah*
 104 x 137
 Purchased, London, Mr A. Buttery,
 1926

Vierpyl, Jan (fl.1697-1723)
Flemish School
1025 *A Presumed Portrait of Francis
 Hutcheson, Philosopher, (1694-1746),
 with his Daughter*
 Signed: *J.C. Vierpyl, 1721*
 91 x 82
 Purchased, London, Leggatt Bros.,
 1940

After **Vignon, Claude (c.1590-1670)**
French School
1912 *A Bishop*
 134.5 x 100
 Purchased, Dublin, Marchioness of
 Ormonde Sale, 1860

Viola, Giovanni (1570-1662)
Italian School
1977 *Jacob and the Angel*
 169 x 213
 Purchased, Rome, Signor Aducci,
 1856

Vlaminck, Maurice de (1876-1958)
French School
1877 *Flowers*
 Signed: *Vlaminck*
 41 x 33
 Purchased, Dublin, Dawson
 Gallery, 1968

Vliet, Hendrijk van der (1611-75)
Delft School
530 *An Interior of the Nieuwe Kerk at Delft*
 59 x 46, on panel
 Purchased, Mr H. Cunliffe, 1901

Vollon, Antoine (1833-1900)
French School
4286CB *Marseilles Harbour with a Lighthouse*
 Signed: *Vollon*
 47 x 56
 Sir Alfred Chester Beatty Gift, 1950

4285CB

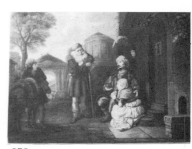

879

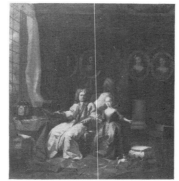

1025

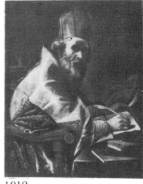

1912

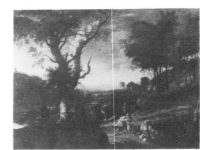

1977

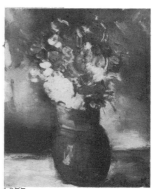

1877

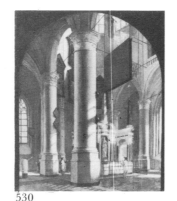

530

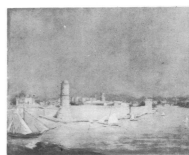

4286CB

Vouet, Simon (1590-1649)
French School
 1982 *The Four Seasons (?)*
 dia. 113
 Purchased, London, Mr N. Orgel,
 1970

Vries, Roelof de (c.1631-after 1681)
Dutch School
 972 *A Landscape with Figures*
 Signed: *R. Vries, 16 . . .*
 61 x 84, on panel
 Presented, Friends of the National
 Collections, 1934

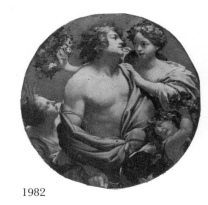

1982

972

W

Waite, Harold (19th century)
English School
1210 *Justin McCarthy, Novelist and Politician,*
 (1830-1912)
 Signed: *Harold Waite*
 61 x 51
 Presented, Mrs L. McCarthy-
 Gimson, 1951

Ward, James (1769-1859)
English School
278 *The Cow Shed*
 95 x 127
 Purchased, 1886

Follower of **Watteau, Antoine (1684-1721)**
French School
801 *A Musical Party (Le Conteur)*
 40 x 32
 Sir Hugh Lane Bequest, 1918

1321 *L'Occupation Selon L'Âge*
 34 x 42
 Purchased, Colonel T. Mansfield,
 1956

Watts, George (1817-1904)
English School
279 *Mrs Caroline Norton (afterwards Stirling*
 Maxwell), Poet, (1808-77), sketch
 42 x 33
 Presented, Mr J. Ross, 1887

Weekes, William (fl.1856-1909)
English School
1532 *A Camel Caravan*
 Signed: *L. J. Weeks*
 61 x 91
 Presented, Sir Alfred Chester
 Beatty, 1954

278

1210

801

1321

279

1532

Weenix, Jan (1640-1719)
Amsterdam School

533 *A Still Life*
 79 x 63
 Purchased, Dublin, Mr J. Nairn,
 1902

 947 *A Still Life: the Garden of a Château*
 Signed: *J. Weenix, 1717*
 122 x 106
 Presented, Mr W. Hutcheson Poe,
 1931

533

947

Weenix, Jan Baptist (1621-63)
Amsterdam School
 488 *In the Campagna*
 42 x 33, on panel
 Purchased, Paris, Sedelmeyer, 1899

 511 *The Sleeping Shepherdess*
 Signed: *Gio. Batta Weenix*
 70 x 60
 Sir Henry Barron Bequest, 1901

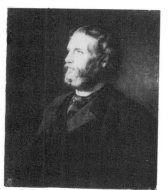

488

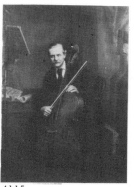

511

Wells, Henry (1828-1903)
English School
 517 *Sir Frederick William Burton, Artist,*
 (1816-1900)
 Painted, 1901
 74 x 61
 Presented, the artist, 1901

Werner, Louis (1824-1901)
Alsacian and Irish Schools
 4115 *Professor W. Elsner*
 173 x 125
 Presented, Dublin, Mr E.
 Werner, 1974

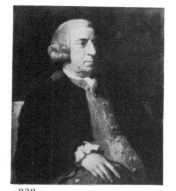

517

4115

West, Benjamin (1738-1820)
Anglo-American School
 838 *Admiral Ommaney*
 Signed: *B. West 1773*
 76 x 63
 Purchased, Captain R. Langton
 Douglas, 1922

Western Greek School (15th century)
 1848 *The Miracle of St Demetrius*
 60.5 x 44.5, tempera on panel
 Purchased, Mr W.E.D. Allen, 1968

838

1848

Western Greek School (c.1700)

1839 *St Spiridon*
 29 x 19, tempera on panel
 Purchased, Mr W.E.D. Allen, 1968

1852 *The Annunciation*
 39.5 x 31.5, tempera on panel
 Purchased, Mr W.E.D. Allen, 1968

1839

1852

Wet, Jacob Willemsz de (c.1610-71/2)
Haarlem School

1315 *Abraham and Melchizedek*
 60 x 84, on panel
 Purchased, London, Colnaghi, 1955

1315

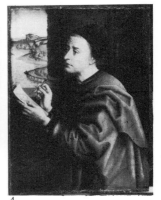
4

After **Weyden, Rogier van der (1399/1400-64)**
Flemish School

4 *St Luke Drawing the Virgin; the Arms of*
 Philippe de Bourgogne, Bishop of Utrecht,
 (c.1464-1524) on reverse
 50 x 36, on panel
 Purchased, Paris, Comte de
 Choiseul Sale, 1866

4 reverse

125

Wheatley, Francis (1747-1801)
English School

125 *The Dublin Volunteers in College Green,*
 4th November, 1779
 175 x 323
 Presented, G. Fitzgerald, 5th Duke
 of Leinster, 1891

374 *A Child with a Dog*
 dia. 69
 Purchased, London, Christie's, 1891

551 *The Virgin's Dream*
 Signed: *F.W. 179(?)*
 45 x 55
 Purchased, London, Shepherd Bros.,
 1903

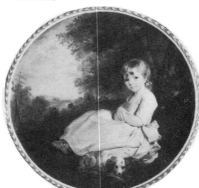
374

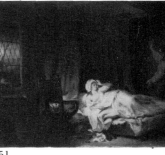
551

617 *Mr and Mrs Richardson*
100 x 126
Purchased, London, Knoedler and
Co., 1910

4339 *The Marquess and Marchioness of*
Antrim
Signed: *F. Wheatley px. 1782*
99.7 x 128.3
Purchased, London, Christie's, 1980

617 4339

Wijnen, Domenicus van (Ascanius) (1661-after 1690)
Amsterdam School
527 *The Temptation of St Anthony Abbot*
Signed with monogram *DVW* and
Ascanius
72 x 72
Presented, Mr A. Ray, 1901

Wijntrank, D. (fl. c.1650)
with
Hagen, Joris van der (1620-69)
The Hague School
29 *Rabbits at the Mouth of a Burrow*
49 x 39, on panel
Purchased, London, Mr C. Waters,
1874

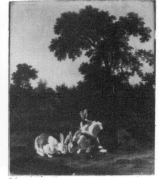

527 29

Wilde, Samuel de (1748-1832)
English School
307 *Charles Macklin, Actor, (c.1695-1797)*
40 x 30
Purchased, London, Christie's, 1881

Wilkie, David (1785-1841)
Scottish School
240 *Napoleon and Pope Pius VII at*
Fontainebleau in 1813
Painted 1836
244 x 196
Purchased, London, Christie's, 1877

651 *Helen Wilkie, the Artist's Sister*
35 x 27, on panel
Presented, Sir Hugh Lane, 1913

1748 *Maria, Wife of Henry Petty-Fitzmaurice,*
2nd Marquess of Lansdowne
32 x 35, on panel
Presented, The Misses Entwissle,
c.1958

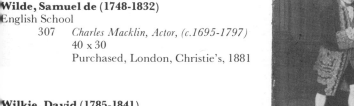

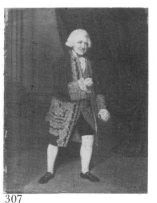

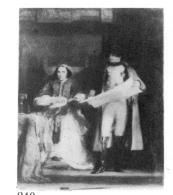

307 240

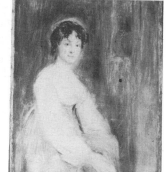

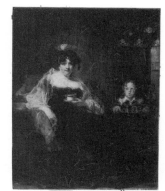

651 1748

Wilson, Benjamin (1721-88)
English School
776 *Margaret (Peg) Woffington, Actress,*
 (1718-60)
 77 x 64
 Purchased, Mr T. Morris, 1917

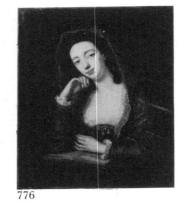

776

157

Wilson, Richard (1714-82)
English School
157 *A View near Rome*
 66 x 97
 Purchased, Dublin, 1872

528 *Solitude*
 Signed: *RW 1762*
 100 x 125
 Purchased, London, Agnew, 1901

746 *A View from Tivoli over the Campagna*
 Signed on reverse: *R. Wilson pinxt.*
 1752 No. 1
 50 x 66
 Milltown Gift, 1902

528

746

747 *A View of Tivoli*
 Signed on reverse: *R. Wilson pinxt.*
 1752 No. 2
 50 x 66
 Milltown Gift, 1902

Winck, Christiaen (1738-97)
German School
714 *The Attack*
 28 x 22, on copper
 Milltown Gift, 1902

715 *The Defence*
 28 x 22, on copper
 Milltown Gift, 1902

747

714

Attributed to Wissing, William (c.1656-87)
English School
4157 *Mrs Catherine Talbot, (d.1679)*
 75 x 62
 Purchased, Dublin, Malahide Castle
 Sale, 1976

715

4157

Witte, Emanuel de (1617-92)
Amsterdam School

450 *The New Church at Delft, with the Tomb*
 of William the Silent
 Signed: *E. de Witte*
 40 x 32, on panel
 Purchased, Amsterdam, F. Muller
 and Co., 1896

805 *An Interior of a Church*
 Signed: *E. de Witte 1669*
 126 x 132
 Sir Hugh Lane Bequest, 1918

450

805

Worsdale, James (c.1692-1767)
English School

134 *The Hellfire Club, Dublin, (c.1735)*
 210 x 275
 Presented, Mr J. Wardell, 1878

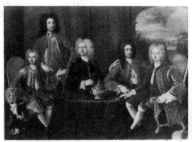

134

170

Wouvermans, Philips (1619-68)
Haarlem School

170 *A Halt of Cavalry*
 Signed with initials
 36 x 41, on panel
 Purchased, London, Christie's, 1887

582 *The Annunciation to the Shepherds*
 46 x 40, on panel
 Presented, Sir Edgar Vincent, 1907

1699 *A Landscape with Figures*
 48 x 66, on panel
 Milltown Gift, 1902

1702 *Horses and Figures at Sutler's Tent*
 64 x 49, on panel
 Milltown Gift, 1902

1712 *Men and Horses*
 38 x 53, on panel
 Milltown Gift, 1902

582

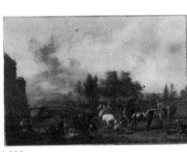

1699

1702

1712

1755 *A Halt with Caravans*
 30 x 39, on panel
 Milltown Gift, 1902

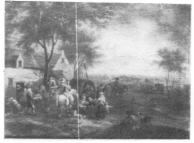 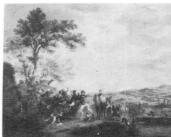

Style of **Wouvermans**
(probably by a French pasticheur)
 1386 *A Rural Road Incident*
 44 x 58, on panel
 Provenance unknown

1755 1386

Wright, John (c.1623-1700)
English School
 4184 *Lady Catherine and Lady Charlotte Talbot*
 Inscribed on back: James Mich.
 Wright, à Londres, pictor Regini/pinxit,
 Dublin anno 1679
 130 x 110
 Purchased, Dublin, Malahide Castle
 Sale, 1976

Attributed to **Wright**
 4161 *Anthony, Count Hamilton,*
 (c.1646-1720), (1687)
 71 x 59
 Purchased, Dublin, Malahide Castle
 Sale, 1976

4184 4161

Wyatt, Thomas (1799-1859)
English School
 960 *George Moore, (1773-1840)*
 76 x 63
 Mr G. Moore Bequest, 1933

145

Wyck, Jan (c.1640-1702)
Haarlem School
 145 *William of Orange at the Siege of Namur*
 107 x 137
 Presented, H. Dawson-Damer, 3rd
 Earl of Portarlington, 1884

960

 748 *A Cavalry Combat*
 28 x 36
 Milltown Gift, 1902

 749 *After the Combat*
 28 x 36
 Milltown Gift, 1902

748 749

988 *The Battle of the Boyne*
 Signed: *Jan Wyck, 1693*
 219 x 302
 Mr G. Jameson Bequest, 1936

988

Wyck, Thomas (c.1616-77)
Haarlem School

 349 *An Interior of a Weaver's Cottage*
 39 x 35, on panel
 Purchased, Paris, M. S. Bourgeois,
 1894

349

 894 *A Portrait of a Lady*
 81 x 64
 Purchased, Mr W. Patterson, 1927

 1652 *A Landscape with Figures*
 56 x 111
 Milltown Gift, 1902

1652

Wynants, Jan (c.1630-84)
Haarlem School

 508 *A Landscape*
 Signed: *J. Wynants, f.*
 94 x 120
 Sir Henry Barron Bequest, 1901

894

Wynants
with

Lingelbach, Johannes (1622-74)
Haarlem School

 280 *A Scene near Haarlem*
 Signed: *J. Wynants, 1667*
 20 x 25
 Purchased, London, Christie's
 Knighton Sale, 1885

508

280

Yverni, Jacques (fl. 1410-38)
Avignon School

1780 *The Annunciation*
 151 x 193, tempera on panel
 Purchased, New York, Wildenstein,
 1965

1780

Z

Zeitblom, Bartholome (1455/60-1518/22)
German School
914 *The Descent of the Holy Spirit*
121 x 66, on panel
Purchased, Dublin, Mr H. Sinclair,
1928

Ziegler, Samuel (b.1882)
American School
1871 *Alaskan Natives*
Signed: *Ziegler*
56 x 66
Purchased, Dublin, Mr A. Windrim,
1968

Ziem, Félix (1821-1911)
French School
1291 *A Scene in a Country Town*
Signed: *Ziem*
38 x 28, on panel
Presented, Sir Alfred Chester
Beatty, 1954

4287CB *Venice: A Canal Scene*
Signed: *Ziem*
55 x 80
Sir Alfred Chester Beatty Gift, 1950

4288CB *Venice: A Sailing Ship*
Signed: *Ziem 1883*
70 x 108
Sir Alfred Chester Beatty Gift, 1950

4289CB *Venice: A Scene with Boats*
Signed: *Ziem*
83 x 117
Sir Alfred Chester Beatty Gift, 1950

914

1871

1291

4287CB

4288CB

4289CB

4290CB *Windmills*
Signed: *Ziem*
34 x 55
Sir Alfred Chester Beatty Gift, 1950

4290CB

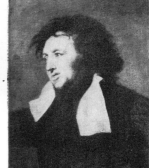

Zoffany, Johann (1733-1810)
Anglo-German School

301 *Charles Macklin, Actor, (c.1695-1797),*
in the part of Shylock
24 x 19
Purchased, London, Christie's, 1888

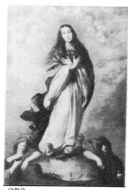

301

539 *David Garrick, Actor, (1717-77)*
76 x 61
Purchased, London, Mr W.
Permain, 1903

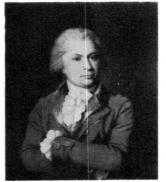

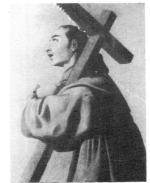

Zurbarán, Francisco de (1598-after 1664)
Spanish School

273 *The Immaculate Conception*
Signed indistinctly
166 x 108
Purchased, London, Christie's, 1886

539 273

962 *St Rufina*
176 x 107.5
Purchased, London, Christie's, 1933

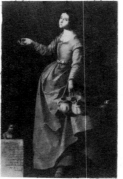

Studio of **Zurbarán**

479 *St Diego of Alcala*
89 x 65
Purchased, 1864

962 479

IRISH SCHOOL

Roberts, *A Landscape,* (4052, detail)

A

Allan, Henry (1865-1912)
654 *A Dutch Interior*
 Signed: *H. Allan*
 26 x 36, on board
 Presented, Mr J. Kavanagh, 1912

654

Allingham, Charles (fl.1802-12)
138 *Thomas Dermody, Poet, (1775-1802)*
 Painted 1802
 Purchased, London, Mrs Noseda,
 1875

138

Ashford, William (c.1746-1824)
577 *A View of Dublin Bay*
 Signed: *W. Ashford 1794*
 69 x 126
 Purchased, London, Mr J. Leger,
 1906

577

4045

4045 *A Landscape with Fishermen*
 Signed: *W Ashford 1801*
 102 x 126
 Purchased, London, Mr M.
 Bernard, 1972

4137 *A View of Dublin from Clontarf*
 114 x 183
 Purchased, London, Spink and Son
 Ltd, 1976

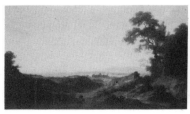

4137

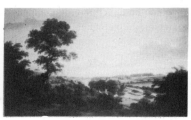

4138

4138 *A View of Dublin from Chapelizod*
 114 x 183
 Purchased, London, Spink and Son
 Ltd, 1976

B

Barret, George (1728/32-84)

174 *A View of Powerscourt Waterfall*
100 x 127
Purchased, London, Christie's, 1880

175 *A View near Avoca*
56 x 72
Purchased, London, Christie's, 1880

1091 *A Landscape with a Man Fording a Stream*
51 x 130
Milltown Gift, 1902

1092 *A Landscape with a Man Fishing*
62 x 36
Milltown Gift, 1902

1627 *The Ruins of a Fortress*
36 x 99
Milltown Gift. 1902

1628 *The Remains of an Italian Mediaeval Castle*
36 x 101
Milltown Gift, 1902

174

175

1091

1092

1627

1628

1629 *A Classical Landscape, with a Cascade in
 the Foreground*
 154 x 100
 Milltown Gift, 1902

1630 *Grassy Cliffs near the Sea*
 150 x 64
 Milltown Gift, 1902

1631 *A River Scene with Rocks by the Seashore*
 154 x 57
 Milltown Gift, 1902

1632 *The Roman Forum*
 98 x 151
 Milltown Gift, 1902

1633 *The Colosseum*
 98 x 151
 Milltown Gift, 1902

1634 *Cliffs and Sea, with a Footbridge*
 97 x 149
 Milltown Gift, 1902

1635 *A Castle on a Hilltop*
 99 x 150
 Milltown Gift, 1902

1636 *A Classical Panorama*
 79 x 225
 Milltown Gift, 1902

1629

1630

1631

1632

1633

1634

1636

1635

1637 *An Italian Ravine*
156 x 103
Milltown Gift, 1902

1753 *A River Scene*
14 x 35
Milltown Gift, 1902

1754 *A River Scene*
14 x 35
Milltown Gift, 1902

1760 *A Stormy Landscape*
55 x 60
Presented, Mrs A. Bodkin through
the Friends of the National
Collections, 1963

1909 *A Landscape with Fishermen*
97 x 133
Presented, Mr T. Berry, 1854

4003 *A Landscape with Figures in the
Background*
62 x 36
Milltown Gift, 1902

Attributed to **Barret**
4086 *A View of the Dargle*
94 x 135
Miss E. Bodkin Bequest, 1974

Barrett, Jeremiah (fl.1753-70)
1319 *Master D. Daly*
Signed: *Jer. Barrett, pinx't A.D. 1765*
76 x 64
Presented, Friends of the National
Collections, 1956

1637

1753

1754

1754

1760

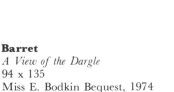
1909

4003

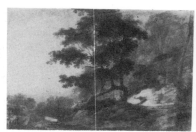
4086

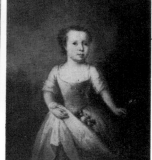
1319

Barry, James (1741-1806)

128 *Edmund Burke, Statesman, Orator,*
Writer, (1729-97)
127 x 99
Purchased, London, H. Graves and
Co., 1875

631 *A Portrait of a Harper*
61 x 47
Purchased, Dublin, Mr J. Gorry,
1910

762 *Adam and Eve*
Signed: *Js. Barry*
233 x 183
Presented, Royal Society of Arts,
1915

971 *A Self-Portrait as Timanthes*
76 x 63
Purchased, Captain R. Langton
Douglas, 1934

1393 *The Death of Adonis*
Signed: *Jas. Barry*
100 x 126
Presented, Mr and Mrs R. Field,
1959

1418 *The Zodiacal Month of October*
120 x 112
Presented, Dr T. MacGreevy, 1960

1759 *Jacomo and Imogen (from Cymbeline)*
48 x 61, on board
Presented, Mrs A. Bodkin through
the Friends of the National
Collections, 1963

1924 *A Man Washing his Feet at a Fountain*
(after Poussin)
Signed: *JB*
16.5 x 21, on panel
Purchased, London, Albany
Gallery, 1969

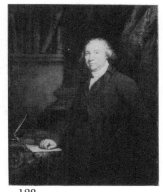

128

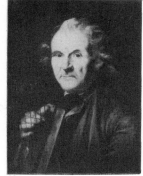

631

762

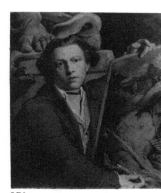

971

1393

1418

1759

1924

Bindon, Francis (before 1700-65)

598 *Jonathan Swift, Satirist, (1667-1745)*
 127 x 102
 Purchased, Trustees of the Berwick
 family, 1908

1344 *Carolan the Harper*
 20 x 17, on copper
 Purchased, Captain Beresford-
 Mundy, 1956

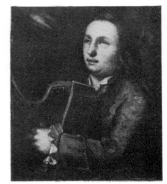

598 1344

Brandt, Muriel (1909-81)

1781 *Christine, Countess of Longford*
 Signed: *Muriel Brandt*
 53 x 76
 Presented, Sir Alfred Chester Beatty,
 1965

1799 *Micheal Mac Liammoir*
 Signed: *Muriel Brandt*
 66 x 86.3
 Purchased, the artist, 1966

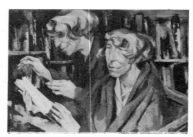
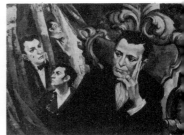

1781 1799

4076 *Professor George O'Brien, (1892-1974)*
 Signed: *Muriel Brandt*
 65 x 85
 Professor G. O'Brien Bequest, 1974

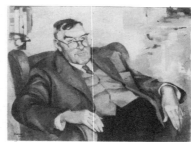
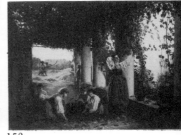

Brennan, Michael George (1839-71)

153 *A Vine Pergola at Capri*
 Signed: *M.G. Brennan, Capri 1866*
 56 x 75
 Purchased, London, Christie's, 1873

4076 153

155 *A Church Interior at Capri*
 Signed: *M.G. Brennan Capri '66*
 74 x 60
 Purchased, London, Christie's, 1873

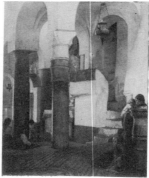

Bridgford, Thomas (1812-78)

596 *A Self-Portrait in Fancy Dress*
 74 x 61
 Purchased, Dublin, 1908

155 596

855 *An Irish Piper, (c.1843)*
 61 x 51
 Mr T. Bridgford Bequest, 1924

857 *'The Masquerader', (A Self-Portrait)*
 74 x 61
 Mr T. Bridgford Bequest, 1924

1404 *Thomas Ettingsol, Writer*
 92 x 72
 Purchased, Dublin, Mrs Lewis, 1959

855

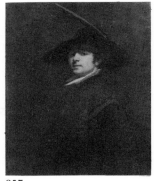

857

Brocas, Samuel Frederick (c.1792-1847)
647 *A View of Bray Head*
 62 x 85
 Purchased, Co. Laois, Mr M.
 Campion, 1913

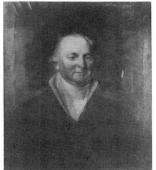

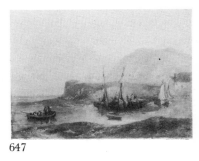

647

1404

Brocas, William (c.1794-1868)
1017 *A Landscape*
 27 x 38, on panel
 Miss H. Reid Bequest, 1939

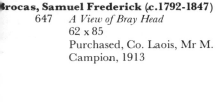

587

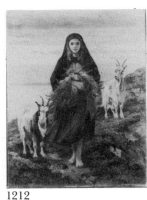

1017

Burke, Augustus (c.1838-91)
587 *A Connemara Landscape*
 Signed: *A. Burke 1865*
 37 x 74
 Purchased, 1908

1212 *A Connemara Girl*
 Signed: *A. Burke, R.H.A.*
 63 x 48
 Presented, Mrs I. Monahan, 1951

1212

C

Carver, Robert (fl.1750-91)

4065 *A Landscape with Peasants and a Dog*
Signed: *R.C. 1754*
128 x 160
Purchased, London, Leger, 1973

4065

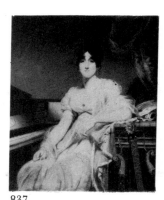

602

Cazneau, Edward (1809-after 1847)

602 *A Self-Portrait*
74 x 61
Purchased, Dublin, Miss Young,
1907

Chinnery, George (1774-1852)

785 *A Portrait of a Mandarin*
65 x 47
Sir Hugh Lane Bequest, 1918

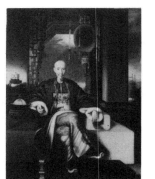

785

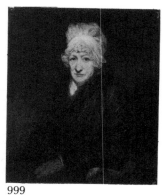

837

837 *Mrs Conyngham*
127 x 102
Purchased, London, Christie's, 1921

999 *Mrs Eustace*
76 x 63
Purchased, Executors of the late
Miss J. Maguire, 1938

1000 *The Artist's Wife*
74 x 59
Purchased, Executors of the late
Miss J. Maguire, 1938

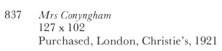
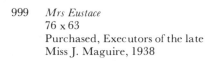
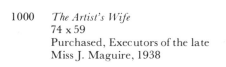

999

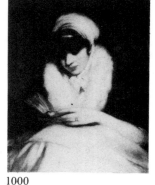

1000

1006　　*A Chinese Scene, Fishermen*
　　　　19 x 26
　　　　Purchased, Executors of the late
　　　　Miss J. Maguire, 1938

1007　　*A Chinese Scene, Women making Tea*
　　　　20 x 26
　　　　Purchased, Executors of the late
　　　　Miss J. Maguire, 1938

1008　　*A Chinese Scene, Boats by Lake*
　　　　20 x 26
　　　　Purchased, Executors of the late
　　　　Miss J. Maguire, 1938

1006

1007

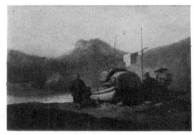

1008

Clarke, Harry (1889-1931)

1878　　*A Winged Angel in Profile*
　　　　239 x 53.5
　　　　Purchased, Dublin, Mr C. Clarke,
　　　　1968

1879　　*A Winged Angel in Profile*
　　　　272 x 31
　　　　Purchased, Dublin, Mr C. Clarke,
　　　　1968

1880　　*A Winged Angel in Profile*
　　　　282 x 29.5
　　　　Purchased, Dublin, Mr C. Clarke,
　　　　1968

1881　　*A Winged Angel in Profile*
　　　　254 x 53.5
　　　　Purchased, Dublin, Mr C. Clarke,
　　　　1968

1878　　　　　　1879　　1880　　1881

1882 *Two Winged Angels in Profile*
192 x 83.5
Purchased, Dublin, Mr C. Clarke,
1968

1883 *Two Winged Angels in Profile*
193 x 86
Purchased, Dublin, Mr C. Clarke,
1968

4136 *A Winged Angel in Profile*
70 x 31
Purchased, Dublin, Mr C. Clarke,
1968

1882 1883

Clarke, Margaret (d.1961)
4063 *Joshua Clarke, Founder, Clarke Stained-glass Studios, (1858-1921)*
Inscribed on mount: *Joshua Clarke by Margaret Clarke R.H.A.*
128 x 102
Purchased, Mr J. Clarke, 1973

4067 *Harry Clarke, (1889-1931)*
81 x 70
Presented, Mr D. Clarke, 1973

4136 4063

Coghill, Egerton (1851-1921)
1786 *A View of Castletownshend, County Cork*
Signed: *E.B. Coghill 1903*
51 x 81.5
Presented, Sir Patrick Coghill, 1965

1786

4067

Collie, George (b.1904)
4029 *Thomas McGreevy, (1893-1967)*
42 x 33
Purchased, the artist, 1971

Comerford, John (c.1762-1832)
634 *Mrs Dobbyn*
67 x 56
Purchased, Dublin, Mr D.
Moulang, 1911

4029 634

1283　*A Portrait of a Gentleman*
　　　Signed: *John Comerford pinxit 1793*
　　　91 x 71
　　　Presented, New York, Mr C.
　　　Doward, 1954

Craig, Humbert (1878-1944)
1757　*A View of Port na Blagh, Sheephaven Bay,*
　　　County Donegal
　　　Signed: *J.H. Craig*
　　　26 x 37, on panel
　　　Professor Dowling Bequest, 1961

1283

1757

Cregan, Martin (1788-1870)
159　*Master John Crewe*
　　　(after Reynolds)
　　　91 x 70
　　　Purchased, Mrs Cregan, 1869

830　*John Doherty, Lawyer and Politician,*
　　　(1783-1850)
　　　Signed: *M. Cregan 1826*
　　　91 x 71
　　　Purchased, Dublin, Messrs Harris
　　　and Sinclair, 1920

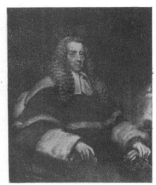

159

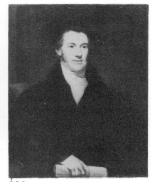

830

865　*Chief Justice Charles Kendal Bushe,*
　　　(1767-1843), in his Robes
　　　Inscribed on reverse and dated 1828
　　　124 x 99
　　　Purchased, Mr P. Bushe, 1925

918　*Mrs Cregan (Jane Schwerzell)*
　　　Painted 1818
　　　76 x 64
　　　Presented, Miss M. Cregan, 1929

1375　*Chief Justice Charles Kendal Bushe,*
　　　(1767-1843)
　　　Signed: *M. Cregan 1830*
　　　49 x 70
　　　Purchased, London, Mr R. Riches,
　　　1958

4130　*John Williamson*
　　　Signed: *M.C. 1825*
　　　76 x 24
　　　Purchased, Old Hall Gallery, 1978

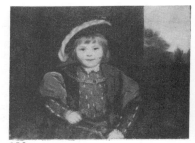

865

918

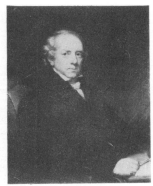

1375

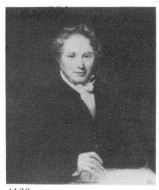

4130

Crowley, Nicholas (1813-57)

 202 *C.H. Phipps, 1st Marquess of Normanby.*
 (1797-1863), sketch
 76 x 61
 Purchased, Dublin, 1884

 1756 *Daniel Murray, Archbishop of Dublin*
 92 x 71
 Purchased, Mrs Kemp, 1863

 4330 *Invitation, Hesitation, Persuasion*
 Signed: *Crowley*
 102 x 127
 Purchased, London, Mr A.
 Thompson, 1979

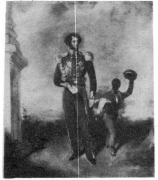 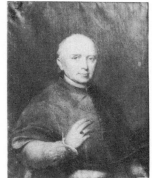

202 1756

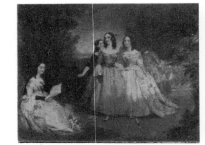

4330 4335

Cruise, John (fl.1827-34)

 4335 *The Nave of St Patrick's Cathedral,*
 Dublin
 Signed: *John Cruise 1828*
 Inscribed: *Interior of St Patrick's*
 Cathedral
 47.8 x 35.5
 Purchased, London, Mr A. Collins,
 1980

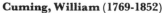

Cuming, William (1769-1852)

 187 *James Caulfield, 1st Earl of Charlemont,*
 (1728-99)
 122 x 99
 Purchased, Dublin, D'Olier Street
 Library Sale, 1882

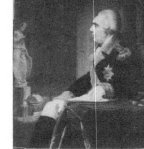 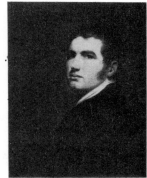

187 305

 305 *Edward Hudson, (d.1833)*
 Painted 1797
 61 x 51
 Presented, Sir Edward Hudson
 Kinahan, 1890

 995 *A Portrait of a Gentleman*
 92 x 71
 Mr R. Walsh Bequest, 1937

 996 *A Portrait of a Gentleman*
 76 x 63
 Mr R. Walsh Bequest, 1937

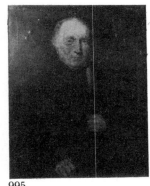 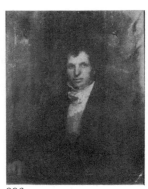

995 996

1725 *A Self-Portrait*
76 x 64
Mrs Haxted Bequest, 1961

4047 *Vincent Waldré, (1742-1814)*
Inscribed on reverse before relining:
Dublin 1800
91 x 70
Purchased, London, Spink and Son
Ltd, 1972

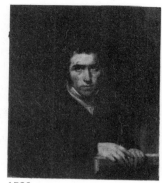
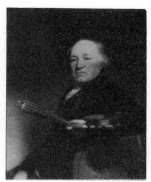

1725 4047

D

Danby, Francis (1793-1861)
162 *The Opening of the Sixth Seal*
185 x 255
Purchased, London, Christie's, 1871

Davidson, Lilian (d.1954)
1289 *Jack B. Yeats, Artist, (1871-1957)*
93 x 74
Lilian Davidson Bequest, 1954

Davis, William (1812-73)
4129 *A View of Rye Water near Leixlip*
Inscribed on reverse: *Rye Water near*
Leixlip by William Davis
51 x 76
Purchased, Dublin, C. O'Connor
and Co. Ltd, 1975

Delane, Solomon (1727-1812)
4195 *A Landscape*
Signed: *Delane Rome 1777*
79 x 99
Purchased, Dublin, C. O'Connor
and Co. Ltd, 1977

Dillon, Gerard (1916-71)
4042 *A Self-Portrait with Pierrot and Nude*
Signed: *Gerard Dillon*
22 x 18, on board
Purchased, Mr G. Dillon Jr, 1972

Doyle, Henry (1827-92)
423 *Richard Doyle, Artist, (1824-83)*
49 x 40
Presumed presented, the artist,
c.1890

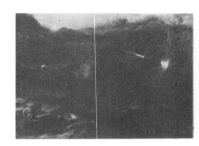
162

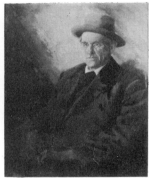
1289

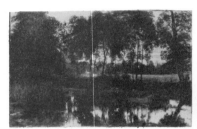
4129

4195

4042

423

Doyle, John (1797-1868)

144 *Christopher Moore, Sculptor,*
1790-1863)
60 x 50
Purchased, London, Mr J. Doyle,
1874

Duffy, Patrick (1822-1909)

608 *A Wicklow Common*
70 x 112
Purchased, the artist's widow, 1910

144

608

E

Ennis, Jacob (1728-70)

4125 *Vulcan Ends the Manufacture of Arms*
 (after Pietro da Cortona)
 Lunette mural from 14 Rutland
 Square, Dublin
 97 x 189
 Purchased, Mr G. Laffan, 1975

4125 4126

4126 *Diana Suspends Hunting*
 (after Pietro da Cortona)
 Lunette mural from 14 Rutland
 Square, Dublin
 97 x 189
 Purchased, Mr G. Laffan, 1975

4127 *Mercury Announces Peace to Mankind*
 (after Pietro da Cortona)
 Lunette mural from 14 Rutland
 Square, Dublin
 97 x 189
 Purchased Mr G. Laffan, 1975

4127

Exshaw, Charles (fl.1747-71)

4056 *A Portrait of a Gentleman*
 Signed: *C. Exshaw, fet 1766*
 76 x 61
 Purchased, Dublin, Hibernian
 Antiques, 1972

4056

F

Faulkner, John (fl.1852-87)

1803 *A Landscape*
61.2 x 86.7
Purchased, Messrs Barry and
Tattan, 1966

Fisher, Jonathan (fl.1763-1809)

969 *A Landscape*
100 x 127
Purchased, Mr A. Troubnileoff,
1934

1797 *A View of the Lower Lake, Killarney*
39.8 x 52
Purchased, Belfast, Mr A.
Thompson, 1966

1813 *A View of the Eagle's Nest, Killarney*
117 x 117
Purchased, Belfast, Mr A.
Thompson, 1967

Fortune, Ambrose (19th century)

1728 *Mrs Frances J. Hadden*
76 x 63
Presented, her descendants, 1962

Fowler, Trevor (fl.1830-44)

4122 *Children Dancing at a Crossroads*
71 x 92
Purchased, Dublin. Mr W. Cherrick,
1975

1803

969

1797

1813

1728

4122

Fox, Robert (fl.1839-88)

 4187 *The Head of an Oriental*
 Signed: *R. Fox*
 60 x 49
 Purchased, Dublin, C. O'Connor
 and Co. Ltd, 1976

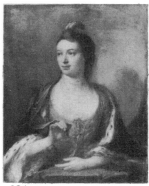

Frye, Thomas (1710-62)

 924 *A Portrait of a Lady*
 99 x 71
 Presented, Sir Alec Martin through
 the Friends of the National
 Collections, 1930

4187 924

 927 *Sir Charles Kemeys-Tynte, (1710-85)*
 Signed: *T. Frye pinx. 1739*
 127 x 102
 Presented, Mr G. Hannen, 1930

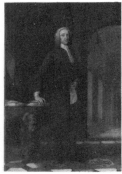

 1904 *John Allen of Bridgewater*
 Signed: *T. Frye pinx. 1739*
 237 x 154
 Purchased, London, Mr M.
 Harvard, 1969

927 1904

G

Gaven, George (fl.1750-75)

399 *John Ponsonby, Speaker, Irish House of
Commons, (1713-89)*
155 x 125
Purchased, London, Lord Ely
Collection, 1891

Gethin, Percy (1874-1916)

1197 *A View near Lough Gill*
Signed: *P.F. Gethin*
71 x 91
Mr W. Crowdy Bequest, 1950

Glew, Edward (1817-70)

1325 *The Leaders of the Irish Confederation in
Council*
63 x 76
Mr I. Rice Bequest, 1956

Grey, Alfred (fl. c.1900)

1056 *The River Bank*
Signed: *A. Grey, R.H.A., 1884*
24 x 34
Sherlock Bequest, 1940

Grey, Charles (1808-92)

426 *A Highland Forester, (Donald McLean)*
Signed: *C. Grey, R.H.A.*
20 x 15, on board
Purchased, Mr A. Grey, 1894

585 *John O'Donovan, Scholar, (1806-51)*
76 x 59
Purchased, New Brighton, Mr R.
O'Donovan, 1906

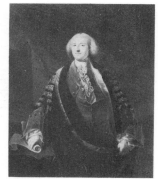

399

1197

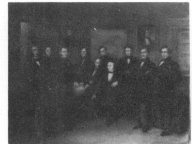

1325

1056

426

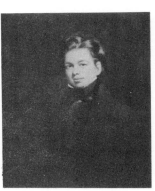

585

1823 *Two Sportsmen in Scotland*
Inscribed on reverse: *On Glasha Sept.*
12th 1854. Mervyn, Viscount
Powerscourt, from C. Grey, 1857
12 x 18, on board
Purchased, Dublin, 1967

4074

1823

Attributed to **Grogan, Nathaniel (c.1740-1807)**

4074 *A Landscape at Tivoli, Cork, with Boats*
37 x 166
Purchased, London, Messrs O. and
P. Johnson, 1973

4303 *A View of Cork Harbour*
91 x 153
Purchased, London, Mr R. Green,
1978

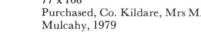
4303

4323

4323 *Forest Figures at Night*
Signed: *N. Grogan*
77 x 108
Purchased, Co. Kildare, Mrs M.
Mulcahy, 1979

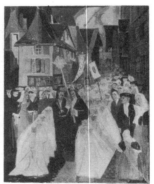

Guinness, May (1863-1955)

1339 *A Religious Procession in Brittany*
Signed: *M. Guinness*
127 x 102
Presented, Mrs M. Lloyd as
Executor of the late May Guinness,
1956

1339

H

Hamilton, Hugh Douglas (c.1739-1808)

195 *Lord Edward Fitzgerald, Soldier and Revolutionary, (1763-98)*
124 x 95
Presented, C. Fitzgerald, 4th Duke of Leinster, 1884

292 *John Fitzgibbon, Earl of Clare, Lawyer and Politician, (1749-1802)*
236 x 145
Purchased, Mount Shannon, through Agnew, 1888

491 *David La Touche, Banker and Politician, (1729-1817)*
56 x 48
Purchased, Dublin, Mr H. Naylor, 1899

578 *Arthur Wolfe, Viscount Kilwarden, Chief Justice of the King's Bench in Ireland, (1739-1803)*
Painted 1795
70 x 56
Purchased, Dublin, 1906

592 *John Philpot Curran, Statesman and Orator, (1750-1817)*
69 x 61
Purchased, Co. Kildare, Mrs Kirkpatrick, 1908

1342 *Cupid and Psyche in the Nuptial Bower*
Signed: *H. Hamilton Dubl.*
198 x 151
Presented, Friends of the National Collections, 1956

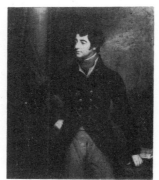
195

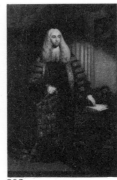
292

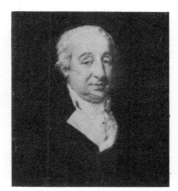
491

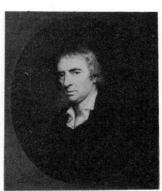
578

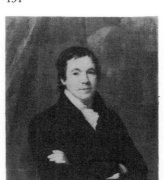
592

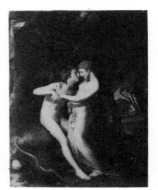
1342

1350 *Richard Edgeworth, Author and Inventor,*
 (1744-1817)
 77 x 65
 Presented, Mrs R. Montagu,
 received, 1956

4172 *A Portrait of a Lady*
 26 x 20, on metal
 Purchased, Mr P. Power, 1976

4173 *Mrs Temple*
 26 x 20, on metal
 Purchased, Mr P. Power, 1976

4174 *A Portrait of a Lady*
 26 x 20, on metal
 Purchased, Mr P. Power, 1976

4175 *Mrs Richardson*
 26 x 20, on metal
 Purchased, Mr P. Power, 1976

4176 *A Portrait of a Gentleman*
 26 x 20, on metal
 Purchased, Mr P. Power, 1976

4177 *A Portrait of a Lady*
 26 x 20, on metal
 Purchased, Mr P. Power, 1976

4178 *Mrs F. Trench*
 26 x 20, on metal
 Purchased, Mr P. Power, 1976

1350 4133

4172

4173

4174

4175

4176

4177

4178

4179 *Mrs Stewart*
 26 x 20, on metal
 Purchased, Mr P. Power, 1976

4180 *A Portrait of a Gentleman*
 26 x 20, on metal
 Purchased, Mr P. Power, 1976

4181 *A Portrait of a Gentleman*
 26 x 20, on metal
 Purchased, Mr P. Power, 1976

4182 *A Portrait of a Gentleman*
 26 x 20, on metal
 Purchased, Mr P. Power, 1976

4183 *R.J. Trench*
 26 x 20, on metal
 Purchased, Mr P. Power, 1976

4179

4180

4181

4182

Attributed to **Hamilton**
4133 *A Portrait of a Gentleman*
 76 x 63
 Provenance unknown

Hamilton, Letitia (1878-1964)
1779 *A View of Bantry Bay, County Cork*
 Signed: *L.M.H.*
 50 x 60
 Presented, Major-General C.
 Hamilton, 1965

4183

4133 1350

1779

Harrison, Sarah (1863-1941)
1219 *Michele Esposito, Pianist and Composer*
 Signed with monogram and dated
 1926
 93 x 76
 Purchased, Mrs V. Dockrell, 1951

1219

1279 *A Self-Portrait*
Signed: *S.C. Harrison*
37 x 27
Purchased, Dublin, Mr J. Gorry,
1954

1280 *Sir Hugh Lane, Director of the National*
Gallery of Ireland, (1875-1915)
41 x 31, on panel
Purchased, Dublin, Mr J. Gorry,
1954

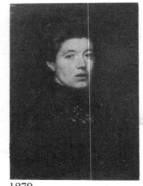

1279

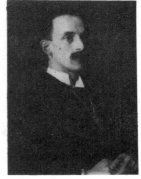

1280

1281 *Henry Harrison, Political Writer,*
(1867-1954)
79 x 66
Purchased, Dublin, Mr J. Gorry,
1954

1405 *Richard Irvine Best, Scholar, (d.1959)*
Signed: *S.C.H.*
Inscribed and dated 1928
44 x 34
Mr R. Best Bequest, 1959

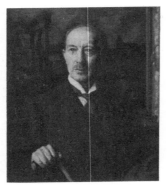

1281

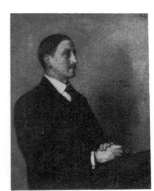

1405

Attributed to **Harrison**

1767 *Reverend John Pentland Mahaffy*
79 x 66
Purchased, Dublin, Mr J. Fenning,
1964

Harwood, James (1816-72)

142 *Samuel Lover, Author and Artist, (1797-*
1868)
74 x 61
Purchased, Dublin Exhibition, Mrs
White, 1872

1767

142

306 *Hugh, 1st Viscount Gough, English Field*
Marshal, (1779-1869)
270 x 174
Presented, G. Gough, 2nd Viscount
Gough, 1889

986 *Samuel Lover, Author and Artist, (1797-*
1868)
76 x 63
Presented, Mr E. McGuire, 1936

306

986

1765 *A Portrait Group*
 Inscribed and dated 1848
 135 x 104
 Presented, Miss S. White-Shannon,
 1961

1765

166

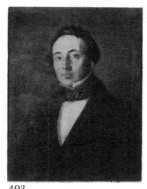

493

1183

averty, Joseph (1794-1864)
 166 *The Blind Piper*
 76 x 59
 Presented, Mr W. O'Brien, 1864

 493 *Richard Robert Madden, Author, (1798-*
 1886)
 71 x 53
 Presented, Dr T. Madden, 1900

 1183 *O'Connell and his Contemporaries; the*
 Clare Election, 1828
 110 x 183
 Presented, Mr Eamon de Valera,
 1950

 1188 *The First Confession*
 36 x 30
 Purchased, Miss P. Barry, 1950

 1304 *Richard Lalor Sheil, Author and*
 Politician, (1791-1851)
 91 x 71
 Purchased, Miss M. Collins, 1955

 4005 *Thomas McNevin, Young Irelander,*
 (1814-48)
 19 x 15
 Purchased, Mrs E. Studdert, 1945

 4035 *Father Matthew Receiving a Repentant*
 Pledge-Breaker
 107 x 137
 Purchased, Mrs Mallagh, 1971

1188

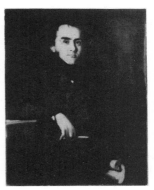

1304

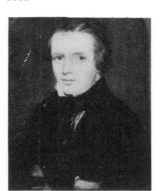

4005

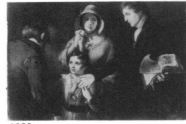

4035

Hayes, Edwin (1819-1904)

951 *A Coast Scene*
 27 x 41, on panel
 Purchased, Dublin, Mr H. Naylor,
 1932

1054 *A View of Dublin Bay*
 Signed: *E. Hayes*
 21 x 31, on board
 Sherlock Bequest, 1940

1055 *Trawlers Leaving Port*
 Signed: *E. Hayes*
 37 x 55
 Sherlock Bequest, 1940

1209 *An Emigrant Ship, Dublin Bay, Sunset*
 Signed: *E. Hayes, A.R.H.A. 1853*
 58 x 86
 Presented, Miss M. Kilgour, 1951

951

1054

1055

1209

Healy, Michael (1873-1941)

1310 *A Landscape*
 17 x 21, on board
 Evie Hone Bequest, 1955

1310

1234

Henry, Paul (1876-1958)

1234 *Dawn, Connemara*
 Signed: *Paul Henry*
 47 x 62
 Presented, Mrs C. Meredith, 1952

1410 *A Connemara Landscape*
 Signed: *Paul Henry*
 51 x 46
 Mr R. Best Bequest, 1959

1869 *Launching the Currach*
 Signed: *Paul Henry*
 41 x 60
 Purchased, Mrs K. Henry, 1968

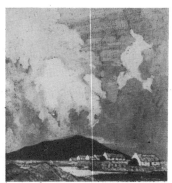

1410

1869

1870 *The Potato Diggers*
Signed: *Paul Henry, 1912*
51 x 46
Purchased, Mrs K. Henry, 1968

4077 *Connemara Cottages*
Signed: *Paul Henry*
69 x 84
Mrs M. Henry Bequest, 1974

4078 *In the West of Ireland*
Signed: *Paul Henry*
51 x 61
Mrs M. Henry Bequest, 1974

4079 *A View of Belfast Lough*
Signed: *Paul Henry*
49 x 60, on board
Mrs M. Henry Bequest, 1974

4080 *Moonlight*
Signed: *Paul Henry*
34 x 43, on board
Mrs M. Henry Bequest, 1974

4081 *A Cottage*
Signed on reverse: *Paul Henry*
16 x 13, on board
Mrs M. Henry Bequest, 1974

4082 *A Donkey(?) Carrying Seaweed*
Signed on reverse: *Paul Henry*
15 x 12, on board
Mrs M. Henry Bequest, 1974

4083 *A Boy on a Donkey Going for Turf*
Signed on reverse: *Paul Henry*
12.4 x 14.9
Mrs M. Henry Bequest, 1974

1870

4077

4078

4079

4080

4081

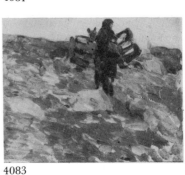

4083

4082

[**215**]

Hickey, Thomas (1741-1824)

258 *Edmund Burke in conversation with his friend Charles James Fox*
80 x 59
Purchased, London, H. Graves and Co., 1886

397 *Reverend Samuel Madden, Philanthropist, (1686-1765)*
53.5 x 43.7
Purchased, Dublin, Bennett, 1886

653 *Sir Armine Wodehouse*
Signed: *T. Hickey, 1773*
76 x 64
Purchased, London, Mr A. Graves, 1913

862 *An Actor between the Muses of Tragedy and Comedy*
Signed: *T. Hickey, 1781*
102 x 128
Purchased, Captain R. Langton Douglas, 1925

863 *Two Children*
Signed: *T. Hickey, 1769*
98 x 80
Purchased, Captain R. Langton Douglas, 1925

1390 *An Indian Girl*
Signed: *T. Hickey, 1787*
102 x 127
Presented, Sir Alec Martin through the Friends of the National Collections, 1959

1789 *Michael Cormak, (1771-99)*
90 x 72.5
Presented, Mr E. Woodroffe, 1966

1860 *Colonel William Kirkpatrick with Attendants: St Thomas's Mount, Madras, in the Distance*
140 x 108.5
Purchased, Dublin, Sir Alfred Chester Beatty Sale, 1968

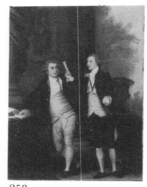

258

397

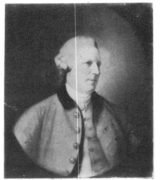

653

862

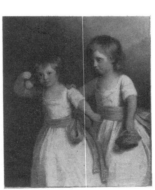

863

1390

1789

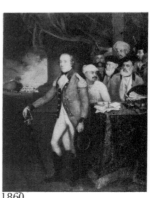

1860

1997 *A Portrait of a Gentleman*
 87 x 60
 Provenance unknown

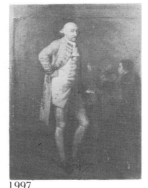
1997

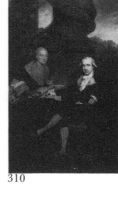
310

tributed to **Hickey**
 310 *Joseph Hickey*
 87 x 59.5
 Purchased, the Hickey family, 1888

 655 *Thomas Leland, Protestant Divine and
 Scholar, (1722-85)*
 66 x 53
 Purchased, Mr J. Kavanagh, 1913

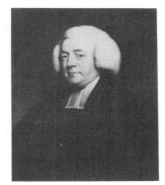
655

581

ome, Robert (1752-1834)
 581 *Frances Barnett Woollery (afterwards Mrs
 Cottingham), in the part of Sigismunda*
 Signed with monogram and dated
 1787
 124 x 99
 Purchased, London, Christie's, 1906

 1144 *Mr Cottingham*
 97 x 79
 Presented, Miss C. Fleming, 1947

 1145 *Mr Cottingham* (another version of
 1144)
 97 x 79
 Presented, Miss C. Fleming, 1947

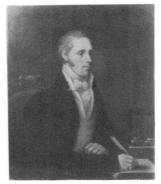
1144

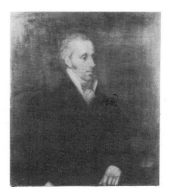
1145

 1146 *Mrs Cottingham*
 98 x 79
 Presented, Miss C. Fleming, 1947

one, David (b.1929)
 1983 *Eoin O'Mahony ('The Pope')*
 Signed: D. Hone, '66
 91 x 76
 Purchased, the artist, 1970

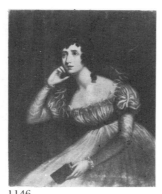
1146

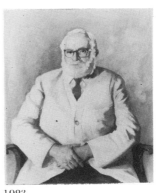
1983

Hone, Evie (1894-1955)

1371 *Snow at Marlay*
 Signed: *E. Hone*
 37 x 49, on board
 Presented, Friends of the National
 Collections, 1957

4322 *A Landscape with a Tree*
 69 x 69, on board
 Miss R. Kirkpatrick Bequest, 1979

1371

4322

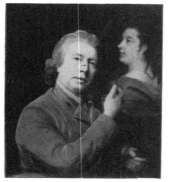

196

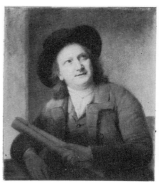

197

Hone the Elder, Nathaniel (1718-84)

196 *A Self-Portrait*
 71 x 59
 Purchased, London, Mrs France,
 1875

197 *A Portrait of a Gentleman*
 Signed: *N. Hone, p. 1784*
 76 x 64
 Purchased, London, Christie's, 1883

440 *The Piping Boy (Camillus, Son of the
 Artist)*
 Signed: *N. Hone, 1769*
 36 x 31
 Purchased, London, Christie's, 1896

525 *A Portrait of a Gentleman*
 Signed: *N. Hone, 1781*
 77 x 64
 Purchased, London, Shepherd Bros.,
 1901

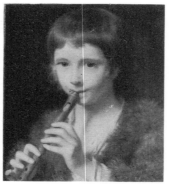

440

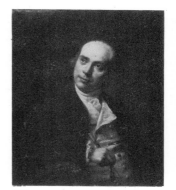

525

886 *A Self-Portrait*
 76 x 122
 Hone Bequest, 1919

1003 *A Self-Portrait*
 76 x 63
 Presented, Sir Alec Martin through
 the Friends of the National
 Collections, 1938

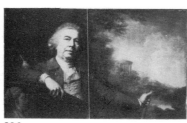

886

1003

1297 *Horace Hone Sketching*
 128 x 105
 Purchased, Mr P. O'Connor, 1954

1790 *The Conjuror, (1775)*
 145 x 173
 Purchased, London, Colnaghi, 1966

1297

1790

588

1185

Hone the Younger, Nathaniel (1831-1917)

588 *Pastures at Malahide*
 82 x 124
 Presented, the artist, 1907

1185 *A View of Ardmore*
 62 x 50
 Hone Bequest, 1919

1214 *A View of St Doulough's, Raheny*
 91 x 71
 Hone Bequest, 1919

1360 *A View of Villefranche from the West*
 62 x 102
 Hone Bequest, 1919

1361 *A View of Villefranche from the East*
 61 x 102
 Hone Bequest, 1919

1362 *A Leafy Lane*
 36 x 27
 Hone Bequest, 1919

1214

1360

1361

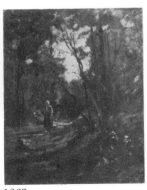

1362

1363 *Fishing Boats Returning*
 Signed: *N.H.* (twice)
 88 x 130
 Hone Bequest, 1919

1364 *Goats and Pine Trees, South of France*
 Signed: *N.H.*
 88 x 123
 Hone Bequest, 1919

1365 *North Africa*
 67 x 51
 Hone Bequest, 1919

1366 *Feeding Pigeons, Barbizon*
 Signed: *N.H.*
 70 x 56, on board
 Hone Bequest, 1919

1367 *Caryatids*
 Signed: *N.H.*
 32 x 49, on board
 Hone Bequest, 1919

1368 *Trees and a Winding Road*
 32 x 46, on board
 Hone Bequest, 1919

1369 *A Shore and Dark Blue Sea*
 32 x 46, on board
 Hone Bequest, 1919

1396 *A View of the Donegal Coast*
 Signed: *N.H.*
 67 x 101
 Hone Bequest, 1919

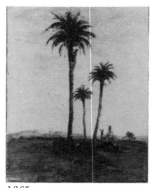

1363

1364

1365

1366

1367

1368

1369

1396

1397 *The Banks of the Seine*
62 x 100
Hone Bequest, 1919

1398 *A View of Kilkee, with the Atlantic*
62 x 97
Hone Bequest, 1919

1399 *Pastures at Malahide*
67 x 97
Hone Bequest, 1919

1400 *A Watering Place under Trees*
52 x 44, on board
Hone Bequest, 1919

1401 *Haymaking by the Sea*
29 x 45, on board
Hone Bequest, 1919

1402 *A Strand with an old Man and a Seated
Figure*
29 x 45, on board
Hone Bequest, 1919

1403 *Moorland*
29 x 45, on board
Hone Bequest, 1919

1425 *The Fishing Fleet, Scheveningen*
36 x 71
Hone Bequest, 1919

1397

1398

1399

1400

1401

1402

1403

1425

Hone the Younger, Nathaniel, continued

1426 *Sheep and Goats under Trees*
 61 x 97
 Hone Bequest, 1919

1427 *A View of Glenmalure, with a Shepherd and Flock*
 62 x 93
 Hone Bequest, 1919

1426

1427

1428 *Drying the Sails*
 Signed: *N. Hone, R.H.A.*
 64 x 93
 Hone Bequest, 1919

1429 *A View of the Cliffs, Etretat*
 Signed with monogram
 61 x 92
 Hone Bequest, 1919

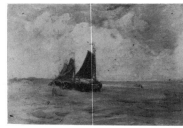
1428

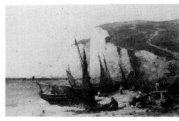
1429

1430 *A Fishing Fleet*
 63 x 92
 Hone Bequest, 1919

1431 *Corn Stooks under Trees*
 61 x 92
 Hone Bequest, 1919

1432 *A View of Fontainebleau, Le Marais des Fées*
 Signed: *N. Hone, R.H.A.*
 65 x 99
 Hone Bequest, 1919

1433 *A View of the Doge's Palace and the Church of the Salute, Venice*
 66 x 97
 Hone Bequest, 1919

1430

1431

1432

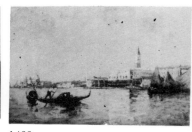
1433

1434 *The Sphinx*
 63 x 92
 Hone Bequest, 1919

1434

1435 *Cows with a Herd under Trees*
 100 x 122
 Hone Bequest, 1919

1435

1436 *A View of the Norfolk Broads*
 Signed: *N.H.*
 87 x 122
 Hone Bequest, 1919

1437 *A Rocky Hillside with Furze*
 35 x 49, on board
 Hone Bequest, 1919

1436

1437

1438 *A Path through Trees with a Cornfield*
 36 x 49, on board
 Hone Bequest, 1919

1439 *A Landscape, Trees and a River*
 37 x 48, on board
 Hone Bequest, 1919

1440 *North County Dublin, Trees by the Sea*
 36 x 46
 Hone Bequest, 1919

1441 *A Breton Fishing Boat*
 51 x 41, on board
 Hone Bequest, 1919

1438

1439

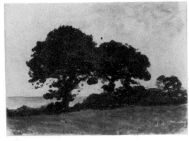

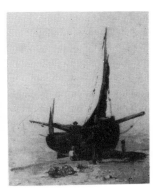

1440

1441

Hone the Younger, Nathaniel, continued

1442 *A View of the Coast (? of Clare)*
 Signed: *N.H.*
 61 x 92
 Hone Bequest, 1919

1443 *A Beach Below a Cliff*
 61 x 92
 Hone Bequest, 1919

1444 *Cattle under Trees*
 Signed: *N. Hone, R.H.A.*
 63 x 92
 Hone Bequest, 1919

1445 *Cattle at Rest in a Field near the Sea*
 Signed: *N.H.*
 62 x 101
 Hone Bequest, 1919

1446 *Binding Corn beneath Trees*
 Signed: *N.H.*
 58 x 73
 Hone Bequest, 1919

1447 *Rocks and Sea*
 Signed: *N.H.*
 49 x 78
 Hone Bequest, 1919

1448 *North County Dublin, Cattle at Rest near
 the Sea*
 Signed with monogram
 49 x 77
 Hone Bequest, 1919

1449 *Trees*
 34 x 49, on board
 Hone Bequest, 1919

1442

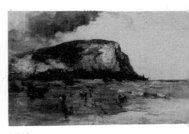
1443

1444

1445

1446

1447

1448

1449

1450 *A River Scene*
 26 x 38, on board
 Hone Bequest, 1919

1452 *A Clearing amongst Trees*
 24 x 19
 Hone Bequest, 1919

1453 *Fields with Three Trees*
 24.5 x 32.5
 Hone Bequest, 1919

1454 *A Landscape with Cattle*
 26 x 35.5
 Hone Bequest, 1919

1455 *A Sandy Coast*
 25 x 38
 Hone Bequest, 1919

1456 *Boats with Brown Sails*
 33 x 46
 Hone Bequest, 1919

1457 *A Hillside with Cattle*
 36 x 46
 Hone Bequest, 1919

1458 *A Mediterranean Coast Scene*
 33 x 46
 Hone Bequest, 1919

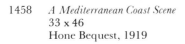

1450

1452

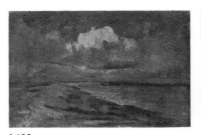

1453

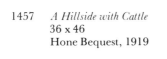

1454

1455

1456

1457

1458

Hone the Younger, Nathaniel, continued

1459 *Sheep and a Shepherd by the Sea*
 46 x 69
 Hone Bequest, 1919

1460 *Mending the Wheel of a Farm Cart near a*
 Tree
 53.5 x 72
 Hone Bequest, 1919

1461 *An Italian Quayside (? Ischia)*
 43 x 53
 Hone Bequest, 1919

1462 *Cliffs: a Storm with Seabirds*
 Signed: *N.H.*
 36 x 54
 Hone Bequest, 1919

1463 *A Hayrick with a Cart and Horses*
 39.5 x 50
 Hone Bequest, 1919

1464 *A Sandy Coast with Cattle*
 41 x 62
 Hone Bequest, 1919

1465 *A Yard with Trees, and a Boy Sitting on*
 a Tree-Trunk
 43 x 62
 Hone Bequest, 1919

1466 *Barges on a River*
 25 x 37, canvas laid on board
 Hone Bequest, 1919

1459

1460

1461

1462

1463

1464

1465

1466

1467 *A Seashore, a Sunny Day*
 21.5 x 35, canvas laid on board
 Hone Bequest, 1919

1468 *Sand Dunes and the Sea, at Portmarnock*
 18 x 29, on board
 Hone Bequest, 1919

1469 *Trees at the Foot of a Hill*
 26 x 36.5, canvas laid on board
 Hone Bequest, 1919

1470 *High Sky over a Cornfield*
 33 x 26.5, canvas laid on board
 Hone Bequest, 1919

1471 *A Landscape, a Grey Day*
 19.5 x 25, canvas laid on board
 Hone Bequest, 1919

1472 *A Stony Field, Trees against the Sky*
 27 x 35, canvas laid on board
 Hone Bequest, 1919

1473 *Trees*
 19 x 29.5, on board
 Hone Bequest, 1919

1474 *A Marsh with Trees at Sunset*
 17.5 x 29, on board
 Hone Bequest, 1919

1467

1468

1469

1470

1471

1472

1473

1474

Hone the Younger, Nathaniel, continued

1475 *Trees with a Gate Beyond*
 24 x 19
 Hone Bequest, 1919

1476 *A Landscape with Trees*
 25.5 x 30, canvas laid on board
 Hone Bequest, 1919

1477 *Sheep Resting, a Cow Grazing*
 20 x 40, on board
 Hone Bequest, 1919

1478 *Sheep near a Seashore*
 26.5 x 41.5, canvas laid on board
 Hone Bequest, 1919

1479 *A Girl in a White Shawl*
 39 x 25, on panel
 Hone Bequest, 1919

1480 *A Woman Gathering Sticks*
 24 x 32, canvas laid on board
 Hone Bequest, 1919

1481 *Trees and a Stream*
 46 x 38, on board
 Hone Bequest, 1919

1482 *Sandhills and Boats*
 Signed with monogram
 23 x 39
 Hone Bequest, 1919

1475

1476

1477

1478

1479

1480

1481

1482

1483	*Heavy Cloud over the Sea* 32 x 45, on board Hone Bequest, 1919
1484	*A Stream below Trees* 34.2 x 45.3, canvas laid on board Hone Bequest, 1919
1485	*A Landscape with Water and Trees* 30 x 45, on board Hone Bequest, 1919
1486	*A View of St Doulough's, Raheny* 29 x 34, canvas laid on board Hone Bequest, 1919
1487	*An Italian Village by the Sea* 51 x 43 Hone Bequest, 1919
1488	*A Horse and Cart in a Field* 23 x 32 Hone Bequest, 1919
1489	*A Landscape, Trees on the Left* 24 x 30.4, canvas laid on board Hone Bequest, 1919
1490	*A Grove of Trees* 27.5 x 35, on board Hone Bequest, 1919

1483

1484

1485

1486

1487

1488

1489

1490

Hone the Younger, Nathaniel, continued

1491 *Feeding Pigeons*
 46 x 37
 Hone Bequest, 1919

1492 *A Fishing Boat on a Strand*
 32 x 45, on board
 Hone Bequest, 1919

1493 *A Haystack*
 24 x 19
 Hone Bequest, 1919

1495 *A Sunset, Dublin Bay*
 30 x 43, on board
 Hone Bequest, 1919

1496 *A Lightship seen from the Shore*
 31 x 45, on board
 Hone Bequest, 1919

1497 *Trees on a Hilltop*
 30 x 46, on board
 Hone Bequest, 1919

1498 *A Farmstead near Trees*
 31 x 46, on board
 Hone Bequest, 1919

1499 *A Schooner at a Quayside*
 33 x 40, on board
 Hone Bequest, 1919

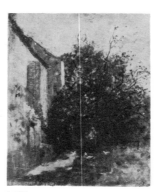

1491

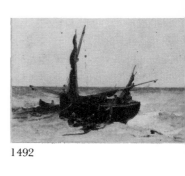

1492

1493

1495

1496

1497

1498

1499

1500 *A View of Malahide Strand*
Signed with monogram
31 x 48, on board
Hone Bequest, 1919

1501 *A Hayfield, Malahide*
Signed with monogram
34 x 50, on board
Hone Bequest, 1919

1500

1501

1502 *A Fishing Boat below a Cliff (? Etretat)*
42 x 63
Hone Bequest, 1919

1503 *Cows Resting under Trees*
Signed with monogram
46 x 35
Hone Bequest, 1919

1504 *A Landscape with Trees and a Hill*
Signed with monogram
44 x 63
Hone Bequest, 1919

1502

1503

1505 *An Italian Village Scene*
Signed: *N.H.*
42 x 64
Hone Bequest, 1919

1506 *A Strand with a Horse and Cart*
42 x 63, on board
Hone Bequest, 1919

1507 *Pastures by the Sea*
37 x 52, on board
Hone Bequest, 1919

1504

1505

1506

1507

1508 *A Mediterranean Coast, Mending Nets*
 36 x 72
 Hone Bequest, 1919

1509 *A Seashore with Fishing Boats*
 32 x 44, on board
 Hone Bequest, 1919

1510 *A Row of Trees near the Shore*
 32 x 44, on board
 Hone Bequest, 1919

1511 *A Path near Trees*
 32 x 44, on board
 Hone Bequest, 1919

1512 *Rough Ground near the Sea*
 30 x 46, on board
 Hone Bequest, 1919

1513 *The Seashore, Holland*
 30 x 45, on board
 Hone Bequest, 1919

1514 *Rough Ground below a Cornfield*
 30 x 45, on board
 Hone Bequest, 1919

1515 *Sandhills and the Sea, Portmarnock*
 33 x 46
 Hone Bequest, 1919

1508

1509

I510

1511

1512

1513

1514

1515

1516 *Hillocks by the Sea*
 30 x 46, on board
 Hone Bequest, 1919

1517 *Cattle Resting*
 33 x 45
 Hone Bequest, 1919

1518 *An Old Road with Trees*
 38 x 59, on board
 Hone Bequest, 1919

1519 *A Spit of Sand with Boats Beyond*
 30 x 45, on board
 Hone Bequest, 1919

1520 *A Girl and a Goat*
 30 x 45, on board
 Hone Bequest, 1919

1521 *A Cornfield below a Hill*
 Signed with monogram
 35 x 46
 Hone Bequest, 1919

1522 *A Wheatfield by the Sea*
 33 x 45, on board
 Hone Bequest, 1919

1523 *A High Sandhill*
 33 x 46
 Hone Bequest, 1919

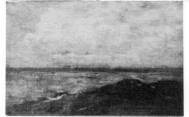

1516

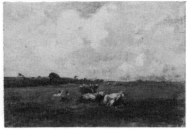

1517

1518

1519

1520

1521

1522

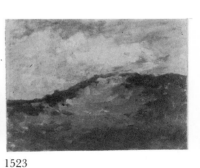

1523

Hone the Younger, Nathaniel, continued

1524 *A View of the Cliffs, Etretat, with Boats*
 35 x 54
 Hone Bequest, 1919

1526 *Cattle Resting*
 Signed with monogram
 35 x 52, on board
 Hone Bequest, 1919

1534 *The Sea and a Low Sky*
 22 x 50, on board
 Hone Bequest, 1919

1535 *Sunset, a Darkening Tree*
 32 x 43, on board
 Hone Bequest, 1919

1536 *A Woodland Path*
 30 x 41, on board
 Hone Bequest, 1919

1537 *A View of a Venetian Palazzo, with a
 Red Sail*
 37 x 46, on board
 Hone Bequest, 1919

1538 *Pastures near the Sea*
 Signed: *N. Hone*
 29 x 45, on board
 Hone Bequest, 1919

1539 *Hay Carts, sketch*
 34 x 46, on board
 Hone Bequest, 1919

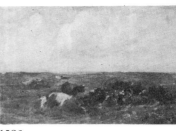

1524

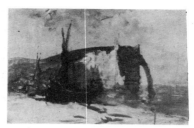

1526

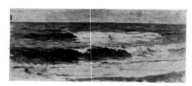

1534

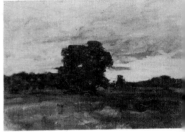

1535

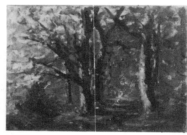

1536

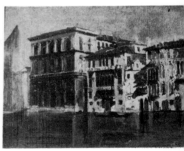

1537

1538

1539

1540 *Trees and Rock, sketch*
32 x 45, on board
Hone Bequest, 1919

1541 *Pastures under Trees*
36 x 50, on board
Hone Bequest, 1919

1542 *Grasscocks under Trees*
38 x 53, on board
Hone Bequest, 1919

1543 *A Landscape with Trees*
31 x 45, on board
Hone Bequest, 1919

1544 **Lilies and Butterflies**
40 x 33, on board
Hone Bequest, 1919

1545 *Haystacks*
32 x 45, on board
Hone Bequest, 1919

1546 *Gathering Kelp*
33 x 61, on board
Hone Bequest, 1919

1547 *Pastures with Cattle Resting*
Signed: *N.H.*
37 x 56, on board
Hone Bequest, 1919

1540

1541

1542

1543

1544

1545

1546

1547

Hone the Younger, Nathaniel, continued

1548 *A Sandy Shore*
 24 x 39
 Hone Bequest, 1919

1553 *A Sailing Boat*
 18 x 25
 Hone Bequest, 1919

1554 *The Spreading Tree*
 16 x 26
 Hone Bequest, 1919

1555 *Trees on a River Bank*
 19 x 24
 Hone Bequest, 1919

1556 *Storm Cloud over the Sea*
 18 x 25
 Hone Bequest, 1919

1557 *A Cliff over the Sea*
 20 x 30
 Hone Bequest, 1919

1558 *Building the Hayrick*
 23 x 28
 Hone Bequest, 1919

1559 *The Cornfields Beyond*
 21 x 31
 Hone Bequest, 1919

1548

1553

1554

1555

1556

1557

1558

1559

| 1560 | *In the Dublin Hills*
16 x 33
Hone Bequest, 1919 |

1560 *In the Dublin Hills*
16 x 33
Hone Bequest, 1919

1561 *A River under Trees*
19 x 27
Hone Bequest, 1919

1562 *Rock and the Sea*
19 x 27
Hone Bequest, 1919

1563 *A Road between Trees*
23 x 32
Hone Bequest, 1919

1564 *Trees in Pasture Land*
19 x 27
Hone Bequest, 1919

1565 *A Rocky Coast*
25 x 30
Hone Bequest, 1919

1566 *Pigs at Pasture*
25 x 35
Hone Bequest, 1919

1567 *A Rocky Coast, with Kelp Gatherers*
23 x 35
Hone Bequest, 1919

1560

1561

1562

1563

1564

1565

1566

1567

Hone the Younger, Nathaniel, continued

1568 *Cliffs and the Sea*
 20 x 30
 Hone Bequest, 1919

1569 *A Landscape, South of France*
 20 x 30
 Hone Bequest, 1919

1568

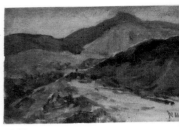

1569

1570 *A Hillside and a Distant Mountain*
 24 x 34
 Hone Bequest, 1919

1571 *Hills, South of France*
 25 x 35
 Hone Bequest, 1919

1572 *A Sandy Shore with Trees*
 23 x 34
 Hone Bequest, 1919

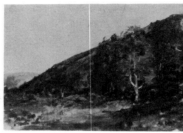

1570

1571

1573 *Sheep at Pasture*
 23 x 35
 Hone Bequest, 1919

1574 *Ships at a Quayside*
 24 x 36, on board
 Hone Bequest, 1919

1575 *Fields and a High Sky*
 25 x 37
 Hone Bequest, 1919

1572

1573

1574

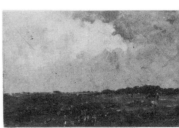

1575

1576 *A Grass Plant*
 35 x 25
 Hone Bequest, 1919

1577 *Corn Stooks*
 42 x 35
 Hone Bequest, 1919

1578 *A House and Out-Offices*
 25 x 33
 Hone Bequest, 1919

1579 *A Wooded Landscape, Moonlight Effect*
 25 x 38
 Hone Bequest, 1919

1580 *Pasture with Cattle*
 23 x 32
 Hone Bequest, 1919

1581 *A Wall with Creeper*
 21 x 34
 Hone Bequest, 1919

1582 *The Seashore, North Dublin*
 24 x 31, on board
 Hone Bequest, 1919

1583 *A Stream in Pasture Land*
 19 x 27
 Hone Bequest, 1919

1576

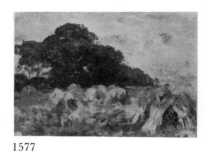

1577

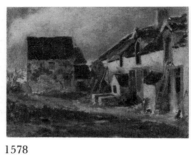

1578

1579

1580

1581

1582

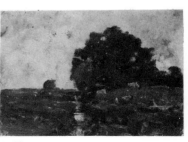

1583

Hone the Younger, Nathaniel, continued

1584 *The White Sail*
20 x 31, on board
Hone Bequest, 1919

1585 *A View of Howth Hill*
18 x 27, on board
Hone Bequest, 1919

1586 *A Tower by the Sea*
19 x 30, on board
Hone Bequest, 1919

1587 *Trees by a River*
24 x 34, on board
Hone Bequest, 1919

1588 *Cornfields in Sunshine*
24 x 33, on board
Hone Bequest, 1919

1589 *Hill Pastures with Cattle*
15 x 32, on board
Hone Bequest, 1919

1590 *A Seashore with Four Figures*
19 x 29, on board
Hone Bequest, 1919

1591 *A Pasture with a Haystack*
19 x 24, on board
Hone Bequest, 1919

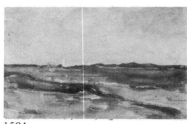

1584

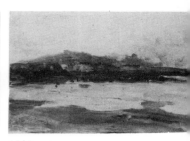

1585

1586

1587

1588

1589

1590

1591

1592 *Sea and Sky, a Summer Day*
 19 x 29, on board
 Hone Bequest, 1919

1593 *Cattle Resting*
 20 x 30, on board
 Hone Bequest, 1919

1594 *A Landscape with a Distant Mountain*
 22 x 32, on board
 Hone Bequest, 1919

1595 *The Sea with Boats, a Fresh Wind*
 19 x 29, on board
 Hone Bequest, 1919

1596 *Trees in a Field*
 19 x 27, on board
 Hone Bequest, 1919

1597 *A Mountain Valley*
 24 x 34, on board
 Hone Bequest, 1919

1598 *A Road through the Hills*
 24 x 34, on board
 Hone Bequest, 1919

1599 *A Sandy Shore with Boats*
 21 x 36, on board
 Hone Bequest, 1919

1592

1593

1594

1595

1596

1597

1598

1599

Hone the Younger, Nathaniel, continued

1600　*A View of the Cliffs, Etretat*
　　　25 x 36, on board
　　　Hone Bequest, 1919

1601　*A Rough Sea, Kilkee*
　　　20 x 26, on board
　　　Hone Bequest, 1919

1602　*A Boy at a Pool*
　　　20 x 33, on board
　　　Hone Bequest, 1919

1603　*The Owner of the Boats*
　　　24 x 32, on board
　　　Hone Bequest, 1919

1604　*Wood for the Winter*
　　　24 x 32, on board
　　　Hone Bequest, 1919

1605　*Haystacks, a Summer Day*
　　　23 x 31, on board
　　　Hone Bequest, 1919

1606　*Sea and Clouds*
　　　25 x 33, on board
　　　Hone Bequest, 1919

1607　*A Summer Sea with Boats*
　　　20 x 30, on board
　　　Hone Bequest, 1919

1600

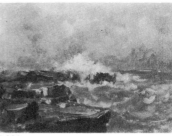
1601

1602

1603

1604

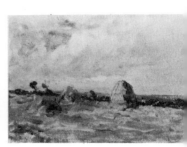
1605

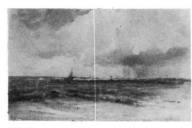
1606

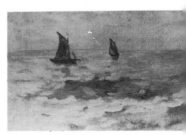
1607

1608 *A Sandy Shore with Figures*
23 x 33, on board
Hone Bequest, 1919

1609 *A Rocky Shore*
20 x 32, on board
Hone Bequest, 1919

1610 *A Shore Scene, Furled Sails*
20 x 32, on board
Hone Bequest, 1919

1611 *Sails on the Skyline*
25 x 33, on board
Hone Bequest, 1919

1612 *Sheep under Trees*
24 x 32, on board
Hone Bequest, 1919

1613 *A Furze Bush on the Seashore*
22 x 35, on board
Hone Bequest, 1919

1614 *Summer Pastures*
18 x 25, on board
Hone Bequest, 1919

1615 *Pastures, a Cloudy Day*
25 x 33
Hone Bequest, 1919

1608

1609

1610

1611

1612

1613

1614

1615

Hone the Younger, Nathaniel, continued

1616 *A View of St George's Head, Kilkee*
 20 x 30, on board
 Hone Bequest, 1919

1617 *Rock Pools, and the Sea*
 23 x 33, on board
 Hone Bequest, 1919

1618 *Trees by the Water, Sunset*
 15 x 25, on board
 Hone Bequest, 1919

1619 *A Harvest Scene, North Dublin*
 25 x 33, on board
 Hone Bequest, 1919

1620 *Woodland and Pasture*
 24 x 34, on board
 Hone Bequest, 1919

1621 *The House by the River*
 20 x 32, on board
 Hone Bequest, 1919

1622 *A View of the Maritime Alps*
 20 x 31, on board
 Hone Bequest, 1919

1623 *Hilly Pastures*
 27 x 35, on board
 Hone Bequest, 1919

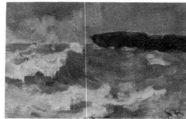

1616

1617

1618

1619

1620

1621

1622

1623

1624 *A Grass-Crowned Bluff by the Sea*
 25 x 35, on board
 Hone Bequest, 1919

1625 *A Cloudy Day, a Seashore with Figures*
 16 x 30, on board
 Hone Bequest, 1919

1625

1624

oward, Hugh (1675-1737)

773 *Arcangelo Corelli, Composer and Violinist,*
 (1653-1713)
 118 x 87
 Purchased, London, Christie's, 1915

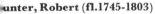

ttributed to Howard

613 *Nicholas Brady*
 71 x 61
 Presented, Mrs W. Brady, 1910

773

613

unter, Robert (fl.1745-1803)

905 *A Portrait erroneously said to be of Francis*
 Hutcheson, Philosopher, (1694-1746)
 76 x 63
 Presented, Sir Alec and Lady
 Martin, 1928

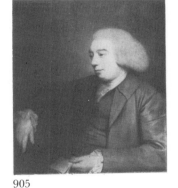

1002 *Simon, Lord Harcourt, English Viceroy in*
 Ireland
 76 x 63
 Purchased, Captain R. Langton
 Douglas, 1938

905

1002

4034 *A Gentleman with a Gun and Dog*
 Signed: *R. Hunter pinxit 1775*
 152 x 198
 Purchased, London, Appleby Bros.
 Ltd, 1971

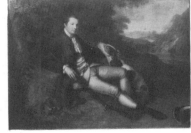

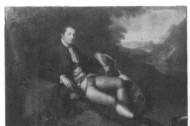

4191 *Sir Robert Waller and his Son Robert*
 107 x 81
 Purchased, London, Mr R. Miles,
 1977

4034

4191

After **Hunter**

4165 *George Nugent-Temple, 1st Marquess of Rockingham, (1753-1813)*
 77 x 56
 Purchased, Dublin, Malahide Castle Sale, 1976

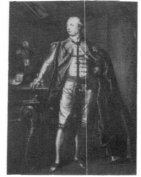

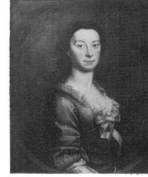

Hussey, Philip (1713-83)

1643 *A Presumed Portrait of Hester van Homrigh ('Vanessa')*
 76 x 63
 Purchased, Co. Meath, Mr G. Briscoe, 1961

4165

1643

4033 *A Man in a Blue Jacket*
 76 x 63
 Provenance unknown

4304 *An Interior with Members of a Family*
 62 x 76
 Purchased, London, Mr R. Green, 1973

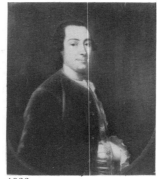

4033

4304

[246]

glis, John (1867-after 1925)

 1898 *In the Demesne*
 31 x 43, on panel
 Provenance unknown

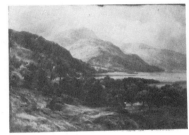

1898 615

ish School (c.1750)

 615 *A View of Leixlip Castle*
 50 x 72
 Purchased, Dublin, T. Stoker Sale,
 1910

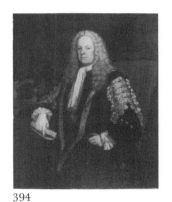

ish School (18th century)

 394 *Henry Boyle, Earl of Shannon, Speaker,*
 Irish House of Commons, (1682-1764)
 125 x 100
 Presented, Mr R. Warren, 1875

394 395

 395 *Sir Charles Wogan, (1698-1753)*
 74 x 61
 Purchased, Mr H. Aylmer, 1891

 421 *William Conolly, M.P., (d.1760)*
 119 x 91
 Purchased, 1894

 422 *Lady Anne Conolly (née Wentworth),*
 (1713-97)
 124 x 98
 Purchased, 1894

421 422

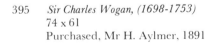

429 *James Napper Tandy, United Irishman,*
(1740-1803)
70 x 57
Presented, Mr Parker, 1872

545 *John Philpot Curran, Statesman and*
Lawyer, (1750-1817)
76 x 64
Purchased, 1903

557 *Henry Mossop, Actor, (1729-73)*
21 x 16
Purchased, 1903

599 *Esther Johnson (Swift's 'Stella'), (1681-*
1728)
30 x 25
Purchased, 1908

660 *John Parnell, Statesman, (1744-1801)*
98 x 76
Purchased, Mr J. Parnell, 1914

820 *John Philpot Curran, Statesman and*
Lawyer, (1750-1817)
129 x 105
Presented, Mrs Maffett, 1919

876 *Samuel Kyle, Protestant Bishop of Cork,*
Scholar, (1771-1848)
91 x 72
Presented, Executors of the late Mr
M. White, 1926

895 *George Berkeley, Protestant Bishop of*
Cloyne, Philosopher, (1685-1753)
113 x 91
Purchased, 1927

429

545

557

599

660

820

876

895

1137 *Charles Caldwell*
 76 x 63
 Presented, Mr D. Cooper, 1947

1227 *Two Princes of the O'Donnells*
 202 x 156
 Presented, Sir Owen O'Malley,
 1951

1270 *Miss Lynch of Barna (afterwards Mrs
 Kelly)*
 76 x 63
 Presented, Mrs Gorges, 1953

1271 *Mrs Kelly, (Sister-in-Law of
 Swift's 'Blue-Eyed Nymph')*
 73 x 58
 Presented, Mrs Gorges, 1953

1345 *Samuel Lovell, (Father of Rachel Jane
 who married Richard Edgeworth)*
 72 x 58
 Presented, Mrs R. Montagu, 1956

1346 *Sir John Edgeworth, (Governor of Ross
 Castle)*
 76 x 63
 Presented, Mrs R. Montagu, 1956

1347 *Mrs Samuel Lovell, (Mother of Rachel
 Jane)*
 72 x 58
 Presented, Mrs R. Montagu, 1956

1348 *Lady Edgeworth, (Daughter of 'The
 Widow Bridgeman')*
 76 x 63
 Presented, Mrs R. Montagu, 1956

1137

1227

1270

1271

1345

1346

1347

1348

1349	Colonel Francis Edgeworth ('The Red Grandfather') 86 x 67 Presented, Mrs R. Montagu, 1956
1352	Thomas, Lord Longford 64 x 53 Presented, Mrs R. Montagu, 1956
1353	Mrs Mary Edgeworth (née Suxbery), (1667-1709) 76 x 63 Presented, Mrs R. Montagu, 1956
1354	Jane Tuite, (Wife of Francis Edgeworth) 76 x 63 Presented, Mrs R. Montagu, 1956
1356	Richard Edgeworth 127 x 102 Presented, Mrs R. Montagu, 1956
1357	Francis Edgeworth, Clerk of the Crown and Hanaper 76 x 63 Presented, Mrs R. Montagu, 1956
1648	Joseph Leeson, (1660-1741) 37 x 32, on panel Milltown Gift, 1902
1649	Margaret, Wife of Joseph Leeson 37 x 32, on panel Milltown Gift, 1902

1349

1352

1353

1354

1356

1357

1648

1649

1730	*Billy Byrne of Ballymanus* 36 x 25 Mrs M. Byrne Bequest, 1963

1784	*Wolfe Tone, (1763-98)* 78 x 65 Provenance unknown

1815	*Spranger Barry, (1719-77)* 84.3 x 66.5 Purchased, London, Christie's, 1910

1730

1784

1923	*Anna Maria Darby* 76 x 61 Mrs H. Krohn Bequest, 1969

4069	*Dean Swift, (1667-1745)* 76 x 64 Presented, Friends of the National Collections, 1973

4164	*Richard Talbot, Earl and Duke of* *Tyrconnell, (1630-91)* 127 x 102 Purchased, Dublin, Malahide Castle Sale, 1976

1815

1923

4069

4164

rish School (c.1800)

4007	*Trompe L'Oeil of Engraving by* *Nathaniel Hone ('The Spartan Boy')* 64 x 51 Purchased, Belfast, Mr A. Thompson, 1970

4008	*Trompe L'Oeil of Engraving by Lowry* 56 x 43 Purchased, Belfast, Mr A. Thompson, 1970

4007

4008

Irish School (c.1805)

1945 *Sir John Edward Browne*
 90 x 74.5
 Provenance unknown

Irish School (1891)

1233 *A Portrait of a Child*
 Signed: *J.H.B. '91*
 41 x 33
 Presented, Mr N. Richardson, 1952

1945 1233

Irish School (19th century)

302 *John Moore, (Father of Thomas Moore)*
 74 x 61
 Purchased, Dublin, Mr R. Collins
 Collection, 1887

302 303

303 *Anastasia Moore (née Codd), (Mother of
 Thomas Moore)*
 74 x 61
 Purchased, Dublin, Mr R. Collins
 Collection, 1887

1116 *Captain McNamara, M.P.*
 76 x 63
 Presented, Miss M. Twigg, 1944

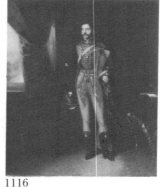

1120 *Patrick Kennedy, Writer of Memoirs and
 Folklorist, (1801-73)*
 76 x 61
 Purchased, Miss K. O'Byrne, 1944

1116 1120

1228 *A Prince of the O'Donnells with Three
 Children*
 236 x 150
 Presented, Sir Owen O'Malley,
 1951

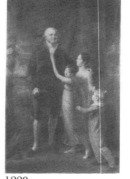
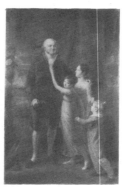

1295 *Denis Florence McCarthy, Poet,
 (1817-82)*
 38 x 30
 Purchased, Dr E. McCarthy, 1954

1228 1295

1351　　*Lovell Edgeworth*
　　　　76 x 65
　　　　Presented, Mrs R. Montagu, 1956

1355　　*A Lady with Two Children, ('The*
　　　　Spanish Grandmother')
　　　　78 x 107
　　　　Presented, Mrs R. Montagu, 1956

1832　　*Ireland Without the Repeal*
　　　　18 x 25, on porcelain
　　　　Purchased, Co. Dublin, Mrs M.
　　　　Morrin, 1967

1833　　*Ireland With the·Repeal*
　　　　18 x 25, on porcelain
　　　　Purchased, Co. Dublin, Mrs M.
　　　　Morrin, 1967

1969　　*At the Races*
　　　　71 x 92
　　　　Provenance unknown

1351

1355

1832

1833

Irish School (20th century)
　　1316　　*A Portrait Group*
　　　　　Signed: *F.B.*
　　　　　29 x 36, on panel
　　　　　Presented, Sir Shane Leslie, 1955

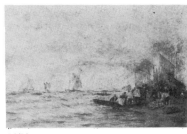

1969

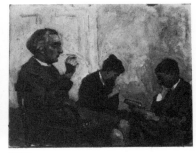

1316

Irish or English School (20th century)
　　4070　　*A Seashore*
　　　　　18 x 26, on paper
　　　　　Provenance unknown

4070

J

Jellett, Mainie (1897-1944)

1326　*Decoration*
　　　Signed: *M. Jellett '29*
　　　89 x 53, on panel
　　　Evie Hone Bequest, 1955

1873　*An Abstract*
　　　63 x 49.5
　　　Purchased, Dublin, Dawson
　　　Gallery, 1968

1874　*A Composition*
　　　Signed: *Mainie Jellett*
　　　62 x 92
　　　Purchased, Dublin, Dawson
　　　Gallery, 1968

1875　*A Composition*
　　　Signed: *Mainie Jellett*
　　　62 x 92
　　　Purchased, Dublin, Dawson
　　　Gallery, 1968

4316　*A Three-Fold Screen*
　　　(each fold) 171 x 58
　　　Miss R. Kirkpatrick Bequest, 1979

4317　*An Abstract Composition*
　　　39 x 115
　　　Miss R. Kirkpatrick Bequest, 1979

1326

1873

1874

1875

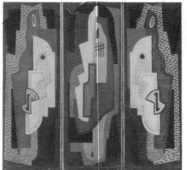

4316

4317

4318 *A Composition – Sea Rhythm*
 44 x 144
 Miss R. Kirkpatrick Bequest, 1979

4318

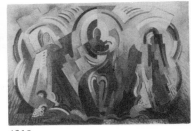

4319 *The Virgin of Eire*
 64 x 92
 Miss R. Kirkpatrick Bequest, 1979

4319

4320 *Achill Horses*
 61 x 92
 Miss R. Kirkpatrick Bequest, 1979

4321 *I Have Trodden the Winepress Alone*
 76 x 56
 Miss R. Kirkpatrick Bequest, 1979

4334 *Six Oil Studies* (not illustrated)
 Part of studio contents
 Purchased, Dublin, Neptune
 Gallery, 1980

4320

4321

Jervas, Charles (c.1675-1739)

177 *Jonathan Swift, Satirist, (1667-1745)*
 74 x 62
 Purchased, Mr Justice Berwick,
 1875

4118 *Jane Seymour Conway*
 92 x 168
 Purchased, Mr C. Rothenburg, 1974

4118

177

Jones, Thomas (1823-93)

123 *Henry Grattan, Statesman and Orator,*
 (1746-1820)
 (after James Ramsey)
 110 x 85
 Presented, Lady Grattan, 1873

132 *Sir Maziere Brady, Lord Chancellor of*
 Ireland, (1796-1871)
 238 x 132
 Presented, Lady Brady, 1874

123

132

624 *B. Colles Watkins, Landscape Painter,*
 (1833-91)
 Signed with monogram; inscribed
 on reverse and dated 1892
 76 x 63
 Presented, Dublin, Mr G. Cope,
 1912

949 *Dr Stoney, F.R.S., (1826-1911)*
 Inscribed: *Dublin 1883*
 143 x 112
 Presented, Miss E. Stoney, 1931

1995 *Henry Grattan, Statesman and Orator,*
 (1746-1820)
 112 x 87
 Provenance unknown

Attributed to **Jones**
521 *G.A. Taylor, Founder of the Taylor Art*
 Prizes and Scholarships
 46 x 33
 Presented, Miss Bagot, 1901

624

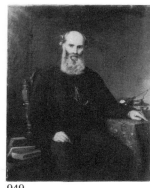

949

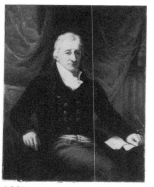

1995

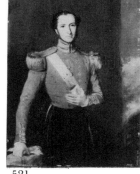

521

K

Kavanagh, Joseph Malachy (1856-1918)

1194 *The Old Convent Gate, Dinan*
Signed: *Kavanagh 1883*
56 x 38
Purchased, Dublin, Dawson
Gallery, 1950

4113 *Sheep in a Landscape*
Signed: *J M Kavanagh*
43 x 54
Presented, Mr M. Fridberg, 1974

4114 *A November Evening*
Signed: *J M Kavanagh*
27 x 36
Presented, Mr M. Fridberg, 1974

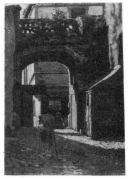

1194

4113

4114

1236

Keating, Seán (1889-1978)

1236 *An Allegory*
Signed: *Keating*
102 x 130
Presented, Friends of the National
Collections, 1952

1330 *A Seascape with Figures*
Signed: *Keating*
46 x 62, on board
Presented, Haverty Trust, 1956

4196 *Homage to Frans Hals*
Signed: *Keating*
76 x 87
Úna Bean Uí Nualláin Bequest,
1977

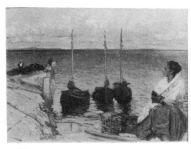

1330

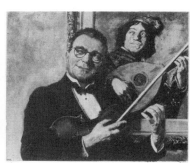

4196

King, J. (19th century)

645 *William Mulready, Artist, (1786-1863)*
Inscribed on reverse: *Painted by J.*
King from photo by P.H.D. 1885
20 x 15, on panel
Presented, Mr F. Cundall, 1913

Kirkwood, Harriet (20th century)

4043 *Dr George Furlong*
51 x 41
Presented, Mr A. Crichton, 1972

645

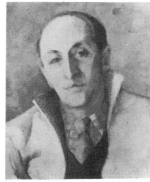

4043

L

Lamb, Charles (1893-1965)

1946 *A Portrait of a Gentleman*
 Signed: *C. Lamb, 1921*
 76.5 x 63.5
 Provenance unknown

1956 *A Portrait of a Gentleman*
 76 x 63
 Provenance unknown

1957 *Lorcan Sherlock, Dublin City Manager*
 76 x 63
 Provenance unknown

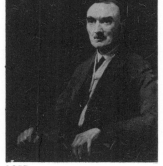

1946

1956

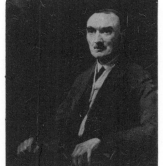

1957

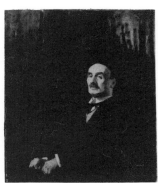

411

Latham, James (1696-1747)

411 *Charles Tottenham, 'Tottenham in His Boots', (1685-1758)*
 Dated 1731
 221 x 145
 Presented, E. Guinness, 1st Lord Iveagh, 1891

431 *Esther Johnson, (Swift's 'Stella'), (1681-1728)*
 74 x 58
 Purchased, Dublin, Mr J. Nairn, 1893

1954 *Henry Maule, Bishop of Cloyne, (1676-1758)*
 76 x 63.5
 Provenance unknown

431

1954

4124 *Eaton Stannard, (d.1755)*
 224 x 137
 Purchased, London, Christie's, 1975

4153 *Andrew Nugent of Dysart, (d.1735)*
 76 x 63
 Purchased, Dublin, Malahide Castle
 Sale, 1976

4154 *Thomas, Baron Delvin and 4th Earl of*
 Westmeath, (1669-1752)
 76 x 63
 Purchased, Dublin, Malahide Castle
 Sale, 1976

4155 *Christopher, Lord Delvin, (d.1752)*
 76 x 64
 Purchased, Dublin, Malahide Castle
 Sale, 1976

4156 *Lady Catherine Nugent, (d.1756)*
 75 x 62
 Purchased, Dublin, Malahide Castle
 Sale, 1976

4124

4153

4154

4155

Latre, G. de (19th century)
 851 *Mrs S.C. Hall (née Fielding), Writer,*
 (1800-81)
 Signed: *de Latre, 1851*
 88 x 61
 Purchased, 1924

4156

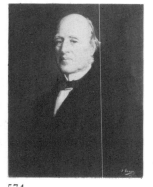
851

Lavery, John (1856-1941)
 574 *W.E.H. Lecky, Historian, (1838-1903)*
 Signed: *J. Lavery*
 63 x 48
 Purchased, the artist, 1906

 637 *John Thomas Gilbert, Antiquarian,*
 (1829-97)
 Inscribed on reverse and dated 1910
 52 x 44
 Presented, Lady Gilbert, 1912

574

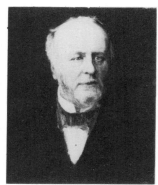
637

831 *Dora Sigerson (Mrs Shorter), Poet,*
 (c.1870-1918)
 Signed: *J. Lavery*
 Dated on reverse 1919
 75 x 63
 Presented, Mr C. Shorter, 1921

923 *T.P. O'Connor, Parliamentarian and*
 Journalist
 Signed: *J. Lavery*
 76 x 63
 Presented, Sir Alex Maguire and Mr
 F. Parker, 1930

831 923

1251 *Lady Lavery in an Evening Cloak*
 Signed: *J. Lavery*
 46 x 36
 Presented, Executors of the late Mr
 E. Marsh, 1953

1644 *Lady Lavery with her Daughter (Mrs*
 Denis Gwynn) and Step-daughter
 (afterwards Lady Semphill), (1911)
 344 x 274
 Purchased, Mr A. Welch, 1959

1251 1644

1736 *The Ratification of the Irish Treaty in*
 the English House of Lords, 1921
 Signed: *J. Lavery.*
 Inscribed on reverse: *Painted in the*
 House of Lords on the afternoon of 16
 December 1921
 36 x 26, on board
 Purchased, London, Fine Art
 Society, 1963

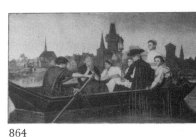

awless, Matthew (1837-64)

864 *The Sick Call*
 Signed: *M. J. Lawless, 1863*
 63 x 103
 Purchased, Captain R. Langton
 Douglas, 1925

864

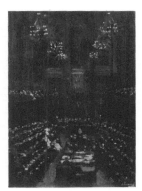

1736

ee, Anthony (fl.1724-67)

698 *Joseph Leeson, (afterwards 1st Earl of*
 Milltown), (1711-83)
 Signed: *A. Lee pinx. 1735*
 197 x 122
 Milltown Gift, 1902

699 *Cecilia Leeson*
 77 x 64
 Milltown Gift, 1902

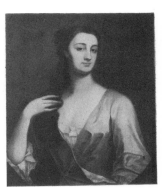

698 699

Leech, William (1881-1968)

1245 *A Convent Garden, Brittany*
 Signed: *Leech*
 132 x 106
 Presented, Mrs M. Bottrell, 1952

1246 *The Sunshade*
 Signed: *Leech*
 81 x 65
 Presented, Mrs M. Bottrell, 1952

1422 *A Woman Darning*
 Signed: *Leech*
 73 x 60
 Mr R. Best Bequest, 1959

1423 *Waving Things, Concarneau*
 Signed: *Leech*
 56 x 82
 Mr R. Best Bequest, 1959

1914 *A Self-Portrait*
 Signed: *Leech*
 64 x 56
 Purchased, Dublin, Dawson
 Gallery, 1969

1915 *Au Cinquième: A Portrait of the Artist's
 Wife*
 Signed: *Leech*
 75 x 60
 Purchased, Dublin, Dawson
 Gallery, 1969

1934 *William Smith O'Brien*
 Signed: *Leech*
 63.5 x 53
 Presented, Mr D. Gwynn and Mrs
 D. Moorehead, 1970

4009 *A View of Quimperle*
 72 x 91
 Purchased, Dublin, Mr J. Gorry,
 1970

1245

1246

1422

1423

1914

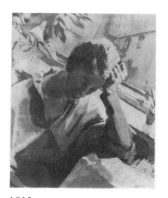

1915

1934

4009

Fanu, Brindsley (20th century)
919 *Joseph Sheridan Le Fanu*
 Signed: *B. Le Fanu 1916*
 36 x 26
 Presented, Mr T. Le Fanu, 1929

Jeune, James (20th century)
1785 *Jimmy O'Dea, Comedian, (1900-65)*
 Signed: *Le Jeune*
 51 x 41
 Presented, Miss R. O'Dea, 1965

919

1785

ewis, John (fl.1740-69)
579 *Margaret (Peg) Woffington, Actress,*
 (1718-60)
 Signed: *Jn. Lewis, April, 1753*
 74 x 62
 Purchased, London, Christie's, 1907

1132 *Thomas Sheridan, Actor and Author,*
 (1719-88)
 Signed: *Jn. Lewis, fecit 175 . . .*
 127 x 102
 Presented, Mr W. Le Fanu, 1946

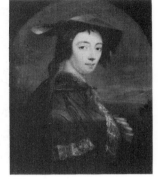
579

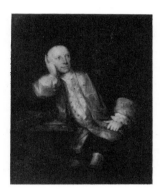
1132

over, Samuel (1797-1868)
4075 *Mrs Lover and her Daughter*
 Signed: *Samuel Lover RHA 1830*
 92 x 71
 Mrs E. Bartlett Bequest, 1974

yon, P. (fl. c.1900)
1950 *A View of Killarney*
 Signed: *P. Lyon*
 37.8 x 81.5
 Provenance unknown

1950

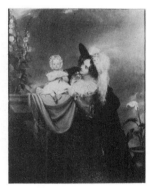
4075

M

McCloy, Samuel (1831-1904)
 4119 *Daydreams*
 Signed: *Samuel McCloy, School of Art*
 Waterford
 41 x 51
 Purchased, Dublin, C. O'Connor and
 Co. Ltd, 1974

1866

4119

McEvoy, William (1858-80)
 1866 *A View of Dublin Bay*
 Signed: *W. McE.*
 61 x 107
 Purchased, Dublin, Mr G. Laffan,
 1968

MacGonigal, Maurice (1900-79)
 1551 *The Black Bottle*
 Signed: *MacCongal*
 51 x 61
 Presented, Haverty Trust, 1960

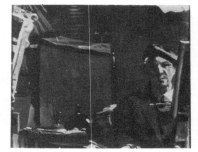

1551

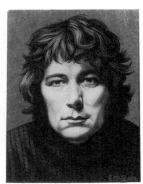

4112

McGuire, Edward (b.1932)
 4112 *Seamus Heaney, (b.1939)*
 Signed: *E McG 1974*
 31 x 23, tempera on panel
 Purchased, Dublin, Dawson
 Gallery, 1974

 4201 *Seán O'Faolain*
 Signed: *Edward McG 1977*
 76 x 64
 Presented, Committee organised by
 Mr S. Mulcahy, 1977

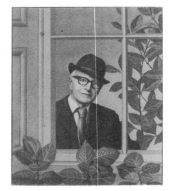

4201

1416

MacIlwaine, J.B.S. (fl. c.1900)
 1416 *Late Summer*
 12 x 15, on board
 Mr R. Best Bequest, 1959

cLachlan, Norman (d.1978)

975 *Edward Martyn, Dramatic Author,*
Nationalist, Philanthropist, (1859-1923)
Signed: *McLachlan*
61 x 51
Presented, Mr J. Holloway, 1934

aclise, Daniel (1806-70)

156 *Merry Christmas in the Baron's Hall*
Signed: *D. Maclise 1838*
183 x 366
Purchased, London, Christie's, 1872

975

156

205 *The Marriage of the Princess Aoife of*
Leinster with Richard de Clare, Earl of
Pembroke (Strongbow)
Exhibited 1854
309 x 505
Presented, Sir Richard Wallace,
1879

1019 *Edmund Kean, Actor, (1787-1833), as*
Hamlet
61 x 51
Purchased, Mrs J. Douglas, 1939

205

1019

1208 *Charles 1, King of England and his*
Children, before Oliver Cromwell
Painted 1836
184 x 235
Purchased, Mr W. Dugdale, 1951

1927 *A Scene from Gil Blas*
Signed: *D. Maclise, 1839*
76.5 x 94, on panel
Purchased, Dublin, Mr W.
Cherrick, 1969

1208

1927

4054 *Thomas Moore*
Signed: *D. MACLISE*
77 x 64
Purchased, London, Mr N. Orgel,
1972

acManus, Henry (c.1810-78)

547 *John Blake Dillon, Young Irelander,*
(1816-66)
18 x 14, on panel
Presented, Miss Duffy, 1903

4054

547

[**265**]

1917 *Reading 'The Nation'*
 30.5 x 35.5
 Sir Charles Gavan Duffy Bequest,
 1903

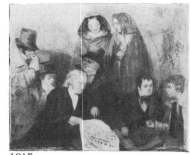

1917

4305

Manning, May (d.1930)

4305 *A Landscape with a Setting Sun*
 Signed: *M.R. Manning*
 41 x 56
 Mrs E. Nuttall Bequest, 1978

Mannix, Robert (1841-1907)

934 *C.H. Granby as Sir Peter Teazle in The
 School for Scandal*
 Signed: *Mannix, 1873*
 91 x 72
 Presented, Mr J. Holloway, 1930

934

4146

Morphey, Garret (fl.1680-1716)

4146 *William, 4th Viscount Molyneux of
 Maryborough, (c.1655-1718)*
 75 x 61
 Purchased, Dublin, Malahide Castle
 Sale, 1976

4147 *Bridget, Viscountess Molyneux, (1665-
 1713)*
 75 x 61
 Purchased, Dublin, Malahide Castle
 Sale, 1976)

4148 *Anne O'Neile (later Mrs Seagrave),
 (c.1685-after 1727)*
 45 x 36
 Purchased, Dublin, Malahide Castle
 Sale, 1976

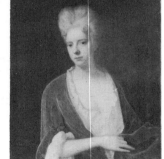

4147

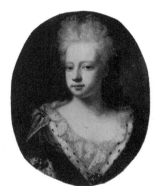

4148

4149 *Rose O'Neile (later Mrs Wogan), (after
 1680-before 1728)*
 45 x 36
 Purchased, Dublin, Malahide Castle
 Sale, 1976

4150 *Frances Talbot, (d.1718)*
 74 x 63
 Purchased, Dublin, Malahide Castle
 Sale, 1976

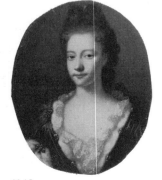

4149

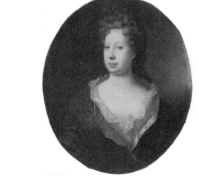

4150

4151 *Caryll, 3rd Viscount Molyneux of Maryborough, (1662-1700)*
75 x 61
Purchased, Dublin, Malahide Castle Sale, 1976

4152 *Colonel Nicholas Wogan of Rathcoffey, (1682?-after 1715)*
Inscribed and dated 1720
70 x 58
Purchased, Dublin, Malahide Castle Sale, 1976

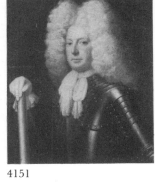

4151

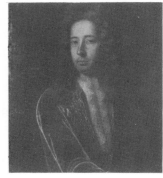

4152

Moynan, Richard (1856-1906)

1057 *A Castle on a River, Sunset*
Signed: *R.T. Moynan R...*
36 x 53
Sherlock Bequest, 1940

4028 *The Death of the Queen*
239 x 148
Purchased, Mr I. Banon, 1971

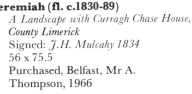

1057

4028

Mulcahy, Jeremiah (fl. c.1830-89)

1795 *A Landscape with Curragh Chase House, County Limerick*
Signed: *J.H. Mulcahy 1834*
56 x 75.5
Purchased, Belfast, Mr A. Thompson, 1966

4062 *An Irish Landscape*
Signed: *J.H. Mulcahy Oct 9, 1840*
99 x 125
Purchased, Dublin, Hibernian Antiques, 1973

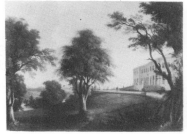

1795

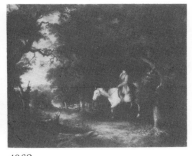

4062

Mulready, William (1786-1863)

387 *The Toy-Seller, (1835)*
112 x 142
Purchased, London, Christie's, 1891

611 *Bathers Surprised*
59 x 44, on panel
Purchased, Sir Hugh Lane, 1911

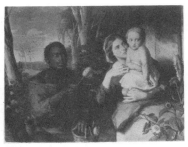

387

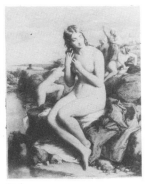

611

616 *The Artist's Father*
17 x 13.5, on panel
Purchased, Dublin, T. Stoker Sale,
1910

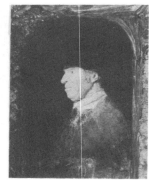

616

963

963 *A Gypsy Encampment, (1810)*
32 x 41
Purchased, London, Christie's, 1933

1382 *A Squire in a Tavern*
Signed: *Wm. Mulready*
53 x 43, on panel
Presented, Washington, Monsignor
J. Ryan, 1958

1825 *Idle Boys*
Signed: *W. M.*
76.5 x 64
Purchased, Mr W. Williamson, 1967

1826 *Cupping the Bees*
Signed: *W. Mulready*
Inscribed on reverse: *W. Mulready,
R.A.*
25.7 x 39.4
Purchased, Sussex, McInnes Gallery,
1967

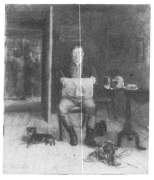

1382

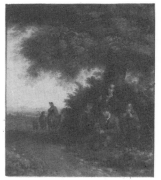

1825

Mulrenin, Bernard (1803-68)

408 *George Petrie, Artist and Archaeologist,
(1790-1866)*
Signed: *B.M.*
26 x 22, on panel
Presented, Mr W. Littledale, 1884

1826

408

Mulvany, George (1809-69)

207 *Daniel O'Connell, Statesman, (1775-
1847)*
90 x 70
Purchased, the artist's daughter,
1884

208 *John Banim, Novelist and Poet, (1798-
1842)*
74 x 61
Purchased, the artist's daughter,
1884

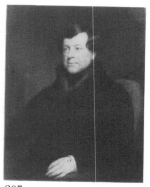

207

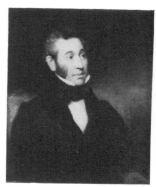

208

926 *A Self-Portrait*
76 x 63
Presented, The Misses Mulvany,
1930

928 *Reverend Thomas Burke, (1830-83)*
127 x 102
Presented, The Misses Mulvany,
1930

932 *Sir Michael O'Loghlen, Lawyer, (1789-1842)*
Signed: *G. Mulvany, R.H.A. 1843*
244 x 152
Presented, Sir Michael O'Loghlen,
1930

1097 *Thomas Moore, Poet, (1779-1852)*
Signed: *G. Mulvany, R.H.A. 1835*
91 x 71
Purchased, Stevens and Browne Ltd,
1942

1276 *The Village Orphans*
Signed: *G.F. Mulvany, 18...*
62 x 91
Purchased, Dublin, Mr D. Shine,
1953

1284 *Thomas Francis Meagher, 'Meagher of the Sword', Young Irelander, (1823-67)*
76 x 63
Presented, Friends of the National
Collections, 1954

1764 *Thomas James Mulvany, (1821-92)*
Inscribed: *G.F. Mulvany, 1852*
92 x 71
Presented, Dublin, Mrs E. Dowling,
1964

1975 *The Wandering Lascar*
143 x 112
Provenance unknown

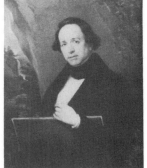

926

928

932

1097

1276

1284

1764

1975

Attributed to **Mulvany**

538　*Sir Frederick William Burton, Artist and*
　　　Director, National Gallery, London,
　　　(1816-1900)
　　　74 x 61
　　　Purchased, Miss Mulvany

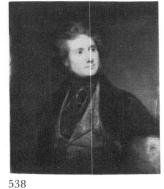

538

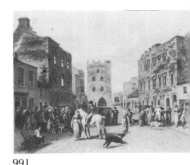

991

Mulvany, John (1766-1838)

991　*A View of Kilmallock*
　　　Signed: *J.G. Mulvany*
　　　68 x 80
　　　Purchased, Mr M. Craig, 1937

1277　*A Kitchen Interior*
　　　55 x 71, on panel
　　　Purchased, Dublin, Mr D. Shine,
　　　1953

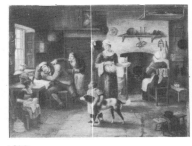

1277

4135

Mulvany, Thomas (1779-1845)

4135　*The Mountain Rivulet*
　　　Signed: *T.J. Mulvany 1838*
　　　36 x 46, on board
　　　Purchased, Dublin, Mealy's Auction
　　　Rooms, 1975

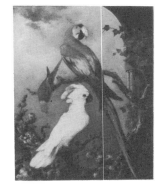

Murphy, Edward (c.1796-1841)

161　*Paroquets*
　　　85 x 61
　　　Purchased, Dublin, Sir Maziere
　　　Brady Collection, 1871

161

Nairn, George (1799-1850)

495 *A Dog*
 20 x 28, on panel
 Presented, Dublin, Mr J. Nairn,
 1899

4200 *The Fairy Queen*
 Signed: *Geog Nairn ARHA 1847 pinxt*
 61 x 78
 Purchased, Dublin, Mr R.
 McConkey, 1977

495

4200

O

O'Brien, Dermod (1865-1945)

1160 *E. Magawley Banon*
 Signed: *D. O'Brien, 1934*
 76 x 61
 Presented, Mr M. Banon, 1947

1414 *The White Dress, (Lady Farrer)*
 30 x 18, on panel
 Mr R. Best Bequest, 1959

1861 *The Deer Park, Powerscourt*
 Signed: *D. O'Brien, 1925*
 62 x 76
 Presented, Dr B. O'Brien, 1968

1862 *Lennox Robinson, (1886-1958)*
 85 x 109
 Purchased, Dr B. O'Brien, 1968

1160

1414

1861

1862

O'Connor, James Arthur (c.1792-1841)

18 *The Poachers*
 Signed: *J.A. O'Connor, 1835*
 55.5 x 70.5
 Purchased, 1879

158 *Moonlight*
 18 x 17, on panel
 Purchased, London, Christie's, 1872

18

158

163 *A View of the Glen of the Dargle*
 Signed: *J.A. O'Connor, 1834*
 36 x 50
 Purchased, London, Christie's, 1873

489 *A Landscape*
 32 x 43, on panel
 Purchased, Co. Dublin, Mr H.
 Scott, 1900

825 *A View of the Devil's Glen*
 63 x 76
 Presented, Captain R. Langton
 Douglas, 1919

1114 *A Landscape*
 Sherlock Bequest, 1940

1182 *A Landscape: Homeward Bound*
 Signed: *J.A. O'Connor*
 63 x 76
 Presented, the family of Sir Robert
 and Lady Woods, 1950

1241 *A Landscape*
 15 x 19, on panel
 Purchased, Mr D. Lowe, 1952

1242 *A Landscape*
 9 x 10, on panel
 Purchased, Mr D. Lowe, 1952

4010 *Ballinrobe House*
 42 x 71
 Purchased, London, Mr C. Kenny,
 1970

163

489

825

1114

1182

1241

1242

4010

4011 *The Mill, Ballinrobe*
42 x 71
Purchased, London, Mr C. Kenny,
1970

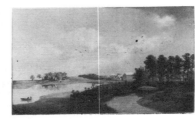
4011

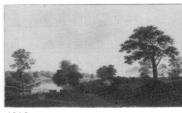
4012

4012 *Pleasure Grounds, Ballinrobe*
42 x 71
Purchased, London, Mr C. Kenny,
1970

4013 *A View of Lough Mask*
42 x 71
Purchased, London, Mr C. Kenny,
1970

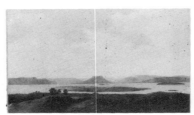
4013

4041

4041 *A Thunderstorm: The Frightened Wagon*
Signed: *J A O'Connor 1832*
65 x 76
Presented, Mr F. McCormick, 1972

4132 *A Frost Piece*
Signed: *J A O'Connor*
20 x 17, on board
Presented, Mr J. Manning, 1975

O'Connor, John (1830-89)
1299 *A Landscape*
Signed: *O'Connor, 18...*
51 x 68
Purchased, Dublin, Mr J. Doyle,
1954

4132

1299

O'Conor, Roderic (1860-1940)
922 *A Self-Portrait*
Signed: *R. O'C '03*
55 x 46
Mr W. Wallace Anderson Bequest,
1929

1642 *La Ferme de Lezaver, Finistère*
Signed: *O'Conor, 1894*
72 x 93
Purchased, London, Messrs Roland,
Browse and Delbanco, 1961

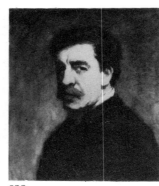
922

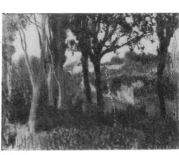
1642

1806 *A Quiet Read*
Canvas stamped: *Atelier O'Conor*
46 x 55.5
Purchased, Dublin, 1966

1806

4038

4038 *A Reclining Nude before a Mirror*
54 x 74
Purchased, London, Messrs Roland
Browse and Delbanco, 1971

4057 *A Landscape with Rocks*
38 x 46
Purchased, Dublin, Mr S.
O'Criadain, 1973

4134 *La Jeune Bretonne*
Signed: *R. O'Conor 90*
65 x 50
Purchased, London, Crane Kalman
Gallery, 1975

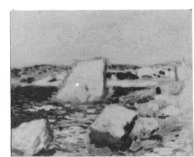
4057

4134

4324 *Between the Cliffs, Aberystwyth*
24 x 32, on panel
Purchased, Dublin, Mr P. Lamb,
1979

O'Doherty, Roisin (20th century)
1794 *Seamus Robinson, (1890-1961)*
Signed: *Roisin O'Doherty*
45.5 x 35.5
Purchased, the artist, 1966

4324

1794

O'Donnell, Conn (18th century)
1200 *Art O'Neill, Harper, (1737-1816)*
100 x 76
Purchased, Dublin, Dr S. O'Kelly,
1951

O'Keefe, John (c.1797-1838)
1809 *Mrs McCarthy, (Grandmother of J.H.
McCarthy)*
69.5 x 56.2
Mrs L. McCarthy-Gimson Bequest,
1966

1200

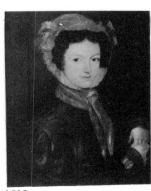
1809

1810 *Mrs John O'Keefe, (Wife of the Artist)*
 76.4 x 63.7
 Mrs L. McCarthy-Gimson Bequest,
 1966

684

O'Neill, George (1828-1917)
 684 *A Deathbed Scene*
 28 x 38, on board
 Purchased, Mr T Collins, 1913

1810

O'Neill, Henry (1817-80)
 313 *John Cornelius O'Callaghan, Historical*
 Writer, (1805-83)
 74 x 62
 Presented, Reverend M.
 O'Callaghan, 1883

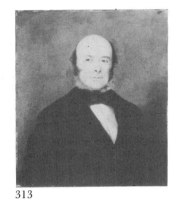

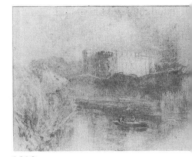

1919

 1919 *Kilkenny Castle*
 18.5 x 25.5
 Purchased, Dublin, Dr W. Pearsall,
 1902

313

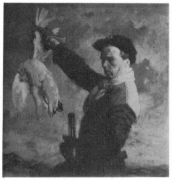

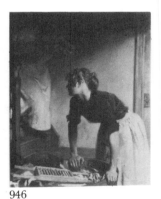

Orpen, William (1878-1931)
 945 *The Dead Ptarmigan, (A Self-Portrait),*
 (c.1909)
 100 x 91
 Lady Poe Bequest, 1930

 946 *The Wash House*
 Signed: *Orpen, 1905*
 91 x 73
 Lady Poe Bequest, 1931

945

946

 955 *A Portuguese Lady*
 92 x 71
 Purchased, London, Knoedler and
 Co., 1932

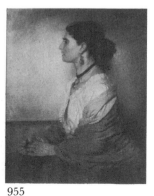

 956 *Looking at the Sea*
 50 x 61, on panel
 Purchased, London, Knoedler and
 Co., 1932

955

956

957 *Sunlight*
Signed: *Orpen*
50 x 61, on panel
Purchased, London, Knoedler and
Co., 1932

970 *The Knacker's Yard*
Signed: *Orpen*
127 x 103
Purchased, Captain R. Langton
Douglas, 1934

976 *Dr E. J. Dillon, War Correspondent and
Publicist*
Signed: *Orpen*
112 x 95
Presented, Mrs Dillon, 1935

1199 *The Vere Foster Family, (c.1905)*
198 x 198
Purchased, Mrs D. May, 1951

1237 *Trees at Howth*
Signed: *Orpen*
91 x 87
Presented, Friends of the National
Collections, 1952

1274 *Augusta Gregory, Dramatist*
61 x 46
Purchased, Mrs F. Orpen, 1953

1341 *The Artist's Parents*
Signed: *Orpen*
169 x 138
Mrs F. Orpen Bequest, 1956

1762 *Death in the Snow*
Signed: *Orpen*
45 x 58.5, on board
Purchased, Dr T. Pym, 1963

957

970

976

1199

1237

1274

1341

1762

1978　　*Lady Orpen in her Drawingroom*
　　　　Signed: *William Orpen, 1901*
　　　　103 x 87
　　　　Presented, Dr E. Fitzpatrick on
　　　　behalf of the Executors of the late
　　　　Mrs R. Parker, 1970

4030　　*The Well of the Saints* or *the Holy Well*
　　　　Signed: *Orpen*
　　　　234 x 186, in tempera
　　　　Purchased, Agnew Somerville
　　　　Gallery, 1971

1978

4030

Osborne, Harriet (fl.1854-78)

1173　　*Maximilian O'Hagan*
　　　　55 x 46
　　　　Presented, Messrs M. Garbaye and
　　　　M. de Letre, 1948

1174　　*Interior*
　　　　Signed with monogram
　　　　46 x 37, on panel
　　　　Presented, Messrs M. Garbaye and
　　　　M. de Letre, 1948

1173

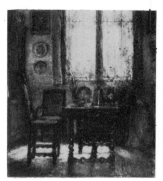
1174

Osborne, Walter (1859-1903)

553　　*The Lustre Jug*
　　　　Signed: *Walter Osborne*
　　　　76 x 61
　　　　Purchased, Executors of the artist,
　　　　1903

554　　*A Galway Cottage*
　　　　Signed: *... Osborne*
　　　　30 x 38, on panel
　　　　Purchased, Executors of the artist,
　　　　1903

555　　*A Self-Portrait*
　　　　Signed: *Walter Osborne*
　　　　46 x 36
　　　　Presented, the artist's widow, 1903

601　　*Thomas W. Moffett, President, Queen's
　　　　College, Galway, (d.1906)*
　　　　Signed: *Walter Osborne*
　　　　213 x 164
　　　　Presented, Lady Moffett, 1908

553

554

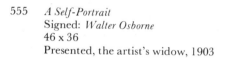
555

601

612 *A Sketch at Rye*
Signed with monogram
13 x 22, on panel
Mr C. O'Brien Bequest, 1910

635 *A Cottage Garden*
Signed: *Walter Osborne*
67 x 49
Purchased, Mrs C. Smith, 1912

612

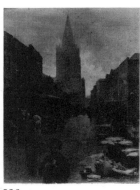

774 *Edward Dowden, Poet and Scholar,*
(1843-1913)
91 x 72
Presented, Miss H. Dowden, 1916

635

836 *St Patrick's Close, Dublin*
Signed: *Walter Osborne*
69 x 51
Purchased, Mrs Fitzgerald, 1921

858 . *A View of Hastings*
Signed: *Walter Osborne*
34 x 41
Presented, Mr E. Huxtable, 1924

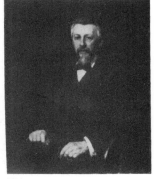

875 *A Portrait of a Lady*
Signed: *Walter Osborne*
138 x 84
Presented, Messrs F. and O.
Ashcroft, 1926

774

836

882 *J.B.S. MacIlwaine, Artist*
Inscribed: *To my friend J.B.S.*
MacIlwaine 1890
Signed: *Walter Osborne*
61 x 51
Purchased, Mr J.B.S. MacIlwaine,
1927

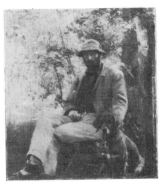

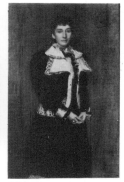

858

931 *Sir Thomas Drew, Architect, (1838-*
1910)
Signed: *W.O. '91*
68 x 51
Presented, Mr C. Pearsall, 1930

875

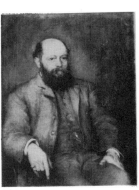

882

931

953 *Gerald Fitzgibbon, Lord Justice of*
 Appeal, (1837-1909)
 Signed: *Walter Osborne, 1894*
 69 x 51
 Presented, Miss E. Fitzgibbon, 1932

987 *Nathaniel Hone, Artist, (1831-1917)*
 86 x 94
 Purchased, Mr D. Egan, 1936

1012 *Mrs G.W. Yeates*
 Signed: *W.O. '91*
 46 x 36
 Purchased, Mr G. Yeates, 1939

1052 *An Apple Garden at Quimperle*
 Signed: *Walter Osborne, Quimperle,*
 1883
 58 x 46
 Sherlock Bequest, 1940

1053 *A Boy Blowing Bubbles*
 Signed: *Walter Osborne*
 31 x 23
 Sherlock Bequest, 1940

1060 *A Portrait of a Lady*
 Signed: *Walter Osborne*
 179 x 125
 Presented, Mr D. O'Brien, 1941

1121 *A Scene in the Phoenix Park*
 Signed: *Walter Osborne*
 71 x 91
 Purchased, Mr J. Bell, 1944

1273 *Mrs Geale-Wybrants*
 76 x 51
 Presented, Executors of the late Mrs
 E. Cuming, 1953

953

987

1012

1052

1053

1060

1121

1273

1388 *Lady Armstrong (née Ferrard)*
Signed: *Walter Osborne, '97*
127 x 102
Presented, Mrs E. Deas, 1959

1389 *Sir Walter Armstrong, Director, The
National Gallery of Ireland, (1850-
1918)*
98 x 80
Presented, Mrs E. Deas, 1959

1818 *The Rehearsal*
52 x 89
**Purchased, Dublin, Stephen Green
Antiques, 1967**

1859 *A Portrait of a Gentleman*
Signed: *Walter Osborne, '97*
76 x 63.5
**Purchased, Dublin, Anthony
Antiques, 1968**

1916 *The Four Courts, Dublin*
Signed: *Walter Osborne*
32.5 x 40.5, on board
**Purchased, Belfast, Mr A. Thompson,
1969**

1929 *Modenke Verhoft*
Inscribed on reverse: *At Antwerp*
21.1 x 13.3, on panel
Sherlock Bequest, 1940

1935 *John William Scharff, (b.1895)*
Signed: *Walter Osborne*
60.5 x 50.2
Presented, Miss M. Hutton, 1970

4314 *A Landscape with Cattle*
Signed: *Walter Osborne, '92*
36 x 51
Presented, Mrs T. Moorehead, 1978

1388

1389

1818

1859

1916

1929

1935

4314

4332 *A Landscape with a Child in White*
23 x 28, on board
Mrs E. Jameson Bequest, 1979

891

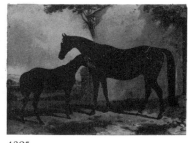

4332

Osborne, William (1823-1901)

891 *The Ward Hunt, (1873)*
109 x 184
Presented, Mr W. Jameson, 1927

4325 *A Mare and Foal*
50.5 x 69
Purchased, Dublin, C. O'Connor
and Co. Ltd, 1978

4325

O'Sullivan, Sean (1906-64)

1011 *Douglas Hyde, President of Ireland, Poet
and Scholar, (1860-1949)*
Signed: *Sean O'Sullivan, R.H.A.*
128 x 102
Purchased, the artist, 1939

1011

1770 *A Self-Portrait*
Signed: *Sean O'Sullivan, R.H.A. '39*
38 x 32
Purchased, Dublin, Mrs J. Burke
through the Dawson Gallery, 1965

1863 *Bulmer Hobson*
Signed: *Sean O'Sullivan, 1952*
61 x 51
Transferred from the National
Museum, 1968

1770

1863

P

Peters, Matthew (1741-1814)

4049 *Sylvia, a Courtesan*
63 x 76, on panel
Purchased, London, Leger Galleries
Ltd, 1972

4053 *Sir William Robinson, (1703-77)*
Signed: *Peter pinxt*
92 x 71
Presented, Mr F. Vickerman, 1972

4049

4053

Petrie, George (1790-1866)

1193 *Mrs Petrie*
77 x 63
Purchased, Mrs L. Rogers, 1950

4130 *A View of O'Connell Street, Dublin*
22 x 17, on panel
Presented, Carlow, Mr H. Maude,
1975

1193

4130

Petrie, James (c.1750-1819)

198 *A Self-Portrait*
11 x 10, on panel
Purchased, Dublin, Mr G.
O'Hanlon, 1875

Pugh, Herbert (fl.1758-88)

1819 *A Landscape with Figures, Cattle and
Sheep*
Signed: *Pugh, fecit 1759*
63.5 x 76.1
Purchased, Dublin, Mr A.
O'Connor, 1967

198

1819

Purser, Sarah (1848-1943)

561 *Mervyn Wingfield, 7th Viscount*
Powerscourt, (1844-1904)
80 x 65
Presented, Lord Powerscourt, 1904

938 *Roger Casement, Patriot and*
Revolutionary, (1864-1916)
102 x 76
Presented, Mr W. Cadbury, 1930

1024 *George W. Russell (AE), Poet, Artist*
and Economist, (1867-1935)
68 x 51
Presented, the artist, 1940

1098 *T. P. Gill, Journalist, Secretary,*
Department of Agriculture and Technical
Instruction
Dated 1898
145 x 88
Presented, Professor W. Magennis,
1942

1101 *T. W. Russell, Vice-President,*
Department of Agriculture and Technical
Instruction
76 x 63
Presented, Comtesse de Saringy,
1942

1181 *Dr Douglas Hyde, Poet, Scholar and*
First President of Ireland, (1860-1949)
76 x 63
Douglas Hyde Bequest, 1949

1220 *Joseph O'Neill, Novelist and Scholar*
Signed on reverse: *S.H. Purser 1926*
74 x 48
Presented, Mrs J. O'Neill, 1951

1376 *Roger Casement*
Study for 938
84 x 61
Presented, Mr J. McGrath, 1958

561

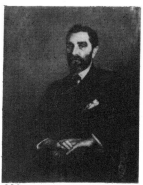

938

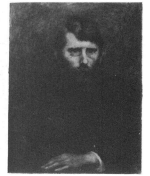

1024

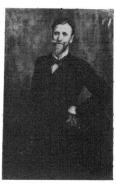

1098

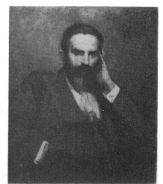

1101

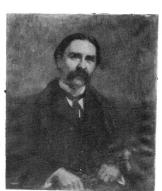

1181

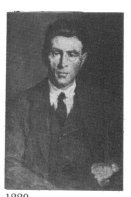

1220

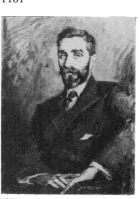

1376

1424 *Le Petit Dejeuner*
35 x 27
Mr R. Best Bequest, 1959

1811 *Reverend J.M. Hamilton.*
91.8 x 73.8
Presented, Miss J. Hamilton, 1966

4120 *Jack B. Yeats, (1871-1957)*
66 x 50, canvas laid on board
Purchased, Dr J. Le Brocquy, 1974

4131 *A Lady Holding a Doll's Rattle*
Inscribed: *à M. Julian Sturgis,*
hommage respectueux. S H Purser 1885
41 x 31
Purchased, Dublin, Hibernian
Antiques, 1975

4188 *Kathleen Behan*
26 x 24, on board
Presented, Friends of the National
Collections, 1976

1424

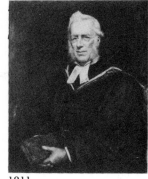
1811

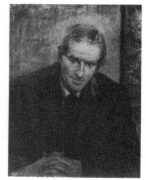
4120

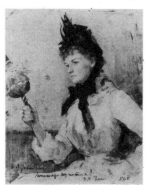
4131

4188

R

Roberts, Thomas (1748-78)

116 *A Landscape with a River and Horses*
42.5 x 52.5
Purchased, Dublin, Cranfield, 1877

935 *A Landscape with a Horse and Donkeys*
61 x 94
Purchased, Dublin, Mr H. Naylor, 1930

4052 *A Landscape*
112 x 153
Purchased, London, Mr L. Koetser, 1972

116

935

Roberts, Thomas Sautelle (c.1760-1826)

848 *A Landscape*
Signed: *T.S.R.*
57 x 83
Purchased, Mr E. Machin, 1923

4052

848

Robinson, Thomas (c.1770-1810)

4329 *Paddy Whack*
Inscribed: *Paddy Whack*
belonged to Major Newberry,
painted by Thos Robinson
60 x 74
Purchased, Dublin, J. Adam and Son, 1979

Rothwell, Richard (1800-68)

222 *Matthew Kendrick, Marine Painter,*
(d.1875)
90 x 69
Purchased, Dublin, Bennett, 1878

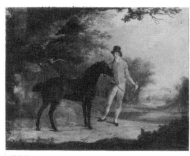

4329

222

223 *A Smiling Child*
 Signed: *Rothwell*
 39 x 36
 Purchased, London, Christie's, 1882

265 *A Self-Portrait*
 72 x 58
 Purchased, Mrs Dickson, 1887

506 *Calisto*
 Signed: *R. Rothwell*
 89 x 112
 Purchased, London, Shepherd Bros.,
 1901

609 *Gerald Griffin, Poet and Novelist,*
 (1803-40)
 168 x 102, on panel
 Purchased, Mrs P. Duffy, 1910

1102 *The Young Mother's Pastime*
 93 x 79
 Purchased, Miss Waters, 1942

1936 *Patrick Redmond*
 77 x 64.5
 Presented, Friends of the National
 Collections, 1970

4331 *Two Children on a Bank, Glendalough*
 behind
 Inscribed on reverse: *Rothwell*
 108 x 150, on panel
 Purchased, Dublin, 1979

223

265

506

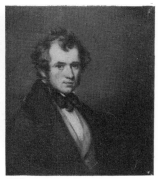
609

1102

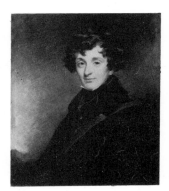
1936

4331

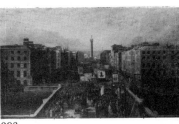
893

Russell, Charles (1852-1910)
 893 *The O'Connell Centenary Celebrations,*
 (1875)
 104 x 163
 Purchased, Dublin, Mr H. Naylor,
 1927

Russell, George (AE) (1867-1935)

1761 *The Virgin and Child*
 61 x 46, on cardboard
 Presented, Reverend H. Rees, 1963

1787 *Iseult Gonne (Mrs Francis Stuart)*
 Signed: *AE*
 56 x 46
 Purchased, Dublin, Dawson
 Gallery, 1965

4068 *Saidbh Trinseach*
 Signed: *AE*
 61 x 76
 Presented, Friends of the National
 Collections, 1973

4071 *A Landscape with a Couple, and a Spirit*
 with a Lute
 Signed: *AE*
 54 x 81, canvas laid on board
 Presented, Mrs F. Hart, 1973

4072 *A Landscape with a Woman and Child*
 and Three Spirits
 41 x 53, canvas laid on board
 Presented, Mrs F. Hart, 1973

4073 *A Spirit or Sidhe in a Landscape*
 25 x 19, on board
 Presented, Mrs F. Hart, 1973

 Series of murals painted for a room
 in Plunkett House, 84 Merrion
 Square, Dublin; numbered
 following original sequence

4097 *A Female with Child by a Pool of Orchids*
4098 277 x 95: 277 x 116.5, mixed media
 on wallpaper, now mounted on
 board
 Presented, Irish Agricultural
 Organisation Society Ltd, 1974

1761

1787

4068

4071

4072

4073

4097

4098

4099
4100
4101

A Female with Cranes (?) by a Pool of
Orchids
277 x 59: 277 x 117.5: 277 x 142,
mixed media on wallpaper, now
mounted on board
Presented, Irish Agricultural
Organisation Society Ltd, 1974

4102
4103

A Female and Two Children with a
Snake
277 x 95: 279 x 104, mixed media on
wallpaper, now mounted on board
Presented, Irish Agricultural
Organisation Society Ltd, 1974

4104

A Female with a Parrot and a Child
277 x 126, mixed media on
wallpaper, now mounted on board
Presented, Irish Agricultural
Organisation Society Ltd, 1974

4105

A Female with a Lyre
277.5 x 116.5, mixed media on
wallpaper, now mounted on board
Presented, Irish Agricultural
Organisation Society Ltd, 1974

4100

4099

4101

4102

4103

4104

4105

4106 *A Sleeping Female holding a Caduceus,*
and a Female blowing a Pipe (?)
136 x 176, mixed media on
wallpaper, now mounted on board
Presented, Irish Agricultural
Organisation Society Ltd, 1974

4107 *A Forest Animal* (overdoor)
75.5 x 125, mixed media on
wallpaper, now mounted on board
Presented, Irish Agricultural
Organisation Society Ltd, 1974

4108 *A Female, Torch and Two Children; A*
4109 *Temple-like Building; Two Females*
4110 *with a Bowl of Fruit, and a Child*
275 x 90: 275 x 117: 276 x 132,
mixed media on wallpaper, now
mounted on board
Presented, Irish Agricultural
Organisation Society Ltd, 1974

4111 *A Female with a Lyre* (overdoor)
75.5 x 133.5, mixed media on
wallpaper, now mounted on board
Presented, Irish Agricultural
Organisation Society Ltd, 1974

4106

4107

4108

4109

4110

4111

Russell, James (fl.1804-27)

1933 *The General Post Office, Dublin*
Signed on reverse and dated 1814
78 x 102.5
Provenance unknown

Ryan, Thomas (b.1929)

4044 *Maurice O'Connell, (1885-1971)*
Signed: *Thomas Ryan ARHA*
50 x 40
Purchased, London, Mrs K. Coady,
1972

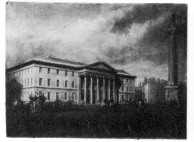
1933

4044

S

Sadler, William (1782-1839)

632 *A View of the Pigeon House, Dublin*
29 x 41, on panel
Presented, Captain G. O'Grady,
1911

633 *A View of the Pigeon House, Dublin*
20 x 32, on panel
Presented, Captain G. O'Grady,
1911

835 *A View of the Provost's House, Trinity College, Dublin*
22 x 32, on panel
Purchased, Dublin, Mr C. Walker,
1921

944 *A Revenue Raid*
36 x 50, on panel
Purchased, Mr D. Cherrick, 1931

1651 *A View of the Four Courts, Dublin*
48 x 65, on panel
Milltown Gift, 1902

1771 *The Search for Michael Dwyer, (1803)*
12 x 19, on panel
Purchased, Dublin, Mrs G. Little,
1965

632

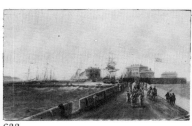
633

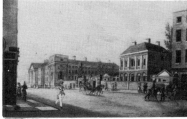
835

944

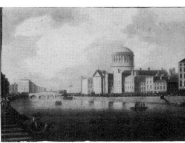
1651

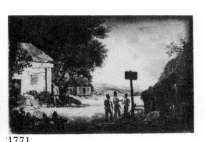
1771

1772 *The French in Killala Bay, (1798)*
 12 x 19, on panel
 Purchased, Dublin, Mrs G. Little,
 1965

1773 *A View of the Inn, Laytown, County
 Meath*
 24 x 30, on panel
 Purchased, Dublin, Mrs G. Little,
 1965

1774 *A View of Howth*
 22 x 34, on panel
 Purchased, Dublin, Mrs G. Little,
 1965

1775 *A View of the Inn, Baldoyle*
 21 x 32, on panel
 Purchased, Dublin, Mrs G. Little,
 1965

1776 *A View of the Salmon Leap, Leixlip*
 30 x 48, on panel
 Purchased, Dublin, Mrs G. Little,
 1965

1777 *A View of Howth Abbey*
 23 x 33, on panel
 Purchased, Dublin, Mrs G. Little,
 1965

1778 *An Inn Scene in a Landscape*
 30 x 46, on panel
 Purchased, Dublin, Mrs G. Little,
 1965

1827 *The Burning of Holmes Emporium*
 28 x 46, on panel
 Purchased, Dublin, Mr R.
 McDonnell, 1967

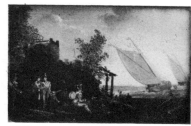
1772

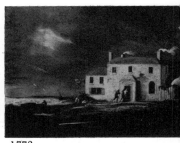
1773

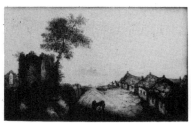
1774

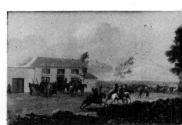
1775

1776

1777

1778

1827

keld, Cecil (d.1969)

4059 *Miss Ffrench Mullan*
Signed: *Salkeld*
92 x 61, on board
Presented, Lady Nelson, 1973

lly, Caroline (20th century)

1552 *The Canal Lock House*
Signed: *Scally*
33 x 44, on board
Presented, Haverty Trust, 1960

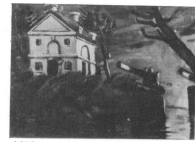

1552

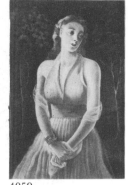

4059

arp, George (1802-77)

85 *Repose*
Inscribed on reverse: *Painted for Henry Toole Esq. by George Sharp. Dublin Dec 19 1867*
51 x 42
Purchased, Dublin, 1878

384 *Creeping to School*
76 x 49
Presented, Mr W. Smith O'Brien, 1864

1828 *A Cock and Unidentified Animal*
64 x 76.6
Purchased, Dublin, Mrs P. Wilson, 1967

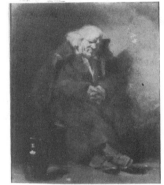

85

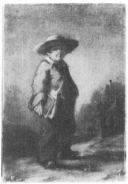

384

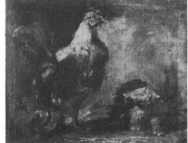

1828

ee, Martin (1769-1850)

26 *A Peasant Girl*
76 x 63
Purchased, London, Christie's, 1875

194 *Francis Rawdon Hastings, Earl of Moira, Marquis of Hastings, (1754-1826)*
74 x 62
Purchased, Mr Justice Berwick, 1875

569 *William Robert Fitzgerald, 2nd Duke of Leinster, (1749-1804)*
65 x 44, on board
Purchased, London, Leggatt Bros., 1904

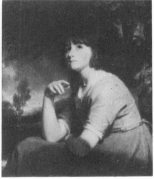

26

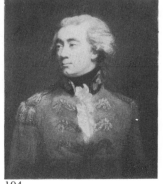

194

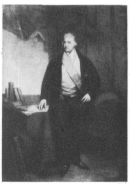

569

775 *Thomas Moore, Poet, (1779-1852)*
91 x 70
Presented, Captain R. Langton
Douglas, 1916

998 *Dr Harrison*
143 x 112
Presented, Mr G. Harrison, 1938

1129 *Walter Blake Kirwan, Dean of Killala,*
(1754-1805)
240 x 148
Mrs E. Anderson Bequest, 1945

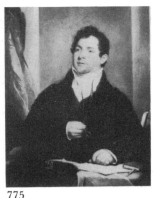

775

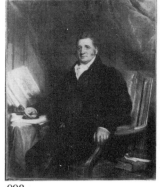

998

1788 *Henry Grattan, (1746-1820)*
76.5 x 64.5
Purchased, Mr G. Laffan, 1965

4058 *Mrs Clementson*
77 x 64
Purchased, Dublin, Mission
Antiques, 1973

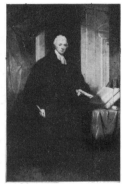

1129

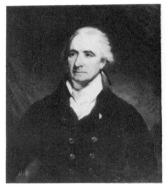

1788

Sheehan (20th century)
4014 *General Liam Lynch, (1893-1923)*
Signed: *Sheehan 1920*
77 x 61
Purchased, Dublin, Mission
Antiques, 1970

Slattery, John (fl.1846-58)
224 *William Carleton, Novelist, (1798-*
1869)
82 x 63
Purchased, Miss Carleton, 1884

Slaughter, Stephen (1697-1765)
317 *John Hoadley, Protestant Archbishop of*
Armagh, (1678-1746)
Signed: *Stepn. Slaughter pinxt, 1744*
122 x 104
Purchased, Dublin, 1890

4058

4014

224

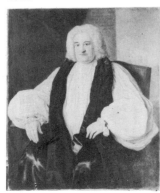

317

797 *A Lady and Child*
Signed: *Stepn. Slaughter pinxt. 1745*
130 x 104
Sir Hugh Lane Bequest, 1918

1058 *Nathaniel Kane, Lord Mayor of Dublin*
Dated 1734
91 x 71
Purchased, Mr L. Barnett, 1940

1061 *Mrs George Rochfort*
Signed: *Stepn. Slaughter pinxit Dublin, 1746*
131 x 109
Presented, Executors of the late Mr W. Rochfort, 1941.

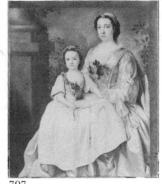
797

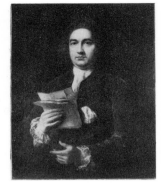
1058

leator, James (1888-1949)
1247 *A Self-Portrait*
61 x 51
Presented, Miss C. Burke, 1952

4084 *Thomas Bodkin, Director, National Gallery of Ireland, (1867-1964)*
Signed: *Sleator*
76 x 64
Miss E. Bodkin Bequest, 1974

4301 *Caroline Scally*
80 x 57, on board
Purchased, Dublin, Mrs G. Scally, 1978

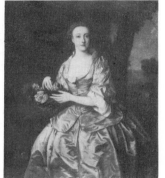
1061

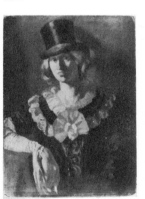
1247

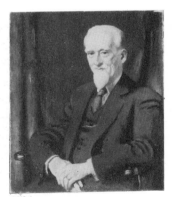
4084

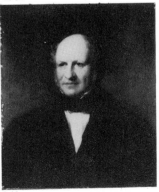
4301

mith the Elder, Stephen (1806-72)
122 *A Self-Portrait*
92 x 71
Purchased, the artist's widow, 1874

141 *William Dargan, (1799-1867)*
Fragment of picture. Painted 1862
72 x 57
Presented, Dargan Testimonial Committee, c.1860

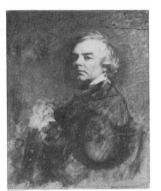
122

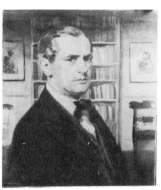
141

248 *J.W. Ponsonby, 4th Earl of*
 Bessborough, (1781-1847)
 33 x 24, on panel
 Presented, Hon. G. Ponsonby, 1889

308 *Peter Purcell, Founder of the Royal*
 Agricultural Society of Ireland, (1788-
 1846)
 85 x 70
 Presented, The Misses Purcell, 1884

309 *Sir Philip Crampton, Surgeon, (1777-*
 1858)
 28 x 24, on panel
 Presented, the artist's son, 1884

407 *Professor J.H. Todd, Author and*
 Antiquary, (1805-69)
 67 x 61
 Purchased, the artist's son, 1880

628 *Mrs La Touche of Bellevue*
 66 x 48
 Purchased, Mrs C. Smith, 1912

1127 *William Smith O'Brien, Young*
 Irelander, (1803-64)
 20 x 16, on panel
 Purchased, Dublin, Mr H. Naylor,
 1945

Smith the Younger, Stephen (1849-1912)
492 *William John Fitzpatrick, Historian and*
 Biographer, (1830-95)
 100 x 61
 Presented, the sons of Mr W.J.
 Fitzpatrick, 1899

913 *John Dwyer Gray, Journalist and*
 Patriot, (1816-75)
 69 x 57
 Purchased, Mrs E. Gray, 1928

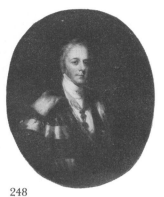

248

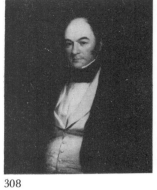

308

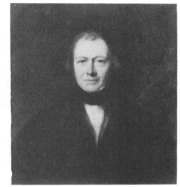

309

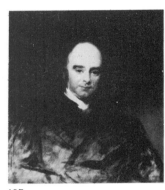

407

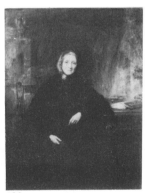

628

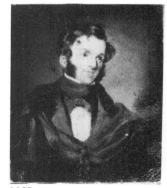

1127

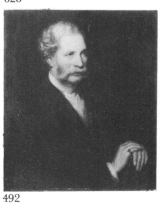

492

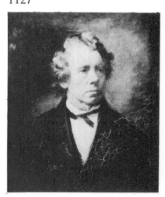

913

1221 *'Rosa'*
71 x 58
Presented, Mrs M. Tuckey, 1951

1222 *A Portrait of a Young Lady*
53 x 43
Presented, Mrs M. Tuckey, 1951

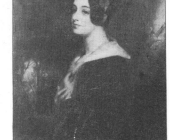 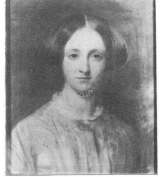

1221 1222

mitz, Gaspar (fl.1662-c.1707)
ish-Dutch School

4142 *Christopher, Lord Delvin, (d.1680)*
72 x 60
Purchased, Dublin, Malahide Castle
Sale, 1976

4143 *Margaret, Countess of Westmeath,*
(d.1700)
74 x 61
Purchased, Dublin, Malahide Castle
Sale, 1976

4144 *General William Nugent, (d.1690)*
73 x 59
Purchased, Dublin, Malahide Castle
Sale, 1976

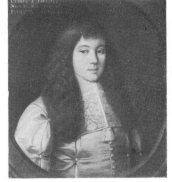

4142 4143

4145 *Colonel John Wogan of Rathcoffy,*
(d.1727)
68 x 55
Purchased, Dublin, Malahide Castle
Sale, 1976

4144 4145

nagg, Thomas (1746-1812)

1981 *A View of Dublin Bay from University*
Rowing Club, Ringsend
61 x 91
Purchased, Dublin, Mr J. Gorry,
1970

1981

olomons, Estella (1882-1968)

1413 *A View of Rosapenna from Beachy Head*
Signed: *E.F. Solomons, 1931*
27 x 35
Mr R. Best Bequest, 1959

1413

1920 *Father O'Flanagan*
 76 x 56
 Presented, Dr M. Solomons, 1969

1921 *Art O'Murnaghan, Designer*
 71 x 66
 Presented, Dr M. Solomons, 1969

1926 *Frank Gallagher, (1893-1962)*
 Signed: *E.F. Solomons*
 76 x 61
 Presented, Mr Eamon de Valera,
 1969

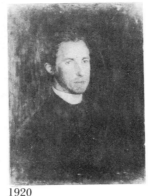
1920

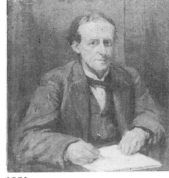
1921

Steiner, Nini (20th century)
4085 *Reverend Matthias Bodkin, S.J.,*
 (1896-1973)
 Signed: *N Steiner 1944*
 51 x 47.5
 Provenance unknown

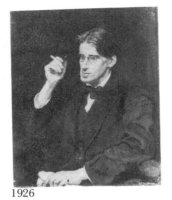
1926

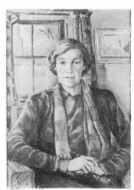
4085

Attributed to **Stephens, James (fl.1829-45)**
1968 *S.C. Smith*
 76.5 x 63.5
 Provenance unknown

Stockum, Hilda van (20th century)
4204 *Evie Hone*
 Signed: *H V S*
 79 x 51
 Purchased, the artist, 1977

4205 *Evie Hone at Work in her Studio*
 Signed: *H V S*
 51 x 41
 Purchased, the artist, 1977

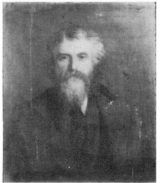
1968

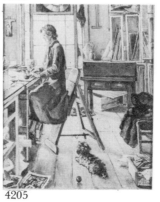
4204

Stoppelaer, Charles (fl.1703-45)
646 *A Portrait of a Gentleman*
 Signed: *C. Stoppelaer Londini pinx.*
 1745
 76 x 62
 Purchased, Mr P. Bate, 1913

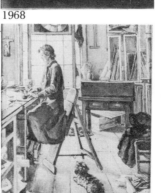
4205

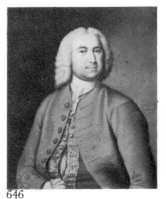
646

wanzy, Mary (1882-1978)

1300 *A Landscape*
 56 x 64
 Presented, Mrs C. Parker, 1954

1312 *A Figure Study*
 27 x 20, on board
 Evie Hone Bequest, 1955

1415 *A Clown by Candlelight*
 14 x 19, on board
 Mr R. Best Bequest, 1959

1300

1312

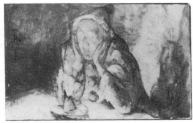

1415

T

Thaddeus, Henry Jones (1859-1929)

889 *John Redmond, Parliamentarian, (1856-1918)*
Signed: *H.J. Thaddeus, 1901*
102 x 82
Purchased, Callingham and Co., 1927

889

229

Thompson, Thomas Clement (c.1780-1857)

229 *John Thomas Troy, Archbishop of Dublin, (1739-1823)*
Painted 1821
74 x 61
Presented, Canon Lee, 1883

320 *Michael Banim, Author, (1796-1874)*
74 x 61
Purchased, Miss Banim, 1885

320

575

575 *A Self-Portrait*
74 x 61
Purchased, Dublin, Bennett, 1906

604 *Elizabeth O'Neill, Actress, (1791-1872)*
59 x 50
Purchased, London, Christie's, 1910

1340 *Christ in the House of Martha and Mary*
Inscribed on reverse: *Painted by T.C. Thompson R.H.A., London, 1847*
58 x 48, laid on panel
Purchased, Mrs E. Keenan, 1953

604

1340

Trevor, Helen Mabel (1831-1900)

500 *The Fisherman's Mother*
Signed: *Helen Mabel Trevor, f.1892*
65 x 53
Helen Trevor Bequest, 1900

501 *An Interior of a Breton Cottage*
Signed: *Helen Mabel Trevor f.1892*
63 x 46
Helen Trevor Bequest, 1900

502 *A Self-Portrait*
66 x 55
Presented, Miss R. Trevor, 1900

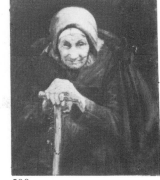

500

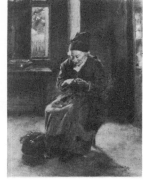

501

597

Tudor, Joseph (fl.1739-59)

597 *A View of Dublin Bay with the North
Wall House*
47 x 153
Purchased, Dublin, Mr R. Reddy,
1908

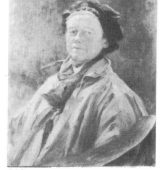

502

Tuohy, Patrick (1894-1930)

1126 *James Stephens, Poet, (1883-1951)*
Signed: *Tuohy*
112 x 87
Purchased, Miss B. Tuohy, 1945

1782 *Frank Fahy*
Signed: *Tuohy*
77 x 62
Purchased, Miss M. Moriarty, 1965

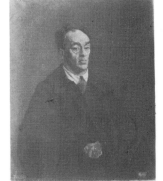

1126

1782

4027 *Biddy Campbell, Daughter of the 2nd
Lord Glenavy*
Signed: *Tuohy*
54 x 32
Presented, Lord Glenavy and the
Hon. M. Campbell, 1971

4116 *A Landscape in the West of Ireland*
Signed: *Tuohy*
23 x 31
Presented, Philadelphia, Mrs P.
Stein, 1974

4027

4116

[**301**]

4117 *A Portrait of a Young Girl*
 Signed: *P.T. 1910*
 31 x 23, on board
 Presented, Philadelphia, Mrs P.
 Stein, 1974

4128 *General Richard Mulcahy*
 38 x 35
 Presented, Mr C. MacGonigal, 1975

4117

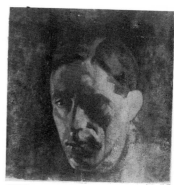

4128

W

Watkins, Bartholomew (1833-91)

388 *A Landscape in Connemara*
30 x 51
Purchased, Dublin, the artist's sister,
1893

636 *A View of the Killaries, from Leenane*
32 x 50
Miss F. Moore Bequest, 1909

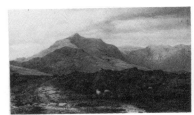

388

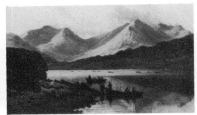

636

Watson, William (d.1765)

4300 *A Portrait of a Young Lady*
Signed: *W. Watson P1759*
76 x 63
Purchased, Dublin, J. Adam and
Son, 1978

4123

West, Richard (1848-1905)

4123 *Tête du Chien, Monaco, Winter Sunset*
76 x 114
Purchased, Dublin, Hibernian
Antiques, 1975

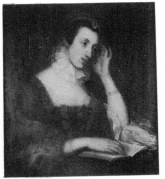

4300

West, Robert (c.1774-1850)

124 *James Hewitt, First Viscount Lifford,*
Lord Chancellor of Ireland 1767-87
(after Reynolds)
74 x 61
Purchased, Dublin, 1874

130 *Lawrence Sterne, Author, (1713-68)*
(after Reynolds)
dia. 27, on metal
Purchased, London, Christie's, 1887

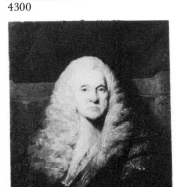

124

130

418　　*A Self-Portrait*
　　　Inscribed on reverse and dated 1816
　　　13 x 10, on panel
　　　Purchased, Dublin, Miss A. Bennett,
　　　1891

466　　*J.H. Brocas, Artist*
　　　Inscribed on reverse and dated 1814
　　　59 x 47
　　　Purchased, Dublin, Mr H. Naylor,
　　　1897

418

466

Whelan, Leo (1892-1956)
967　　*Rory O'Connor, Revolutionary and
　　　Soldier, (1883-1922)*
　　　Signed: *Leo Whelan, 1922*
　　　76 x 63
　　　Purchased, the artist, 1934

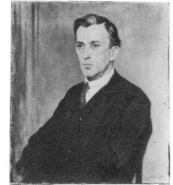

1758

Williams, Alexander (d.1930)
1758　*Rocky Cliffs by the Sea*
　　　Signed: *Alexander Williams, R.H.A.*
　　　38 x 63
　　　Professor Dowling Bequest, 1961

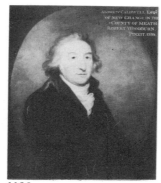

967

Woodburn, Robert (fl.1792-1803)
1136　*Andrew Caldwell*
　　　Inscribed and dated 1793
　　　76 x 63
　　　Presented, Mr D. Cooper, 1947

1136

Υ

Yeats, Jack B. (1871-1957)

941 *The Liffey Swim*
Signed: *Jack B: Yeats*
61 x 91
Presented, Haverty Trust, 1931

1050 *Morning in a City*
Signed: *Jack B. Yeats*
61 x 91
Presented, Haverty Trust, 1941

1134 *Men of Destiny*
Signed: *Jack B. Yeats*
51 x 69
Presented, Jack B. Yeats National
Loan Exhibition Committee, 1945

1147 *Above the Fair*
·Signed: *Jack B. Yeats*
91 x 122
Presented, Reverend Senan on
behalf of a group of private citizens,
1947

1309 *Pastures at Coole*
Signed: *Jack B. Yeats*
25 x 37, on board
Evie Hone Bequest, 1955

1370 *The Power Station*
Signed: *Jack B. Yeats*
24 x 36, on board
Presented, Mr and Mrs R. French,
1957

941

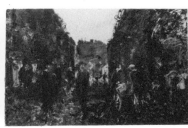

1050

1134

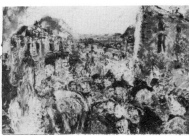

1147

1309

1370

[**305**]

1374 *A Cavalier's Farewell to his Steed*
 Signed: *Jack B. Yeats*
 36 x 46, on board
 Mrs D. Case Bequest, 1958

1406 *A Lake Regatta*
 Signed: *Jack B. Yeats*
 23 x 36, on board
 Mr R. Best Bequest, 1959

1407 *Draughts*
 Signed: *Jack B. Yeats*
 23 x 36, on board
 Mr R. Best Bequest, 1959

1408 *In the Tram*
 Signed: *Jack B. Yeats*
 23 x 36, on board
 Mr R. Best Bequest, 1959

1409 *The Islandbridge Regatta*
 Signed: *Jack B. Yeats*
 46 x 61
 Mr R. Best Bequest, 1959

1549 *'Before the Start', Galway Point to Point*
 Signed: *Jack B. Yeats*
 46 x 61
 Mrs J. Egan Bequest through the
 Friends of the National Collections,
 1960

1550 *Many Ferries*
 Signed: *Jack B. Yeats*
 51 x 69
 Mrs J. Egan Bequest through the
 Friends of the National Collections,
 1960

1737 *The Double Jockey Act*
 Signed: *Jack B. Yeats*
 61 x 46
 Purchased, Dr E. MacCarvill, 1963

1374

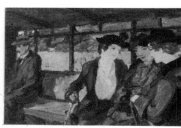

1406

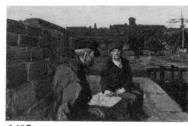

1407

1408

1409

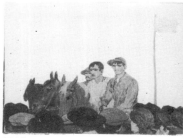

1549

1550

1737

1766　*About to Write a Letter*
Signed: *Jack B. Yeats*
91 x 61
Purchased, estate of the late Mr R.
McGonigal, 1964

1769　*Grief: 1951*
Signed: *Jack B. Yeats*
102 x 153
Purchased, London, Victor
Waddington Galleries, 1965

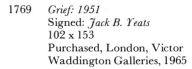

1766　　　　　1769

1791　*Dinner Hour at the Docks, 1928*
Signed: *Jack B. Yeats*
23.5 x 36.5, on panel
Presented, Mrs Smyllie in memory
of the late Mr R. Smyllie, 1966 　.

1804　*A Cleric, (1913)*
Signed: *Jack B. Yeats*
36.3 x 23.3, on board
Presented, Executors of the late Mr
W. Cadbury, 1966

1791

1804

1905　*The Flower Girl, (1926)*
Signed: *Jack B. Yeats*
46 x 61
Presented, I.B.M. Ltd, 1969

1906　*The Last Dawn But One, (1948)*
Signed: *Jack B. Yeats*
51 x 69
Purchased, Dublin, Messrs Whitney,
Moore and Keller, 1969

4031　*No Flowers*
Signed: *Jack B. Yeats*
61 x 92
Presented, Mrs M. Waddington,
1971

1905　　　　　1906

4206　*In Memory of Boucicault and Bianconi*
Signed: *Jack B. Yeats*
61 x 92
Presented, Mr J. Huston, 1977

4031　　　　　4206

4309 *For the Road*
 Signed: *Jack B. Yeats*
 61 x 92
 Presented, Mr and Mrs F.
 Vickerman, 1978

4309

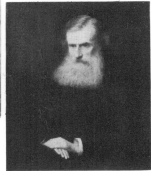

Yeats, John Butler (1839-1922)
 595 *John O'Leary, Fenian, (1830-1907)*
 91 x 71
 Presented, National Literary
 Society, 1908

595

 869 *John O'Leary, Fenian, (1830-1907)*
 Signed: *J.B. Yeats, 1904*
 112 x 87
 Presented, Mr C. Sullivan in
 memory of Mr J. Quinn, 1926

 870 *Standish James O'Grady, Author,*
 (1832-1915)
 Signed: *J.B. Yeats, 1904*
 112 x 87
 Presented, Mr C. Sullivan in
 memory of Mr J. Quinn, 1926

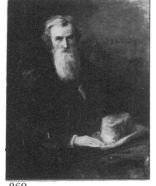

869

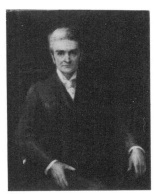

870

 871 *AE (George W. Russell), Poet, (1867-*
 1935)
 Signed: *J.B. Yeats, 1903*
 112 x 87
 Presented, Mr C. Sullivan in
 memory of Mr J. Quinn, 1926

 872 *William Butler Yeats, Poet, (1865-*
 1939)
 Signed: *J.B. Yeats, 1900*
 77 x 64
 Presented, Mr C. Sullivan in
 memory of Mr J. Quinn, 1926

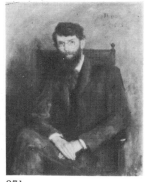

871

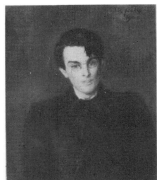

872

 873 *George Moore, Novelist, (1852-1933)*
 Painted 1905
 77 x 64
 Presented, Mr C. Sullivan in
 memory of Mr J. Quinn, 1926

 874 *Douglas Hyde, Poet and Scholar, First*
 President of Ireland, (1860-1949)
 Inscribed: *John B. Yeats, R.H.A. 1906*
 107 x 86
 Presented, Mr C. Sullivan in
 memory of Mr J. Quinn, 1926

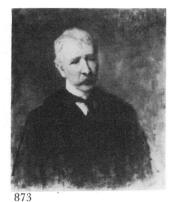

873

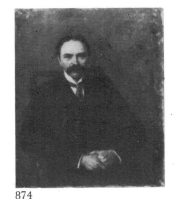

874

910 *Reverend P.S. Dineen, Lexicographer,*
 (1860-1934)
 Signed: *J.B. Yeats, 1905*
 77 x 64
 Presented, Mr W.B. Yeats, 1928

1004 *Miss K. Leney*
 Signed: *J.B. Yeats, 1902*
 66 x 51
 Miss K. Leney Bequest, 1938

1142 *Jack B. Yeats as a Boy*
 61 x 51
 Presented, Mr Jack B. Yeats, 1947

1179 *The Artist's Wife, (d.1900)*
 61 x 91
 Presented, Friends of the National
 Collections, 1949

1180 *Lilly (Susan) Yeats*
 Signed: *J.B. Yeats, 1901*
 91 x 71
 Presented, Friends of the National
 Collections, 1949

1298 *Susan Mitchell, Poet, (1866-1926)*
 Signed: *J.B. Yeats*
 79 x 56
 Purchased, Miss K. Brabazon, 1954

1318 *Augusta Gregory, Dramatist, (1852-*
 1932)
 Signed: *J.B. Yeats, 1903*
 62 x 52
 Presented, Friends of the National
 Collections, 1956

1343 *Frances Elizabeth Geoghegan as a Child*
 46 x 36
 Mrs Geoghegan Bequest, 1956

910

1004

1142

1179

1180

1298

1318

1343

1395	*Hester Dowden as a Child, (1868-1949)* 76 x 63 Purchased, Mrs L. Robinson, 1959
1724	*Rosa Butt* Signed: *J.B. Yeats, 1900* 92 x 71 Presented, Sir William Ball, 1960
1726	*Mrs Caughey* Signed: *J.B. Yeats, 1916* 102 x 76 Presented, Mrs L. Caughey-Guest, 1961
1727	*Mrs Caughey* Signed: *J.B. Yeats, 1916* 102 x 71 Presented, Mrs L. Caughey-Guest, 1961
1800	*Mrs Heaven, (Sister of Sir Hugh Lane)* 60 x 51.5 Presented, Dr T. MacGreevy, 1966
1821	*Mary Lapsley Guest, (d.1964)* Signed: *J.B. Yeats, 1916* 105 x 84 Mrs M. Lapsley Guest Bequest, 1967
1963	*John O'Leary, (1830-1907)* Signed: *J.B. Yeats, 1887 or 9* 92 x 71 Transferred from the National Museum, 1969
4032	*Violet Osborne (Mrs Stockley), Sister of Walter Osborne, (b.1866)* Signed: *J.B. Yeats 1891* 61 x 51 Miss V. Stockley Bequest, 1971

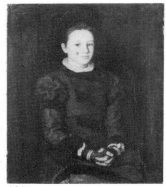

1395

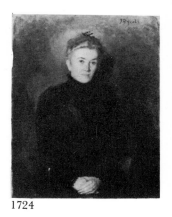

1724

1726

1727

1800

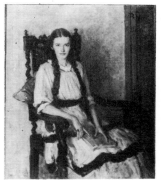

1821

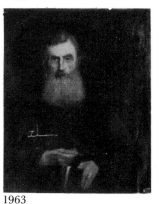

1963

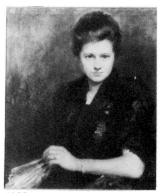

4032

4040 *Jack B. Yeats, (1871-1957)*
Signed indistinctly
61 x 51
Presented, Mr V. Waddington, 1972

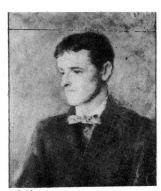

4040

APPENDIX 1
Current Attribution
Permanent Catalogue Numbers and Artists

	Morales	47	Bol	93	Sassoferrato	135	Dicksee
	Thulden	48	Rembrandt	94	Vecchia	136	Lely
	Benson	49	Cuyp	95	Panini	137	Reynolds
	Weyden	50	Huysum	96	Rosa	138	Allingham
	No Entry	51	Rubens	97	Bassano	139	Landseer
	Strigel	52	Moucheron	98	Granacci	140	Partridge
	No Entry	53	Knijf	99	No Entry	141	Smith
	Molyn	54	No Entry	100	Bellini	142	Harwood
	Poel	55	Helst	101	No Entry	143	Lucas
	Steenwyck	56	Potter	102	No Entry	144	Doyle
	Heem	57	Jordaens	103	Maso da San Friano	145	Wyck
	Ribera	58	Velde			146	No Entry
	David	59	Bergen	104	Maso da San Friano	147	Maas
	Velazquez	60	Rubens			148	Jongh
	Huber	61	Neer	105	Moroni	149	Pape
	Schäuffelin	62	Mytens	106	Cotignola	150	Mytens
	Coello	63	Guardi	107	Eeckhout	151	Cuyp
	O'Connor	64	Flinck	108	Machiavelli	152	Anthonisen
	No Entry	65	Helst	109	Batoni	153	Brennan
	No Entry	66	Neer	110	Master of Marradi	154	Rubens
	Faber	67	Lanfranco			155	Brennan
	Poel	68	Palma Giovane	111	No Entry	156	Maclise
	Teniers	69	No Entry	112	Florentine School	157	Wilson
	No Entry	70	Domenichino			158	O'Connor
	Snyders	71	Cantarini	113	Coypel	159	Cregan
	Shee	72	Lanfranco	114	No Entry	160	Harlow
	Ruisdael	73	Aldegrever	115	Veronese School	161	Murphy
	Bega	74	Cappelle	116	Roberts	162	Danby
	Wijntrank	75	Titian	117	Palmezzano	163	O'Connor
	Murillo	76	Fontana	118	Reni	164	No Entry
	Antolinez	77	Tosini	119	Delen	165	Loutherbourg
	Ostade	78	Salmeggia	120	Mengs	166	Haverty
	Murillo	79	Giordano	121	Tintoretto	167	Bachelier
	Ribalta	80	Salmeggia	122	Smith	168	Genisson
	Hondecoeter	81	Maratti	123	Jones	169	Dyck
	Palamedesz	82	Tintoretto	124	West	170	Wouvermans
	Ruisdael	83	Sassoferrato	125	Wheatley	171	Raphael
	Jordaens	84	Titian	126	Hogarth	172	Raphael
	Miereveld	85	Sharp	127	Hogarth	173	Bakhuysen
	No Entry	86	No Entry	128	Barry	174	Barret
	Teniers	87	Padovanino	129	Gainsborough	175	Barret
	Boel	88	Pordenone	130	West	176	Berchem
	Fyt	89	Carracci	131	Lawrence	177	Jervas
	Jongh	90	Tintoretto	132	Jones	178	Bonifazio de'Pitati
	Molenaer	91	Bassano	133	Berthon		
	Jordaens	92	Guardi	134	Worsdale	179	Both

180	Bray	242	Angelico	304	English School	365	Sesto
181	Bellotto	243	Faber	305	Cuming	366	Preti
182	Bellotto	244	Bellini	306	Harwood	367	Carpi
183	Cignani	245	Berchem	307	Wilde	368	Furini
184	Correggio	246	Bleker	308	Smith	369	Cano
185	Coques	247	Monogrammist I.S.	309	Smith	370	Holbein
186	Cranach	248	Smith	310	Hickey	371	Suess von
187	Cuming	249	Cooper	311	Kneller		Kulmbach
188	No Entry	250	Dobson	312	Chanet	372	Pencz
189	Pourbus	251	Stone	313	O'Neill	373	Cotes
190	Francia	252	Droochsloot	314	No Entry	374	Wheatley
191	Gainsborough	253	Eeckhout	315	No Entry	375	Cox
192	Guercino	254	Flinck	316	Richmond	376	Constable
193	Hals	255	Harlow	317	Slaughter	377	Barker
194	Shee	256	Hoppner	318	Simpson	378	Burnet
195	Hamilton	257	Jackson	319	Rembrandt	379	Lawrence
196	Hone the Elder	258	Hickey	320	Thompson	380	Poorter
197	Hone the Elder	259	Danby	321	Codde	381	Romney
198	Petrie	260	Lely	322	Hooch	382	No Entry
199	Huysmans	261	Longhi	323	Potter	383	Smith
200	Kauffman	262	Nuzzi	324	Dusart	384	Sharp
201	No Entry	263	Moreelse	325	Gael	385	Harding
202	Crowley	264	Cooper	326	Claesz	386	Kennedy
203	No Entry	265	Rothwell	327	Gyselaer	387	Mulready
204	Maes	266	Signorelli	328	Croos	388	Watkins
205	Maclise	267	Slingeland	329	Koninck	389	Dyck
206	Morland	268	Slingeland	330	Key	390	Teniers
207	Mulvany	269	Sorgh	331	Swinton	391	Halswelle
208	Mulvany	270	Borch	332	Delff	392	Halswelle
209	No Entry	271	Vadder	333	Duyster	393	No Entry
210	Newton	272	Vadder	334	Teniers	394	Irish School
211	No Entry	273	Zurbarán	335	Duck	395	Irish School
212	Spagna	274	Bergen	336	Griffier	396	Sherwin
213	Beccaruzzi	275	Dyck	337	Moucheron	397	Hickey
214	Poussin	276	Velde	338	Bloemen	398	Hogarth
215	Rembrandt	277	Brescian School	339	Neapolitan School	399	Gaven
216	Reynolds	278	Ward	340	Ryckaert	400	Heere
217	Reynolds	279	Watts	341	Haansbergen	401	English School
218	No Entry	280	Wynants	342	Herp	402	No Entry
219	Ribera	281	English School	343	Asch	403	Chambers
220	Roberts	282	English School	344	Strij	404	Bruyn
221	Velazquez	283	Segar	345	Romeyn	405	Kauffman
222	Rothwell	284	No Entry	346	Cuyp	406	Capalti
223	Rothwell	285	Stoop	347	Maes	407	Smith
224	Slattery	286	Canaletto	348	Lingelbach	408	Mulrenin
225	Solemackers	287	Ruisdael	349	Wyck	409	Pickersgill
226	Steen	288	Teniers	350	Flemish School	410	English School
227	Steen	289	Teniers	351	Florentine School	411	Latham
228	Storck	290	Teniers	352	Bastiani	412	No Entry
229	Thompson	291	Dutch School	353	Tiepolo	413	Dyck
230	No Entry	292	Hamilton	354	Spanish School	414	Lely
231	No Entry	293	Hudson	355	No Entry	415	Barret
232	No Entry	294	Hudson	356	Brouwer	416	Joseph
233	No Entry	295	Hayman	357	Diano	417	Cotes
234	No Entry	296	Kneller	358	No Entry	418	West
235	Dyck	297	Hayter	359	Dyck	419	Gower
236	Goyen	298	Maratti	360	Master of the	420	No Entry
237	Brooking	299	Lawrence		Barbara Legend	421	Irish School
238	Quinkhard	300	Lawrence	361	Mabuse	422	Irish School
239	Oliverio	301	Zoffany	362	Maes	423	Doyle
240	Wilkie	302	Irish School	363	Renieri	424	Lambinet
241	No Entry	303	Irish School	364	Palmezzano	425	Stomer

426 Grey	488 Weenix	550 Lely	612 Osborne
427 Rubens	489 O'Connor	551 Wheatley	613 Howard
428 French School	490 Beach	552 Ijsenbrandt	614 Opie
429 Irish School	491 Hamilton	553 Osborne	615 Irish School
430 Raeburn	492 Smith	554 Osborne	616 Mulready
431 Latham	493 Haverty	555 Osborne	617 Wheatley
432 Vermeulen	494 Signorelli	556 Duyster	618 Hogarth
433 Jouderville	495 Nairn	557 Irish School	619 Aertsz
434 Ibbetson	496 Avercamp	558 Lorme	620 Ghirlandaio
435 Ochtervelt	497 Troost	559 Hayter	621 No Entry
436 Duyster	498 Ijsenbrandt	560 Hogarth	622 Browne
437 Holland	499 Stuart	561 Purser	623 Rossum
438 Hanneman	500 Trevor	562 Stuart	624 Jones
439 Rembrandt	501 Trevor	563 No Entry	625 Valckenburg
440 Hone the Elder	502 Trevor	564 Quillard	626 Solimena
441 Teniers	503 Blacklock	565 Gainsborough	627 Aitkin
442 Mantegna	504 Dance	566 Hoppner	628 Smith
443 Pot	505 Cooper	567 Spilsbury	629 No Entry
444 Kauffman	506 Rothwell	568 Mallary	630 No Entry
445 Potter	507 Ruisdael	569 Shee	631 Barry
446 Pritchett	508 Wynants	570 Ramsay	632 Sadler
447 Pritchett	509 Hondecoeter	571 Ravesteyn	633 Sadler
448 Swagers	510 Berchem	572 Goya	634 Comerford
449 Saftleven	511 Weenix	573 Ross	635 Osborne
450 Witte	512 Hondt	574 Lavery	636 Watkins
451 No Entry	513 Rubens	575 Thompson	637 Lavery
452 No Entry	514 Heda	576 Key	638 No Entry
453 No Entry	515 Hagen	577 Ashford	639 Bylert
454 No Entry	516 Lorme	578 Hamilton	640 Moreelse
455 No Entry	517 Wells	579 Lewis	641 Ochtervelt
456 No Entry	518 Mogford	580 Palma Vecchio	642 Richardson
457 No Entry	519 Verrocchio	581 Home	643 Orley
458 No Entry	520 Lawrence	582 Wouvermans	644 English School
459 No Entry	521 Jones	583 Bastien-Lepage	645 King
460 Fontana	522 Signorelli	584 Jonson	646 Stoppelaer
461 Herring	523 Raeburn	585 Grey	647 Brocas
462 No Entry	524 Morland	586 Inchbold	648 Collins
463 No Entry	525 Hone the Elder	587 Burke	649 Linnell
464 Eddis	526 Costa	588 Hone the Younger	650 Horstock
465 Smibert	527 Wijnen	589 Horemans	651 Wilkie
466 West	528 Wilson	590 Horemans	652 English School
467 Pellegrini	529 Luycks	591 Etty	653 Hickey
468 Leyster	530 Vliet	592 Hamilton	654 Allan
469 Keyser	531 Palamedesz	593 Cooke	655 Hickey
470 Lippi	532 Jonson	594 Collins	656 Piazzetta
471 Cranach	533 Weenix	595 Yeats	657 Veronese
472 Good	534 Jamesone	596 Bridgford	658 Greco
473 Marieschi	535 No Entry	597 Tudor	659 Mazo
474 Kneller	536 Stothard	598 Bindon	660 Irish School
475 No Entry	537 Bonington	599 Irish School	661 No Entry
476 Schalcken	538 Mulvany	600 Goya	662 No Entry
477 No Entry	539 Zoffany	601 Osborne	663 No Entry
478 Chardin	540 Goubau	602 Cazneau	664 No Entry
479 Zurbarán	541 English School	603 Uccello	665 No Entry
480 Venetian School	542 Italian School	604 Thompson	666 Mazzolino
481 Hall	543 Kennedy	605 Soest	667 Pereda
482 Opie	544 Jardin	606 Pourbus	668 Gainsborough
483 Guercino	545 Irish School	607 Lievens	669 Vallain
484 No Entry	546 No Entry	608 Duffy	670 Desportes
485 Kneller	547 MacManus	609 Rothwell	671 Desportes
486 Kneller	548 No Entry	610 Heimbach	672 Dyck
487 Michel	549 English School	611 Mulready	673 Carracci

674	Romney	736	Reynolds	798	Constable	854	Deane
675	Gainsborough	737	Reynolds	799	Chardin	855	Bridgford
676	Reinagle	738	Rosa	800	Lemaire	856	Strozzi
677	Scott	739	Rosa	801	Watteau	857	Bridgford
678	Magnasco	740	Smith	802	Lancret	**858**	**Osborne**
679	Beerstraten	741	Swanevelt	803	Greuze	859	John
680	Stuart	742	Utrecht	804	Faber	860	Moroni
681	Prins	743	Peeters	805	Witte	861	Domenico di
682	Molenaer	**744**	**Veronese**	806	Kamper		Michellino
683	Hunt	745	No Entry	807	Goyen	862	Hickey
684	O'Neill	746	Wilson	808	Rembrandt	863	Hickey
685	No Entry	747	Wilson	809	Dyck	864	Lawless
686	No Entry	748	Wyck	810	Bol	865	Cregan
687	No Entry	749	Wyck	811	Snyders	866	Lotto
688	No Entry	750	German School	812	Cornelisz of	867	Stuart
689	No Entry	751	Joest		Amsterdam	868	Italian School
690	No Entry	752	Thulden	813	Chardin	869	Yeats
691	No Entry	753	No Entry	814	Poussin	870	Yeats
692	No Entry	754	No Entry	815	Venetian School	871	Yeats
693	No Entry	755	No Entry	816	Poussin	872	Yeats
694	No Entry	756	No Entry	817	Sargent	873	Yeats
695	No Entry	757	No Entry	818	Fernandez	874	Yeats
696	No Entry	758	No Entry	819	Guardi	875	Osborne
697	No Entry	759	English School	820	Irish School	876	Irish School
698	Lee	760	Llanos-y-Valdes	821	No Entry	877	Dutch School
699	Lee	761	No Entry	822	Stuart	878	Opie
700	**Breenberg**	762	Barry	823	Master of Saint	879	Victoors
701	Batoni	763	Claude Lorraine		Augustine	880	English School
702	Batoni	764	No Entry	824	No Entry	881	Brandon
703	Batoni	765	No Entry	825	O'Connor	882	Osborne
704	Batoni	766	No Entry	826	Soldenhoff	883	No Entry
705	Canaletto	767	No Entry	827	Romano	884	Clerisseau
706	Both	768	Tintoretto	828	Gericault	885	Cariani
707	No Entry	769	No Entry	829	Pantoja de la Cruz	886	Hone the Elder
708	No Entry	770	Munns	830	Cregan	**887**	**Kauffman**
709	No Entry	771	Grammorseo	831	Lavery	**888**	**Kauffman**
710	No Entry	772	Master of the Parrot	832	Hobbema	889	Thaddeus
711	No Entry	773	Howard	833	Torrance	890	Lastman
712	No Entry	774	Osborne	834	Kick	891	Osborne
713	Dughet	775	Shee	835	Sadler	892	Garstin
714	Winck	776	Wilson	836	Osborne	893	Russell
715	Winck	777	Holl	837	Chinnery	894	Wyck
716	Os	778	Florentine School	838	West	895	Irish School
717	Coninck	779	Bordone	839	Girolamo di	896	Robert
718	No Entry	780	Florentine School		Benvenuto	897	Hasselt
719	Claude Lorraine	781	Strozzi	840	Beccafumi	898	Feti
720	No Entry	782	Titian	841	Silvestro dei	899	Collier
721	Lebel	783	Piombo		Gherarducci	900	Siberechts
722	Lebel	784	Goya	842	Biagio di Antonio	901	Reynolds
723	Troy	785	Chinnery		Utile	902	Seisenegger
724	Lemoine	786	Romney	843	Linnell	903	Master of the
725	Panini	787	Doughty	844	Linnell		Tired Eyes
726	Panini	788	Lawrence	**845**	**Master of the**	904	Hecke
727	Panini	789	Romney		**Prodigal Son**	905	Hunter
728	Panini	790	Reynolds	846	Santa Croce	906	Stubbs
729	Pater	791	Hogarth	847	Post	907	Stuart
730	Pater	792	Hogarth	848	Roberts	908	Breslau
731	Pater	793	Gainsborough	849	Borch	909	Batoni
732	No Entry	794	Gainsborough	850	Pompe	**910**	**Yeats**
733	Reynolds	795	Gainsborough	851	Latre	911	Brueghel
734	Reynolds	796	Gainsborough	852	Monet	912	Belle
735	Reynolds	797	Slaughter	853	Corot	913	Smith

14	Zeitblom	976	Orpen	1038	Monamy	1100	Albertinelli
15	Paget	977	Furse	1039	Monamy	1101	Purser
16	Ruisdael	978	Styrian School	1040	Italian School	1102	Rothwell
17	No Entry	979	Salzburg School	1041	Raphael	1103	Barocci
18	Cregan	980	Gentileschi	1042	Correggio	1104	Stevens
19	Le Fanu	981	Lys	1043	Canaletto	1105	Tissot
20	Perronneau	982	Bazzani	1044	Stone	1106	De Gree
21	Sargent	983	Bazzani	1045	Vernet	1107	Solimena
22	O'Conor	984	Morisot	1046	Helt-Stockade	1108	Lely
23	Lavery	985	Tonks	1047	Cuyp	1109	Castro
24	Frye	986	Harwood	1048	Cuyp	1110	Crome
25	Poussin	987	Osborne	1049	Flemish School	1111	Tiepolo
26	Mulvany	988	Wyck	1050	Yeats	1112	Ugolino da Siena
27	Frye	989	Lauri	1051	Blanche	1113	Dalmasio
28	Mulvany	990	Carracci	1052	Osborne	1114	O'Connor
29	No Entry	991	Mulvany	1053	Osborne	1115	Roymerswaele
30	No Entry	992	No Entry	1054	Hayes	1116	Irish School
31	Osborne	993	Passeri	1055	Hayes	1117	Giorgio d'Alemagna
32	Mulvany	994	Castiglione	1056	Grey	1118	Velasquez
33	Kessel	995	Cuming	1057	Moynan	1119	Velasquez
34	Mannix	996	Cuming	1058	Slaughter	1120	Irish School
35	Roberts	997	Scorel	1059	J.B.	1121	Osborne
36	No Entry	998	Shee	1060	Osborne	1122	Tintoretto
37	No Entry	999	Chinnery	1061	Slaughter	1123	Smith
38	Purser	1000	Chinnery	1062	Tempel	1124	Fry
39	Pillement	1001	Cock	1063	Dutch School	1125	Medley
40	Pillement	1002	Hunter	1064	Rubens	1126	Tuohy
41	Yeats	1003	Hone the Elder	1065	Reni	1127	Smith
42	Perugino	1004	Yeats	1066	Bertin	1128	Bonifazio de'Pitati
43	Biondo	1005	Coster	1067	Rottenhammer	1129	Shee
44	Sadler	1006	Chinnery	1068	Empoli	1130	Orchardson
45	Orpen	1007	Chinnery	1069	Giordano	1131	Fielding
46	Orpen	1008	Chinnery	1070	Ficherelli	1132	Lewis
47	Weenix	1009	Monet	1071	Correggio	1133	Stuart
48	Knight	1010	Janssens	1072	Bonifazio de'Pitati	1134	Yeats
49	Jones	1011	O'Sullivan	1073	No Entry	1135	Fagan
50	Corot	1012	Osborne	1074	Neapolitan School	1136	Woodburn
51	Hayes	1013	Nicolas	1075	Neapolitan School	1137	Irish School
52	Longhi	1014	Bettera	1076	No Entry	1138	Rigaud
53	Osborne	1015	Aelst	1077	No Entry	1139	Boyle
54	Bassano	1016	Bloemen	1078	Bolognese School	1140	Tommaso
55	Orpen	1017	Brocas	1079	Baptiste	1141	Bassano
56	Orpen	1018	Penni	1080	Italian School	1142	Yeats
57	Orpen	1019	Maclise	1081	No Entry	1143	Lessore
58	Mangin	1020	Crespi	1082	Herp	1144	Home
59	Dance	1021	Butteri	1083	Domenichino	1145	Home
60	Wyatt	1022	Rimini School	1084	Italian School	1146	Home
61	Dusart	1023	No Entry	1085	Veronese	1147	Yeats
62	Zurbarán	1024	Purser	1086	Pagani	1148	Turner de Lond
63	Mulready	1025	Vierpyl	1087	Dutch School	1149	English School
64	Delacroix	1026	Spanish School	1088	Allori	1150	Dobson
65	Forain	1027	Spanish School	1089	Bartolo	1151	Romney
66	Sisley	1028	Montemezzano	1090	Bugiardini	1152	English School
67	Whelan	1029	Titian	1091	Barret	1153	Einsle
68	Roworth	1030	Titian	1092	Barret	1154	English School
69	Fisher	1031	Turchi	1093	Piscelli	1155	No Entry
70	Orpen	1032	Bourdon	1094	Piscelli	1156	No Entry
71	Barry	1033	Lundens	1095	Boudewijns	1157	No Entry
72	Vries	1034	No Entry	1096	Boudewijns	1158	No Entry
73	Cranach	1035	Greuze	1097	Mulvany	1159	No Entry
74	German School	1036	Grant	1098	Purser	1160	O'Brien
75	McLachlan	1037	Titian	1099	Ricci	1161	No Entry

1162 Antwerp Mannerist	1223 Pourbus	1284 Mulvany	1345 Irish School
1163 Stuart	1224 Orley	1285 Claesz	1346 Irish School
1164 Romney	1225 Brekelenkam	1286 Henry	1347 Irish School
1165 Reynolds	1226 Scheffer	1287 Henry	1348 Irish School
1166 French School	1227 Irish School	1288 Henry	1349 Irish School
1167 Lemercier	1228 Irish School	1289 Davidson	1350 Hamilton
1168 Lemercier	1229 Dolci	1290 Franciabigio	1351 Irish School
1169 Lemercier	1230 Dietrich	1291 Ziem	1352 Irish School
1170 Lemercier	1231 Markievicz	1292 Detaille	1353 Irish School
1171 Lemercier	1232 Bartolommeo	1293 Innes	1354 Irish School
1172 Lemercier	1233 Irish School	1294 Procter	1355 Irish School
1173 Osborne	1234 Henry	1295 Irish School	1356 Irish School
1174 Osborne	1235 Riminaldi	1296 Mandyn	1357 Irish School
1175 Moyaert	1236 Keating	1297 Hone the Elder	1358 Perreal
1176 Feselen	1237 Orpen	1298 Yeats	1359 Flemish School
1177 Hemessen	1238 Sabatte	1299 O'Connor	1360 Hone the Younger
1178 Pensionante del	1239 Reni	1300 Swanzy	1361 Hone the Younger
Saraceni	1240 No Entry	1301 Bandinelli	1362 Hone the Younger
1179 Yeats	1241 O'Connor	1302 Venetian School	1363 Hone the Younger
1180 Yeats	1242 O'Connor	1303 Greco-Venetian	1364 Hone the Younger
1181 Purser	1243 Unknown	School	1365 Hone the Younger
1182 O'Connor	1244 Sidaner	1304 Haverty	1366 Hone the Younger
1183 Haverty	1245 Leech	1305 Upper Rhine School	1367 Hone the Younger
1184 Gurschner	1246 Leech	1306 Kelly	1368 Hone the Younger
1185 Hone the Younger	1247 Sleator	1307 Cross	1369 Hone the Younger
1186 Pritchett	1248 Vasari	1308 Gleizes	1370 Yeats
1187 Pritchett	1249 Luini	1309 Yeats	1371 Hone
1188 Haverty	1250 Milanese School	1310 Healy	1372 Dyck
1189 Appiani	1251 Lavery	1311 Marchand	1373 Pencz
1190 No Entry	1252 Newton	1312 Swanzy	1374 Yeats
1191 No Entry	1253 Michel	1313 Gris	1375 Cregan
1192 No Entry	1254 Troyon	1314 Picasso	1376 Purser
1193 Petrie	1255 Dupré	1315 Wet	1377 Ribera
1194 Kavanagh	1256 Gerome	1316 Irish School	1378 Michelin
1195 English School	1257 Raffaëlli	1317 Italo-Flemish School	1379 Honthorst
1196 Le Sueur	1258 Steer	1318 Yeats	1380 Coter
1197 Gethin	1259 Marchand	1319 Barrett	1381 Master of the
1198 Rubens	1260 Marchand	1320 Bosch	Magdalen Legend
1199 Orpen	1261 No Entry	1321 Watteau	1382 Mulready
1200 O'Donnell	1262 Marchand	1322 Grant	1383 Jonson
1201 Master of St Verdiana	1263 Marchand	1323 Guercino	1384 Tintoretto
1202 Pisano	1264 Moreau	1324 Titian	1385 Ghirlandaio
1203 Sienese Copyist	1265 Holbein	1325 Glew	1386 Wouvermans
1204 Sienese Copyist	1266 English School	1326 Jellett	1387 Carreno
1205 Sienese Copyist	1267 Raphael	1327 Conder	1388 Osborne
1206 Sienese Copyist	1268 Procter	1328 Harpignies	1389 Osborne
1207 Sienese Copyist	1269 Rouland	1329 John	1390 Hickey
1208 Maclise	1270 Irish School	1330 Keating	1391 Scorel
1209 Hayes	1271 Irish School	1331 Carracci	1392 Scorel
1210 Waite	1272 Franco-Flemish	1332 Bacchiacca	1393 Barry
1211 Forbes-Robertson	School	1333 Tintoretto	1394 Bol
1212 Burke	1273 Osborne	1334 Reni	1395 Yeats
1213 Reinagle	1274 Orpen	1335 Italian School	1396 Hone the Younger
1214 Hone the Younger	1275 Tissot	1336 Italian School	1397 Hone the Younger
1215 Daubigny	1276 Mulvany	1337 Italian School	1398 Hone the Younger
1216 Lower Rhine School	1277 Mulvany	1338 Padovanino	1399 Hone the Younger
1217 Ribot	1278 Cranach	1339 Guinness	1400 Hone the Younger
1218 Berne-Bellecour	1279 Harrison	1340 Thompson	1401 Hone the Younger
1219 Harrison	1280 Harrison	1341 Orpen	1402 Hone the Younger
1220 Purser	1281 Harrison	1342 Hamilton	1403 Hone the Younger
1221 Smith	1282 Balducci	1343 Yeats	1404 Bridgford
1222 Smith	1283 Comerford	1344 Bindon	1405 Harrison

1406	Yeats	1468	Hone the Younger	1530	Moran	1592	Hone the Younger
1407	Yeats	1469	Hone the Younger	1531	Panini	1593	Hone the Younger
1408	Yeats	1470	Hone the Younger	1532	Weekes	1594	Hone the Younger
1409	Yeats	1471	Hone the Younger	1533	Italian School	1595	Hone the Younger
1410	Henry	1472	Hone the Younger	1534	Hone the Younger	1596	Hone the Younger
1411	Kelly	1473	Hone the Younger	1535	Hone the Younger	1597	Hone the Younger
1412	Kelly	1474	Hone the Younger	1536	Hone the Younger	1598	Hone the Younger
1413	Solomons	1475	Hone the Younger	1537	Hone the Younger	1599	Hone the Younger
1414	O'Brien	1476	Hone the Younger	1538	Hone the Younger	1600	Hone the Younger
1415	Swanzy	1477	Hone the Younger	1539	Hone the Younger	1601	Hone the Younger
1416	MacIlwaine	1478	Hone the Younger	1540	Hone the Younger	1602	Hone the Younger
1417	Stevenson	1479	Hone the Younger	1541	Hone the Younger	1603	Hone the Younger
1418	Barry	1480	Hone the Younger	1542	Hone the Younger	1604	Hone the Younger
1419	Paget	1481	Hone the Younger	1543	Hone the Younger	1605	Hone the Younger
1420	Greuze	1482	Hone the Younger	1544	Hone the Younger	1606	Hone the Younger
1421	French School	1483	Hone the Younger	1545	Hone the Younger	1607	Hone the Younger
1422	Leech	1484	Hone the Younger	1546	Hone the Younger	1608	Hone the Younger
1423	Leech	1485	Hone the Younger	1547	Hone the Younger	1609	Hone the Younger
1424	Purser	1486	Hone the Younger	1548	Hone the Younger	1610	Hone the Younger
1425	Hone the Younger	1487	Hone the Younger	1549	Yeats	1611	Hone the Younger
1426	Hone the Younger	1488	Hone the Younger	1550	Yeats	1612	Hone the Younger
1427	Hone the Younger	1489	Hone the Younger	1551	MacGonigal	1613	Hone the Younger
1428	Hone the Younger	1490	Hone the Younger	1552	Scally	1614	Hone the Younger
1429	Hone the Younger	1491	Hone the Younger	1553	Hone the Younger	1615	Hone the Younger
1430	Hone the Younger	1492	Hone the Younger	1554	Hone the Younger	1616	Hone the Younger
1431	Hone the Younger	1493	Hone the Younger	1555	Hone the Younger	1617	Hone the Younger
1432	Hone the Younger	1494	No Entry	1556	Hone the Younger	1618	Hone the Younger
1433	Hone the Younger	1495	Hone the Younger	1557	Hone the Younger	1619	Hone the Younger
1434	Hone the Younger	1496	Hone the Younger	1558	Hone the Younger	1620	Hone the Younger
1435	Hone the Younger	1497	Hone the Younger	1559	Hone the Younger	1621	Hone the Younger
1436	Hone the Younger	1498	Hone the Younger	1560	Hone the Younger	1622	Hone the Younger
1437	Hone the Younger	1499	Hone the Younger	1561	Hone the Younger	1623	Hone the Younger
1438	Hone the Younger	1500	Hone the Younger	1562	Hone the Younger	1624	Hone the Younger
1439	Hone the Younger	1501	Hone the Younger	1563	Hone the Younger	1625	Hone the Younger
1440	Hone the Younger	1502	Hone the Younger	1564	Hone the Younger	1626	No Entry
1441	Hone the Younger	1503	Hone the Younger	1565	Hone the Younger	1627	Barret
1442	Hone the Younger	1504	Hone the Younger	1566	Hone the Younger	1628	Barret
1443	Hone the Younger	1505	Hone the Younger	1567	Hone the Younger	1629	Barret
1444	Hone the Younger	1506	Hone the Younger	1568	Hone the Younger	1630	Barret
1445	Hone the Younger	1507	Hone the Younger	1569	Hone the Younger	1631	Barret
1446	Hone the Younger	1508	Hone the Younger	1570	Hone the Younger	1632	Barret
1447	Hone the Younger	1509	Hone the Younger	1571	Hone the Younger	1633	Barret
1448	Hone the Younger	1510	Hone the Younger	1572	Hone the Younger	1634	Barret
1449	Hone the Younger	1511	Hone the Younger	1573	Hone the Younger	1635	Barret
1450	Hone the Younger	1512	Hone the Younger	1574	Hone the Younger	1636	Barret
1451	No Entry	1513	Hone the Younger	1575	Hone the Younger	1637	Barret
1452	Hone the Younger	1514	Hone the Younger	1576	Hone the Younger	1638	Veli
1453	Hone the Younger	1515	Hone the Younger	1577	Hone the Younger	1639	Dutch School
1454	Hone the Younger	1516	Hone the Younger	1578	Hone the Younger	1640	Carlone
1455	Hone the Younger	1517	Hone the Younger	1579	Hone the Younger	1641	Liège School
1456	Hone the Younger	1518	Hone the Younger	1580	Hone the Younger	1642	O'Conor
1457	Hone the Younger	1519	Hone the Younger	1581	Hone the Younger	1643	Hussey
1458	Hone the Younger	1520	Hone the Younger	1582	Hone the Younger	1644	Lavery
1459	Hone the Younger	1521	Hone the Younger	1583	Hone the Younger	1645	Le Nain
1460	Hone the Younger	1522	Hone the Younger	1584	Hone the Younger	1646	Nattier
1461	Hone the Younger	1523	Hone the Younger	1585	Hone the Younger	1647	Baptiste
1462	Hone the Younger	1524	Hone the Younger	1586	Hone the Younger	1648	Irish School
1463	Hone the Younger	1525	No Entry	1587	Hone the Younger	1649	Irish School
1464	Hone the Younger	1526	Hone the Younger	1588	Hone the Younger	1650	Batoni
1465	Hone the Younger	1527	Barocci	1589	Hone the Younger	1651	Sadler
1466	Hone the Younger	1528	Cerezo	1590	Hone the Younger	1652	Wyck
1467	Hone the Younger	1529	Molenaer	1591	Hone the Younger	1653	Turchi

1654	No Entry	1716	Furini	1778	Sadler	1838	Constantinople School
1655	Teniers	1717	No Entry	1779	Hamilton	1839	Western Greek School
1656	Coypel	1718	Armfield	1780	Yverni	1840	Moscow School
1657	Berchem	1719	Murillo	1781	Brandt	1841	Moscow School
1658	Furini	1720	Murillo	1782	Tuohy	1842	Moscow School
1659	Guercino	1721	Navarrete	1783	Kettle	1843	Constantinople School
1660	Powell	1722	Courbet	1784	Irish School	1844	Moscow School
1661	Dyck	1723	Boucher	1785	Le Jeune	1845	Moscow School
1662	English School	1724	Yeats	1786	Coghill	1846	Moscow School
1663	English School	1725	Cuming	1787	Russell	1847	Greek School
1664	Rosa da Tivoli	1726	Yeats	1788	Shee	1848	Western Greek School
1665	Bassano	1727	Yeats	1789	Hickey	1849	Greek School
1666	Rosa da Tivoli	1728	Fortune	1790	Hone the Elder	1850	Moscow School
1667	Italian School	1729	Rigaud	1791	Yeats	1851	Asia Minor School
1668	Guercino	1730	Irish School	1792	Beechey	1852	Western Greek School
1669	Troppa	1731	Laurie-Wallace	1793	Tintoretto	1853	Central Greek School
1670	Ferri	1732	Vernet	1794	O'Doherty	1854	Russian School
1671	Empoli	1733	Vernet	1795	Mulcahy	1855	Asia Minor School
1672	Bloemen	1734	Reynolds	1796	Daubigny	1856	Balkan School
1673	Bakhuysen	1735	Largillière	1797	Fisher	1857	Novgorod School
1674	Os	1736	Lavery	1798	Vallejo	1858	Constantinople School
1675	No Entry	1737	Yeats	1799	Brandt		
1676	English School	1738	Dyck	1800	Yeats	1859	Osborne
1677	Rembrandt	1739	Stern	1801	Mignard	1860	Hickey
1678	Neranne	1740	Italian School	1802	Collins	1861	O'Brien
1679	Furini	1741	Velde	1803	Faulkner	1862	O'Brien
1680	No Entry	1742	Velde	1804	Yeats	1863	O'Sullivan
1681	Compe	1743	Stuart	1805	Teniers	1864	Maso da San Friano
1682	Carracci	1744	Coccorante	1806	O'Conor	1865	Maso da San Friano
1683	Dandini	1745	Fuseli	1807	Forbes-Robertson	1866	McEvoy
1684	Bertin	1746	Ficherelli	1808	Hale	1867	La Tour
1685	English School	1747	Lippi	1809	O'Keefe	1868	English School
1686	Guercino	1748	Wilkie	1810	O'Keefe	1869	Henry
1687	No Entry	1749	Italo-Flemish School	1811	Purser	1870	Henry
1688	Amigoni	1750	Vernet	1812	Dubois	1871	Ziegler
1689	Spanish School	1751	Tassi	1813	Fisher	1872	Bradford
1690	Moro	1752	Tassi	1814	Longhi	1873	Jellett
1691	Orrente	1753	Barret	1815	Irish School	1874	Jellett
1692	Guercino	1754	Barret	1816	Lehmann	1875	Jellett
1693	Italian School	1755	Wouvermans	1817	Lehmann	1876	Moore
1694	Dutch School	1756	Crowley	1818	Osborne	1877	Vlaminck
1695	Reni	1757	Craig	1819	Pugh	1878	Clarke
1696	English School	1758	Williams	1820	Procaccini	1879	Clarke
1697	Batoni	1759	Barry	1821	Yeats	1880	Clarke
1698	Dutch School	1760	Barret	1822	Marquet	1881	Clarke
1699	Wouvermans	1761	Russell	1823	Grey	1882	Clarke
1700	French School	1762	Orpen	1824	Roslin	1883	Clarke
1701	French School	1763	Quadal	1825	Mulready	1884	Grant
1702	Wouvermans	1764	Mulvany	1826	Mulready	1885	Domenichino
1703	Maratti	1765	Harwood	1827	Sadler	1886	Schiffer
1704	Spanish School	1766	Yeats	1828	Sharp	1887	Schiffer
1705	Rubens	1767	Harrison	1829	Stuart	1888	Velde
1706	Balen	1768	Paolo	1830	Lely	1889	Boulogne the Elder
1707	Ficherelli	1769	Yeats	1831	Lely	1890	Everdingen
1708	Francken	1770	O'Sullivan	1832	Irish School	1891	Stanfield
1709	Francken	1771	Sadler	1833	Irish School	1892	Michelangelo
1710	Morland	1772	Sadler	1834	Fiammingo	1893	Mola
1711	Meulen	1773	Sadler	1835	Greek School	1894	Spanish School
1712	Wouvermans	1774	Sadler	1836	Central European School	1895	David
1713	Meulen	1775	Sadler			1896	Poerson
1714	Armfield	1776	Sadler	1837	Constantinople School	1897	No Entry
1715	Graat	1777	Sadler			1898	Inglis

1899	Quadal	1959	English School	4018	Marinot	4080	Henry
1900	Brett	1960	Bellotto	4019	Marinot	4081	Henry
1901	Velazquez	1961	English School	4020	Marinot	4082	Henry
1902	No Entry	1962	Veronese	4021	Marinot	4083	Henry
1903	Fennell	1963	Yeats	4022	Marinot	4084	Sleator
1904	Frye	1964	Velde	4023	Marinot	4085	Steiner
1905	Yeats	1965	Barker	4024	Danby	4086	Barret
1906	Yeats	1966	No Entry	4025	Spanish School	4087	No Entry
1907	Fyt	1967	Furini	4026	Spanish School	4088	Tchelitchev
1908	Reni	1968	Stephens	4027	Tuohy	4089	Sogliani
1909	Barret	1969	Irish School	4028	Moynan	4090	Romagna School
1910	Domenichino	1970	Fabre	4029	Collie	4091	Italian School
1911	Roman School	1971	Dutch School	4030	Orpen	4092	Keil
1912	Vignon	1972	Dutch School	4031	Yeats	4093	Flemish-French School
1913	Flemish School	1973	English School	4032	Yeats		
1914	Leech	1974	Eddis	4033	Hussey	4094	Francken
1915	Leech	1975	Mulvany	4034	Hunter	4095	Italo-Flemish School
1916	Osborne	1976	English School	4035	Haverty	4096	Florentine School
1917	MacManus	1977	Viola	4036	Newton	4097	Russell
1918	Pascucci	1978	Orpen	4037	Raeburn	4098	Russell
1919	O'Neill	1979	Durand	4038	O'Conor	4099	Russell
1920	Solomons	1980	Elwes	4039	English School	4100	Russell
1921	Solomons	1981	Snagg	4040	Yeats	4101	Russell
1922	Henry	1982	Vouet	4041	O'Connor	4102	Russell
1923	Irish School	1983	Hone	4042	Dillon	4103	Russell
1924	Barry	1984	Velazquez	4043	Kirkwood	4104	Russell
1925	Celesti	1985	Velazquez	4044	Ryan	4105	Russell
1926	Solomons	1986	Velazquez	4045	Ashford	4106	Russell
1927	Maclise	1987	Spanish School	4046	Drake	4107	Russell
1928	Goya	1988	Italian School	4047	Cuming	4108	Russell
1929	Osborne	1989	Bronzino	4048	Italian School	4109	Russell
1930	Velazquez	1990	Flemish School	4049	Peters	4110	Russell
1931	Austen	1991	Rubens	4050	Gonzales	4111	Russell
1932	English School	1992	Neer	4051	Livesay	4112	McGuire
1933	Russell	1993	Flemish School	4052	Roberts	4113	Kavanagh
1934	Leech	1994	Dyck	4053	Peters	4114	Kavanagh
1935	Osborne	1995	Jones	4054	Maclise	4115	Werner
1936	Rothwell	1996	Metsu	4055	Gerard	4116	Tuohy
1937	Dyck	1997	Hickey	4056	Exshaw	4117	Tuohy
1938	Pellegrini	1998	Bentley	4057	O'Conor	4118	Jervas
1939	Berchem	1999	French School	4058	Shee	4119	McCloy
1940	Romano	2000	are allocated to	4059	Salkeld	4120	Purser
1941	Rubens	↓	drawings and	4060	David	4121	Glannon
1942	Titian	3999	watercolours	4061	Fagan	4122	Fowler
1943	Gainsborough	4000	Dodson	4062	Mulcahy	4123	West
1944	Carré	4001	Venetian School	4063	Clarke	4124	Latham
1945	Irish School	4002	Furini	4064	Reynolds	4125	Ennis
1946	Lamb	4003	Barret	4065	Carver	4126	Ennis
1947	English or Irish School	4004	Italian School	4066	Topolski	4127	Ennis
1948	English or Irish School	4005	Haverty	4067	Clarke	4128	Tuohy
		4006	Pietro da Cortona	4068	Russell	4129	Davis
1949	Brakenburg	4007	Irish School	4069	Irish School	4130	Petrie
1950	Lyon	4008	Irish School	4070	Irish or English School	4131	Purser
1951	English School	4009	Leech	4071	Russell	4132	O'Connor
1952	Somerville	4010	O'Connor	4072	Russell	4133	Hamilton
1953	Unknown	4011	O'Connor	4073	Russell	4134	O'Conor
1954	Latham	4012	O'Connor	4074	Grogan	4135	Mulvany
1955	Berckmans	4013	O'Connor	4075	Lover	4136	Clarke
1956	Lamb	4014	Sheehan	4076	Brandt	4137	Ashford
1957	Lamb	4015	Essex	4077	Henry	4138	Ashford
1958	Hogarth	4016	Marinot	4078	Henry	4139	Scottish School
		4017	Marinot	4079	Henry	4140	Lely

4141	Lely	4191	Hunter	4241CB	Isabey	4291CB	Bonvin
4142	Smitz	4192	Hill	4242CB	Israels	4292CB	Both
4143	Smitz	4193	Henry	4243CB	Jacque	4293CB	Cameron
4144	Smitz	4194	Henry	4244CB	Jacque	4294CB	Helmick
4145	Smitz	4195	Delane	4245CB	Jacque	4295CB	Henner
4146	Morphey	4196	Keating	4246CB	Jacque	4296CB	Lefebvre
4147	Morphey	4197	Bourdon	4247CB	Jacque	4297CB	Leys
4148	Morphey	4198	English School	4248CB	Jacque	4298CB	Monticelli
4149	Morphey	4199	French School	4249CB	Jongkind	4299CB	Unknown
4150	Morphey	4200	Nairn	4250CB	Jongkind	4300	Watson
4151	Morphey	4201	McGuire	4251CB	Lépine	4301	Sleator
4152	Morphey	4202	Gabrielli	4252CB	Lépine	4302	Ferrari
4153	Latham	4203	Hare	4253CB	Leys	4303	Grogan
4154	Latham	4204	Stockum	4254CB	L'Hermitte	4304	Hussey
4155	Latham	4205	Stockum	4255CB	L'Hermitte	4305	Manning
4156	Latham	4206	Yeats	4256CB	Maris	4306	Butts
4157	Wissing	4207	Luytens	4257CB	Mauve	4307	No Entry
4158	Tilson	4208	Purtscher	4258CB	Meissonier	4308	Garstin
4159	Italian School	4209CB	Berchere	4259CB	Meissonier	4309	Yeats
4160	English School	4210CB	Berchere	4260CB	Meissonier	4310	Cregan
4161	Wright	4211CB	Bonheur	4261CB	Meissonier	4311	French School
4162	Riley	4212CB	Boudin	4262CB	Meissonier	4312	English School
4163	Riley	4213CB	Breton	4263CB	Meissonier	4313	Fragonard
4164	Irish School	4214CB	Breton	4264CB	Mesdag	4314	Osborne
4165	Hunter	4215CB	Cazin	4265CB	Millet	4315	Provost
4166	Rigaud	4216CB	Cazin	4266CB	Neuville	4316	Jellett
4167	English School	4217CB	Chelminski	4267CB	Neuville	4317	Jellett
4168	Austrian School	4218CB	Corot	4268CB	Neuville	4318	Jellett
4169	Canevari	4219CB	Couture	4269CB	Pasini	4319	Jellett
4170	French School	4220CB	Couture	4270CB	Pasini	4320	Jellett
4171	French School	4221CB	Couture	4271CB	Pasini	4321	Jellett
4172	Hamilton	4222CB	Daubigny	4272CB	Rousseau	4322	Hone
4173	Hamilton	4223CB	Decamps	4273CB	Rousseau	4323	Grogan
4174	Hamilton	4224CB	Detaille	4274CB	Rousseau	4324	O'Conor
4175	Hamilton	4225CB	Detaille	4275CB	Schreyer	4325	Osborne
4176	Hamilton	4226CB	Detaille	4276CB	Schreyer	4326	Reynolds
4177	Hamilton	4227CB	Diaz	4277CB	Steer	4327	Allston
4178	Hamilton	4228CB	Dreux	4278CB	Stevens	4328	English School
4179	Hamilton	4229CB	Dupré	4279CB	Thaulow	4329	Robinson
4180	Hamilton	4230CB	Forain	4280CB	Tissot	4330	Crowley
4181	Hamilton	4231CB	Fromentin	4281CB	Troyon	4331	Rothwell
4182	Hamilton	4232CB	Fromentin	4282CB	Troyon	4332	Osborne
4183	Hamilton	4233CB	Fromentin	4283CB	Troyon	4333	Landseer
4184	Wright	4234CB	Gerome	4284CB	Marcke	4334	Jellett
4185	John	4235CB	Guillaumet	4285CB	Veyrassat	4335	Cruise
4186	Fernandez	4236CB	Harpignies	4286CB	Vollon	4336	Kneller
4187	Fox	4237CB	Harpignies	4287CB	Ziem	4337	Italian School
4188	Purser	4238CB	Henner	4288CB	Ziem	4338	Forbes
4189	Mallary	4239CB	Hervier	4289CB	Ziem	4339	Wheatley
4190	Belmont	4240	No Entry	4290CB	Ziem	4340	Maubert

APPENDIX 2
Changes of Attribution
Since the 1971 Catalogue of Paintings

Old Attribution	Permanent Catalogue Number	New Attribution
Quellinus	2	Thulden
School of Rubens	38	Jordaens
School of Rubens	51	Rubens
Rosa	63	Guardi
Gordone	82	Tintoretto
Attributed to Michelangelo	98	Attributed to Granacci
Bellini	100	Attributed to Bellini
Pontormo	103	Maso da San Friano
Pontormo	104	Maso da San Friano
Bonifazio de'Pitati	121	Tintoretto
Pellegrini da San Daniele	213	Attributed to Beccaruzzi
Style of Cano	273	Zurbarán
Attributed to Ribera	298	After Maratti
German School	354	Spanish School, c.1520
Irish School, 18th century	399	Gaven
Slaughter	421	Irish School, 18th century
Studio of Rubens	427	Rubens
Attributed to Ricci	542	Italian School, 18th century
Ashford	615	Irish School, c.1750
Bassano	673	Attributed to Carracci
After Bellotto	705	Studio of Canaletto
After Dyck	809	Dyck
North Italian School, 16th century	866	Lotto
Feti	898	After Feti
Master of Verrucchio	1022	Rimini School, 15th century
After Bellotto	1043	Studio of Canaletto
Milanese School	1065	After Reni
Follower of Giordano	1069	Giordano
After Correggio	1078	Bolognese School, 17th century
Follower of Sarto	1080	Italian School, 16th century
Attributed to Fuseli	1093	Piscelli
Attributed to Fuseli	1094	Piscelli
Roman School, 17th century	1103	Follower of Barocci
Appiani	1189	Circle of Appiani
After Parmigianino	1248	Circle of Vasari
After Maratti	1331	After Carracci
Follower of Sarto	1336	Italian School, 16th century
Follower of Veronese	1337	Italian School, 16th century
Irish School	1350	Hamilton
Irish School, 1718	1648	Irish School, 18th century
Irish School, 1718	1649	Irish School, 18th century
Coypel	1656	Attributed to Coypel
Giordano	1667	Italian School, 17th century
School of Castiglione	1691	Attributed to Orrente
School of Caravaggio	1695	After Reni
Coypel	1705	After Rubens
Vernet	1732	Attributed to Vernet
Vernet	1733	Attributed to Vernet
Prud'hon	1739	Stern
Vernet	1744	Coccorante
Vignali	1747	Lippi
Avignon School	1780	Yverni
Greek School, mid 13th century	1858	Constantinople School, c.1325
Pontormo	1864	Maso da San Friano
Pontormo	1865	Maso da San Friano
La Tour (Georges)	1867	La Tour (Étienne)
After Domenichino	1908	After Reni
Costanzi	1911	Roman School, 17th century
Preti	1912	After Vignon
Londani	1918	Pascucci
Brekelenkam	1949	Brakenburg

[323]

Old Attribution	Permanent Catalogue Number	New Attribution
Attributed to Latham	1954	Latham
Irish School, 20th century	1956	Lamb
Irish School, 20th century	1957	Lamb
Italo-Flemish School, 17th century	1977	Viola
Italian School, 17th century	1988	Giordano
Kauffman	1997	Hickey
After Tintoretto	4001	Venetian School, 16th century
Giordano	4006	After Pietro da Cortona

APPENDIX 3
Identified Portraits

Abbot, Mary
(Mrs Romney)
Romney (674)

A'Court, William
(1st Lord Heytesbury)
Eddis (464)

Addison, Joseph
English School, 17th century (401)

Ailesbury, Thomas, 4th Earl of
(Lord Bruce)
Reynolds (734)
Reynolds (736)

Alexander, Mr G.
(with Alacrity)
Reynolds (901)

Alexander, Lady
Attributed to Jamesone (534)

Alexander, William
(Bishop of Armagh)
Browne (622)

Allen of Bridgewater, John
Frye (1904)

Alva, The Duke of
(as Barak, husband of Sisera)
Pereda (667)

Amelia of Solms
(Princess of Orange) (?)
Attributed to Hanneman (438)

Amherst, Geoffrey and Sarah
Fagan (1135)

Anne, Princess
After Dyck (389)

Antrim, The Marquess and Marchioness of
Wheatley (4339)

Archdale, Captain
Reynolds (901)

Argyll, Elizabeth, Duchess of
(née Gunning)
Attributed to Romney (1151)

Armagh, William Alexander, Archbishop of
Browne (622)

Armagh, John Hoadly, Archbishop of
Slaughter (317)

Armagh, Richard Robinson, Archbishop of
(Lord Rokeby)
Sherwin (396)

Armit, John
Wheatley (125)

Armstrong, Lady
(née Ferrard)
Osborne (1388)

Armstrong, Sir Walter
Osborne (1389)

Arran, Arthur, 2nd Earl of
Sherwin (396)

Ashbourne, William, 2nd Lord
Irish School, 20th century (1316)

Athlone, Godert, Earl of
Kneller (486)

Aungier, Mr C.
Osborne (891)

Bachelier, Calude
Flemish-French School, 1568 (4093)

Bagot, Mr
Reynolds (734)

Balthasar Carlos, Infante
Carreno (1387)
After Velazquez (1984)

Banim, John
Mulvany (208)

Banim, Michael
Thompson (320)

Banks, Frances Jane
(Mrs Hadden)
Fortune (1728)

Barret, Mr
Reynolds (734)

Barret the Younger, George
Barret (415)

Barry, Henry
(4th Lord Santry)
Worsdale (134)

Barry, James
Barry (971)
Opie (614)

Barry, Spranger
Irish School, 18th century (1815)

Basterot, M. le Comte de
French School, 19th century (4311)

Bath, The Earl of
English School, 18th century (1868)

Bayly, John
(with Whip)
Reynolds (901)

Becher, Lady Elizabeth
(née O'Neill)
Thompson (604)

Butler, Mr T.
Osborne (891)

Butt, Rosa
Yeats (1724)

Byrne of Ballymanus, Billy
Irish School, 18th century (1730)

Caldbeck, Councillor
Wheatley (125)

Caldwell, Andrew
Woodburn (1136)

Callan, Philip
(with Ruth)
Reynolds (901)

Callis, Anne
(Mrs Western)
Hogarth (792)

Camden, John, 1st Marquess of
Lawrence (299)

Campbell, Biddy
Tuohy (4027)

Carhampton, Lady
Sherwin (396)

Carhampton, Simon, 1st Earl of
Worsdale (134)

Carleton, John
Wheatley (125)

Carleton, William
Slattery (224)

Carlotta
John (1329)

Carolan, Turlough
(The Blind Harper)
Bindon (1344)

Caroline of England, Queen
Hogarth (126)

Carteret, Lord John
(Earl Granville)
Hudson (294)

Casement, Sir Roger
Purser (938)
Purser (1376)

Cassilis, Thomas, 9th Earl of
(was Sir Thomas Kennedy)
Reynolds (734)
Reynolds (737)

Castiglione, Baldassare
Titian (782)

Catherine of Austria, Archduchess (?)
Seisenegger (902)

Caughley, Mary
Yeats (1726)
Yeats (1727)

Cauldwell, Charles
Irish School, 18th century (1137)

Caulfield, Anne
(Mrs Arthur Orpen)
Orpen (1341)

Caulfield, Francis William
(2nd Earl of Charlemont)
Lawrence (379)

Caulfield, James
(1st Earl of Charlemont)
Cuming (187)
Livesay (4051)
Quadal (1763)
Reynolds (734)
Reynolds (737)
Sherwin (396)

Caulfield, Thomas
(with Sunbeam)
Reynolds (901)

Cazneau, Edward
Cazneau (602)

Charlecote, Bridget
(Viscountess Molyneux of Maryborough)
Morphey (4147)

Charlemont, Francis, 2nd Earl of
Lawrence (379)

Charlemont, James, 1st Earl of
Cuming (187)
Livesay (4051)
Quadal (1763)
Reynolds (734)
Reynolds (737)
Sherwin (396)

Charles I
(King of England)
Stone (251)

Charles I, The children of
After Dyck (389)

Charles II
(King of England)
After Dyck (389)
Studio of Velde (58)
After Velde (1742)

Charles V, Emperor
Spanish School, 17th century (1689)
After Titian (1030)

Charleton, William
Slattery (224)

Chaworth, Mary
(Mrs Musters) (?)
Hoppner (256)

Chiaramonti, Gregorio L.B.
(Pope Pius VII)
Wilkie (240)

Chinnery, Mrs
(née Vigne)
Chinnery (1000)

Ciocchi del Monte, Cardinal Antonio
Piombo (783)

Clanbrassil, James, Earl of
Sherwin (396)

Clanricarde, Henry, 12th Earl and 1st Marquess
Sherwin (396)

Clare, John, Earl of
Hamilton (292)
Sherwin (396)
Wheatley (125)

Clarke, Harry
Clarke (4067)

Clarke, Joshua
Clarke (4063)

Clary, Julie
(later Bonaparte)
Gérard (4055)

Clements, Colonel
Worsdale (134)

Clementson, Mrs
Shee (4058)

Clive, Kitty
(Catherine Rafter)
Attributed to Richardson (642)

Cloyne, George Berkeley, Bishop of
Irish School, 18th century (895)
Smibert (465)

Cloyne, Henry Maule, Bishop of
Irish School, 18th century (876)
Latham (1954)

Codd, Anastasia
(Mrs Moore)
Irish School, 19th century (303)

Collins, Maurice
Topolski (4066)

Collins, Mrs
Collins (648)

Collins, William
Linnell (844)

Congreve, William
Kneller (4336)

Congreve, Captain William
(with his son William)
Reinagle (1213)

Dimpfel, Christopher
Slingeland (268)

Dineen, The Reverend Patrick S.
Yeats (910)

Dobbyn, Mrs
Comerford (634)

Doherty, John
Cregan (830)

Donegall, Anne, Countess of
(née Hamilton)
Cotes (373)

Douglas, R.M.
Reynolds (901)

Dowd, Richard
Reynolds (901)

Dowden, Edward
Osborne (774)

Dowden, Hester
Yeats (1395)

Doyle, Richard
Doyle (423)

Drake, Mr
Reynolds (734)

Drew, Thomas
Osborne (931)

Drogheda, Charles, 6th Earl of
Sherwin (396)

Drummond, Thomas
Pickersgill (409)

Drury, J.G.
Osborne (891)

Dublin, Robert Fowler, Archbishop of
Sherwin (396)

Dublin, John Charles McQuaid, Archbishop of
Elwes (1980)

Dublin, Daniel Murray, Archbishop of
Crowley (1756)

Dublin, Peter Talbot, Archbishop of
Italian School, c.1660 (4159)

Dublin, John Thomas Troy, Archbishop of
Thompson (229)

Duckett, Mr W.
Osborne (891)

Dudley, Robert
(Earl of Essex)
English School, 16th century (304)

Duffy, Mr M.
Osborne (891)

Dunbar, William
(with Hawk)
Reynolds (901)

Durham, Mr
Kelly (1306)

Edgcumbe, Captain George
(1st Earl of Mount-Edgcumbe)
Reynolds (137)

Edgeworth, Francis
Irish School, 18th century (1357)

Edgeworth, Colonel Francis
Irish School, 18th century (1349)

Edgeworth, Mrs
(née Suxbery, wife of Colonel Francis)
Irish School, 18th century (1353)

Edgeworth, Sir John
Irish School, 18th century (1346)

Edgeworth, Lady
Irish School, 18th century (1348)

Edgeworth, Lovell
Irish Schoool, 19th century (1351)

Edgeworth, Richard
Irish School, 18th century (1356)

Edgeworth, Richard Lovell
Hamilton (1350)

Edward VI
(King of England)
After Holbein (1265)

Elizabeth, Princess
After Dyck (389)

Elizabeth I
(Queen of England)
English School, 16th century (541)

Elsner, Professor W.
Werner (4115)

Ely, Frances, Countess of
Kauffman (200)

Ely, Henry, Earl of
Kauffman (200)

Erskine, David Stewart
(11th Earl of Buchan)
Raeburn (523)

Erwin, Dr
Reynolds (734)

Esposito, Michele
Harrison (1219)

Essex, Robert, 2nd Earl of
Segar (283)

Ettingsol, Thomas
Bridgeford (1404)

Eustace, Mrs
Chinnery (999)

Fahy, Frank
Tuohy (1782)

Farnese, Prince Alexander
(grandson of Charles V)
Coello (17)

Farrer, Lady
O'Brien (1414)

Featherstone, Sir Matthew
Reynolds (734)

Ferrard, Miss
(Lady Armstrong)
Osborne (1388)

Fersen, Countess Carlotta
(née Sparre)
Nattier (1646)

Fforde, Francis
Reynolds (901)

Fielding, Anna
(Mrs Hall)
Latre (851)

Fitzgerald, Charles
(4th Duke of Leinster)
Lehmann (1816)

Fitzgerald, Lord Edward
(son of 1st Duke of Leinster)
Hamilton (195)

Fitzgerald, Lady Elizabeth
(The Fair Geraldine)
English School, 16th century (1195)

Fitzgerald, Henrietta
(Mrs Grattan)
Spilsbury (567)

Fitzgerald, Lady Pamela
(wife of Lord Edward; with her daughter Pam.
Mallary (4189)

Fitzgerald, William Robert
(2nd Duke of Leinster)
Shee (569)
Sherwin (396)
Wheatley (125)

Fitzgibbon, Gerald
Osborne (953)

Grove family, A member of the
Attributed to Beechey (1792)

Gunning, Elizabeth
(Duchess of Argyll; sister of Maria Gunning)
Attributed to Romney (1151)

Gunning, Maria
(Countess of Coventry)
Cotes (417)

Gwynn, Mrs Denis
(née Eileen Lavery)
Lavery (1644)

Hadden, Mrs George
(née Frances Banks)
Fortune (1728)

Haggerston, Sir Charles
Belle (912)

Hall, Mrs Samuel Carter
(née Anna Fielding)
Latre (851)

Hamilton, Lady Anne
(Duchess of Hamilton)
English School, 17th century (1149)

Hamilton, Anne Douglas
(Countess of Donegall)
Cotes (373)

Hamilton, Count Anthony
Wright (4161)

Hamilton, Lady Claude
Swinton (331)

Hamilton, Gustavus
(2nd Viscount Boyne)
After Hogarth (127)

Hamilton, The Reverend J.M.
Purser (1811)

Handcock, Miss
Smibert (465)

Harcourt, Lord Simon
Hunter (1002)

Hare, St George
Hare (4203)

Harpur, Thomas
Osborne (891)

Harrington, Charles, 5th Earl of
Powell (1660)

Harrington, Lady
(5th Countess of Harrington)
Stone (1044)

Harrington, Seymour, 6th Earl of
Grant (1322)

Harrison, Dr
Shee (998)

Harrison, Henry
Harrison (1281)

Harrison, Sarah
Harrison (1279)

Hastings, Francis Rawdon
(Earl of Moira and Marquess of Hastings)
Shee (194)

Hatton, Lady Anne
Sherwin (396)

Hawkins, Sir William
Sherwin (396)

Heaney, Seamus
Maguire (4212)

Heaphy, Mary
(Mrs O'Keefe)
O'Keefe (1810)

Heaven, Mrs
(née Ruth Lane)
Yeats (1800)

Helen, George Robert
Kauffman (887)

Helen, Mrs George
(née Dorothea Daniel)
Kauffman (888)

Hely Hutchinson, The Rt Hon. John
Reynolds (4326)

Henley, Robert
(2nd Earl of Northington)
Reynolds (217)

Henry of Straffan, Joseph
(nephew of Joseph II Leeson)
Reynolds (734)
Reynolds (736)

Hery, Claude
Flemish-French School, 1568 (4093)

Hesse, The Princess of
Hogarth (126)

Hewitt, James
(1st Viscount Lifford)
West (124)

Heytesbury, The Hon. Mrs
Eddis (1974)

Heytesbury, Lord William
Eddis (464)

Hickey, Joseph
Attributed to Hickey (310)

Hoadly, Dr Benjamin
(brother of John)
Hogarth (398)

Hoadly, John
(Archbishop of Armagh)
Slaughter (317)

Hobart, Lord Robert
(4th Earl of Buckinghamshire)
Sherwin (396)

Hobson, Bulmer
O'Sullivan (1863)

Hogarth, William
After Hogarth (1958)

Holloway, Joseph
Newton (4036)

Homan, Mrs
(née Ormsby)
Forbes (4338)

Homrigh, Hester van
('Vanessa') (?)
Hussey (1643)

Hone, Evie
Stockum (4204)
Stockum (4205)

Hone, Horace
Hone the Elder (1297)

Hone, Mr J.
Osborne (891)

Hone, John Camillus
Hone the Elder (440)
Irish School, c.1800 (4007)

Hone the Elder, Nathaniel
Hone the Elder (196)
Hone the Elder (886)
Hone the Elder (1003)

Hone the Younger, Nathaniel
Brandon (881)
Osborne (987)

Hoppner, John
Hoppner (556)

Horton, Mrs Christopher
(Duchess of Cumberland)
Gainsborough (795)

Hudson, Edward
Cuming (305)

Huet, Mr
Reynolds (734)

Hundertpfundt, Anthony
Huber (15)

Hunt, Mrs John
(Judith)
Hunt (683)

Hutchinson, Francis
(with his daughter Ann) (?)
Vierpyl (1025)

Hyde, Dr Douglas
(1st President of Eire)
O'Sullivan (1011)
Purser (1181)
Yeats (874)

Hyde, Seymour Sydney
(6th Earl of Harrington)
Grant (1322)

Ibsen, Mrs Sigurd
(née Berligot Bjornsen)
Breslau (908)

Infanta Margharita
After Velazquez (1119)

Infanta Maria Teresa
(Queen of France)
After Velazquez (14)

Infante Balthasar Carlos
Carreno (1387)
After Velazquez (1984)

Innocent X, Pope
After Velazquez (1901)

Ironmonger, Mr
Reynolds (734)

Isabella of Austria
After Dyck (1937)

James, Mr G.W.
Reynolds (901)

James, Sir John
Smibert (465)

James II
(King of England; as Duke of York)
After Dyck (389)

Jameson, Mr W.G.
Osborne (891)

Janverin, Eliza
(Mrs Taylor)
Romney (789)

Johnson, Esther
('Stella')
Irish School, 18th century (599)
Latham (431)

Johnston, General James
Gainsborough (794)

Johnston, Sir John Allen
Wheatley (125)

Johnston, Mr
Wheatley (125)

Joly, Jasper
Wheatley (125)

Jones, Dochie
(Mrs Garstin)
Garstin (4308)

Joyce, James
Blanche (1051)
Tchelitchev (4088)

Kane, Nathaniel
(Lord Mayor of Dublin)
Slaughter (1058)

Kauffman, Angelica
Kauffman (200)

Kavanagh, Julia
Chanet (312)

Kean, Edmund
Maclise (1019)

Keating, Séan
Orpen (4030)

Kelly, James
Osborne (891)

Kelly, Miss
(Mrs Gorges)
Rouland (1269)

Kelly, Mrs
Irish School, 18th century (1271)

Kelly, Mrs
(née Lynch of Barna)
Irish School, 18th century (1270)

Kemeys-Tynte, Sir Charles
Frye (927)

Kendrick, Matthew
Rothwell (222)

Kennedy, Patrick
Irish School, 19th century (1120)

Kennedy, Sir Thomas
(9th Earl of Cassilis)
Reynolds (734)
Reynolds (737)

Kenny, James
Newton (210)

Kick, Simon
Kick (834)

Killala, Walter Blake Kirwan, Dean of
Shee (1129)

Kilwarden, Arthur, 1st Viscount
Hamilton (578)

King, Mrs
(née Spence)
Gainsborough (793)

Kirkpatrick, Colonel William
Hickey (1860)

Kirwan, Walter Blake
(Dean of Killala)
Shee (1129)

Knoblauch, Heinrich
Faber (243)

Knoblauchin, Katherina
(sister of Heinrich)
Faber (21)

Koch, Monsieur A.
Henner (4295CB)

Kyle, Samuel
(Bishop of Cork)
Irish School, 18th century (876)

Lamb, William
(2nd Viscount Melbourne)
Harlow (255)

Lane, Sir Hugh Percy
Harrison (1280)

Lane, Ruth
(Mrs Heaven)
Yeats (1800)

Langley, Charles
Reynolds (901)

Lansdowne, John, 2nd Marquess of
After Fabre (1970)

Lansdowne, Maria, 2nd Marchioness of
(née Maddox)
Wilkie (1748)

Lapsley Guest, Mrs George
Yeats (1821)

La Touche, David
Hamilton (491)
Wheatley (125)

La Touche of Bellevue, Mrs
Smith (628)

Lavery, Lady Hazel
Lavery (1251)
Lavery (1644)

Lavery, Sir John
Lavery (1644)

Lawrence, Sir Henry Montgomery
Dicksee (135)

Lawrence, T.E.
(of Arabia)
Gurschner (1184)

Lecky, M.P., William Edward Hartpole
Lavery (574)

Leech, William
Leech (1914)

Leech, Mrs William
(May)
Leech (1915)

Leeson, Lady Anne
(née Preston; 1st Countess of Milltown; 2nd wife of
 Joseph II)
Batoni (703)
After Batoni (1650)

Leeson, Cecilia
(née Leigh; 1st wife of Joseph II)
Lee (699)

Leeson, Lady Cecilia
(daughter of Joseph III)
After Batoni (1697)

Leeson, Edward Nugent
(6th Earl of Milltown)
Grant (1036)

Leeson, Lady Elizabeth
(née French; Countess of Milltown; 3rd wife of
 Joseph II)
After Batoni (1697)

Leeson, Joseph I
Irish School, 18th century (1648)

Leeson, Joseph II
(1st Earl of Milltown)
Batoni (701)
After Batoni (1697)
Lee (698)
Reynolds (734)
Reynolds (735)

Leeson, Joseph III
(2nd Earl of Milltown)
Batoni (702)
After Batoni (909)
Reynolds (734)
Reynolds (736)

Leeson, Joseph IV
(3rd Earl of Milltown)
After Batoni (1697)

Leeson, Margaret
(née Brice; wife of Joseph I)
Irish School, 18th century (1649)

Le Fanu, Joseph Sheridan
Le Fanu (919)

Leicester, Robert, Earl of
English School, 16th century (304)

Leigh, Cecilia
(Mrs Leeson)
Lee (699)

Leinster, Caroline, Duchess of
(née Granville; wife of 4th Duke)
Lehmann (1817)

Leinster, Charles, 4th Duke of
Lehmann (1816)

Leinster, Emily, Duchess of
(née Lennox; wife of 1st Duke)
Reynolds (4064)

Leinster, William, 2nd Duke of
Shee (569)
Sherwin (396)
Wheatley (125)

Leland, Thomas
Attributed to Hickey (655)

Lemon, Margaret
Lely (550)

Leney, Kate
Yeats (1004)

Lennox, Lady Emily
(Duchess of Leinster; wife of 1st Duke)
Reynolds (4064)

Leonard, Mr T.
Osborne (891)

Lifford, James, 1st Viscount
West (124)

Lifford, Lord
Sherwin (396)

Linden, Louis van der
Rembrandt (319)

Loftus, Sir Adam
English School, 17th century (410)

Loftus, Henry
(Earl of Ely)
Kauffman (200)

Long, William
Wheatley (125)

Longford, Christine, Countess of
(née Patti)
Brandt (1781)

Longford, Lord Thomas
Irish School, 18th century (1352)

Longhi, Pietro
Longhi (952)

Lonsdale, James
(with Light Cavalry)
Reynolds (901)

Lovell, Samuel
Irish School, 18th century (1345)

Lovell, Mrs Samuel
Irish School, 18th century (1347)

Lover, Samuel
Harwood (142)
Harwood (986)

Lover, Mrs Samuel
(née Berrel)
Lover (4075)

Lowther, Sir William
Reynolds (734)
Reynolds (735)

Lucan, Patrick, Earl of
English School, c.1690 (4328)
Attributed to Rigaud (4166)
Attributed to Riley (4163)

Lucy, Bridget
(Viscountess Molyneux of Maryborough)
Morphey (4147)

Lurgan, Lord
(with Master Magrath)
Reynolds (901)

Luttrell, Anne
(Mrs Horton; Duchess of Cumberland)
Gainsborough (795)

Luttrell, Simon
(1st Earl of Carhampton)
Worsdale (134)

Lynch, General Liam
Sheehan (4014)

Lynch of Barna, Miss
(Mrs Kelly)
Irish School, 18th century (1270)

Lyons, Francesca
English School, 18th century (1152)

McCarthy, Charlotte
Forbes-Robertson (1211)
Hale (1808)

McCarthy, Denis Florence
Irish School, 19th century (1295)

McCarthy, M.P., Justin
(father of Charlotte and Justin H.)
Waite (1210)

McCarthy, Justin Huntley
(as a saint)
Forbes-Robertson (1807)

McCarthy, Mrs
(grandmother of Justin H.)
O'Keefe (1809)

McGreevy, Dr Thomas
Collie (4029)

McHale, John
(Archbishop of Tuam)
Capalti (406)

MacIlwaine, John Bedell Stanford
Osborne (882)

McKenna, Stephen
Irish School, 20th century (1316)

McKillop, David
Reynolds (901)

Mackinnon children, The
Hogarth (791)

Macklin, Charles
(as Sir P. MacSycophant and Shylock)
Wilde (307)
Zoffany (301)

McLean, Donald
Grey (426)

Mac Liammoir, Micheal
Brandt (1799)

McNamara, M.P., Captain
Irish School, 19th century (1116)

McNamara, Francis
John (4185)

McNevin, Thomas
Haverty (4005)

McQuaid, John Charles
(Archbishop of Dublin)
Elwes (1980)

Madden, Richard Robert
Haverty (493)

Madden, The Reverend Samuel
Hickey (397)

Maddox, Maria
(2nd Marchioness of Lansdowne)
Wilkie (1748)

Magawley Banon, Edward
O'Brien (1160)

Mahaffy, The Reverend John Pentland
Attributed to Harrison (1767)

Maher, Mr W.A.
Osborne (891)

Malahide, Colonel Richard, 2nd Baron Talbot de
Canevari (4169)

Malone, Richard
(Lord Sunderlin)
Reynolds (1734)

Mangan, Mr S.
Osborne (891)

Margharita, Infanta
After Velazquez (1119)

Maria Teresa, Infanta
(Queen of France)
After Velazquez (14)

Marinot, Florence
(daughter of the artist)
Marinot (4021)

Markievicz, Constance, Comtesse de
(née Gore-Booth)
Markievicz (1231)

Marlet, Dr Adolphe
Courbet (1722)

Marselaer, Frederick
Dyck (235)

Martin, Mr H.
(with Flag)
Reynolds (901)

Martinengo, Count (?)
Fontana (460)

Martyn, Edward
McLachlan (975)

Mary, Princess
(mother of William III)
After Dyck (389)

Mary Tudor
(Queen of England)
Heere (400)
English School, 16th century (1266)

Massey, William
(with Mrs Trollope)
Reynolds (901)

Matthew, Father
Haverty (4035)

Maule, Henry
(Bishop of Cloyne)
Irish School, 18th century (876)
Latham (1954)

Maurice
(Prince of Orange; Stadtholder)
Molyn (8)

Maxwell, Mr
Reynolds (734)

Maxwell, William
Osborne (891)

Meagher, Thomas Francis
Mulvany (1284)

Melbourne, William, 2nd Viscount
Harlow (255)

Meldon, Mr J.
Osborne (891)

Meyer, Lady Dorothy
(née Moulton)
Drake (4046)

Meyer, Dr Kuno
John (859)

Meyer, Sir Robert
Hill (4192)

Mills, Eliza
(Mrs Petrie)
Petrie (1193)

Milltown, Lady Anne, 1st Countess of
(2nd wife of Joseph II)
Batoni (703)
After Batoni (1650)

Milltown, Edward, 6th Earl of
Grant (1036)

Milltown, Lady Elizabeth, Countess of
(3rd wife of Joseph II)
After Batoni (1697)

Milltown, Joseph II, 1st Earl of
Batoni (702)
After Batoni (1697)
Lee (698)
Reynolds (734)
Reynolds (735)

Milltown, Joseph III, 2nd Earl of
Batoni (702)
After Batoni (909)
Reynolds (734)
Reynolds (736)

Milltown, Joseph IV, 3rd Earl of
(as a boy)
After Batoni (1697)

Minarelli, Baroness
Einsle (1153)

Mitchell, Susan
Yeats (1298)

Mocenigo, The daughter of Doge
After Veronese (1085)

Moffett, Sir Thomas W.
Osborne (601)

Moira, Francis, Earl of
(Marquess of Hastings)
Shee (194)

Molyneux, Sir Capel
Reynolds (901)

Molyneux of Maryborough, Bridget, Viscountess of
(née Charlecote; wife of 4th Viscount)
Morphey (4147)

O'Connell, M.P., Daniel
Haverty (1183)
Irish School, 19th century (1832)
Mulvany (207)

O'Connell, Maurice
Ryan (4044)

O'Connor, Rory
Whelan (967)

O'Connor, Mr T.P.
Lavery (923)

O'Conor, Roderic
O'Conor (922)

O'Dea, Jimmy
Le Jeune (1785)

O'Donnell, Sir George and Sir Richard (?)
Irish School, 18th century (1227)

O'Donnell, Sir Neil
(with his children) (?)
Irish School, 19th century (1228)

O'Donovan, John
Grey (585)

O'Faolain, Séan
McGuire (4201)

O'Flanagan, Father
Solomons (1920)

O'Grady, Standish James
Yeats (870)

O'Hagan, Maximilian
Osborne (1173)

O'Keefe, Mrs John
(née Mary Heaphy)
O'Keefe (1810)

O'Leary, John
Yeats (595)
Yeats (869)
Yeats (1963)

Olivares, Gaspar, Count-Duke of
(as Sisera)
Pereda (667)

O'Loghlen, Sir Michael
Mulvany (932)

O'Mahony, Eoin
('The Pope')
Hone (1983)

Ommaney, Admiral
West (838)

O'Murnaghan, Art
Solomons (1921)

O'Neile, Anne
(Mrs Segrave)
Morphey (4148)

O'Neile, Rose
(Mrs Wogan)
Morphey (4149)

O'Neill, Art
O'Donnell (1200)

O'Neill, Elizabeth
(Lady Becher)
Thompson (604)

O'Neill, Joseph
Purser (1220)

Orange, Amelia of Solms, Princess of (?)
Attributed to Hanneman (438)

Orange, Frederick Henry and Maurice, Princes of
Molyn (8)

Orange, William, Prince of
(King William III)
Dutch School, 17th century (291)
Kneller (311)
Maas (147)
Velde (1741)
Wyck (145)

O'Reilly, Count Andrew
Austrian School, c.1800 (4168)

O'Reilly, Mr J.R.
Osborne (891)

Oriel, Lord John
Sherwin (396)
After Stuart (867)

Ormonde, James, 1st Duke of
Lely (136)
Attributed to Lely (4140)

Ormonde, James, 2nd Duke of
Kneller (485)

Ormsby, Miss
(Mrs Homan)
Forbes (4338)

O'Rourke Moran, Mr P.
(with Old Rosy Maid)
Reynolds (901)

Orpen, Mr (Arthur), Mrs (Anne), and William
Orpen (1341)

Orpen, Lady Grace
(née Knewstub)
Orpen (1978)

Orpen, William
Conder (1327)
Orpen (945)
Orpen (1341)

Orsini, Clarice (?)
Ghirlandaio (1385)

Osborne, Violet
(Mrs Stockley)
Yeats (4032)

Osborne, Walter
Osborne (555)

Ossory, Thomas, Earl of
Attributed to Lely (1831)

Ostade, Adriaen van
Rossum (623)

O'Sullivan, Séan
Sullivan (1770)

Owenson, Sydney
(Lady Morgan)
Berthon (133)

Padilla, Conor
Henry (1922)

Pamfili, Gianbattista
(Pope Innocent X)
After Velazquez (1901)

Panini, Giovanni Paolo
Panini (95)

Parnell, M.P., Charles Stewart
Hall (481)

Parnell, John
Irish School, 18th century (660)

Patch, Thomas
Reynolds (734)

Patti, Christine
(Countess of Longford)
Brandt (1781)

Pellegrini, Carlo
Bastien-Lepage (583)

Persse, Isabelle Augusta
(Lady Gregory)
Orpen (1274)
Yeats (1318)

Persse Joyce, Mrs
(née Arabella Persse)
Luytens (4207)

Pery, Viscount Edmund
Stuart (822)

Pethard, Councillor
Wheatley (125)

Petrie, George
Mulrenin (408)

Scharff, John William
Osborne (1935)

Schomberg, Captain Sir John
Wheatley (125)

Schwerzell, Jane
(Mrs Cregan)
Cregan (918)

Segrave, Mrs John
(née Anne O'Neile)
Morphey (4148)

Semphill, Lady Alice
(née Lavery)
Lavery (1644)

Sexton, Edmond
(Viscount Pery)
Stuart (822)

Shannon, Henry, 1st Earl of
Irish School, 18th century (394)

Shannon, Richard, 2nd Earl of
Sherwin (396)

Shaw, Bernard
Stuart (1829)

Shaw, George Bernard
Collier (899)

Shaw, Captain John
Stuart (907)

Shaw, M.P., Robert
After Stuart (499)

Sheil, M.P., Richard Lalor
Haverty (1304)

Sheridan, Caroline
(Mrs Norton; Lady Stirling Maxwell)
Watts (279)

Sheridan, Charles Kinnaird
Landseer (139)

Sheridan, Mrs Richard Brinsley
(Marcia Maria; sister-in-law of Charles)
Landseer (139)

Sheridan, Thomas
Lewis (1132)

Sherlock, Lorcan
Lamb (1957)

Shorter, Mrs Clement
(née Dora Sigerson)
Lavery (831)

Shrewsbury, John, 1st Earl of
English School, c.1670 (4160)

Sidney, Sir Henry
English School, 16th century (880)

Sigerson, Dora
(Mrs Shorter)
Lavery (831)

Sinclair, Sir John
Stuart (1743)

Sisson, Miss
Doughty (787)

Sleator, James
Sleator (1247)

Smibert, John
Smibert (465)

Smith, Anthony
Reynolds (901)

Smith, Stephen Catterson
Attributed to Stephens (1968)

Smith the Elder, Stephen
Smith (122)

Smithson, Hugh
(Duke of Northumberland)
Gainsborough (129)

Smyth, Major-General L.C.
Osborne (891)

Soest, Gerard van
Soest (605)

Solms, Amelia van
(Princess of Orange) (?)
Attributed to Hanneman (438)

Somerset, Anne, Duchess of
English School, 16th century (759)

Sparre, Carlotta Frederika
(Countess Fersen)
Nattier (1646)

Spence, Miss
(Mrs King)
Gainsborough (793)

Spencer, Earl
Osborne (891)

Spring Rice, Thomas
(2nd Baron Monteagle)
Furse (977)

Stanhope, Anne
(Duchess of Somerset)
English School, 16th century (759)

Stanhope, Charles
(5th Earl of Harrington)
Powell (1660)

Stannard, Eaton
Latham (4124)

Steele, Sir Richard
Kneller (296)

'Stella'
(Esther Johnson)
Irish School, 18th century (599)
Latham (431)

Stephens, James
Tuohy (1126)

Sterling, Sir William
Reynolds (734)

Sterne, Lawrence
West (130)

Steuart-Denham, General Sir James
Raeburn (430)

Stevenson, Sir John Andrew
Joseph (416)

Stewart, Mrs Mary
Hamilton (4179)

Stirling Maxwell, Lady Caroline
(Mrs Norton)
Watts (279)

Stockley, Mrs
(née Violet Osborne)
Yeats (4032)

Stoney, Dr
Jones (949)

Strafford, Thomas, Earl of
After Dyck (413)

Stuart, Prince Charles Edward
(Bonnie Prince Charlie; as a boy)
Panini (95)

Stuart, Mrs Francis
(née Iseult Gonne)
Russell (1787)

Stuart, Prince Henry
(Cardinal of York; as a boy)
Panini (95)

Stuart, James Edward
(The Old Pretender)
Panini (95)

Stuart, Major
(with Senator)
Reynolds (901)

Sunderlin, Lord Richard
Reynolds (1734)

Suxbery, Mary
(Mrs Edgeworth)
Irish School, 18th century (1353)

Swift, Dean Jonathan
Bindon (598)
Irish School, 18th century (4069)
Jervas (177)

Tajo, El Conde del
Goya (600)

Talbot, Lady Catherine and Lady Charlotte
(daughters of Colonel R. Talbot)
Wright (4184)

Talbot, Sir Gilbert
Tilson (4158)

Talbot, John
(1st Earl of Shrewsbury)
English School, c.1670 (4160)

Talbot, Peter
(Archbishop of Dublin)
Italian School, c.1660 (4159)

Talbot, Colonel Richard
(Earl and Duke of Tyrconnell)
English School, 17th century (4167)
Irish School, 18th century (4164)
After Rigaud (1138)

Talbot, Mrs Richard
(née Catherine Boynton)
Wissing (4157)

Talbot, Colonel Richard Wogan
(2nd Baron Talbot de Malahide)
Canevari (4169)
Sherwin (396)

Talbot, Mrs Richard W.
Sherwin (396)

Talbot of Carton, Sir William
(father of Sir Gilbert and Peter Talbot)
Riley (4162)

Talbot of Malahide, Richard
(son of John Talbot)
Attributed to Lely (4141)

Talbot, Mrs Richard
(née Frances Talbot)
Morphey (4150)

Tandy, James Napper
Irish School, 18th century (429)
Wheatley (125)

Tasso, Torquato
After Velazquez (1930)

Taylor, Mrs Edward
(née Eliza Janverin)
Romney (789)

Taylor, George Archibald
Attributed to Jones (521)

Taylor, Joseph
Reynolds (901)

Temple, George, 2nd Earl
(1st Marquess of Buckingham)
Reynolds (733)
Sherwin (396)

Temple, Mary, Countess
(Countess Nugent)
Reynolds (733)
Sherwin (396)

Temple, Mrs
Hamilton (4173)

Temple, Richard, 3rd Earl
(1st Duke of Buckingham and Chandos)
Reynolds (733)

Thomond, Murrough, 1st Marquess of
Lawrence (131)
Sherwin (396)

Thompson, Mr T.
Osborne (891)

Thompson, Thomas Clement
Thompson (575)

Throckmorten, Elizabeth
(Lady Raleigh)
English School, 16th century (282)

Tierney, Sir George
Hayter (559)

Tighe, Mary
Romney (1164)

Tisdal, Mr
Wheatley (125)

Todd, Professor James Henthorn
Smith (407)

Todhunter, John
Paget (915)

Tone, Theobald Wolfe
Irish School, 18th century (1784)

Tonneman, Jeronimus
(with his son Jeronimus)
Troost (497)

Tottenham, M.P., Charles
Latham (411)

Trench, Mrs F.
Hamilton (4178)

Trench, Mr R. J.
Hamilton (4183)

Trevor, Helen Mabel
Trevor (502)

Trinseach, Saidbh
Russell (4068)

Troy, John Thomas
(Archbishop of Dublin)
Thompson (229)

Tuam, John McHale, Archbishop of
Capalti (409)

Tuite, Jane
(Mrs Edgeworth)
Irish School, 18th century (1354)

Turbett, Thomas
Osborne (891)

Turner, Charles
Reynolds (734)

Tyrconnell, Richard, Earl and Duke of
English School, 17th century (4167)
Irish School, 18th century (4164)
After Rigaud (1138)

Tyrell, Sir John
Ramsay (570)

Tyrone, George, Earl of
(Marquess of Waterford)
Sherwin (396)

Ussher, Arthur
Jonson (1383)

'Vanessa'
(Hester van Homrigh) (?)
Hussey (1643)

Vaudreuil, Louis-Philippe, Marquis de
Roslin (1824)

Vere Foster family, The
Orpen (1199)

Vierpyl, Simon
Reynolds (734)

Vigne, Marianne
(Mrs Chinnery)
Chinnery (1000)

Vischer, Georg
Pencz (1373)

Wadding, Father Luke
After Maratti (298)

Wade, Field-Marshal George
Hogarth (560)

Waldré, Vincent
Cuming (4067)

Waller, Sir Robert
(with his son Sir Robert)
Hunter (4191)

Ward, Mr
Reynolds (736)
Reynolds (737)

Waterford, George, Marquess of
Sherwin (396)

Waterhouse, Mr S.
(with S.S.)
Reynolds (901)

Alkmaar
Ruisdael (27)

Amsterdam
Beerstraten (679)
Kessel (933)
Prins (681)

Antwerp
Genisson/Willem (168)

Ardmore
Hone the Younger (1185)

Arras
Sabatte (1238)

Baldoyle
Sadler (1775)

Ballinrobe
O'Connor (4010)
O'Connor (4011)
O'Connor (4012)

Bantry Bay
Hamilton (1779)

Bathford (on right)
Barker (377)

Belfast Lough
Henry (4079)

Boulogne
Lemercier (1168)

Bray Head
Brocas (647)

Breviandes
Marinot (4017)

Cadiz
English School, 16th century (281)

Capri
Brennan (155)

Castle Townsend
Coghill (1786)

Cork
Attributed to Grogan (4303)

Curragh Chase House
Mulcahy (1795)

Dargle, River
Attributed to Barret (4086)
O'Connor (163)

Delft
Poel (22)
Vliet (530)
Witte (450)

Devil's Glen, The
O'Connor (825)

Dinan
Kavanagh (1194)

Dresden
Bellotto (181)
Bellotto (182)

Dublin (from Chapelizod)
Ashford (4138)

Dublin (The Custom House)
Kettle/Cuming (1783)

Dublin (The Four Courts)
Kettle/Cuming (1783)
Osborne (1916)
Sadler (1651)

Dublin (The General Post Office)
Russell (1933)

Dublin (O'Connell Street)
Petrie (4130)
Russell (893)

*Dublin (The Pigeon House
 and Poolbeg Lighthouse)*
Sadler (632)
Sadler (633)

*Dublin (The Provost's House
 and Trinity College)*
Sadler (835)

Dublin (The Rotunda Hospital)
Turner de Lond (1148)

Dublin (St Patrick's Cathedral)
Cruise (4335)

Dublin (St Patrick's Close)
Osborne (836)

*Dublin (Trinity College
 and The Bank of Ireland)*
Moynan (4028)
Wheatley (125)

Dublin Bay
Ashford (577)
Ashford (4137)
Hayes (1054)
Hone the Younger (1495)
McEvoy (1886)
Snagg (1981)
Tudor (597)

Egmont Castle
Croos (328)

Etretat
Hone the Younger (1429)
Hone the Younger (1524)
Hone the Younger (1600)

Felixstowe
Brett (1900)

Finistère
O'Conor (1642)

Florence (on left)
Florentine School, 15th century (780)

Fontainebleau
Hone the Younger (1432)

Glandore
Henry (1286)

Glendalough
Rothwell (4331)

Glenmalure
Hone the Younger (1427)

Harborne
Cox (375)

Hastings
Osborne (858)

Howth
Hone the Younger (1585)
Sadler (1774)
Sadler (1777)

Kilkee
Hone the Younger (1398)
Hone the Younger (1616)

Kilkenny Castle
O'Neill (1919)

Killaries, The
Watkins (636)

Killarney
Fisher (1797)
Fisher (1813)
Lyon (1950)

Kilmallock
Mulvany (991)

Laytown
Sadler (1773)

Leixlip
Davis (4129)
Irish School, c.1750 (615)
Sadler (1776)

eman, Lake
nchbold (586)

ochaber
ameron (4293CB)

ondon (Chelsea)
eane (854)

ondon (Greenwich)
issot (1105)

ondon (Thames Bridges)
rant (1884)

ondon (Westminster Bridge)
cott (677)

adras
ickey (1860)

alahide
one the Younger (1500)

almaison
érard (4055)

arlay
one (1371)

arseilles
ollon (4286CB)

ask, Lough
'Connor (4013)

ayfield
odson (4000)

elville Sound
radford (1872)

aworth Castle
lacklock (503)

the Forest
arinot (4018)

Paestum
Roberts (220)

Paris
Hone the Younger (1397)
Raffaëlli (1257)

Pisa (on right)
Florentine School, 15th century (780)

Portmarnock
Hone the Younger (1468)
Hone the Younger (1515)

Port na Blagh
Craig (1757)

Powerscourt
Barret (174)
O'Brien (1861)

Quimperle
Leech (4009)
Osborne (1052)

Raheny
Hone the Younger (1214)
Hone the Younger (1486)

Rhenen-on-the-Rhine
Goyen (807)

Rome
Barret (1632)
Barret (1633)
After Claude Lorraine (719)
Panini (95)
Panini (725)
Panini (726)

Rosapenna
Solomons (1413)

Rotterdam
Lorme (516)
Lorme (558)

Rye
Osborne (612)

St Mammes
Sisley (966)

Sonnenstein, Castle
After Bellotto (1960)

Tête du Chien, La (Monaco)
West (4123)

Tivoli (Cork)
Attributed to Grogan (4074)

Tivoli (Italy)
Wilson (747)

Venice
Canaletto (286)
Studio of Canaletto (705)
Studio of Canaletto (1043)
Cooke (593)
Hone the Younger (1433)
Hone the Younger (1537)
Marieschi (473)
Pritchett (446)
Pritchett (447)
Pritchett (1186)
Pritchett (1187)
Ziem (4287CB)
Ziem (4288CB)
Ziem (4289CB)

Vermoise
Marinot (4023)

Verona
Holland (437)
Thaulow (4279CB)

Versailles
Le Sidaner (1244)

Villefranche
Hone the Younger (1360)
Hone the Younger (1361)

APPENDIX 5
Old Testament Subjects

aron
Constantinople School, c.1325 (1858)

bel, Cain and
talian School, 17th century (1667)

braham and the three Angels
Navarrete (1721)

Abraham meeting Melchizedek
Wet (1315)

Adam and Eve, The Expulsion of
After Domenichino (1083)

Adam and Eve with Cain and Abel
After Pietro da Cortona (4006)

Adam tempted by Eve
Barry (762)

Ahab dedicating the Temple
Diano (357)

The Ark
Boel (42)

Identified Saints and Archangels

Agatha
After Guercino (1668)
Jordaens (46)

Agnes
Dolci (1229)

Alexis
La Tour (1867)

Ambrose
Jordaens (46)

Andrew
Boulogne the Elder (1889)
Master of St Verdiana (1201)
Moscow School, mid 16th century (1846)
Follower of Scorel (1392)

Anne (mother of the Virgin)
Fernandez (818)
Poussin (925)

Ansanus of Siena
Beccafumi (840)

Anthony Abbot
Constantinople School, late 17th century
 (1838)
Ghirlandaio (620)
School of Ijsenbrandt (552)
Jnen (527)

Anthony of Padua
Cotignola (106)
Panico (89)
Balta (34)

Apollonia
Maso da San Friano (103B)

The Apostles together
Antwerp Mannerist, c.1518 (1162)
Central European School, late 17th
 century (1836)
French School, 11th–12th centuries
 (4170)
French School, 11th–12th centuries
 (4171)
Lanfranco (67)
Moscow School, 15th century (1844)
Larson (1896)
Syrian School, 15th century (978)
Venetian School, 16th century (4001)
Witblom (914)

Augustine
After Guercino (483)
Jordaens (46)
Master of St Augustine (823)

Barbara
Italian School, 15th century (4091)

Bartholomew
Maso da San Friano (1864)
Moscow School, mid 16th century (1846)
Salmeggia (80)

Basil
Asia Minor School, 15th century (1851)

Benedict
Ghirlandaio (620)
Maso da San Friano (104D)

Bernard of Siena
Master of St Verdiana (1201)

Bonaventura
Pseudo Domenico di Michellino (861)
Machiavelli (108)

Catherine of Alexandria
School of Bronzino (1989)
After Correggio (184)
Italian School, 17th century (1040)
Jordaens (46)
After Luini (1249)
After Reni (1239)

Catherine of Siena
Spagna (212)

Cecilia
Cignani (183)
Attributed to Domenichino (70)

Charles Borromeo
Procaccini (1820)
After Reni (118)

Christopher
Cranach (973)

Clare
Palma Giovane (68)

Cosmas and Damian
Angelico (242)

Demetrius
Balkan School, late 15th century (1856)
Moscow School, early 16th century (1850)
Western Greek School, 15th century
 (1848)

Diego of Alcala
Studio of Zurbarán (479)

Dominic
After Cano (369)
After Reni (118)
Rubens (427)

Elizabeth (sister of the Virgin)
Jordaens (46)
After Maratti (1703)
Moscow School, early 17th century (1840)
Moscow School, late 17th century (1841)

Poussin (925)
After Romano (1940)
Circle of Vasari (1248)

Elizabeth of Hungary
Thulden (752)

Eustace
Attributed to Provost (4315)

Evangelists, The Four
French School, 11th–12th centuries
 (4070)

Francis of Assisi
Follower of Barocci (1103)
Attributed to Beccaruzzi (213)
Cotignola (106)
Pseudo Domenico di Michellino (861)
Greco (658)
After Guercino (483)
Maso da San Friano (104A)
Panico (89)
After Reni (118)
Rubens (51)
Spagna (212)
Teniers the Younger (1655)

Francis Xavier
After Reni (118)

Gabriel, Archangel
see also Appendix 7 (The Annunciation)
Bastiani (352)
Moscow School, mid 16th century (1846)

Galganus
Bartolo (1089)

Geminian
After Correggio (1042)

George
Asia Minor School, 15th century (1851)
Attributed to Bordone (779)
After Correggio (1042)
Greek School, c.1700 (1849)
Moscow School, early 16th century
 (1850)
Novgorod School, early 15th century
 (1857)
Palma Giovane (68)
Attributed to Provost (4315)
After Reni (118)

Gregory
Franco-Flemish School, c.1475 (1272)
Jordaens (46)

Gregory the Great of Armenia
Moscow School, mid 16th century (1846)

Ignatius
Thulden (2)

Irene
Giordano (79)

Isidore
Spanish School, 17th century (1987)

James the Less
Boulogne the Elder (1889)
Coypel (113)
Moscow School, mid 16th century (1846)
Silvestro dei Gherarducci (841)
Spanish School, c.1520 (4026 reverse)
Veronese (115)

Jerome
Attributed to Beccaruzzi (218)
Brescian School, 16th century (277)
Cariani (885)
After Correggio (1071)
After Domenichino (1885)
Ghirlandaio (620)
Girolamo di Benvenuto (839)
Italo-Flemish School, c.1600 (1749)
Jordaens (46)
Lys (981)
Machiavelli (108)
Maso da San Friano (104C)
After Michelangelo (1892)
Morales (1)
Nicolas (1013)
Attributed to Reni (1334)

John the Baptist
Studio of Albertinelli (1100)
Allori (1088)
Bacchiacca (1332)
School of Bartolommeo (1232)
Bugiardini (1090)
Cantarini (71)
Cariani (885)
After Carracci (1331)
Constantinople School, c.1325 (1858)
After Correggio (1042)
Ghirlandaio (620)
Giordano (1069)
Attributed to Granacci (98)
Greek School, 17th century (1835)
Guardi (63)
Herp (1082)
Italian School, 15th century (4091)
Italian School, 16th century (1080)
Italian School, 16th century (1336)
Italian School, 16th century (1337)
After Maratti (1703)
Moscow School, mid 16th century (1846)
Moyaert (1175)
Attributed to Murillo (33)
Palma Vecchio (580)
Palmezzano (117)
Poussin (925)
Preti (366)
After Romano (1940)
Rosa (96)
Studio of Sesto (365)
Sogliani (4089)
Tommaso (1140)
Vallejo (1798)
Circle of Vasari (1248)

John the Evangelist
Asia Minor School, early 18th century (1855)
Balducci (1282)
Boulogne the Elder (1889)
Constantinople School, late 14th century (1843)
Coypel (113)
French School, 11th–12th centuries (4170)
Giorgio d'Alemagna (1117)
Liège School, 16th century (1641)
Lower Rhine School, mid 15th century (1216)
Maso da San Friano (103A)
Attributed to Mignard (1801)
Moscow School, mid 16th century (1846)
Moscow School, early 17th century (1840)
Moscow School, late 17th century (1841)
Perugino (942)
Poussin (214)
Copy of Raphael (171)
Rimini School, 15th century (1022)
After Rubens (1941)
Russian School, 18th century (1854)
Salmeggia (78)
Salzburg School, c.1425 (979)

Joseph
see also Appendix 7 (The Holy Family, Nativity and Flight into Egpyt)
Guercino (152)
After Guercino (483)
Attributed to Ribera (12)

Laurence
Asia Minor School, 15th century (1851)
After Bandinelli (1301)
Maso da San Friano (104B)

Louis of Toulouse
After Guercino (483)
Machiavelli (108)

Lucy
Master of St Verdiana (1201)
Palmezzano (117)

Luke
French School, 11th–12th centuries (4170)
Moscow School, mid 16th century (1846)
After Weyden (4)

Margaret
Ghirlandaio (620)

Mark
French School, 11th–12th centuries (4170)
Machiavelli (108)
Moscow School, mid 16th century (1846)

Mary Magdalen
Balducci (1282)
Attributed to Benson (3)
After Correggio (1071)
Ficherelli (1707)

Flemish School, 16th century (350)
Furini (1679)
Ghirlandaio (620)
Girolamo di Benvenuto (839)
Italian School, 15th century (4091)
Liège School, 16th century (1641)
Lower Rhine School, mid 15th century (1216)
Maso da San Friano (103A)
Moscow School, late 17th century (184
Murillo (1720)
Perugino (942)
Pisano (1202)
Poussin (214)
Renieri (363)
After Rubens (1941)
Signorelli (266)
Silvestro dei Gherarducci (841)
Tiepelo (1111)

Mary of Egypt
Cerezo (1528)

Matthew
French School, 11th–12th centuries (4170)
Moscow School, mid 16th century (184
Roymerswaele (1115)
After Veronese (1962)

Menas the Egyptian
Greek School, 17th century (1847)

Michael, Archangel
Greek School, c.1700 (1849)
Mazzolino (666)
Moscow School, mid 16th century (184
Procaccini (1820)

Nicholas of Bari
Asia Minor School, 15th century (1851
Greek School, 17th century (1847)
Greek School, c.1700 (1849)
Master of the Barbara Legend (360)
Novgorod School, early 15th century (1857)

Nicholas of Mozhaisk
Moscow School, early 17th century (1840)

Nicholas of Tolentino
Franciabigio (1290)

Paraskevi
Asia Minor School, 15th century (1851

Paul
Jordaens (46)
Lemoine (724)
Moscow School, mid 16th century (184
Copy of Raphael (172)

Peter
Antolinez (31)
Coypel (113)
French School, 11th–12th centuries (4170)
Jordaens (38)

Jordaens (46)
Maso da San Friano (103C)
Moscow School, mid 16th century (1846)
Pensionante del Saraceni (1178)
Pisano (1202)
After Raphael (1041)
Copy of Raphael (171)
After Reni (1695)
Russian School, 18th century (1854)
Follower of Scorel (1391)

Peter Martyr
After Correggio (1042)
After Titian (1942)

Petronius
After Reni (118)

Philip
Moscow School, mid 16th century (1846)
Veronese (115)

Philip Benizzi
Palmezzano (364)

Procopius
Ribera (219)

Raphael, Archangel
Bastiani (352)
French School, 17th century (1166)
Saftleven (449)

Romanus
Moscow School, mid 16th century (1846)

Romold
Coter (1380)
Master of the Magdalen Legend (1381)

Rufina
Zurbarán (962)

Sebastian
Dyck (275)
After Dyck (1661)
Giordano (79)
Jordaens (46)
Attributed to Ribera (1377)

Simon
Boulogne the Elder (1889)
Moscow School, mid 16th century (1846)

Simplicius
Solimena (1107)

Spiridon
Western Greek School, c.1700 (1839)

Stephen
After Domenichino (1910)
Yverni (1780)

Thaddeus
Master of St Verdiana (1201)

Thomas
Ferrari (4302)
Moscow School, mid 16th century (1846)

Veronica
School of Bassano (1141)

Zenobius
Maso da San Friano (1865)

APPENDIX 7
The Lives of the Virgin and Christ

The Adoration of the Magi/Shepherds
see The Nativity

The Annunciation
Carlone (1640)
French School, 11th–12th centuries (4171)
Italian School, 14th century (868)
Master of St Verdiana (1201)
Pourbus (1223)
Rubens (60)
Russian School, 18th century (1854)
Western Greek School, c.1700 (1852)
Yverni (1780)

The Apocalypse
Danby (162)
French School, 11th–12th centuries (4170)

The Arrival in Bethlehem
Schäuffelin (16)

The Ascension of Christ
Flemish School, 16th century (1049)

The Assumption of the Virgin
Central European School, late 17th
 century (1836)
Pseudo Domenico di Michellino (861)
Poerson (1896)

The Baptism of Christ
Rosa (96)
Russian School, 18th century (1854)

The Betrayal of Christ
Stomer (425)
Upper Rhine School, early 16th century
 (1305)

Christ at Cana
Francken I (4094)

Christ bidding farewell to his Mother
David (13)

Christ calling the Sons of Zebedee
Boulogne the Elder (1889)

Christ carried by St Christopher
Cranach (973)

Christ carrying the Cross
School of Bassano (1141)
Bazzani (982)
Flemish School, 16th century (1049)
Attributed to Mignard (1801)

Christ circumcised
Russian School, 18th century (1854)

Christ curing One Possessed
Coypel (113)

Christ entering Jerusalem on Palm Sunday
Moscow School, 15th century (1844)

Christ in Limbo
Mandyn (1296)

Christ in the House of Levi (Matthew)
After Veronese (1962)

Christ in the House of Martha and Mary
Le Sueur (1196)
Rubens/Brueghel (513)
Thompson (1340)

Christ in the House of Simon
Signorelli (266)
Tiepelo (1111)

*Christ meets his Mother on
 the way to Calvary*
Bazzani (982)

Christ's Presentation in the Temple
Flemish School, 16th century (1049)

Christ teaching in the Temple
Eeckhout (253)

Christ washed after his Birth
Moscow School, late 16th century (1842)
Moscow School, early 17th century (1845)

Christ with St Joseph
Guercino (192)

The Crucifixion
Constantinople School, late 14th century
 (1843)
Cranach (471)

The Virgin interceding for Pope Leo I
Romano (827)

The Virgin of Intercession
Greek School, 17th century (1835)
Moscow School, mid 16th
 century (1846)

The Virgin of Eire
Jellett (4319)

The Virgin of the Prophesies
Orley (1224)

The Virgin of the Rosary
Llanos-Valdes (760)

The Virgin of the Seven Sorrows
Flemish School, 16th century (1049)

The Virgin sewing
After Reni (1065)

The Virgin's Birth
Russian School, 18th century (1854)

The Virgin's Presentation in the Temple
Russian School, 18th century (1854)

The Visitation
Jordaens (46)

APPENDIX 8
Mythological, Historical and Literary Subjects

Acis and Galatea, The Marriage of
Poussin (814)

Adonis, The Death of
Barry (1393)

Aesop
Giordano (1988)
After Velazquez (1118)

Alexander, Timoclea brought before
Vecchia (94)

Amphitrite, The Triumph of
Attributed to Coypel (1656)

Angelica tending the wounded Medoro
Lippi (1747)

Anghiari, The Battle of
Florentine School, 15th century (778)

The Apotheosis of Rousseau
Robert (896)

Archimedes and Hiero of Syracuse
Ricci (1099)

Argus receiving Io (Ovid)
Claude Lorraine (763)

Ariadne and Bacchus
Troy (723)

Aurora
After Guercino (1686)

Bacchanalia
De Gree (1106)
Neapolitan School, 17th century (1074)
Poussin (816)

Bacchus, The Triumph of
School of Rubens (1064)

Bacchus and Ariadne
Troy (723)

Baone, Count Alberto da
Celesti (1925)

The Bookworm
Helmick (4294CB)

Boucicault and Bianconi, In Memory of
Yeats (4206)

Boyne, The Battle of the
Wyck (988)

Calisto (Shakespeare)
Rothwell (506)

Carolan the Harper
Bindon (1344)

Charles I and his Children before Cromwell
Maclise (1208)

Charles II, The Embarkation of
After Velde the Elder (1742)

Charles II after the Battle of Solebay
Studio of Velde the Elder (58)

Corday, The Arrest of Charlotte
Scheffer (1226)

The Courtier (B. Castiglione)
Titian (782)

Cupid
Bolognese School, 17th century (1078)
Lippi (1747)
Riminaldi (1235)

Cupid, The Birth of
After Amigoni (1688)

Cupid and Psyche
Hamilton (1342)

Cupid and Venus
Batoni (704)
Fragonard (4313)
Tosini (77)

Cupid Chastised
Stern (1739)

Cupid with Nymphs and Satyr
Bolognese School, 17th century (1078)

Cyrus, The Shepherdess finding
Castiglione (994)

Democritus and Heraclitus
Italo-Flemish School, c.1600 (1317)

Demosthenes strengthening his Voice
Delacroix (964)

D'Este, Margaret
English School, 19th century (1154)

Diana
Batoni (703)
After Batoni (1650)
Nattier (1646)

Diana and Endymion
Tintoretto (768)

Diana and her Attendants
Gabrielli (4202)

Diana suspends Hunting
Ennis (4126)

The Doge wedding the Adriatic
Guardi (92)

Sculpture, The Muse of
Italian School, 16th century (1335)

Shylock (Shakespeare)
Zoffany (301)

Spring and Summer
Strozzi (856)

Strongbow and Eva (Aoife),
The Marriage of
Maclise (205)

A Sybil
Italian School, 17th century (1740)

Timoclea brought before Alexander
Vecchia (94)

Titania and Puck (Shakespeare)
Romney (381)

Treaty, The Ratification
of the Irish (1921)
Lavery (1736)

Venice, An Allegory of
Tintoretto (1384)

Venus and Cupid
Batoni (704)
Fragonard (4313)
Tosini (77)

Venus chastising Cupid
Stern (1739)

Venus Reclining
After Titian (1037)

Vertumnus and Pomona
Maes (347)

Victoria, The News of the Death of Queen
Moynan (4028)

Volunteers in College Green, The Dublin
Wheatley (125)

Vulcan ends the Manufacture of Arms
Ennis (4125)

William III at the Battle of the Boyne
Wyck (988)

William III at the Siege of Namur
Wyck (145)

William III landing at Margate
Kneller (311)

William of Orange arriving in England
Velde (1741)

APPENDIX 9
Gifts and Bequests before 1900

Donor and year	Artist and picture number
Sir Walter Armstrong (1893)	Poorter (380)
(1896)	Saftleven (449)
Mr F. Baring (1893)	After Guercino (483)
Sir Henry Barron (1878)	Cignani (183)
	Furini (368)
	Style of Furini (1967)
	Maes (204)
Dr Barry (1873)	Herring (461)
Mr T. Berry (1854)	Barret (1909)
(1859)	After Rubens (1941)
(1862)	Bloemen (338)
	Attributed to Vernet (1750)
(1865)	Dyck (169)
Mr C. Bianconi (1865)	Jordaens (57)
Mr A. Brady (1864)	Delff (332)
(1865)	Stuart (1743)
Lady Brady (1874)	Jones (132)
Mr M. Brooks (1867)	Attributed to Maes (362)
Mr W. Browne (1864)	After Rubens (154)
Sir John Brunner (1898)	Hall (481)
Mr E. Cane (1862)	Moore (1876)
The 7th Earl of Carlisle (1864)	Lely (136)
F. Caulfield, 2nd Earl of Charlemont (1853)	Genisson/Willems (168)
Mr R. Clouston (1855)	Bacchiacca (1332)
	After Bellotto (1960)
	Attributed to Everdingen (1890)
	Italian School, 16th century (1336)
	Ryckaert (340)
Mr G. Coffey (1894)	Smith (383)
J. Daly, 4th Lord Dunsandle (1897)	Eddis (464)
The Dargan Testimonial Committee (1860s)	Smith the Elder (141)
H. Dawson-Damer, 3rd Earl of Portarlington (1878)	Storck (228)
(1884)	Wyck (145)
Sir George Donaldson (1894)	Stomer (425)

Donor and year	Artist and picture number
Mr H. Doyle (1886)	Simpson (318)
(c.1890)	Doyle (423)
Lord Dunsandle (1897)	Eddis (464)
E. Eliot, 3rd Earl of St Germans (1854)	Boel (42)
	Bol (47)
The 4th Marquess of Ely (1878)	Kauffman (200)
A. Fitzgerald, 3rd Duke of Leinster (1868)	Giordano (79)
C. Fitzgerald, 4th Duke of Leinster (1884)	Hamilton (195)
(before 1898)	Sherwin (396)
G. Fitzgerald, 5th Duke of Leinster (1891)	Wheatley (125)
Lady Fitzgerald (1896)	Kauffman (444)
	Potter (445)
	Pritchett (446)
	Pritchett (447)
	Swagers (448)
The sons of Mr W. Fitzpatrick (1899)	Smith the Younger (492)
G. Gough, 2nd Viscount Gough (1889)	Harwood (306)
Lady Grattan (1873)	Jones (123)
Sir Arthur Guinness (1856)	Bachelier (167)
E. Guinness, 1st Lord Iveagh (1891)	English School, 17th century (410)
	Latham (411)
The 3rd Marquess of Headfort (1892)	Joseph (416)
Mr J. Heugh (1872)	Cuyp (49)
G. Howard, 7th Earl of Carlisle (1864)	Lely (136)
Sir Edward Hudson Kinahan (1890)	Cuming (305)
Mr T. Hutton (1865)	Follower of Titian (1324)
Lord Iveagh (1891)	English School, 17th century (410)
	Latham (411)
Mr S. Joseph (1892)	Dusart (324)
Mrs M. Kavanagh (1884)	Chanet (312)
Canon Lee (1883)	Thompson (229)
The 3rd Duke of Leinster (1868)	Giordano (79)
The 4th Duke of Leinster (1884)	Hamilton (195)
(before 1898)	Sherwin (396)
The 5th Duke of Leinster (1891)	Wheatley (125)
Mr W. Littledale (1884)	Mulrenin (408)
J. Loftus, 4th Marquess of Ely (1878)	Kauffman (200)
Monsignor McHale (1890)	Capalti (406)
Mr C. Marley in memory of Mr H. Doyle (1892)	After Dyck (413)
Mr R. Millner (1893)	Potter (323)
Lady Morgan (1860)	Berthon (133)
Mr J. Nairn (1899)	Nairn (495)
Mrs Nicolay	Copy of Raphael (171)
	Copy of Raphael (172)
Mrs Noseda (1873)	After Hogarth (127)
Mr W. O'Brien (1864)	Haverty (166)
The Reverend M. O'Callaghan (1883)	O'Neill (313)
Mr J. Orpin (1897)	Pellegrini (467)
Mr Parker (1872)	Irish School, 18th century (429)
Mr H. Pfungst (1893)	Gael (325)
(1895)	School of Bruyn (404)
The Hon. G. Ponsonby (1889)	Smith the Elder (248)
The 3rd Earl of Portarlington (1878)	Storck (228)
(1884)	Wyck (145)
Viscount Powerscourt (1857)	After Tintoretto (4001)
	Venetian School, 16th century (4001)
(1864)	Tosini (77)
(1866)	Attributed to Domenichino (70)
(1878)	Quinkhard (238)
The Misses Purcell (1884)	Smith the Elder (308)
Mr G. Richmond (1890)	Richmond (316)
Mr J. Ross (1887)	Watts (279)
Mrs A. Rowley (1898)	Opie (482)
The 3rd Earl of St Germans (1854)	Boel (42)
	Bol (47)
Mr G. Salting (1893)	Barker (377)
Mr S. Smith (1884)	Smith the Elder (309)

APPENDIX 10
Gifts after 1900

Donor and year	Artist and picture number	
Sir Alfred Chester Beatty Gift (1950) *(continued)*	Fromentin (4232CB) Fromentin (4233CB) Gerome (4234CB) Guillaumet (4235CB) Harpignies (4236CB) Harpignies (4237CB) Helmick (4294CB) Henner (4238CB) Henner (4295CB) Isabey (4241CB) Israels (4242CB) Jacque (4243CB) Jacque (4244CB) Jacque (4245CB) Jacque (4246CB) Jacque (4247CB) Jacque (4248CB) Jongkind (4249CB) Jongkind (4250CB) Lefebvre (4296CB) Lépine (4251CB) Lépine (4252CB) Leys (4253CB) Leys (4297CB) L'Hermitte (4254CB) L'Hermitte (4255CB) Marcke (4284CB) Maris (4256CB) Mauve (4257CB) Meissonier (4258CB) Meissonier (4259CB) Meissonier (4260CB)	Meissonier (4261CB) Meissonier (4262CB) Meissonier (4263CB) Mesdag (4264CB) Millet (4265CB) Monticelli (4298CB) Neuville (4266CB) Neuville (4267CB) Neuville (4268CB) Pasini (4269CB) Pasini (4270CB) Pasini (4271CB) Rousseau (4272CB) Rousseau (4273CB) Rousseau (4274CB) Schreyer (4275CB) Schreyer (4276CB) Steer (4277CB) Stevens (4278CB) Thaulow (4279CB) Tissot (4280CB) Troyon (4281CB) Troyon (4282CB) Troyon (4283CB) Unknown Artist (4299CB) Veyrassat (4285CB) Vollon (4286CB) Ziem (4287CB) Ziem (4288CB) Ziem (4289CB) Ziem (4290CB)
Sir Alfred Chester Beatty (other gifts) (1951)	Berne-Bellecour (1218) Daubigny (1215) Master of St Verdiana (1201) Pisano (1202) Ribot (1217)	Sienese Copyist (1203) Sienese Copyist (1204) Sienese Copyist (1205) Sienese Copyist (1206) Sienese Copyist (1207)
(1952)	Sidaner (1244) Unknown Artist (1243)	
(1953)	Claesz (1285) Dupré (1255) English School, 16th century (1266) Gerome (1256) Grant (1884) After Holbein (1265) Marchand (1259) Marchand (1260) Marchand (1262)	Marchand (1263) Michel (1253) Moreau (1264) Procter (1268) Raffaëlli (1257) After Raphael (1267) Steer (1258) Troyon (1254)
(1954)	Follower of Barocci (1527) Cerezo (1528) Detaille (1292) French School, 17th century (1421) Innes (1293) Italian School, 16th century (1533) Attributed to Lely (1830) Attributed to Lely (1831)	Molenaer (1529) Moran (1530) Attributed to Panini (1531) Procter (1294) Tissot (1275) Weekes (1532) Ziem (1291)
(1956)	Harpignies (1328) John (1329)	
(1965)	Brandt (1781)	
(1971)	English School, 20th century (4039)	
Mr D. Clark (1973) Lord Cloncurry (1928) Sir Patrick Coghill (1965)	Clark (4067) After Batoni (909) Coghill (1786)	

Donor and year	Artist and picture number
Miss L. Collins (1973)	Topolski (4066)
Mr D. Cooper (1947)	Irish School, 18th century (1137)
	Woodburn (1136)
Mr G. Cope (1912)	Jones (624)
Miss M. Cregan (1929)	Cregan (918)
Mr A. Crichton (1972)	Kirkwood (4043)
Mr F. Cundall (1913)	King (645)
Mrs E. Deas (1959)	Osborne (1388)
	Osborne (1389)
Mr Eamon de Valera (1950)	Haverty (1183)
(1955)	Cross (1307)
(1969)	Solomons (1926)
Mrs Dillon (1935)	Orpen (976)
Mr R. Dodson (1919)	Dodson (4000)
Mrs J. Douglas (1956)	Italo-Flemish School, c.1600 (1317)
Mr C. Doward (1954)	Comerford (1283)
Miss H. Dowden (1916)	Osborne (774)
Mrs E. Dowling (1964)	Mulvany (1764)
Mr E. Duckett (1942)	After Veronese (1085)
Miss Duffy (1903)	MacManus (547)
Miss V. Durham (1955)	Kelly (1306)
The Misses Entwissle (c.1958)	Wilkie (1748)
Miss M. Farmer through the Government (1963)	Laurie-Wallace (1731)
Mr and Mrs Field (1959)	Barry (1393)
Miss E. Fitzgibbon (1932)	Osborne (953)
Miss C. Fleming (1947)	Home (1144)
	Home (1145)
	Home (1146)
The Fortune family (1962)	Fortune (1728)
Mr and Mrs R. French (1957)	Yeats (1370)
Mr M. Fridberg (1974)	Kavanagh (4113)
	Kavanagh (4114)
Mrs R. Gahan (1977)	Luytens (4207)
Sir John Galvin (1970)	Elwes (1980)
Messrs M. Garbaye and M. de Letre (1948)	Lemercier (1167)
	Lemercier (1168)
	Lemercier (1169)
	Lemercier (1170)
	Lemercier (1171)
	Lemercier (1172)
	Osborne (1173)
	Osborne (1174)
Mrs N. Garstin (1927)	Garstin (892)
Lady Gilbert (1912)	Lavery (637)
Lord Glenavy and the Hon. M. Campbell (1971)	Tuohy (4027)
Mrs Gorges (1953)	Irish School, 18th century (1270)
	Irish School, 18th century (1271)
	Rouland (1269)
Miss E. Gorst (1939)	Janssens (1010)
E. Guinness, 1st Lord Iveagh (1901)	Lawrence (520)
Mr D. Gwynn and Mrs D. Moorehead (1970)	Leech (1934)
Major-General C. Hamilton (1965)	Hamilton (1779)
Miss J. Hamilton (1966)	Purser (1811)
Mr G. Hannen (1930)	Frye (927)
Mr G. Harrison (1938)	Shee (998)
Mrs F. Hart (1973)	Russell (4071)
	Russell (4072)
	Russell (4073)
The Haverty Trust (1931)	Yeats (941)
(1941)	Yeats (1050)
(1956)	Keating (1330)
(1960)	MacGonigal (1551)
	Scally (1552)
Dr F. Henry (1977)	Attributed to Bourdon (4197)
	English School, c.1690 (4198)
	French School, 19th century (4199)
Mr P. Higgins (1940)	Helt-Stockade (1046)

Donor and year	Artist and picture number	
Mr L. Hirsch (1905)	Master of the Parrot (772)	
Mr J. Holloway (1930)	Mannix (934)	
(1934)	McLachlan (975)	
Mr T. Homan (1980)	Forbes (4338)	
Mr N. Hone (1907)	Hone the Younger (588)	
W. Howard, 8th Earl of Wicklow (1957)	Flemish School, c.1500 (1359)	
Sir Henry Howorth (1902)	Grammorseo (771)	
Mr and Mrs J. Hunt (1950)	Le Sueur (1196)	
Mr J. Huston (1977)	Yeats (4206)	
Mr W. Hutcheson Poe (1931)	Knight (948)	
	Weenix (947)	
Miss M. Hutton (1970)	Osborne (1935)	
Mr E. Huxtable (1924)	Osborne (858)	
I.B.M. Ltd (1969)	Yeats (1905)	
Irish Agricultural Organisation Society Ltd (1974)	Russell (4097)	Russell (4105)
	Russell (4098)	Russell (4106)
	Russell (4099)	Russell (4107)
	Russell (4100)	Russell (4108)
	Russell (4101)	Russell (4109)
	Russell (4102)	Russell (4110)
	Russell (4103)	Russell (4111)
	Russell (4104)	
Lord Iveagh (1901)	Lawrence (520)	
Mrs M. Jack (1919)	Kauffman (887)	
	Kauffman (888)	
Mr W. Jameson (1927)	Osborne (891)	
Mr J. Kavanagh (1912)	Allan (654)	
Mrs C. Kennedy (1903)	Kennedy (543)	
Miss M. Kilgour (1951)	Hayes (1209)	
Miss F. Knox (1919)	Stuart (822)	
Sir Hugh Lane (1902)	Attributed to Jamesone (534)	
see also Appendix 11 (1904)	Hoppner (566)	
(1907)	Horemans (589)	
	Horemans (590)	
(1913)	Collins (648)	
	English School, 19th century (652)	
	Horstok (650)	
	Linnell (649)	
	Wilkie (651)	
(1914)	Beerstraten (679)	Hunt (683)
	Attributed to Carracci (673)	Magnasco (678)
	Desportes (670)	Pereda (667)
	Desportes (671)	Studio of Piazzetta (656)
	Gainsborough (668)	Romney (674)
	Gainsborough (675)	Vallain (669)
	Greco (658)	Veronese (657)
	Llanos-y-Valdes (760)	
(1915)	Shee (775)	
Captain R. Langton Douglas (1916)	O'Connor (825)	
(1919)	Post (847)	
(1923)	After Batoni (909)	
V. Lawless, Lord Cloncurry (1928)	Spilsbury (567)	
Mrs Lecky (1904)	Le Fanu (919)	
Mr T. Le Fanu (1929)	Lewis (1132)	
(1946)	Irish School, 20th century (1316)	Lemercier (1171)
Sir Shane Leslie (1955)	Lemercier (1167)	Lemercier (1172)
Messrs M. de Letre and M. Garbaye (1948)	Lemercier (1168)	Osborne (1173)
	Lemercier (1169)	Osborne (1174)
	Lemercier (1170)	
Miss J. Levins (1957)	Attributed to Perreal (1358)	
Mrs L. McCarthy-Gimson (1951)	Forbes-Robertson (1211)	
	Waite (1210)	
Mr F. McCormick (1972)	O'Connor (4041)	
Mr C. MacGonigal (1975)	Tuohy (4128)	
Mr J. McGrath (1958)	Purser (1376)	
Dr T. McGreevy (1960)	Barry (1418)	
(1966)	Attributed to Mignard (1801)	
	Yeats (1800)	

onor and year	Artist and picture number	
Mr E. McGuire (1936)	Harwood (986)	
Mr and Mrs E. McGuire (1966)	Tintoretto (793)	
Mr T. Madden (1900)	Haverty (493)	
Mrs Maffett (1919)	Irish School, 18th century (820)	
Professor W. Magennis (1942)	Purser (1098)	
Mr Alex Maguire and Mr F. Parker (1930)	Lavery (923)	
Mrs J. Mann (1950)	Pritchett (1186)	
	Pritchett (1187)	
Mr J. Manning (1975)	O'Connor (4132)	
Mme F. Marinot (1970)	Marinot (4016)	Marinot (4020)
	Marinot (4017)	Marinot (4021)
	Marinot (4018)	Marinot (4022)
	Marinot (4019)	Marinot (4023)
Mr Alec Martin (1924)	Deane (854)	
Mr Alec and Lady Martin (1928)	Hunter (905)	
see also Appendix 13		
Mr H. Maude (1975)	Petrie (4130)	
Mrs C. Meredith (1943)	Attributed to Lely (1108)	
	Solimena (1107)	
(1952)	Henry (1234)	
(1953)	Henry (1286)	
	Henry (1287)	
	Henry (1288)	
illtown Gift (1902)	Circle of Appiani (1189)	Follower of Carracci (1682)
	Armfield (1714)	After Claude Lorraine (719)
	Armfield (1718)	Coccorante (1744)
	Bakhuysen (1673)	Compe (1681)
	Balen (1706)	Coninck (717)
	Baptiste (1079)	After Correggio (1042)
	Barret (1091)	After Correggio (1071)
	Barret (1092)	Attributed to Coypel (1656)
	Barret (1627)	Dandini (1683)
	Barret (1628)	School of David (1895)
	Barret (1629)	Dietrich (1230)
	Barret (1630)	After Domenichino (1083)
	Barret (1631)	Dughet (713)
	Barret (1632)	Dutch School, 17th century (1694)
	Barret (1633)	Dutch School, 17th century (1698)
	Barret (1634)	After Dyck (1661)
	Barret (1635)	After Dyck (1738)
	Barret (1636)	Studio of Empoli (1068)
	Barret (1637)	Studio of Empoli (1671)
	Barret (1753)	English School, 16th century (759)
	Barret (1754)	English School, 18th century (1662)
	Barret (4003)	English School, 18th century (1663)
	School of Bassano (1665)	English School, 18th century (1676)
	Batoni (701)	English School, 18th century (1696)
	Batoni (702)	English School, 19th century (1685)
	Batoni (703)	Ferri (1670)
	Batoni (704)	Ficherelli (1070)
	After Batoni (1650)	Ficherelli (1707)
	After Batoni (1697)	Ficherelli (1746)
	Berchem (1657)	Francken III (1708)
	Bertin (1066)	Francken III (1709)
	Bertin (1684)	French School, 18th century (1700)
	Bolognese School, 17th century (1078)	French School, 18th century (1701)
	Follower of Bonifazio de'Pitati (1072)	Furini (1658)
	Both (706)	Furini (1679)
	Boudewijns/Bout (1095)	Furini (1716)
	Boudewijns/Bout (1096)	Furini (4002)
	After Bourdon (1032)	After Fuseli (1745)
	Breenberg (700)	Fyt (1907)
	Studio of Canaletto (705)	German School, c.1500 (750)
	Studio of Canaletto (1043)	Giordano (1069)
	After Carracci (990)	Graat (1715)
	After Carracci (1331)	Grant (1036)

Donor and year	Artist and picture number
Mrs A. Murnaghan in memory of the late Mr Justice J. Murnaghan (1974)	Flemish-French School, 1568 (4093)
Miss K. Murphy (1948)	French School, 17th century (1166)
Mr F. Murray (1911)	Hogarth (618)
Transferred from the National Library (1971)	Newton (4036)
National Literary Society (1908)	Yeats (595)
Transferred from the National Museum (1968)	O'Sullivan (1863)
	Quadal (1899)
(1969)	Yeats (1963)
Lady Nelson (1973)	Salkeld (4059)
Una Bean Uí Nualláin (1977)	Keating (4196)
Dr B. O'Brien (1968)	O'Brien (1861)
Mr D. O'Brien (1941)	Osborne (1060)
Mrs W. O'Brien (1932)	Mangin (958)
Mr M. O'Connor (1919)	Soldenhoff (826)
Miss R. O'Dea (1965)	Le Jeune (1785)
Captain G. O'Grady (1911)	Sadler (632)
	Sadler (633)
Sir Michael O'Loghlen (1930)	Mulvany (932)
Sir Owen O'Malley (1951)	Irish School, 18th century (1227)
	Irish School, 19th century (1228)
Mrs J. O'Neill (1951)	Purser (1220)
Mrs W. Osborne (1903)	Osborne (555)
Mr C. Padilla (1969)	Henry (1922)
Mr G. Paget (1960)	Paget (1419)
Mrs C. Parker (1954)	Swanzy (1300)
Mr F. Parker and Sir Alec Maguire (1930)	Lavery (923)
Mr C. Pearsall (1930)	Osborne (931)
Mrs Pemberton (1915)	Munns (770)
Mr H. Pfungst (1901)	After Signorelli (522)
Mr and Mrs W. Philips (1974)	Glannon (4121)
Mr S. Philipson (1951)	Scheffer (1226)
Lord Powerscourt (1904)	Purser (561)
Miss S. Purser (1914)	Prins (681)
(1940)	Purser (1024)
Mr J. Quinn (1923)	Master of the Prodigal Son (845)
Mr A. Ray (1901)	Wijnen (527)
The Reverend R. Rees (1963)	Russell (1761)
Mr N. Richardson (1952)	Irish School, 1891 (1233)
Mr Justice Ross on behalf of a committee representing all religious denominations (1912)	Browne (622)
The Royal Society of Arts (1915)	Barry (762)
Monsignor J. Ryan (1958)	Mulready (1382)
Comtesse de Saringy (1942)	Purser (1101)
Dr M. Scott (1977)	Purtscher (4208)
Mr S. Scott (1928)	Stuart (907)
Mrs P. Selby-Smith (1976)	Mallary (4189)
The Reverend Senan on behalf of a group of private citizens (1947)	Yeats (1147)
Mrs B. Shaw (1928)	Collier (899)
Mr C. Shorter (1921)	Lavery (831)
The Sickert Trust (1947)	Lessore (1143)
Mrs J. Smith (1978)	French School, 19th century (4311)
Mrs Smyllie in memory of the late Mr R. Smyllie (1966)	Yeats (1791)
Messrs C. Smythe and P. Bander (1972)	Drake (4046)
Dr M. Solomons (1969)	Solomons (1920)
	Solomons (1921)
Mrs P. Stein (1974)	Tuohy (4116)
	Tuohy (4117)
Miss E. Stoney (1931)	Jones (949)
Mr C. Sullivan in memory of the late Mr J. Quin (1926)	Yeats (869)
	Yeats (870)
	Yeats (871)
	Yeats (872)
	Yeats (873)
	Yeats (874)

Donor and year	Artist and picture number
Mrs Todhunter (1928)	Paget (915)
Miss R. Trevor (1900)	Trevor (502)
Mrs M. Tuckey (1951)	Smith the Younger (1221)
	Smith the Younger (1222)
Mrs E. Turton (1914)	Reinagle (676)
Miss M. Twigg (1944)	Irish School, 19th century (1116)
Mr F. Vickerman (1972)	Peters (4053)
Mr and Mrs F. Vickerman (1978)	Yeats (4309)
Sir Edgar Vincent (1907)	Wouvermans (582)
(1910)	Lievens (607)
Mrs M. Waddington (1971)	Yeats (4031)
Mr V. Waddington (1972)	Yeats (4040)
Mr T. Ward (1900)	Avercamp (496)
(1901)	Luycks (529)
Mr H. Wells (1901)	Wells (517)
Mr E. Werner (1974)	Werner (4115)
Miss S. White-Shannon (1961)	Harwood (1765)
The 8th Earl of Wicklow (1957)	Flemish School, c.1500 (1359)
Dr Willoughby (1928)	Reynolds (901)
Lady Wolseley (1918)	Holl (777)
Mr E. Woodroffe (1966)	Hickey (1789)
The family of Sir Robert and Lady Woods (1950)	O'Connor (1182)
Mr G. Wyndham (1966)	Copy of Mallary by A. de Brie (568)
Mr J. B. Yeats (1947)	Yeats (1142)
J. B. Yeats National Loan Exhibition Committee (1945)	Yeats (1134)
Mr W. B. Yeats (1928)	Yeats (910)

APPENDIX 11
Bequests after 1900

Donor and year	Artist and picture number
Mrs E. Anderson (1945)	Shee (1129)
Sir Henry Barron (1901)	Berchem (510)
	Hagen (515)
	Heda (514)
	Hondecoeter (509)
	Hondt (512)
	Lorme (516)
	Rubens/Brueghel (513)
	Ruisdael (507)
	Weenix (511)
	Wynants (508)
Mrs T. Bartlett (1974)	Lover (4075)
Mr R. Best (1959)	Harrison (1405)
	Henry (1410)
	Kelly (1411)
	Kelly (1412)
	Leech (1422)
	Leech (1423)
	MacIlwaine (1416)
	O'Brien (1414)
	Purser (1424)
	Solomons (1413)
	Stevenson (1417)
	Swanzy (1415)
	Yeats (1406)
	Yeats (1407)
	Yeats (1408)
	Yeats (1409)

Donor and year	Artist and picture number
Miss E. Bodkin (1974)	Attributed to Barret (4086)
	Sleator (4084)
Mr T. Bridgford (1924)	Bridgford (855)
	Bridgford (857)
Mr W. Brooke (1907)	Inchbold (586)
Mr H. Brunning (1908)	Cooke (593)
Mrs M. Byrne (1963)	Irish School, 18th century (1730)
Mr W. Cadbury (1966)	Yeats (1804)
Miss A. Callwell (1904)	Austen (1931)
Mrs D. Case (1958)	Yeats (1374)
Miss A. Clarke (1903)	Duyster (556)
Lord Cloncurry (1929)	Sargent (921)
Mr D. Cooper (1947)	Woodburn (1136)
Mr W. Crowdy (1950)	Gethin (1197)
Miss M. Crowe (1970)	Carré (1944)
Mrs E. Cuming (1953)	Osborne (1273)
Miss L. Davidson (1954)	Davidson (1289)
Professor Dowling (1961)	Craig (1757)
	Williams (1758)
Sir Charles Gavan Duffy (1903)	MacManus (1917)
Lady Ferguson (1905)	Revesteyn (571)
Miss K. Ffrench (1939)	Montemezzano (1028)
	Spanish School, 17th century (1026)
	Spanish School, 17th century (1027)
	After Titian (1029)
	After Titian (1030)
Lady Helen Fitzgerald (1967)	Lehmann (1816)
	Lehmann (1817)
Major T. Fuge (1952)	Sabatte (1238)
Mr A. Garstin (1978)	Garstin (4308)
Mrs Geoghegan (1956)	Yeats (1343)
Mr M. de Groot (1948)	Moyaert (1175)
Miss M. Guinness (1956)	Guinness (1339)
Mr W. Gumbleton (1911)	Valckenburg (625)
Mrs Haxted (1961)	Cuming (1725)
Mrs M. Henry (1974)	Henry (4077)
	Henry (4078)
	Henry (4079)
	Henry (4080)
	Henry (4081)
	Henry (4082)
	Henry (4083)
Mr J. Holloway (1930)	Mannix (934)
Miss Evie Hone (1955)	Gleizes (1308)
	Gris (1313)
	Healy (1310)
	Jellett (1326)
	Marchand (1311)
	Picasso (1314)
	Swanzy (1312)
	Yeats (1309)
Mrs N. Hone (1919)	Hone the Elder (886)
	Hone the Younger, see pages 219—45
Dr Douglas Hyde (1949)	Purser (1181)
Mrs E. Jameson (1979)	Osborne (4332)
Mr G. Jameson (1936)	Wyck (988)
Mr M. Kennedy (1945)	Fry (1124)
	Smith (1123)
Mrs W. Kennedy (1979)	English School, 17th century (4328)
Miss R. Kirkpatrick (1979)	Hone (4322)
	Jellett (4316)
	Jellett (4317)
	Jellett (4318)
	Jellett (4319)
	Jellett (4320)
	Jellett (4321)
Mrs H. Krohn (1969)	Irish School, 18th century (1923)

Donor and year	Artist and picture number	
Sir Hugh Lane (1918) see also Appendix 9	Bol (810) Attributed to Bordone (779) Chardin (799) Chardin (813) Chinnery (785) Claude Lorraine (763) Constable (798) Cornelisz (812) Doughty (787) Dyck (809) School of Faber (804) Florentine School, 15th century (778) Florentine School, 15th century (780) Gainsborough (793) Gainsborough (794) Gainsborough (795) Gainsborough (796) Goya (784) Goyen (807) Greuze (803) Hogarth (791) Hogarth (792)	Kamper (806) Lancret (802) Lawrence (788) Lemaire (800) Piombo (783) Poussin (814) Poussin (816) Rembrandt (808) Reynolds (790) Romney (786) Romney (789) Sargent (817) Slaughter (797) Snyders (811) Strozzi (781) Stubbs (906) Tintoretto (768) Titian (782) Venetian School, late 16th century (8 Follower of Watteau (801) Witte (805)
Mrs M. Lapsley-Guest (1967) V. Lawless, Lord Cloncurry (1929) Mrs Lecky (1912)	Yeats (1821) Sargent (921) Attributed to Bylert (639) Attributed to Moreelse (640) After Velazquez (1118) After Velazquez (1119) After Velazquez (1984) After Velazquez (1985) After Velazquez (1986)	
Miss K. Leney (1938) Mrs L. McCarthy-Gimson (1966)	Yeats (1004) Forbes-Robertson (1807) Hale (1808) O'Keefe (1809) O'Keefe (1810)	
Mr and Mrs E. McGuire (1966) Mr E. Marsh (1953)	Tintoretto (1793) Lavery (1251) Newton (1252)	
Mr E. Martyn (1924)	Corot (853) Monet (852)	
Miss F. Moore (1909) Mr G. Moore (1933) Mrs Nugent (1914) Mrs E. Nuttall (1978) Professor O'Brien (1974) Mr C. O'Brien (1910) Mrs F. O'Farrell (1961) Mr M. O'Kennedy (1945) Mrs F. Orpen (1956) Mrs R. Parker (1970)	Watkins (636) Wyatt (960) Molenaer (682) Manning (4305) Brandt (4076) Osborne (612) Baptiste (1647) Medley (1125) Orpen (1341) Durand (1979) Orpen (1978)	
Sir Claude Phillips (1925) Mr J. Poe (1926)	Follower of Moroni (860) Dutch School, 17th century (877) Attributed to Opie (878)	
Lady Poe (1930)	Orpen (945) Orpen (946)	
Miss H. Reid (1939)	Aelst (1015) Bettera (1014) Bloemen (1016) Brocas (1017) Glew (1325)	
Mr I. Rice (1956) Mr W. Rochfort (1941) Mr P. Sherlock (1940)	Slaughter (1061) Dutch School, 17th century (1063) Dutch School, 17th century (1087) Dutch School, 17th century (1972)	

Donor and year	Artist and picture number
Mr P. Sherlock (1940) *(continued)*	Dutch School, 18th century (1971)
	English School, 18th century (1932)
	Fielding (1131)
	Grey (1056)
	Hayes (1054)
	Hayes (1055)
	'J.B.' (1059)
	Moynan (1057)
	O'Connor (1114)
	Orchardson (1130)
	Osborne (1052)
	Osborne (1053)
	Osborne (1929)
	Tempel (1062)
	After Velde the Younger (1964)
(1941)	Brett (1900)
	Stanfield (1891)
Mr T. Smith (1933)	Dusart (961)
Dr B. Somerville-Large (1966)	Teniers the Younger (1805)
Miss V. Stockley (1971)	Yeats (4032)
Mrs Stretton (1908)	Collins (594)
Mrs Torrance (1921)	Torrance (833)
Miss H. Trevor (1900)	Trevor (500)
	Trevor (501)
Mr W. Wallace Anderson (1929)	O'Conor (922)
Miss M. Wallis (1980)	Landseer (4333)
Mr R. Walsh (1937)	Cuming (995)
	Cuming (996)
Mr M. White (1926)	Irish School, 18th century (876)

APPENDIX 12
Works Bought at Known Sales and Auctions

Allnutt Sale, London (1863)	Jordaens (46)
Lord Ashburton Sale, London (1871)	Panini (95)
Beckett-Denison Sale, London (1885)	Faber (243)
Besborodko Sale, Paris (1869)	Attributed to Murillo (33)
	Sassoferrato (83)
Blamire Sale, London (1863)	Bega (28)
	Heem (11)
	Italo-Flemish School, c.1600 (1749)
Blenheim Palace Sale, London (1886)	Brescian School (277)
	Teniers the Younger (288)
	Teniers the Younger (289)
Bromley-Davenport Sale, London (1863)	Palmezzano (117)
Carr Sale, Shipton (1862)	After Dyck (1937)
	After Mabuse (361)
	Attributed to Ribera (12)
	Thulden (2)
	After Velazquez (1930)
Chatsworth Sale, London (1958)	Coter (1380)
	Master of the Magdalen Legend (1381)
Sir Alfred Chester Beatty Sale, Dublin (1968)	Hickey (1860)
Collins Sale, Dublin (1887)	Irish School, 19th century (302)
	Irish School, 19th century (303)
Comte de Choiseul Sale, Paris (1866)	Attributed to Granacci (98)
	Strigel (6)
	After Weyden (4)
Demidoff Sale, Paris (1870)	Titian (84)
Dr Doyle Sale, Dublin (1977)	Gabrielli (4202)
Dublin Art Loan Exhibition (1899)	Michel (487)
Dublin Library Sale (1882)	Cuming (187)
Bishop of Ely Sale, London (1864)	Knijf (53)

Donor and year	Artist and picture number
Mr P. Sherlock (1940) *(continued)*	Dutch School, 18th century (1971)
	English School, 18th century (1932)
	Fielding (1131)
	Grey (1056)
	Hayes (1054)
	Hayes (1055)
	'J.B.' (1059)
	Moynan (1057)
	O'Connor (1114)
	Orchardson (1130)
	Osborne (1052)
	Osborne (1053)
	Osborne (1929)
	Tempel (1062)
	After Velde the Younger (1964)
(1941)	Brett (1900)
	Stanfield (1891)
Mr T. Smith (1933)	Dusart (961)
Dr B. Somerville-Large (1966)	Teniers the Younger (1805)
Miss V. Stockley (1971)	Yeats (4032)
Mrs Stretton (1908)	Collins (594)
Mrs Torrance (1921)	Torrance (833)
Miss H. Trevor (1900)	Trevor (500)
	Trevor (501)
Mr W. Wallace Anderson (1929)	O'Conor (922)
Miss M. Wallis (1980)	Landseer (4333)
Mr R. Walsh (1937)	Cuming (995)
	Cuming (996)
Mr M. White (1926)	Irish School, 18th century (876)

APPENDIX 12
Works Bought at Known Sales and Auctions

Allnutt Sale, London (1863)	Jordaens (46)
Lord Ashburton Sale, London (1871)	Panini (95)
Beckett-Denison Sale, London (1885)	Faber (243)
Besborodko Sale, Paris (1869)	Attributed to Murillo (33)
	Sassoferrato (83)
Blamire Sale, London (1863)	Bega (28)
	Heem (11)
	Italo-Flemish School, c.1600 (1749)
Blenheim Palace Sale, London (1886)	Brescian School (277)
	Teniers the Younger (288)
	Teniers the Younger (289)
Bromley-Davenport Sale, London (1863)	Palmezzano (117)
Carr Sale, Shipton (1862)	After Dyck (1937)
	After Mabuse (361)
	Attributed to Ribera (12)
	Thulden (2)
	After Velazquez (1930)
Chatsworth Sale, London (1958)	Coter (1380)
	Master of the Magdalen Legend (1381)
Sir Alfred Chester Beatty Sale, Dublin (1968)	Hickey (1860)
Collins Sale, Dublin (1887)	Irish School, 19th century (302)
	Irish School, 19th century (303)
Comte de Choiseul Sale, Paris (1866)	Attributed to Granacci (98)
	Strigel (6)
	After Weyden (4)
Demidoff Sale, Paris (1870)	Titian (84)
Dr Doyle Sale, Dublin (1977)	Gabrielli (4202)
Dublin Art Loan Exhibition (1899)	Michel (487)
Dublin Library Sale (1882)	Cuming (187)
Bishop of Ely Sale, London (1864)	Knijf (53)

Lord Ely Sale, London (1891)	Gaven (399)
Farrer Sale, London (1866)	Faber (21)
	Neer (61)
	Neer (66)
Gibson-Craig Sale, London (1887)	English School, 16th century (281)
	English School, 16th century (282)
Graham Sale, London (1886)	After Cano (369)
Hadzor Sale, London (1889)	Cuyp (151)
	Mytens (150)
	Pape (149)
Hamilton Palace Sale (1882)	Bonifazio de 'Pitati (178)
	Oliverio (239)
	Poussin (214)
	Spagna (212)
Hardwicke Sale, London (1888)	Dutch School, 17th century (291)
Knighton Sale, London (1882)	Wynants/Lingelbach (280)
Malahide Castle Sale, Co. Dublin (1976)	Austrian School, c.1800 (4168)
	Canevari (4169)
	English School, c.1670 (4160)
	English School, 17th century (4167)
	After Hunter (4165)
	Irish School, 18th century (4164)
	Italian School, c.1660 (4159)
	Latham (4153)
	Latham (4154)
	Latham (4155)
	Latham (4156)
	Attributed to Lely (4140)
	Attributed to Lely (4141)
	Morphey (4146)
	Morphey (4147)
	Morphey (4148)
	Morphey (4149)
	Morphey (4150)
	Morphey (4151)
	Morphey (4152)
	Attributed to Rigaud (4166)
	Riley (4162)
	Attributed to Riley (4163)
	Scottish School, 16th century (4139)
	Smitz (4142)
	Smitz (4143)
	Smitz (4144)
	Smitz (4145)
	Tilson (4158)
	Attributed to Wissing (4157)
	Wright (4184)
	Attributed to Wright (4161)
Narischkine Sale, Paris (1883)	Bellotto (181)
	Bellotto (182)
Naylor Sale, Dublin (1959)	Bol (1394)
Nieuwenhuys Sale, London (1886)	Slingeland (267)
Marchioness of Ormonde Sale, Dublin (1860)	After Vignon (1912)
Perkins Sale, London (1890)	Renieri (363)
Marquis de la Rochelle Sale, Paris (1873)	Mytens (62)
Secretan Sale, Paris (1889)	Delen/Hals (119)
Somervell Sale, London (1887)	Signorelli (266)
Thornley Stoker Sale, Dublin (1910)	Aertsz (619)
	Irish School, c.1750 (615)
	Mulready (616)
Archdeacon Thorp Sale, Durham (1863)	Guardi (63)
	Moucheron (52)
	Salmeggia (78)
	Salmeggia (80)
	After Veronese (1962)
Whitehead Sale, London (1868)	Potter (56)
(1874)	Hogarth (126)

APPENDIX 13
Gifts from the Friends of the National Collections

Donor and year	Artist and picture number
(1904) (With a contribution from the National Gallery)	Quillard (564)
1934)	Vries (972)
1936)	Tonks (985)
1947)	Turner de Lond (1148)
1949)	Yeats (1179)
	Yeats (1180)
1952)	Keating (1236)
	Orpen (1237)
1954)	Mulvany (1284)
1956)	Barrett (1319)
	Hamilton (1342)
	Yeats (1318)
1957)	Hone (1371)
1970)	Rothwell (1936)
1973)	Irish School, 18th century (4069)
	Russell (4068)
1976)	Purser (4188)
Date unknown	Daubigny (1796)
Mrs A. Bodkin (1963)	Barret (1760)
	Barry (1759)
Mr G. Boyle (1947)	Boyle (1139)
Mrs J. Egan (1960)	Yeats (1549)
	Yeats (1550)
Mr H. Jacob (1943)	De Gree (1106)
Sir Alec Martin (1930)	Frye (924)
(1938)	Hone the Elder (1003)
(1959)	Hickey (1390)
Sir Alec and Lady Martin (1947)	School of Bassano (1141)
Mlle Zillhardt (1928)	Breslau (908)